[ BILL CURTSINGER ]

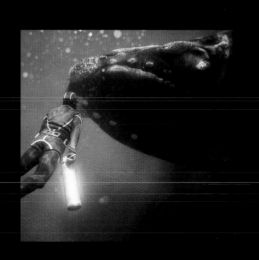

# EXTREME
# NATURE

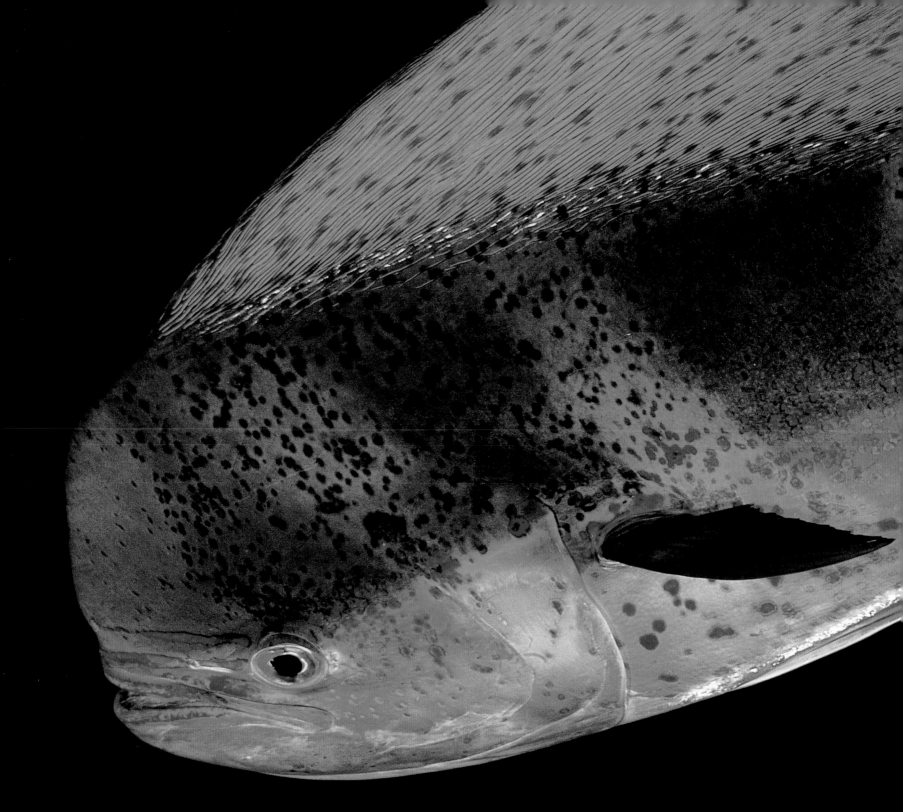

# TEXT AND PHOTOGRAPHS
## by BILL CURTSINGER

EDITORIAL DIRECTOR
VALERIA MANFERTO DE FABIANIS

GRAPHIC DESIGN
CLARA ZANOTTI

GRAPHIC LAYOUT
PAOLA PIACCO

EDITORIAL COORDINATION
MARIA VALERIA URBANI GRECCHI

# WHITE STAR PUBLISHERS

© 2005 White Star S.p.A.
Via Candido Sassone, 22/24
13100 Vercelli - Italy
www.whitestar.it

ISBN 88-544-0078-5

REPRINTS:
1 2 3 4 5 6   09 08 07 06 05

CONTENTS

4

1  Diver, Andy Pruna,
meets right whale in
Argentinian waters.

2-3  Dolphins,
*Coryphaena hippurus*,
Bahamas. Dolphins
fish are one of the
fastest fish in the sea,
clocked at over 50 km
per hour with short
sprints even faster

5  A leopard seal,
*Hydrurga leptonyx*,
stares at me through
veil of Antarctic
plankton.

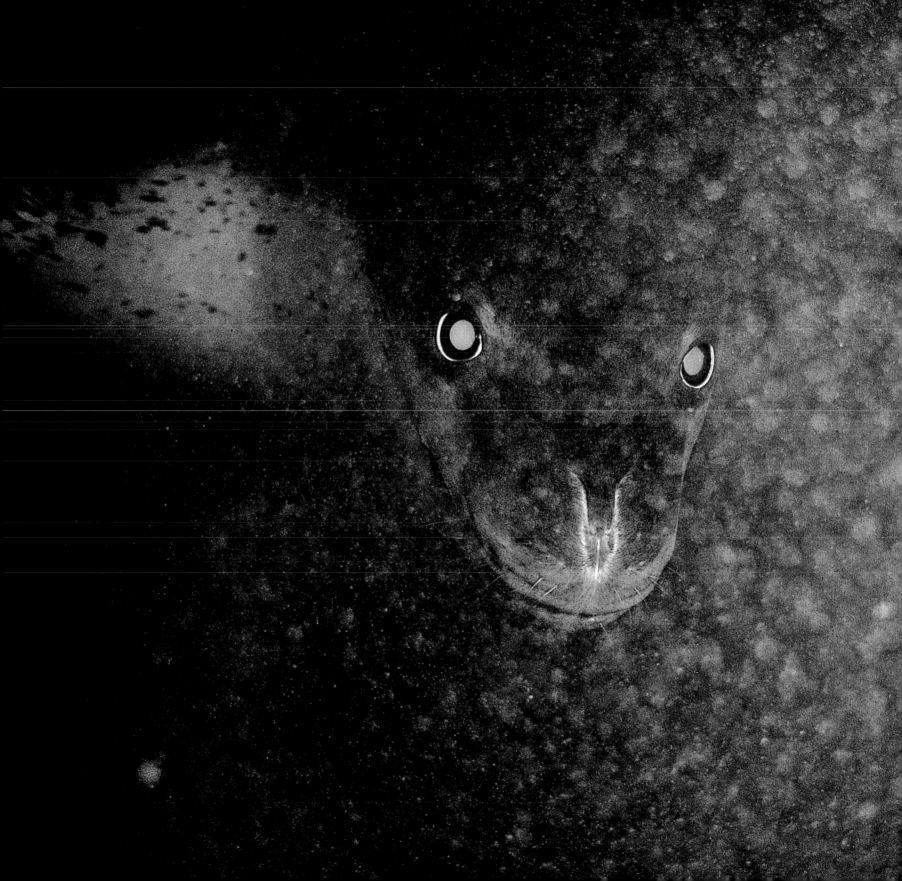

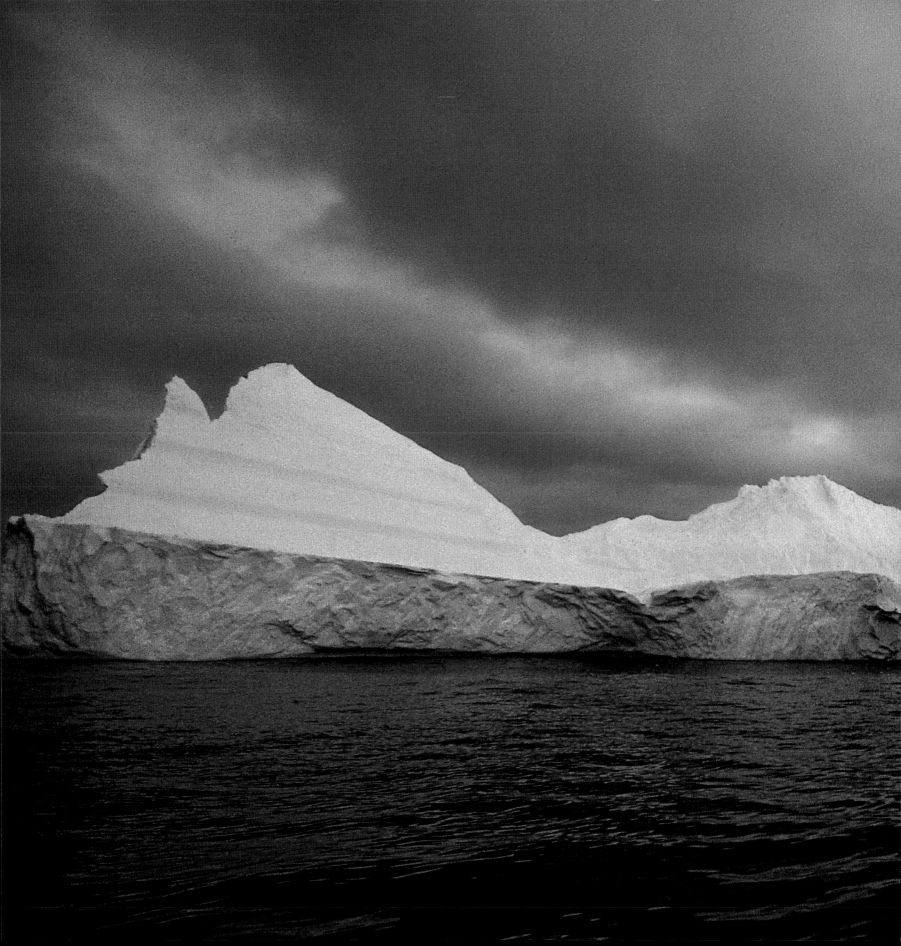

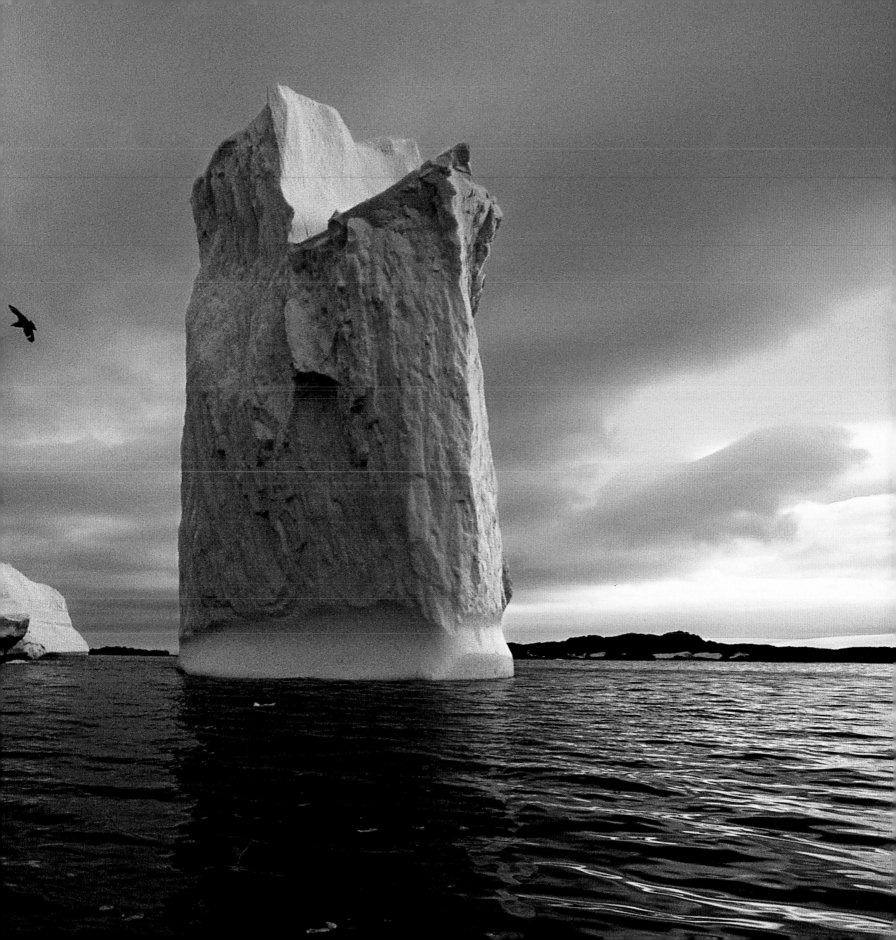

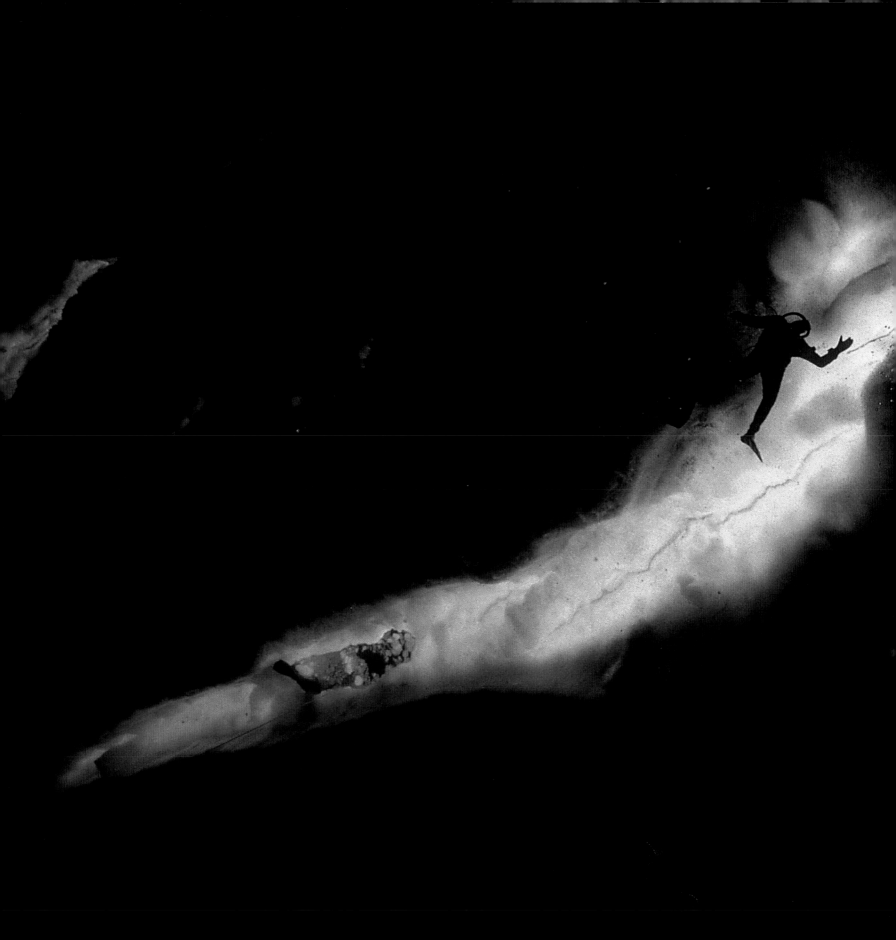

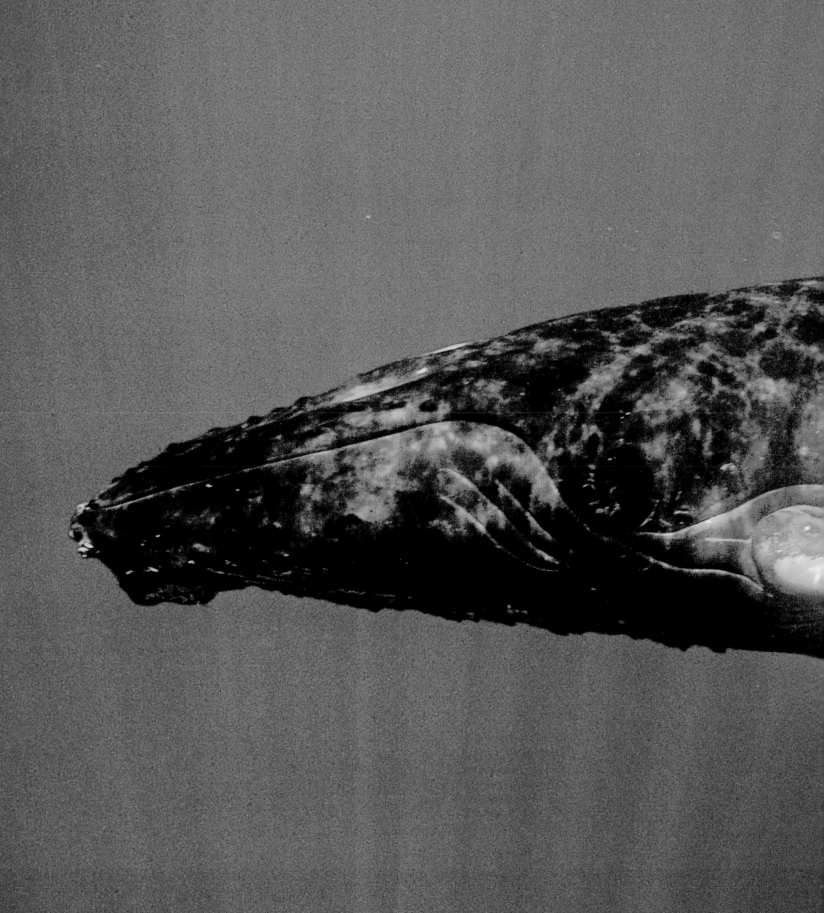

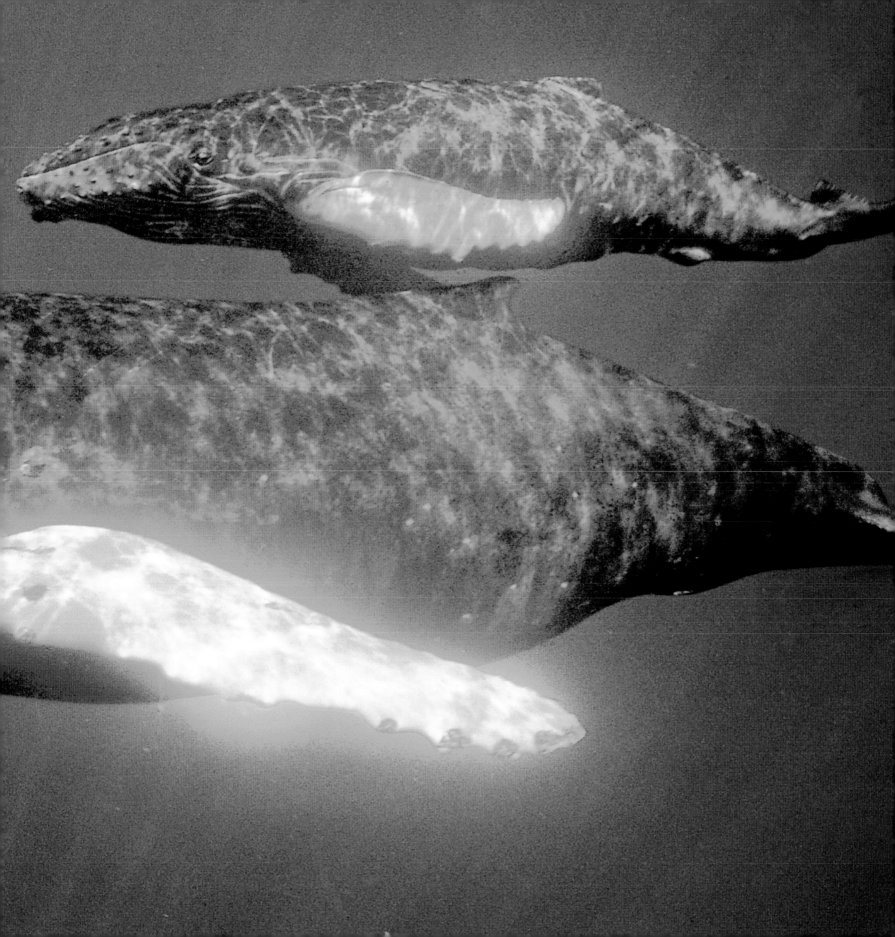

# PREFACE

T HERE IS A MYSTERIOUS BLUE UNDER-WORLD THAT FASCINATES ME. IT BEGAN WHEN I WAS TEN YEARS OLD AND CLIMBED INTO A WIND-SWEPT FIR TREE THAT CRADLED ME IN ITS TWISTED HORIZONTAL LIMBS. THE FIR STOOD NEXT TO MY GRANDPARENT'S BEACH COTTAGE ON THE OREGON COAST.

Often, the breeze blowing off the Pacific would be swift and cold, but I'd stay in my tree, enthralled by the constantly changing blues, intent on imagining the world beneath the waves.

Even now, after years of travel for National Geographic and trips to many of the world's oceans, that fascination has only increased. Perhaps it is because I know more now, thanks to Bill Curtsinger. Bill's haunting images take me below the blue I observed as a boy, and into the seldom seen world of the coldest ocean regions. The environment is inhospitable, known only to those few divers with the skill, courage and the commitment to work under difficult circumstances. Bill's territory is not the kaleidoscope of color emblematic of the warm water coral reefs that most people asso-

ciate with underwater photography. Instead, he prefers the subtle, graceful world lit by a larger palette of blues and greens. "If I had to pick my favorite place on earth to photograph, it would be the Antarctic. I have been there five times," he says. Bill prefers severe landscapes and elusive subjects. But don't think for a minute that his blue-green world isn't rich. The polar and temperate oceans are productive, in fact, the most productive waters on earth. Which is why documenting the life in them is so important.

This is Bill's passion, but it is a passion complimented by an artist's eye. "I am an artist and a biologist who seeks out clever and rarely seen subjects," he says. "To do this I have to learn everything I can about my subject, and what makes this particular species different from all the rest. I must know their habits and behaviors. I learn what they eat, what eats them, their population status, as well as the conservation efforts that exist in order to understand and save them from extinction." Like the best of the National Geographic con-tributors, Bill is a photographer with a mission.

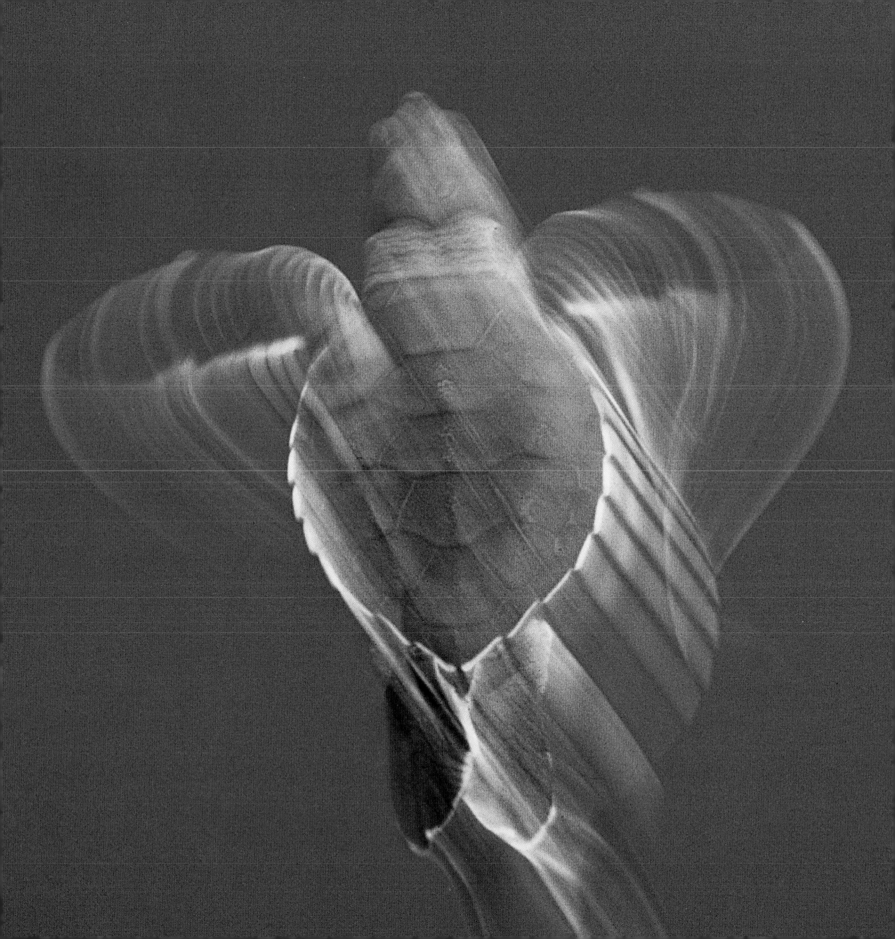

His is not a lecturing, pedantic mission, but rather a quiet, calm mission, in keeping with his quiet, calm personality. His work is mysterious, evocative; and it often pushes the edge. Take one of Bill's photographs from his February 1994 National Geographic magazine cover article on sea turtles. The image—a sea turtle caught on a long-line is alarming and beautiful, an illustration of the convergence of Bill's commitment to conservation and his commitment to art. It is art with a message. The photographer is transparent; his goal is to help the reader to care, to appreciate the turtle's beauty, and to mourn its fate.

When I look at Bill's sea turtle photos, or the pictures from any of his thirty-three stories for National Geographic magazine, I immediately sense his connection with his subjects. His photographs are honest; they lack pretense. A Bill Curtsinger photograph makes it clear that he has spent the time and effort to become truly connected with a porpoise, seal, whale, walrus, gray reef shark, or whatever subject he photographs. His commitment has nearly cost him his life. In 1972, Bill was attacked by a gray reef-shark while on assignment in the Caroline Islands for National Geographic. He's had close calls while diving under the ice in Antarctica and the Gulf of St. Lawrence and photographing fishermen's nets in the Gulf of Maine. But Bill, like all veteran photographers, understands risk. He, and others like him, know that getting close is the first rule of photography. There is no other way to tell a story. Anything less is doomed to failure.

The photographs in *Extreme Nature* are a testament to Bill's love of the planet we inhabit. This is original work. It is also important work. Bill Curtsinger takes us beneath the mysterious blue ocean that humanity has contemplated for generations. It takes me back to my childhood perch above the blue, and reveals the mysteries beneath to be even more fascinating than I could have imagined.

*CHRIS JOHNS*
*EDITOR IN CHIEF*
*National Geographic Magazine*

VOL. 140, NO. 5 — NOVEMBER 1971

# NATIONAL GEOGRAPHIC

VOL. 149, NO. 1 — JANUARY 1976

# NATIONAL GEOGRAPHIC

VOL. 168, NO. 1 — JULY 1985

# NATIONAL GEOGRAPHIC

16TH-CENTURY
*Basque*
Whaling
IN AMERICA 40

VOL. 172, NO. 6 — DECEMBER 1987

# NATIONAL GEOGRAPHIC

OLDEST
KNOWN
SHIPWRECK

VOL. 185, NO. 2 — FEBRUARY 1994

# NATIONAL GEOGRAPHIC

## SEA TURTLES
In a Race for Survival 94

VOL. 187, NO. 1 — JANUARY 1995

# NATIONAL GEOGRAPHIC

## Gray Reef Sharks 45

# INTRODUCTION

M Y LIFELONG INTEREST IN BEING ON AND IMMERSED IN WATER BEGAN WHEN I WAS A YOUNG BOY GROWING UP IN SOUTHERN NEW JERSEY. I SPENT A LOT OF TIME FISHING AND HUNTING IN THE WOODS AROUND MY HOUSE.

I learned to swim in a dark brown, tannin-filled river called Rancocas Creek that was a mile or so away. I also spent countless days fishing that creek for whatever I could catch, bass, pickerel, sunfish, and catfish. It was here too, where I first became interested in hydrology, the science that studies the properties, distribution, circulation and transport of water. A smaller creek known locally as Bobby's Run flowed into the Rancocas right where I used to fish and swim. Bobby's Run also ran adjacent to a farmer's watermelon field about a half-mile north. Once on a hot summer day, a friend and I "removed" a couple of watermelons from that field, placed them in Bobby's Run and walked back to our swimming hole with our hands in our pockets and grins on our faces. We sat down and waited. Given the strength of Bobby's Run that day I knew that sooner or later, those illicitly acquired watermelons would be ours. In about an hour, the watermelons came bobbing down the creek to where we waited cooled by the waters that bore them

along to our youthful, light-fingered hands. I didn't make a career in hydrology per se, or stealing watermelons for that matter, but at this place along Rancocas Creek I started to become the water person I am today. I also learned a few of life's important lessons; don't steal other people's property, be patient, and believe in nature.

When I was old enough to drive, I started exploring the Pine Barrens --an unbroken forest of pine, oak and cedar stretching over one million acres across southern New Jersey. The Pine Barrens comprises about 22% of the state's landmass. What makes this place so unique is that it is located smack in the middle of one of America's biggest population centers- - the megalopolis between New York City and Washington, D.C. The Pine Barrens is where I began to realize I wanted to find a way to earn a living in nature. I walked the sandy trails, picked blueberries and cranberries, hunted deer and duck, fished for pickerel, canoed and swam the rivers and ponds, and found a little of who I was and who I wanted to be. Growing up, I didn't get much guidance as to who I might become and how I might get there. Our dinner table, like the rest of the household, was more like a battlefield that I just wanted to sur-

17  A photographer's quest begins. Images from the world's edge.

vive. My relationship with my father was tentative at best. He was abusive to all of us and it wasn't until my twin brother and I finally teamed up to assert ourselves with him that my life there started to change. I was sixteen. He was still my father, but he was suddenly without "portfolio," and I never listened to a word he had to say after that.

Looking back, I realize my father gave me a great gift, although I didn't know it at the time; he taught me how not to be a father. Our house was void of books, except those I bought or borrowed: there was no interesting or intellectual conversation of any kind. My grandfather in Michigan, Russell Kemp, provided some of that when I saw him during summer visits. Each month he used to send me his National Geographic Magazine when he had read it. That gesture and those pages: how important they were to me! My grandfather and grandmother died in an auto accident while I was in the Navy, but I like to think of how proud he would have been to see me in a career he helped inspire.

The heart of the Pine Barrens was about 22 miles (36Km) from where I grew up in Lumberton Township. I remember the pristine lakes and ponds where I used to swim and picnic during the summer. I remember Lake Absegami the 60+acre lake with a beautiful Indian name. To my young eyes it seemed more like an ocean. When the lifeguards went home for the day, I would swim across to the outlet on the western side and back, well over a mile. I was about fifteen. Along a narrow shallow spur on the southern shore I used to sit for hours and watch big red-bellied turtles sunbathe on logs. Occasionally I would throw a rock their way to get some kind of reaction. I'm sure I didn't invent that game; watch turtles, get bored, throw rocks. The very first photograph I ever made was of a red-bellied turtle resting on a log on the edge of a Pine Barrens pond. I made that picture with a camera I bought at a local photo shop, a Kodak Retinette 1A 35mm rangefinder. The camera didn't have a light meter and in order to use it successfully I had to learn the fundamentals of photography. This was a good thing. New students to photography should put away their digital automatic cameras once in a while, pick up a camera you have to think with, and start learning about light. Around this time I started to buy my first nature books. In them, I found more inspiration.

During the Vietnam War, I was drafted out of college in Arizona and ended up in the Navy, a member of an elite photo unit called Atlantic Fleet Combat Camera

Group). We were based in Norfolk, Virginia. I became a Navy diver and began traveling the world to make photographs. I volunteered to go to Antarctica and went in 1968. I was assigned to the National Science Foundation's Office of Polar Programs. At the time, the Navy supported the US Antarctic science effort with ships, helicopters, fixed-wing aircraft and supply runs from New Zealand and the U.S. The very first marine mammals I ever worked with were seals in Antarctica during my first trip there. This was also my introduction to cold water diving—an uncomfortable passion I can't seem to give up. Thirty days after leaving the Navy in 1970, I landed my first assignment for National Geographic: a story on life on the Antarctic Peninsula. With this assignment I first found a niche photographing whales, seals and dolphins all around the world for the Geographic. This effort continues today. My latest National Geographic article on harbor porpoises in the Gulf of Maine in June 2003 brings my contributions to over thirty-three articles; six of them cover stories. In 1979, after the first dozen years photographing marine mammals, my efforts were compiled into my very first book, *Wake of the Whale*, written by Ken Brower and published by David Brower of Friends of the Earth.

There are pictures and there are photographs. You take pictures, but you make photographs. Professional photographers make photographs. Before I go into the field, I already know the kinds of photographs I hope to make. I direct all my energy to that end. I often have dreams about these photographs, dreams of swimming with a beast I've never seen before and coming home with extraordinary images from that encounter. I think about them all the time. Sometimes it all works. Sometimes an image never goes beyond being, well, just a dream. Some photographs are surprises, and I have learned over the years to be ready for unplanned moments of opportunity. Once, I was sitting on the edge of a sea cliff at Cape Crozier, Antarctica. 130,000 breeding pairs of penguins come here each southern summer to nest. Behind me was a colony of them that stretched across a huge hill. In the water below me, a flat piece of sea ice was drifting by. On it was a large group of Adélie penguins. It was an overcast day and the light was flat. I was captivated by the penguins facing me, and the strong black & white design they created against the white sea ice. I grabbed a camera loaded with black & white film. After a frame or two, a leopard seal leaned over the edge of the far side of the floe, well out of frame. In

unison, every single penguin turned towards the predatory seal. I kept my eyes and camera focused on the penguins as they reacted, and photographed the other side of the group. In a way, that leopard seal helped me produce these two images of Adélie penguins, front and back. My eye was simply in the right place at the right time.

Being in the right place at the right time is what I try to do. I try to be ready for whatever surprises come my way and make the best images I can from them. I am a photographer. I am not a diver. Diving is a means to an end: I use it as a way to be with the animals that mean the most to me, as someone might use a car to get their horse at a distant stable. Diving allows me to make images of creatures most people have never seen and may never see in their lifetime. I'm at ease underwater: I am able to forget about the diving and concentrate on the photographs I want to make. A defining and unique characteristic about my work is that I have little interest in the colorful, flamboyant environment of coral reefs that most people associate with the underwater world. The most productive oceans on the planet are polar and temperate, not tropical coral environments. Most of the commercially valuable fish species found in fish markets worldwide come from temperate waters. The challenge of

photographing the not so obvious, or what has not been seen before; in the most remote, coldest, regions of the planet has been the motivation for much of my photography. I prefer to document severe landscapes and elusive animal subjects.

My underwater world feels primeval and primitive sometimes, and for much of my career I have entered this underwater realm without the guidance and help of someone who had been there before me. That was true for my marine mammal work, as well as many other species both aquatic and marine that I have photographed. That is what, *Extreme Nature*, is all about; taking readers to the edge of our world with photographs of underwater creatures that might be new to them, in an artful and unique way. This kind of underwater photography is difficult and often dangerous. I have had to acquire skills beyond what a recreational diver acquires at a local dive shop. Enjoying the underwater world of a coral reef is one thing, working in a cold dark sea is quite another. The effort just to get myself in situations where I can encounter the animals I want to work with can be enormous. Many of the species I have captured on film had never been photographed underwater before. I like to think of myself as artist and biologist. Weeks of preparation precede every assignment. I have to learn everything I

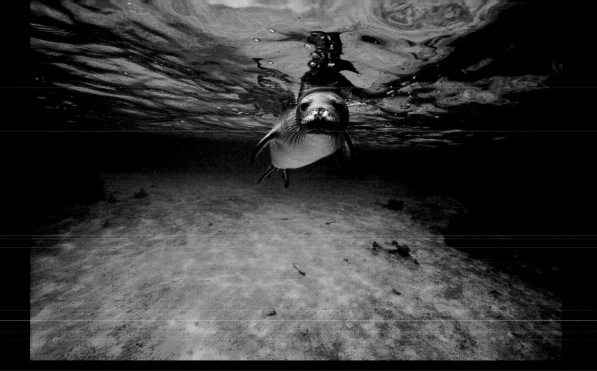

21  The most beautiful and endangered of all seals, the Hawaiian Monk Seal.
With fewer than 2000 alive today this species faces extinction.

can about my subject, and what makes a particular species different from the rest. I must know its habits, and understand its behaviors, whether it is migration patterns, range, foraging practices or reproductive behavior. I also learn about any on-going research or conservation efforts that exist to understand or help save the species from extinction. I have to figure out where to put myself so that I might work successfully. Before I go I have to convince my editor and myself that by spending time and money in a certain place I will be able to extract images that will be new and different; that tell a story. Any professional photographer, especially those that work in the editorial market as I do, might tell you why they would not recommend this as a career choice. You work in a very tough competitive field where many try to board the train and the few that manage to get onboard rarely arrive at their hoped-for destination. You have to be away from home, family and

friends weeks or months at a time. The Antarctic is a long way from everywhere and once there, well, you're there. Along with any assignment you're lucky enough to get comes the following truth: you are only as good as your last story. If you don't pull this one off, you might not get another chance, especially from top-tier publishers like the National Geographic. Every time you step out the door and begin another assignment there is a weight on your shoulders; money is being spent and expectations are high. New and innovative coverage is expected, and an editor is waiting back in the office to see how well you have done. Being a freelance photographer and writer is not a career for the uncommitted or thin-skinned. Here is one more truth about the editorial world I've somehow managed to stay with: be prepared for rejection. It comes with the territory and it comes from all corners, and the risk of feeling it never seems to go away. But ask me if I would do this all over again and my answer would be, I guess, in a heartbeat. Being far away from the ones you love for so long is almost as taxing as the assignment itself. You worry about everything, hopeful that you have done all you can do to keep home, family, and relationships together until you return.

One way I've managed to stay connected to my family, especially in places where it is difficult or impossible to phone home, is through my journals. I would sit down and write about the day's events and draw maps and pictures of things I saw or things that interested me. In some unplanned way, this always helped me to stay connected. Today it's easier to stay in touch with cell phones and email, but I still like the old fashion way, too. The two journals reproduced here are ones I call, *Traveling to Owen*. Owen is my youngest son and in 1995, the night before I left for an assignment in Southeast Alaska, he handed me a small blank book he had made in school. It was a signature of eight sheets of paper folded in half and sewn into a binder at the crease. It was a handsome little book with a striped design on the cover. Owen was nine at the time. He asked me to write in it about my trip while in Alaska. I did. The final entry sort of explains why this process worked so well for me and I like to think, for Owen as well: "July 14, 1995. Dear Owen: This is the final page and the last entry in this book. You handed me this empty blank book a month ago and asked me to write in it about my trip to Alaska, and I did. I felt in many ways that you were right here with me as I met

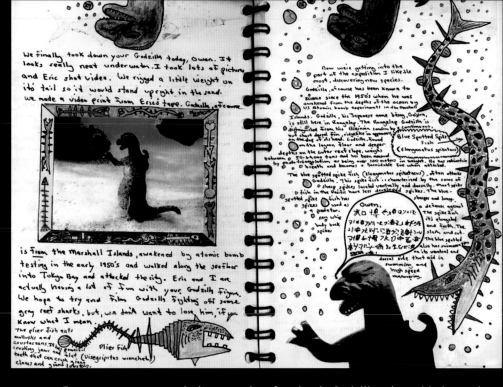

The journal page contains handwritten text:

We finally took down your Godzilla today, Owen. It looks really neat underwater. I took lots of pictures and Eric shot video. We rigged a little weight on its tail so it would stand upright in the sand. We made a video print from Eric's tape. Godzilla, of course,

Now we're getting into the part of the expedition I like the most, discovering new species. Godzilla, of course has been known to science since the 1950's when he was awakened from the depths of the ocean by US atomic bomb experiments in the Marshall Islands. Godzilla, his Japanese name being Gojira, is still here in Rongelay. The Rongelay Godzilla is distinguished from his Bikinian cousin by a continuous, but short dorsal fin, ridgelike in appearance on the dug of his head. Godzilla, found on the lagoon floor and deeper depths on the outer reef slope, weighs between 0,50-60,000 tons and has been named by gradu transmogrification, or being over 300 meters in length. He has radioactive breath and becomes a formidable foe when attacked.

The blue spotted spike fish (Elongnatus spiketecus), often attacks Godzilla. This spike fish is characterized by the rows of sharp spikes located ventrally and dorsally. Most spike fish in the Pacific have less developed spikes. The blue-spotted spike fish has stronger and longer spikes used as a predator. Its long whip body back spikes

Owen, [Japanese characters]

a defense against the spike that its elongated and forth. The blue spotted also has swimming on its ventral end dorsal side that aid in swimming, and high speed maneuvering.

Blue Spotted Spike Fish (Elongnatus spiketeus)

is from the Marshall Islands, awakened by atomic bomb testing in the early 1950's and walked along the seafloor into Tokyo Bay and attacked the city. Eric and I are actually having a lot of fun with your Godzilla figure. We hope to try and film Godzilla fighting off some gray reef sharks, but we don't want to lose him, if you know what I mean.

The plier fish eats mollusks and crustaceans. It has powerful crushing jaws and plate teeth that can crush giant clams and giant lobsters.

Plier Fish (Visegriptus wrenchcha)

23  Fantasy creatures and photographs of a plastic Godzilla adorn this journal page I created for my son Owen in, *Traveling to Owen*.

new people, sailed new seas, dove new waters and had many new and exciting adventures. Each day when I would sit down and write or draw something, you didn't seem so far away. It was a lot of fun creating the words and pictures; fun sharing my travels with you in this way. I was a long distance, many miles away but every evening while writing in this little book you made in school I felt closer, like I was traveling to you each night, *Traveling To Owen*. I want to tell you that even though I did this for you, by asking me to do this you gave me something too. So, thank you Owen, thank you. I love you forever. Dad " Today, Owen is in University majoring in creative writing.

In the summer of 2003 my wife of twenty-nine years and mother of our two sons, Kate Mahoney, died of breast cancer. She battled this disease for over seven years. She quietly passed away one morn-

ing in June in a room on the first floor of our home in Maine. She was a painter and a printmaker and art was her first love. Many of the images in this book are from moments we shared together. For the first eight years of our marriage we were rarely apart. She traveled with me on all of my assignments in those years, and assisted my efforts in so many ways. She was a great supporter of my dreams and the work on these pages. For my sons and I, the transition to life without her has been a hard one. We see her now, after her long struggle, at peace in the world we shared and loved and we know she no longer suffers as she did. Her love and her brilliant smile will be with us forever. We are fortunate to have so many beautiful creations, her paintings and prints that we remember her by and that speak to us everyday. And above all, there are three words that remind us of her the most. We put them on her stone in a cemetery overlooking the Royall River near our home in Maine; "Art, Love and Laughter."

I have always had an inner voice that speaks to me when things seem gloomy. This voice is something I really hear, deeply and honestly, in a visceral way. As a young man I listened to it, and I knew that there was more for me out there in the big wide world. Even back then I had my dreams and I somehow managed to get to where I wanted to go, in spite of what was. I often speak to people young and old in schools and at public venues where I present my work. I don't dwell on my story but I do talk about not ignoring that inner voice that calls to you. If you want to get somewhere, if you want to scale heights you fear are impossible, you must believe you can. You have to believe in your voice and in the journey you would like to make. I believed in myself and I believed in what I wanted to do, and I just kept on going toward the next mountain I had to climb in order to get there. Many of the photographs I hope to be remembered for are in this book. The leopard seal eyes, the swimming sea turtle hatchling, the Emperor penguins underwater, the harp seal beneath Arctic ice, the secretive harbor porpoises in the Gulf of Maine, and the wild Atlantic salmon swimming upstream are some of my favorites. I will add to this list. I like to think that my work has revealed to some how splendid a place our planet is and has helped others discover their own sense of wonder and reverence for our planet's natural gifts especially those that often go unnoticed or unseen.

# THE ANSWER
By Robinson Jeffers

*Then what is the answer?- Not to be deluded by dreams.*
*To know that great civilizations have broken down into violence,*
*and their tyrants come, many times before.*
*When open violence appears, to avoid it with honor or choose*
*the least ugly faction; these evils are essential.*
*To keep one's own integrity, be merciful and uncorrupted*
*and not wish for evil; and not be duped*
*By dreams of universal justice or happiness. These dreams will*
*not be fulfilled.*
*To know this, and know that however ugly the parts appear*
*the whole remains beautiful. A severed hand*
*Is an ugly thing and man dissevered from the earth and stars*
*and his history... for contemplation or in fact...*
*Often appears atrociously ugly. Integrity is wholeness,*
*the greatest beauty is*
*Organic wholeness, the wholeness of life and things, the divine beauty*
*of the universe. Love that, not man*
*Apart from that, or else you will share man's pitiful confusions,*
*or drown in despair when his days darken.*

From THE COLLECTED POETRY OF ROBINSON JEFFERS, edited by Tim Hunt.

Used with the permission of the publishers, Stanford University Press. ©1936, renewed 1966 by Donnan and Garth Jeffers.

Copyright transferred 1995 to the Board of Trustees of the Leland Stanford Junior University"

# TRAVELING TO OWEN: JOURNALS TO
## MY SON OWEN: STAYING CONNECTED FROM FAR-FLUNG PLACES.

26  Detail of journal page from Rongelap Trip.

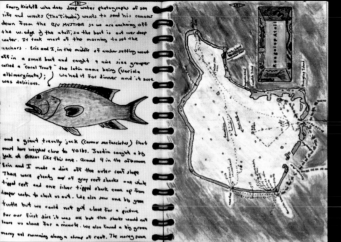

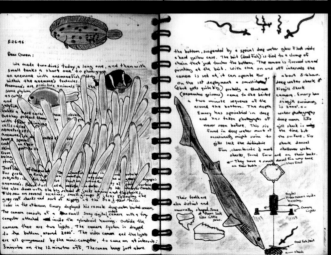

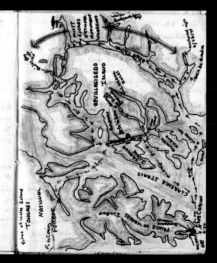

27 left  Two spreads, Journey to Rongelap, Marshall Islands.

27 right  Two spreads, SE Alaska.

# [BILL CURTSINGER]

# EXTREME NATURE

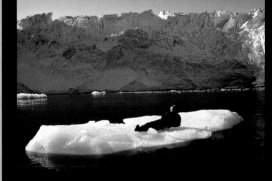

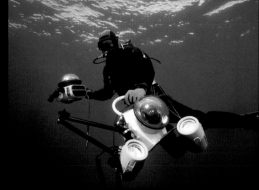

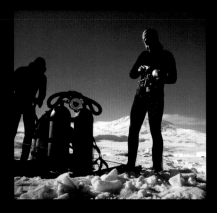

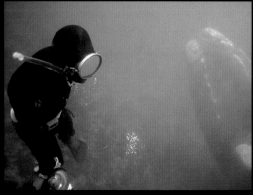

Preparing to dive beneath
Antarctic Ice, 1968.

With right whales, 1972.

Waiting for turtles on remote
Mexican beach, 1993.

30-31 A curious Blue shark swims by my camera, Gulf of Maine The small pores visible here are called Ampullae of Lorenzini. They are electroreceptive organs used to detect the electrical field produced by other animals.

32-33 A Blue jack at Bikini Atoll moves through the water column. I use a fill flash and a slow shutter speed to capture its speed.

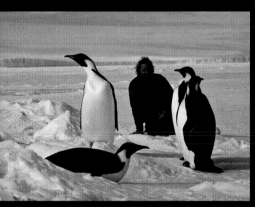

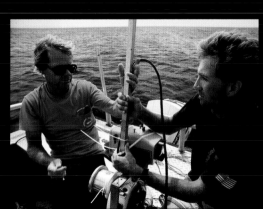

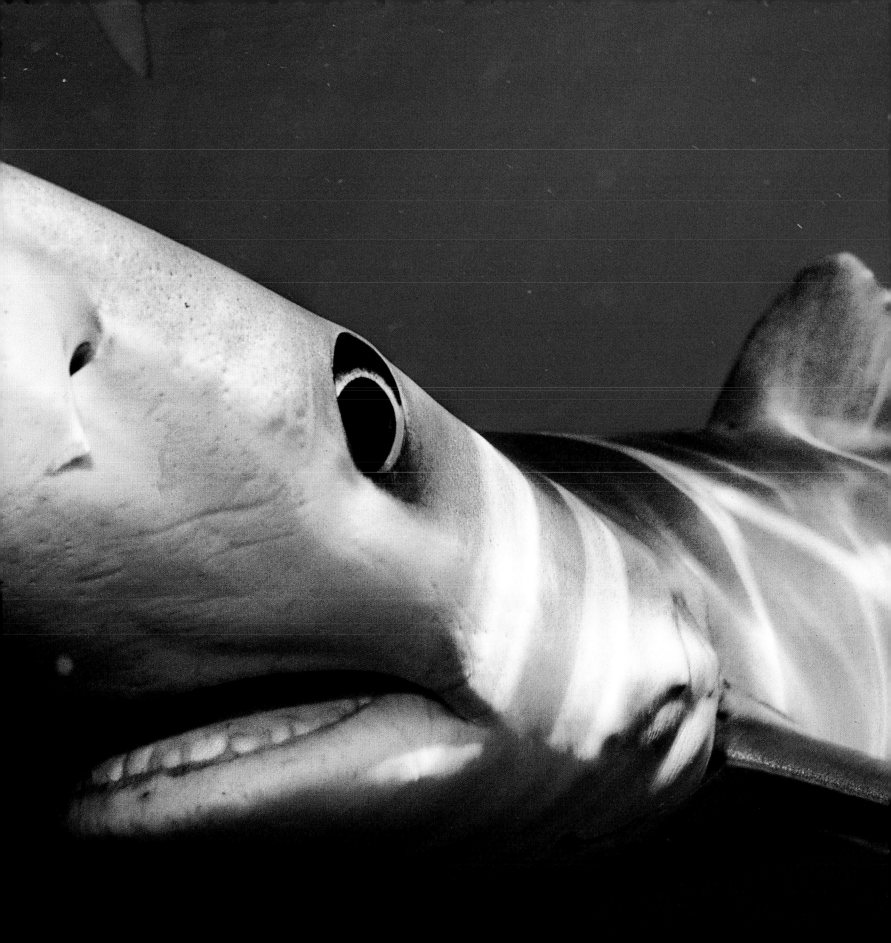

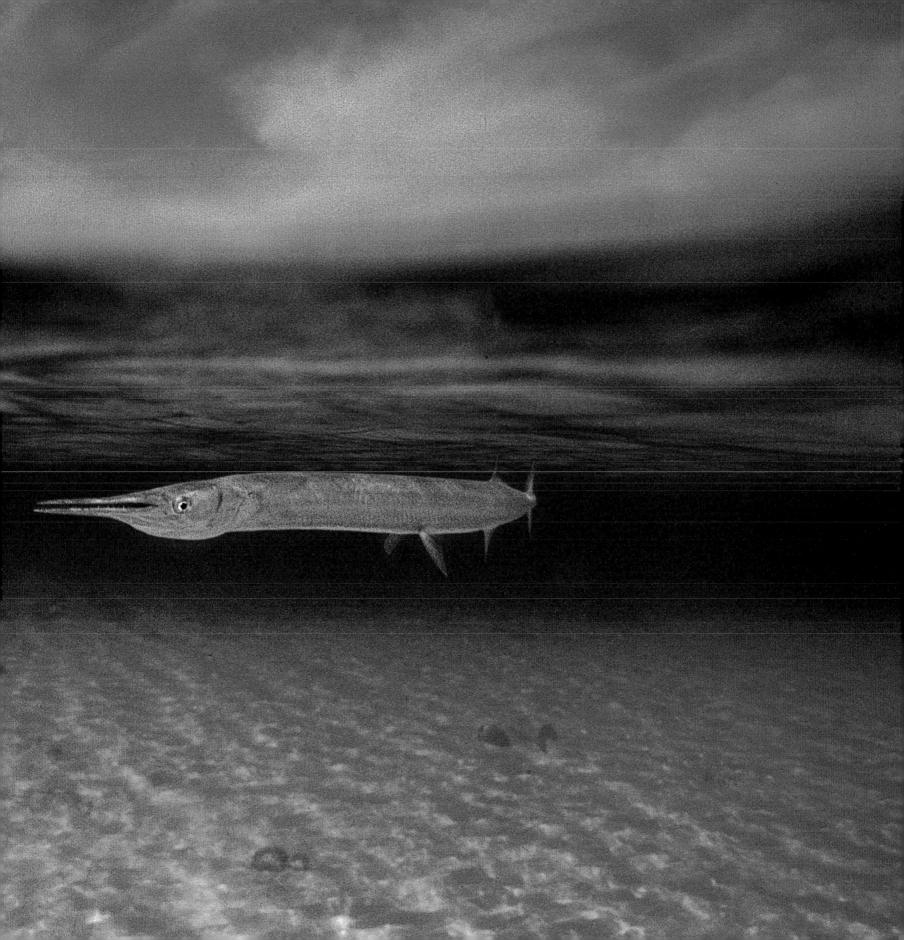

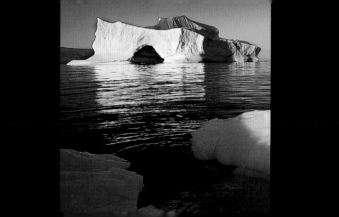

# ANTARCTICA

## TERRA AUSTRALIS INCOGNITA

# ANTARCTICA

## TERRA AUSTRALIS INCOGNITA

I F YOU COUNT EUROPE AND ASIA AS SEPARATE CONTINENTS THERE ARE SEVEN IN ALL. THE FIFTH LARGEST IS ANTARCTICA.

For centuries it went unseen and humankind did not bear witness to its existence until the early 1800s, at least no witnesses we know about. It was the big Terra Australis Incognita somewhere in the Southern Ocean. Terra Incognita until the Russians, the Scandinavians, the British, the Americans, and a couple of South American nations started planting their flags there. I have always wondered if some boatload of non Euro-Americans, Polynesian seafarers or Chinese or some other adventurers might have had their ocean canoes or ships blown south. Ship-wrecked and illequipped as they might have been, they never lived long enough to figure out how to make a go of it in Antarctica or how to make their way back north. I like to imagine an archaeologist some day stumbling on some artifact that confirms such a scenario, a Chinese junk at the bottom of the Weddell Sea.

My very first glimpse of Antarctica was from the tiny window of a four-engine, propeller-driven US Navy Super Constellation. The year was 1968, some 150 years after Antarctica had been formally discovered by Euro-Americans. I was flying from Christchurch, New Zealand to the US Antarctic base at McMurdo. The flight time was over eight hours. I remember it taking forever, a flight that would never end– until I looked out the window and had my first view of the frozen world below. I had volunteered to go to Antarctica when I was a photographer in the US Navy assigned to the Atlantic Fleet Combat Camera group. This was usually a dreaded assignment for sailors in my unit but I wanted to go the minute I learned it was possible. I always had a fascination with the polar world and here was a free ticket! I was assigned to the National Science Foundation's Antarctic Research Program that first trip. Since 1968 I have returned to the Antarctic three more time on assignment for the Navy and then the National Geographic.

One question I am asked more than any other is, "in all your travels, where is your favorite place on earth?" My answer often surprises. It is the Antarctic. Uninhabited by any aboriginal peoples and visited by relatively few humans, Antarctica remains, for the most part, a pristine untouched continent. In four separate trips to Antarctica, I have spent over 18 months of my life there, and I would go back tomorrow. I love it that

36 An iceberg drifts along the Antarctic Peninsula. An archway carved by the sea beckons the unwary.

39 Emperor penguins fly through icy waters with speed and agility.

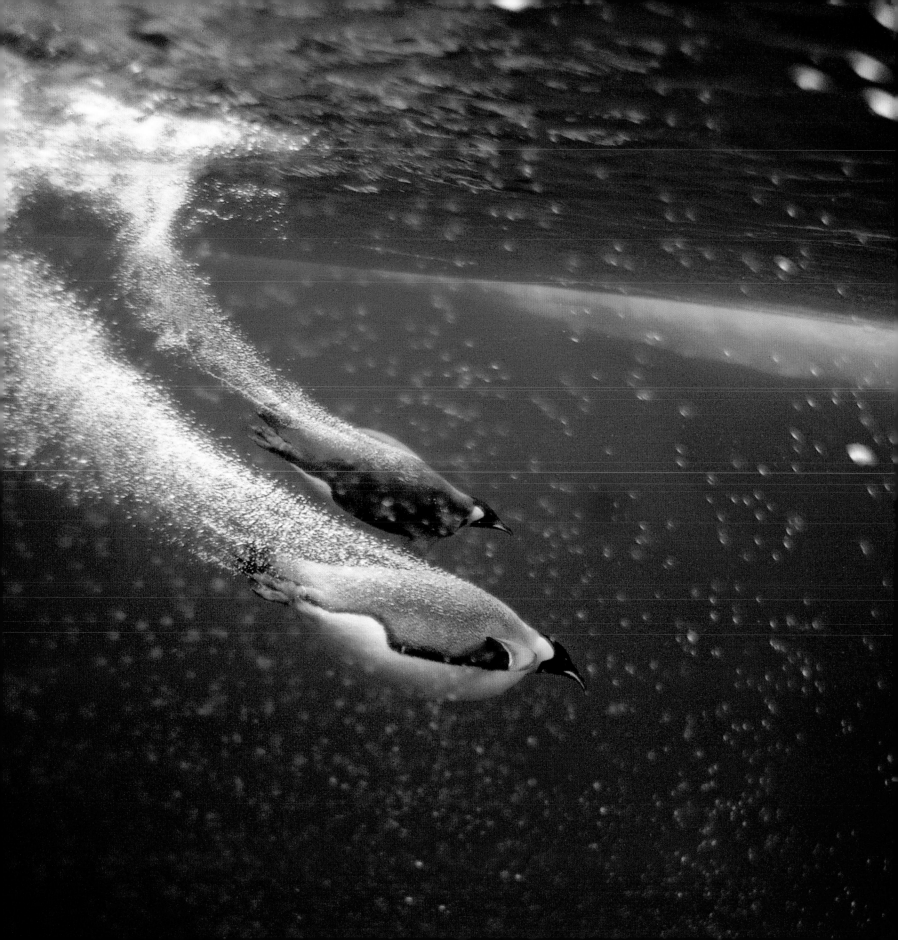

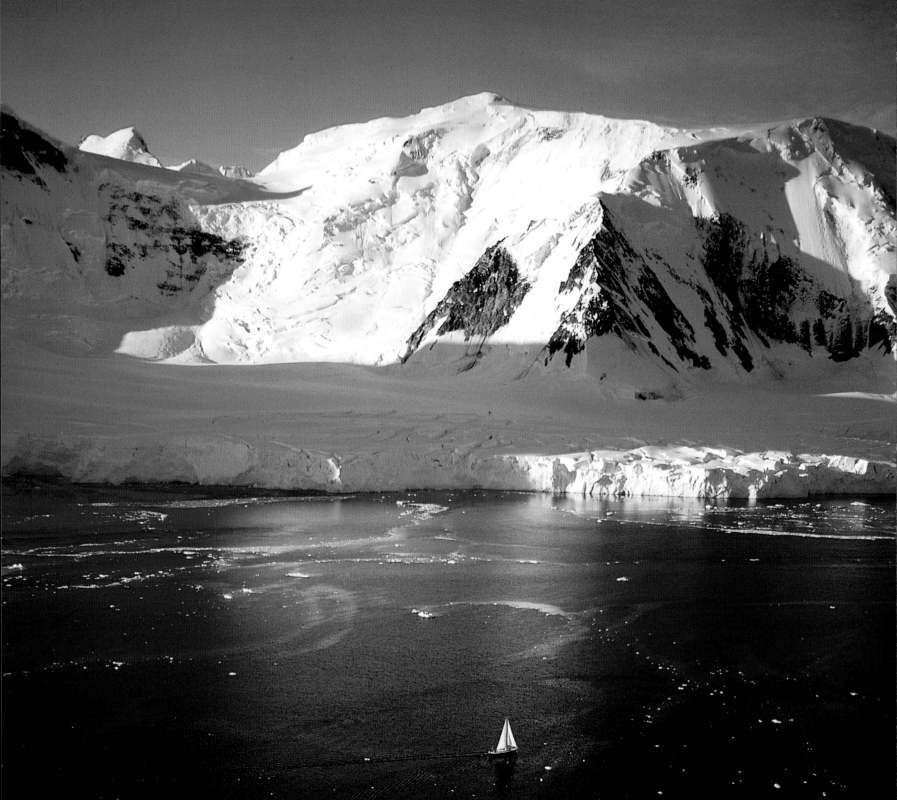

40  Our 17m sailboat *Awahnee* in Gerlache Strait, Antarctic Peninsula.

41 left  Young Elephant seal dwarfs a human diver, Antarctic Peninsula.

41 right  Me with emperor penguins, McMurdo Sound.

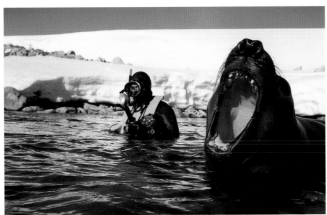 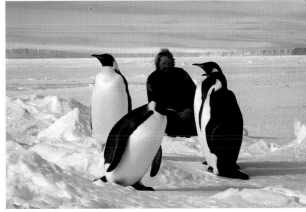

much. The Antarctic environment can be cruel and un-forgiving; where many species struggle mightily to stay alive. It is also a place of extraordinary beauty and bio-logical diversity, where the resident flora and fauna has evolved interesting strategies for life in a freezer.

My second trip to the Antarctic was by boat. I trav-eled from Punta Arenas, on the Strait of Magellan, Chile to the US Base at Palmer Station along the Antarctic Peninsula. This boat trip brought home for me one sim-ple fact: the ocean freezes. Even though I already knew this, looking out at what appears to be an endless frozen sea from the deck of a ship gave me an intimate reminder of just how harsh a world I was entering once again. This is a world of extremes where only the well-equipped sur-vive. In winter, the ocean freezes not just along the shore—the margin extends outward from the coast to about 60°S latitude. Seawater temperature fluctuates be-tween −1.8° and 10°C. The strongest winds on earth have been recorded in the Antarctic. Enormous waves in the Southern Ocean have humbled many a sailor and sent some to the bottom. The biggest waves I have ever seen from the deck of a ship were in the Drake Passage be-tween Cape Horn and the Antarctic Peninsula. There, on a pitching ice-breaker in a chaotic sea, I made my way down a passageway by walking alternately on the deck, then on the bulkhead wall where it met the deck, as it presented the next horizontal surface on which to move along.

From the deck of that ship I saw my first iceberg. Where the Antarctic ice sheets meet the water's edge is the birthplace of the Southern Ocean's great icebergs. For me, icebergs are grand monuments to the polar world I love so much. To a mariner navigating Antarctic waters, they are a terrifying sight—every sailor's night-

mare. What you see drifting on the surface could extend down underwater several hundred feet. Infinite in variety, size and shape, icebergs also provide a platform for birds and mammals to rest on. Born on the polar plateau, pushed seaward by the forces of glaciation, they become mariners themselves, sailing the Antarctic sea on wind and current until they breakup and melt into the waters that bear them ever northward.

So how could anything live here, especially in this frozen ocean? In fact, the Southern Ocean is one of the most biologically productive seas on earth. Krill, the common name for a small shrimp like crustacean, *Euphausia superba*, is probably the most important marine species found here and is often characterized as the primary member of the Antarctic food chain. Almost every living marine creature in the Antarctic eats krill directly, or is dependent on krill for its survival. Many fish species, whales, seals, and seabirds eat krill. Penguins make distant journeys from their nesting young on land to the open sea to feed on krill during the summer months. They swim, walk and toboggan their way back to feed their young regurgitated krill, pink blobs of protein that resemble the original shrimp only in color. I was walking along an Antarctic beach once, and came across an animal's skull. It had washed ashore in a storm. The skull had been tossed around, but there were a few teeth still left in the jaw-bone. The skull was obviously from a seal, but the teeth were very un-seal-like. They had several rounded points that look like small enameled waves frozen at their crest. These teeth were not from a seal that bites into and eats a lot of flesh. The upper and lower rows of teeth interlock to form a kind of strainer. I had found the skull of a

crabeater seal (*Lobodon carcinophagus*). They do not eat crabs, they eat krill. They eat lots of krill, 60 million tons annually, by some estimates, and their un-seal-like teeth are designed with this food source in mind. Gulping whole mouthfuls of krill-filled sea water, the crabeater uses its teeth as a strainer, just pushing out the water and swallowing its meal. Crabeaters are the seal of the great Antarctic pack-ice. Pack-ice is drifting pieces of seasonal sea-ice broken up by wind and wave. Pack ice is circumpolar and its journey is governed by oceanic circulation. This is real crabeater country, where they feed, mate, give birth and tend to their young. Only rarely have they been observed on land. The pack-ice has to be near shore, or one goes by boat to the pack-ice to see crabeater seals.

The Antarctic and its fauna have a way of simplifying the ebb and flow of life. My introduction to the law of the frozen jungle came on a distant ice-covered beach at Cape Crozier; where I really began to develop an understanding and appreciation for the animal world. The minutiae of my college biology courses suddenly seemed distantly relevant. Old terms challenged my intellectual curiosity anew; evolution, ecology, ethology, survival strategies, reproductive biology, predator-prey relationships. Cape Crozier was where the pieces of the larger puzzle of the natural world started to fit together. Working on this puzzle has been a life-long quest for me. At Cape Crozier I also first realized I wanted to be a seal. I wanted to really see them, swim in their world, think like a seal, and try to place myself somewhere along the path of their daily lives in order to learn something new and bring their secretive world to the printed page. Weeks of watching leopard

seals from the ice-front at Cape Crozier did this to me. My life has not been the same since.

Of the five Phocid seals found in the Antarctic, the leopard seal is the only one that eats warm-blooded prey. Although krill is thought to be its primary food source some portion of its diet is comprised of other seals and penguins. Leopard seals have a fondness for eating juveniles of every seal species found in the southern ocean. They also eat emperor, chinstrap, king, gentoo, crested, Magellanic, and Adélie penguins. Adélie penguins are the most abundant and widely distributed penguins in the Antarctic. The Adélie penguin rookery at Cape Crozier numbers some 300,000 birds, and leopard seals hunt them down as the penguins swim back and forth from their nest sites onshore to feeding areas in the pack ice. In 2003 a leopard seal attacked and killed a female marine biologist snorkeling near her British base along the Antarctic Peninsula at Rothera Research Station. This is the first ever known lethal attack by a leopard seal on a human. I have been underwater with leopard seals on several occasions and consider their presence nearby one to give all my attention to, but I have never felt personally threatened by one. They are elegant swimmers, and watching them give chase to and ultimately capture swift swimming penguins is truly one of the great spectacles of nature. It is a life or death swim for a penguin. It is survival in a harsh, cold, unforgiving environment for the leopard seal. It is the real world. As a young man new to this, it was my biological "come-uppance".

Diving has long been considered a quiet endeavor. As a boy I read Cousteau's, *Silent World* and thought then that the world beneath the waves must be a pretty qui-

et place. Nothing could be farther from the truth. The sea is a cacophony of noise. Sound travels faster and further underwater then it does in air. If you pause in your breathing cycle underwater, one can hear all sorts of strange and wonderful sounds. Beneath the annual sea-ice of McMurdo Sound you can hear a snow tractor crunching across the sea-ice above. You can hear trucks go by. You can hear the rumble of an aircraft landing on the ice at Williams Field, two miles away. You can hear Weddell seals. Weddell seals are, for me, the aboriginals of the Antarctic, the natives, the locals, the year-rounders. They don't go north to the pack-ice for the winter, or to the relative warmth of some sub-Antarctic island. As the Antarctic descends into the darkness of another polar winter, other species head north. But as the world above is freezing over, Weddell seals are happily going about their business under the ice. They distinguish themselves from other Antarctic species in many ways. They are the most southerly naturally occurring mammal in the world. They also happen to be one of the deepest diving mammals in the world; they have recorded for science a dive to almost 2000ft for over an hour. Take it from me, that's quite a feat for a fellow mammal. They have very large eyes adapted to low light levels beneath the ice. They maintain breathing holes with their teeth. And if that weren't enough, they possess a complicated sonar system to catch prey and navigate their way back to their breathing holes. They also produce a bizarre and wonderful song I can only describe as an otherworldly trill. You can hear this song underwater. Imagine yourself, for a moment, a Weddell seal. Look up at the ceiling in the room where you now sit. Imagine it the underside of the ice and the

ceiling of your world with only one tiny hole where you can go to catch a breath of sweet air. You are 2000ft (600 m) beneath that ceiling of ice and a long way laterally from that little hole. It is dark. You have just spent the better part of an hour hunting for a giant Antarctic cod. A little internal bell starts to ring in your lungs telling you it's time to go up. You will trill your way calmly back to that breathing hole, maybe with a fish, maybe not. There are hundreds, thousands of Weddell seals doing just that right now. May the trilling never end.

For many years I dreamed of photographing the largest and most elegant of all penguin species, the emperor penguin. Since I am an underwater photographer my dream was to photograph them in their frigid watery world, beneath Antarctic ice. To my knowledge no one had done this before me. They are seldom seen underwater and lead secretive lives in the open sea when away from their nesting sites. Penguins do not fly and appear humorous and slightly awkward when they walk on ice or land, but underwater they are truly in their own element. Whatever mobility they lack on land they make up for when swimming. Their high-speed underwater maneuvers place them among nature's supreme swimmers. While on assignment in the Antarctic in 1984, my dream came true when I was approached underwater by a group of emperor penguins. I was diving at the edge of the annual sea-ice in McMurdo Sound. At first I thought they might just go away but instead they performed a spectacular twenty-minute tutorial in the art of high-speed underwater swimming. Their performance had a beautiful circus-like quality, with me at center stage. They swam above,

below, and all around me showing off their superior swimming skills, while I watched and photographed in awe. Penguins have a thick layer of fat beneath their skin and also a dense layer of feathers that traps air for warmth. When they accelerate underwater the trapped air is compressed out from the feathers and a trail of bubbles, like an aircraft contrail, is left behind. The more bubbles they leave behind the faster they are swimming. I suspect that after some time underwater they require a little time at the surface to fluff and preen air back into their feathers for warmth. Some of my photographs of penguins swimming are of blurred emperors whizzing by. It was often difficult to follow them with my camera because they swim so fast. But the encounter did provide me with some great photographs and some of the most interesting moments I have ever had underwater; I realized my long-held dream of photographing emperor penguins in their frigid watery world. The floating pack-ice and fast-ice attached to land provide for penguins a platform on which to rest and preen, escape from predators, navigate from place to place, and just go with the flow. If you watch Adélie penguins come and go at their large rookery at Cape Crozier, it seems as if they ride an ice floe until it drifts adjacent to where their nest site is on land. Then they hop off and swim to shore. The drifting ice floe is their bus and when they get to their stop they simply get off. It really does seem this way, as far-fetched as it might sound. With leopard seals swimming around the sea edge of any nesting rookery, it makes perfect sense for a penguin to shorten its swim to shore by staying on that ice floe until it takes him, more or less, to where he wants to go.

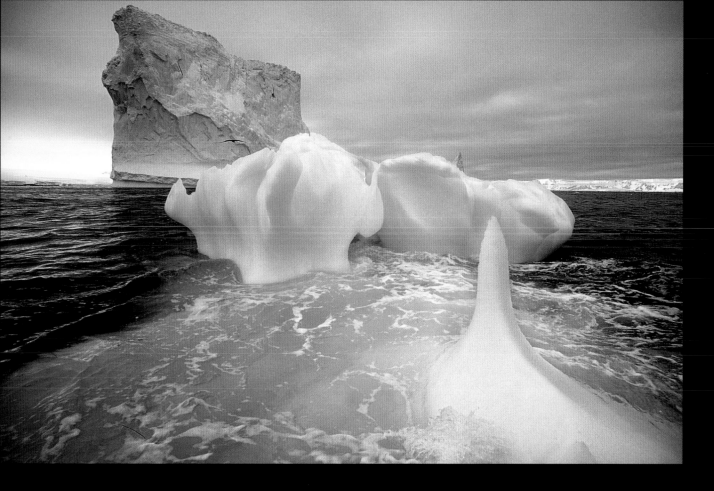

Silent sailors

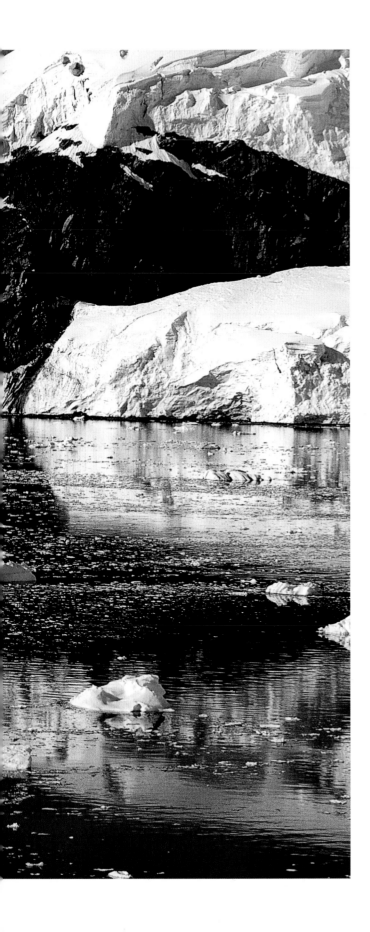

# Sunset
## Palmer Archipelago

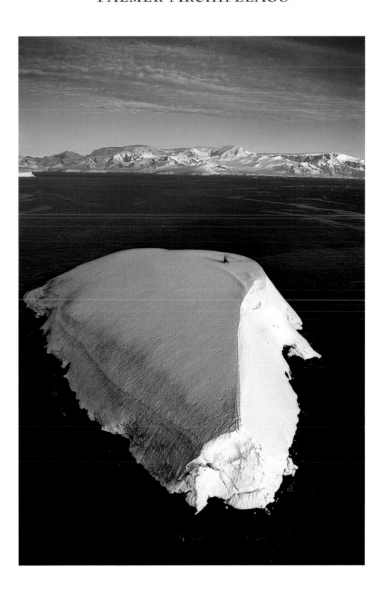

46-47  U.S. R/V *Hero* anchored in Paradise Harbor, King George Island, Antarctic Peninsula.

47  U.S. Coast Guard helicopter lands on small snow covered island, along Antarctic Peninsula.

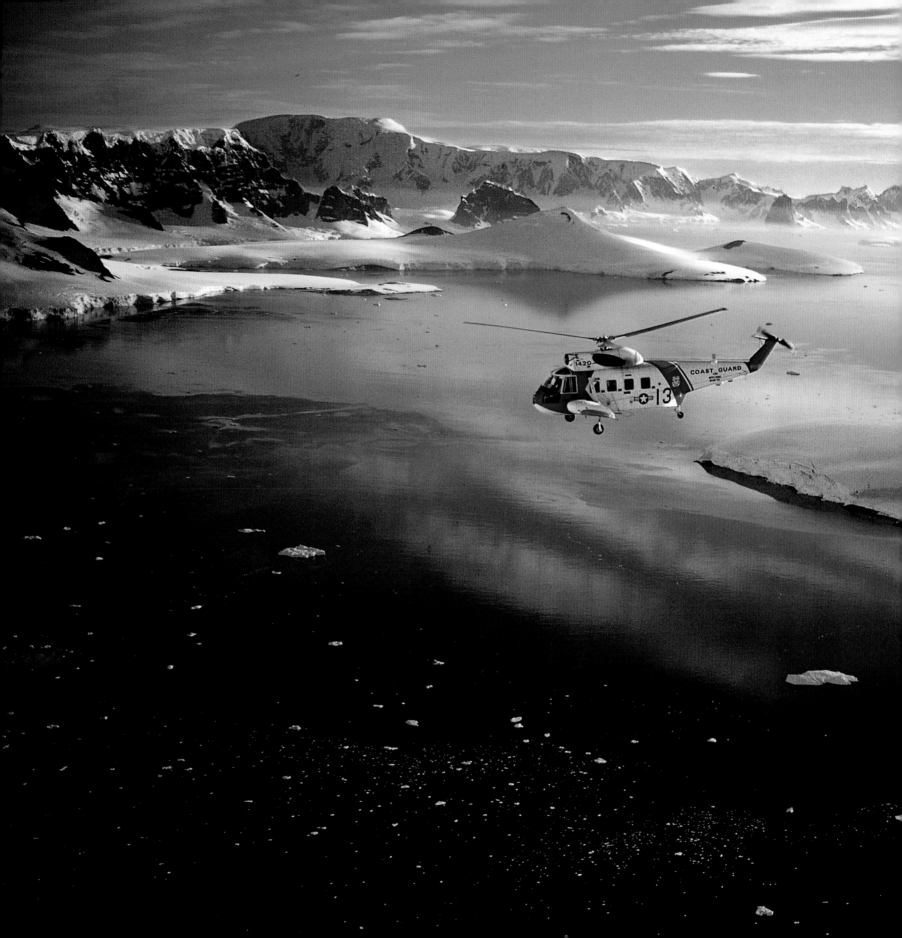

48-49  U.S. Coast Guard helicopter over
Gerlache Strait, Antarctic Peninsula.

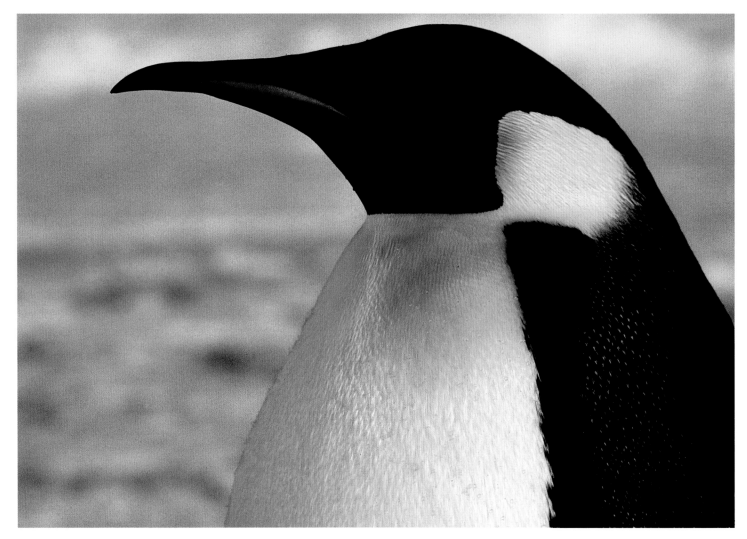

50  The dignified profile of the most beautiful of all penguins, the emperor.

51  Emperor penguins survey the sea ice of McMurdo Sound.

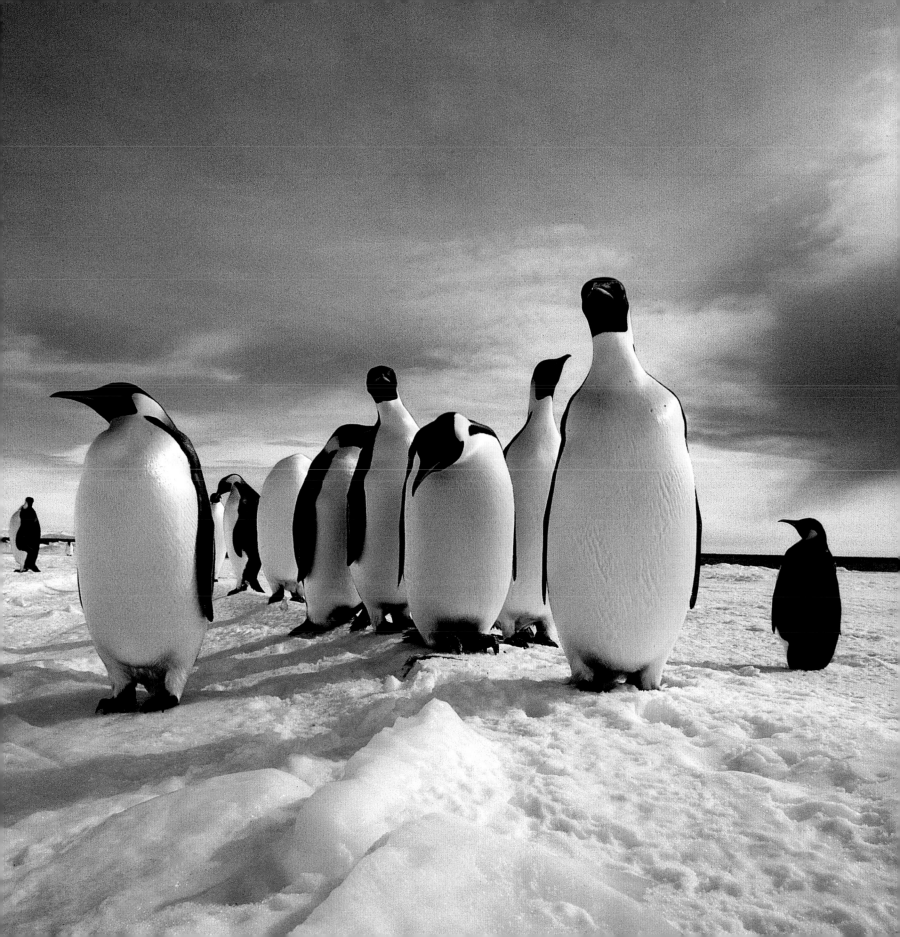

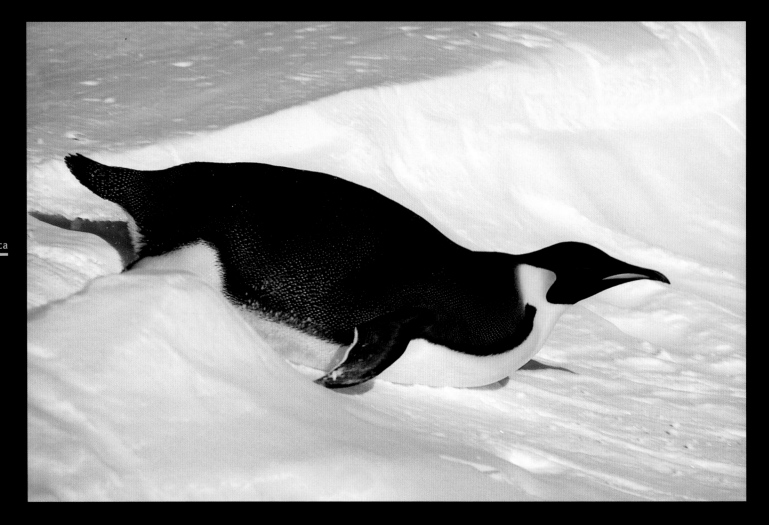

52  Penguins often plop onto their stomachs and use their feet to push themselves along.

53  Emperor and Adélie penguins travel together across the sea ice of McMurdo Sound.

54-55  Emperor penguins toboggan near Cape Hallet, Victorialand. A grouned tabular iceberg
frozen into the sea ice looms in the background.

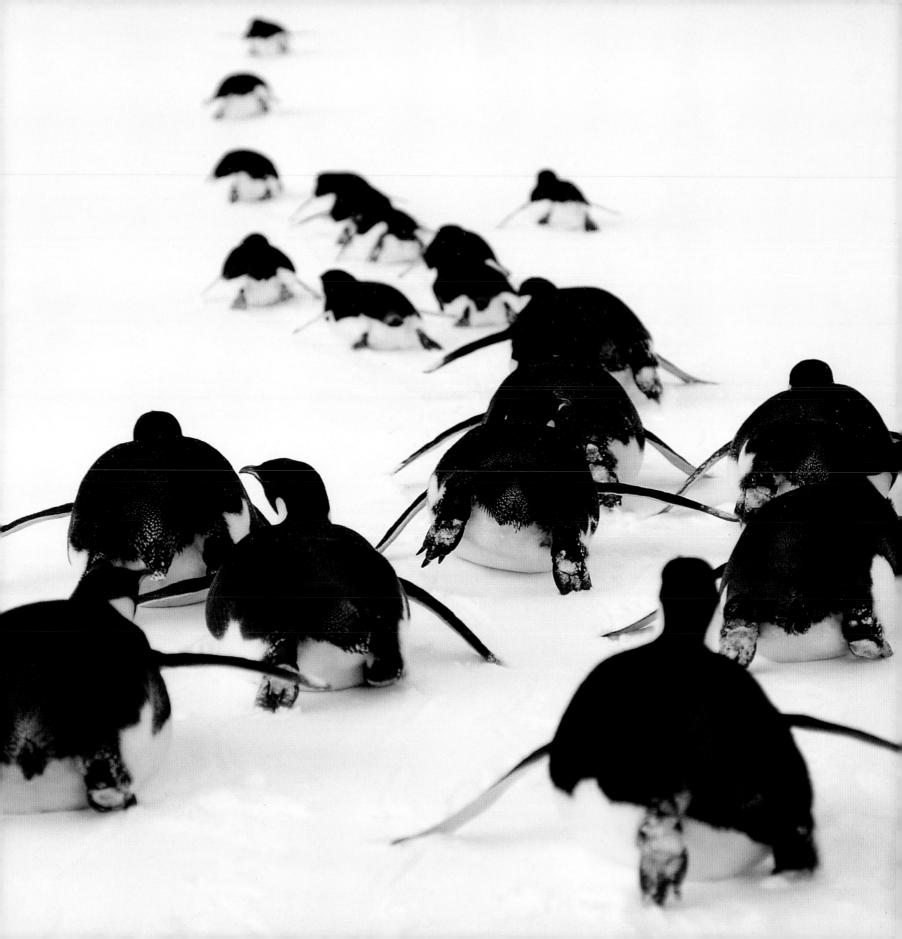

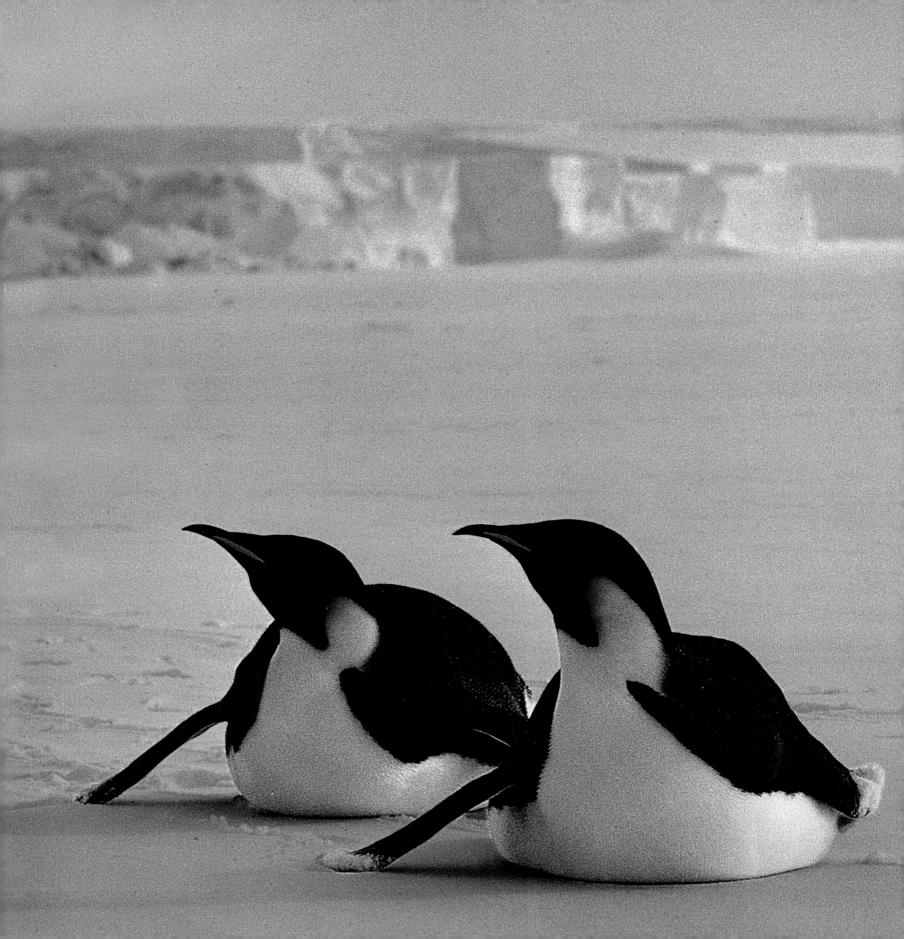

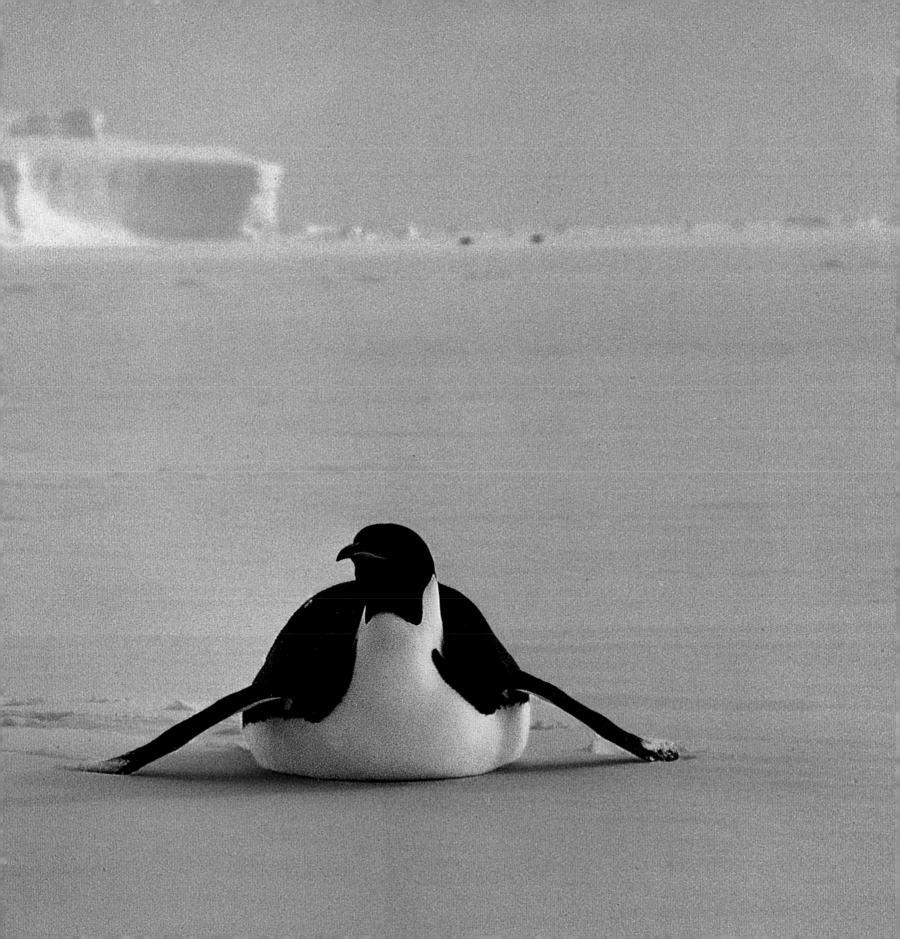

56  A leopard seal sleeping on small iceberg,
Antarctic Peninsula.

56-57  Lone Adélie penguin on a small iceberg
along Antarctic Peninsula.

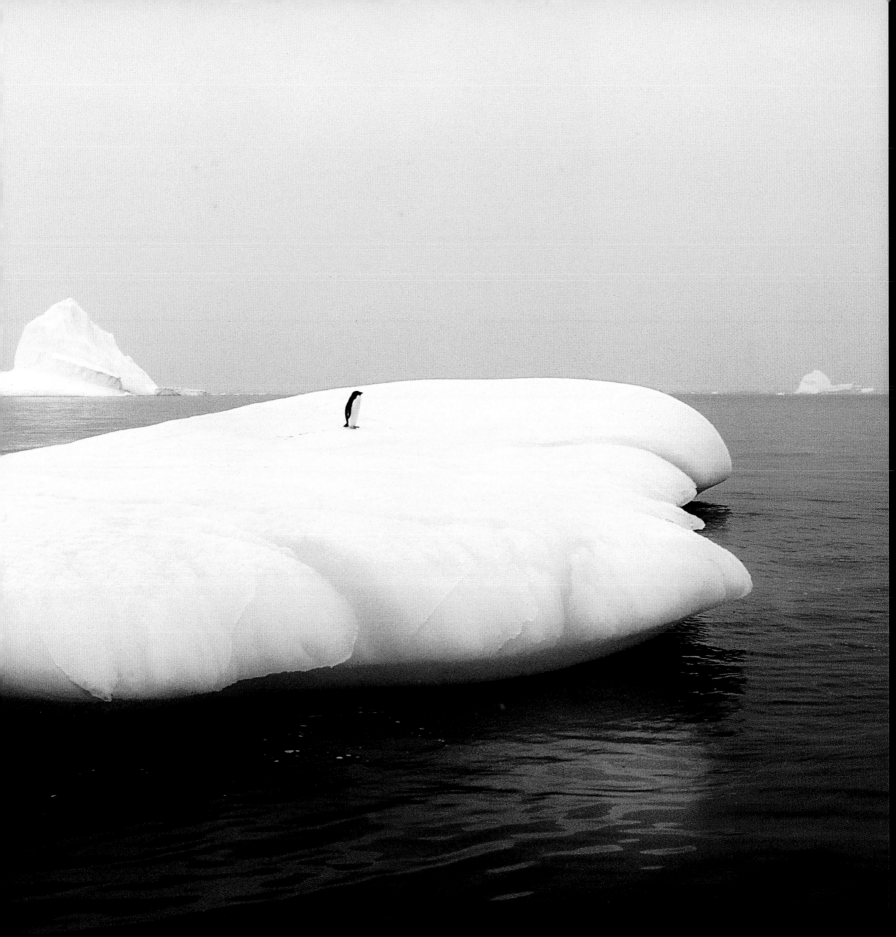

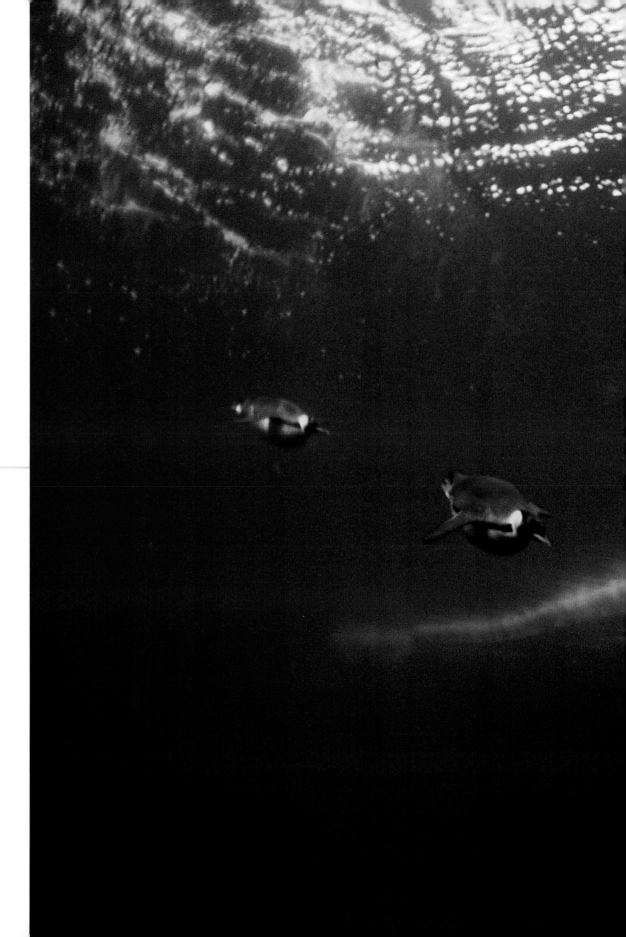

58-59  Emperor penguins
swim along the edge of
the annual sea ice in
McMurdo Sound.

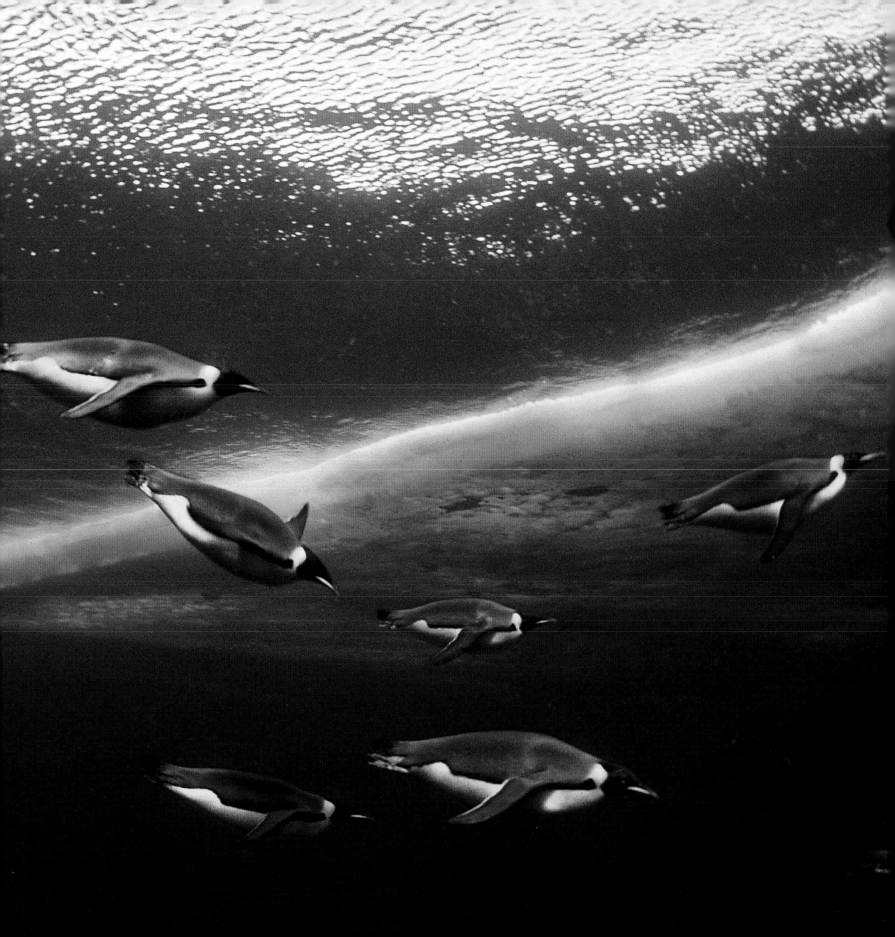

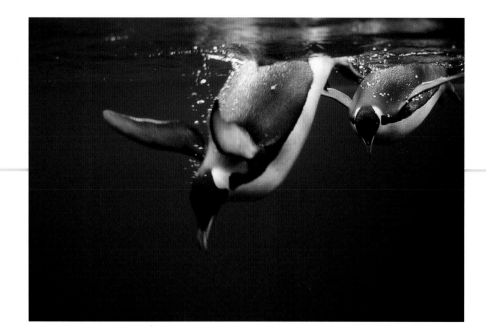

60 and 60-61 As emperor penguins accelerate underwater, insulating air is compressed out of their dense layer of feathers and trails behind.

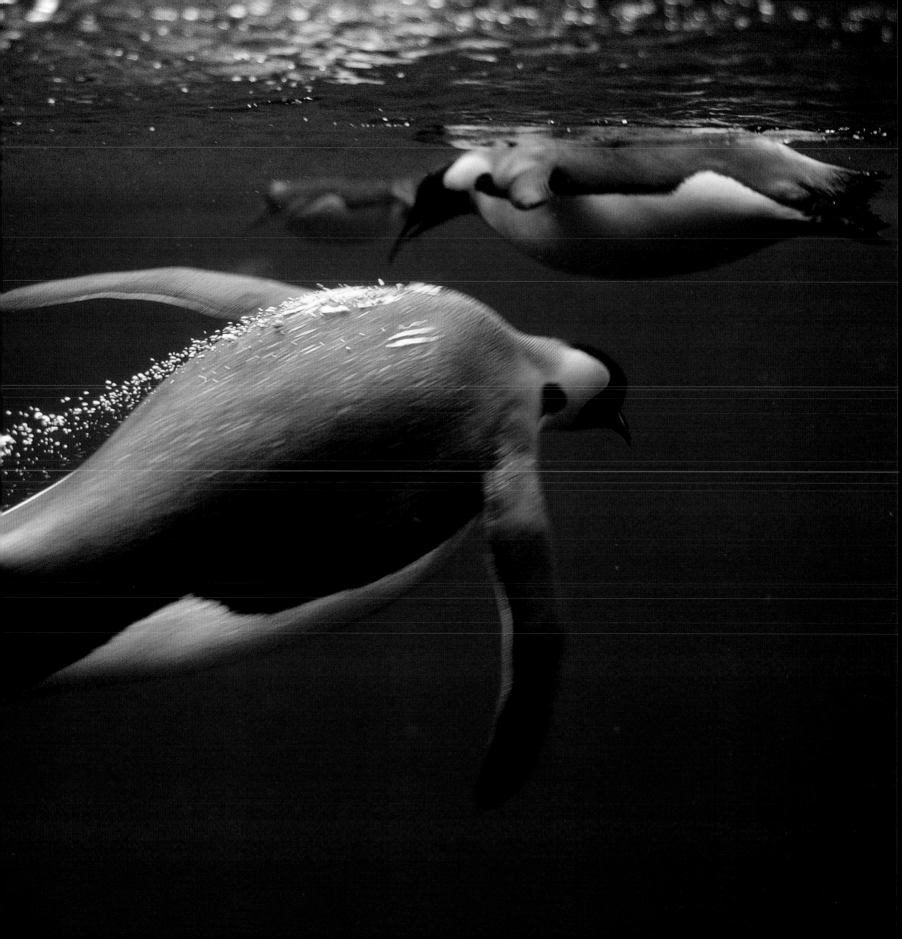

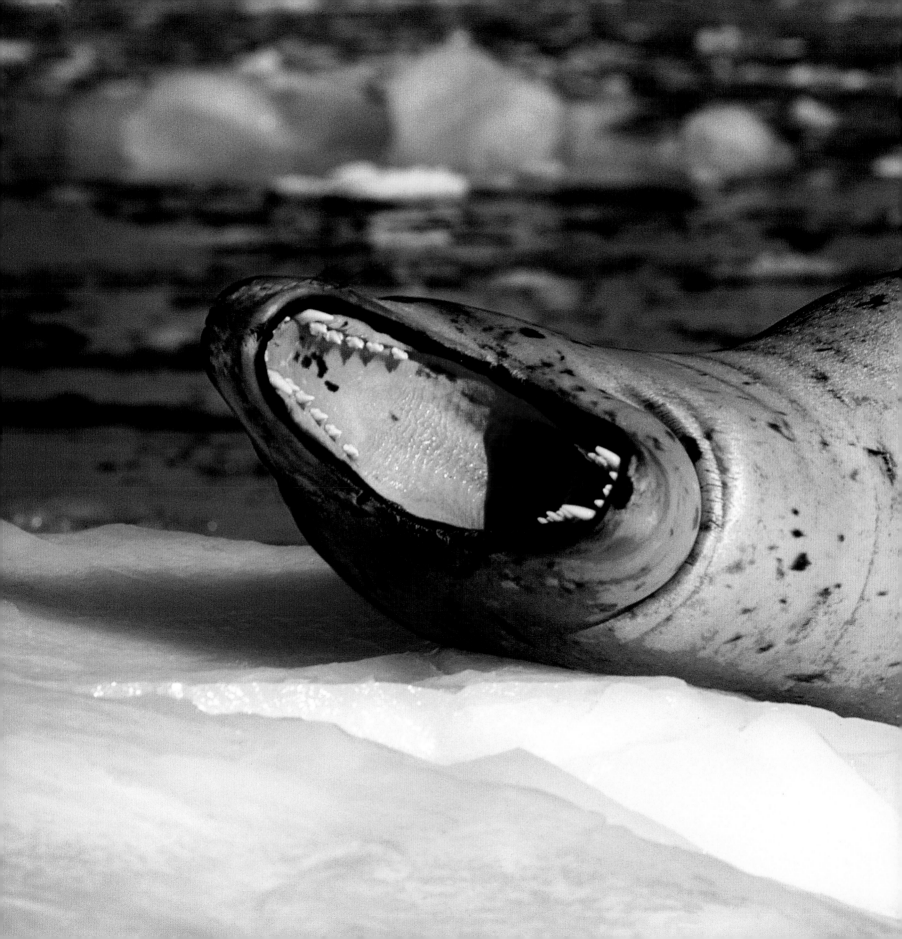

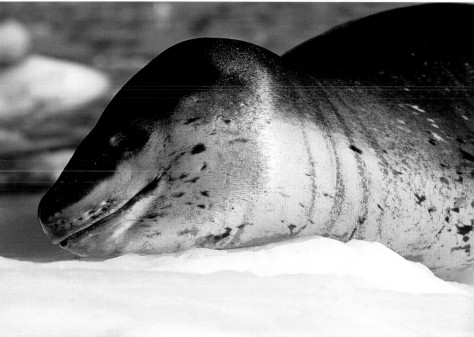

62-63 and 63  A leopard seal yawns and rests on small iceberg, Antarctic Peninsula.

64-65 Small elephant seal swimming in shallows along Anvers Island, Antarctic Peninsula.

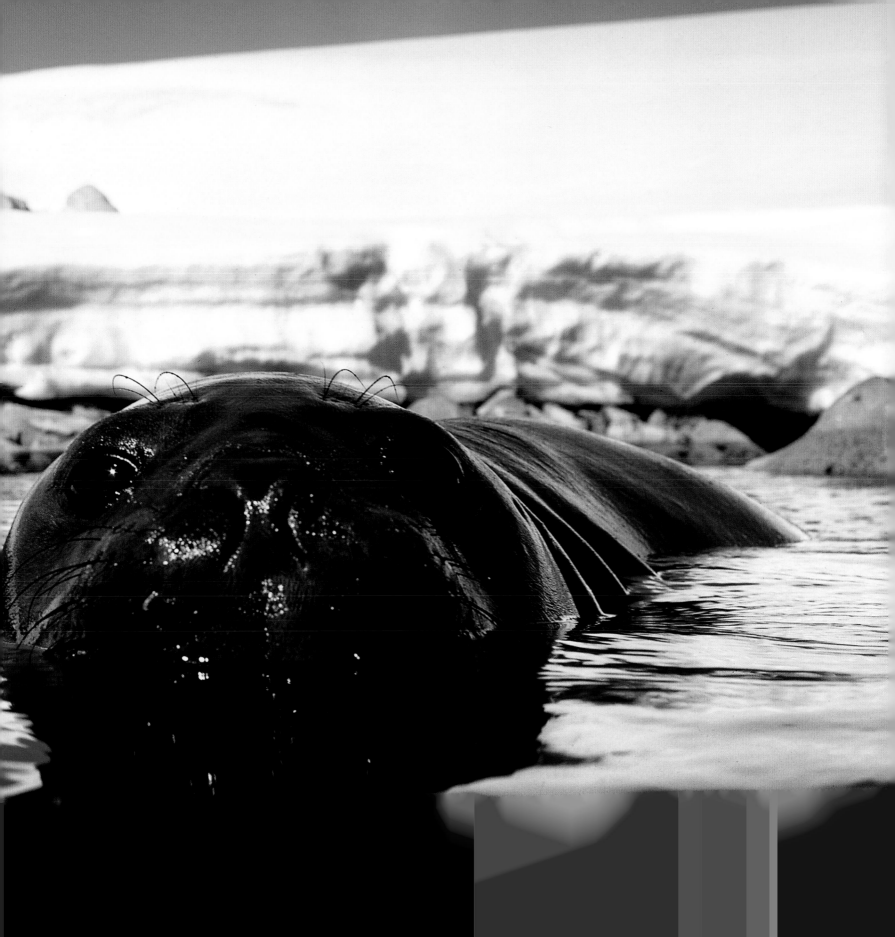

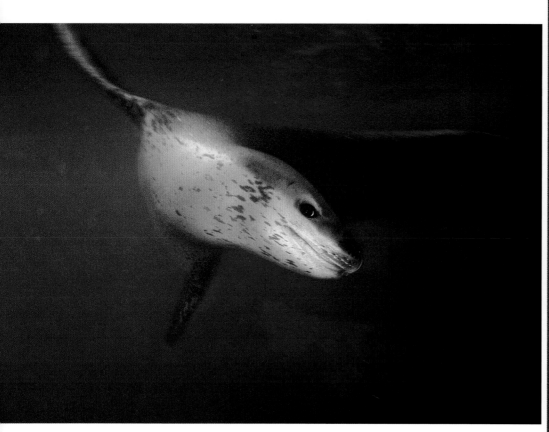

66 and 66-67  A leopard seal demonstrates its
matchless agility underwater.

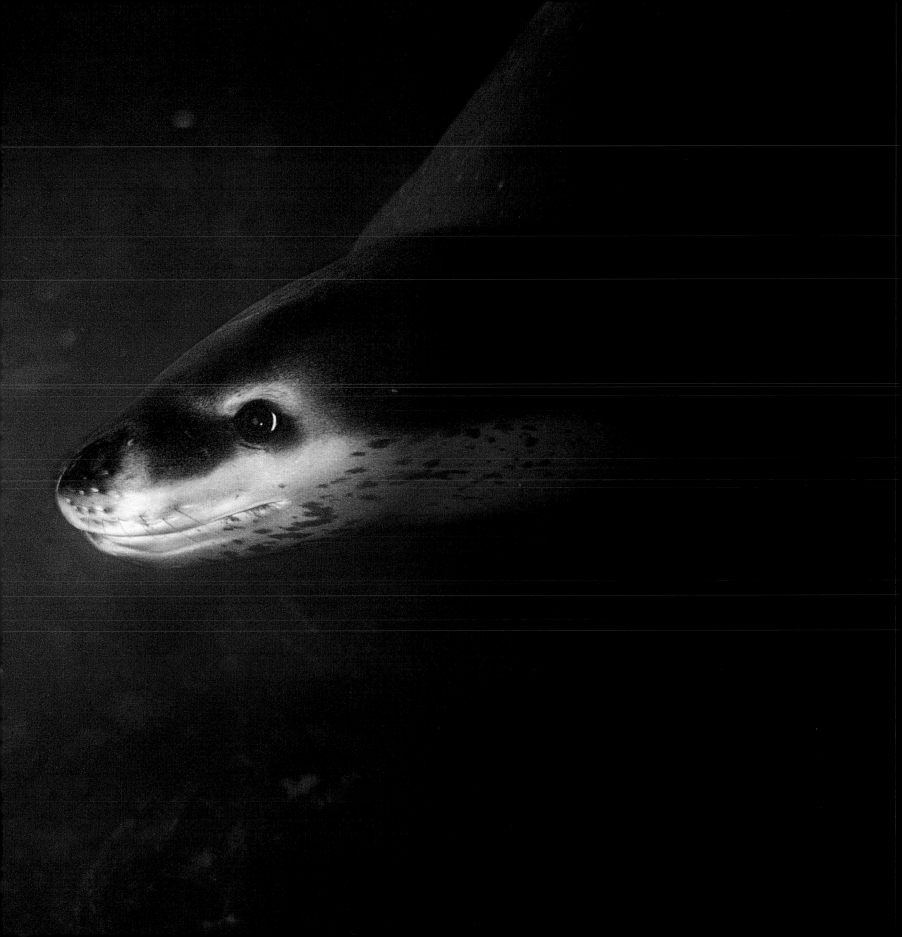

68 and 69  Leopard seals can easily outmaneuver a swimming penguin
underwater and are often curious about divers.

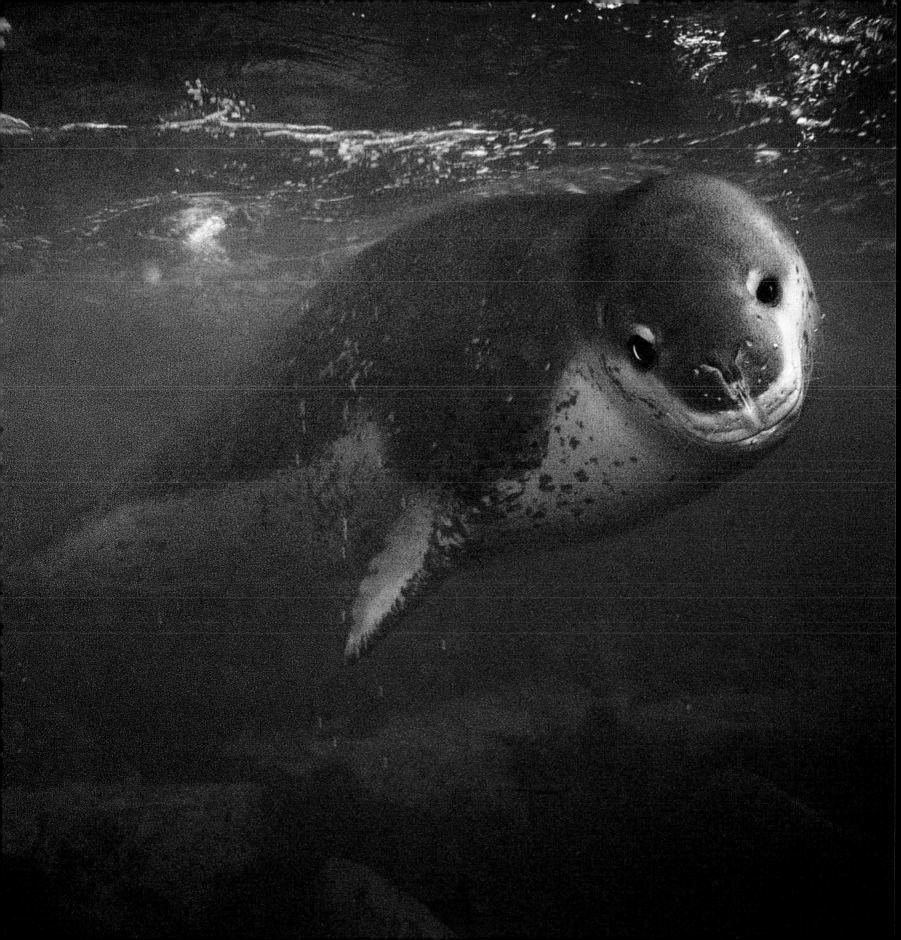

70 A Weddell seal rests beneath the convoluted layers of sea ice, McMurdo Sound.

71

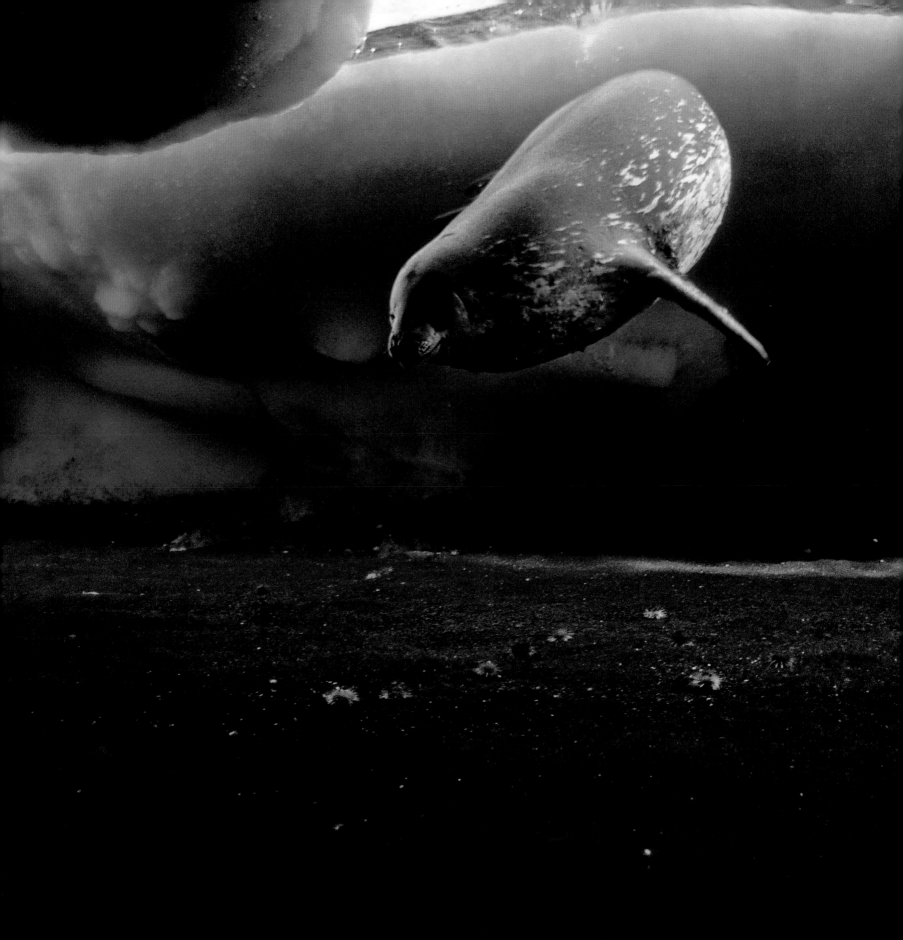

# Weddell seals

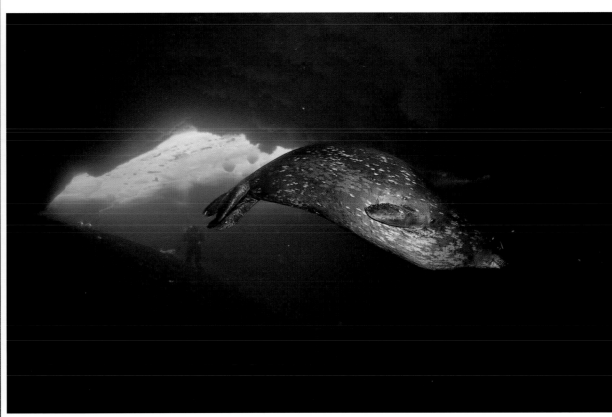

72-73 and 73  Weddell seals can dive to over 2000 ft (600m)
for over one hour.

# DRIFTING GHOSTS

## AND BOTTOM BEASTS

C ONSIDER THE ATTENTION GIVEN TO AN ASTRO-NAUT WHEN HE OR SHE PERFORMS A SPACE WALK. THE ASTRONAUT, RIGHTLY SO, IS COMFORTABLY ENSHROUDED IN THE FINEST SPACE SUIT MODERN TECHNOLOGY CAN PRODUCE.

Every breath, heartbeat, movement, word, task, is being watched, filmed, and monitored by hundreds of technicians at ground control. The space walker performs pre-planned tasks he or she has trained months for, at a cost of millions of dollars. Of course there is risk, danger, and the possibility that someday something very serious can go wrong. And it does, as we well know. I'm reminded of a photograph I made of a marine biologist descending beneath Antarctic ice. The image has a space-like quality, an "inner space" feeling. Above the diver is the sun lit ceiling of sea-ice, maybe 8 feet thick, that separates her from the world above. She has entered as hostile an environment as one could conjure up for our species. She is also about as far from human help as one can be on this planet. The water temperature is more or less -1.8° C. The suit she wears is an $800 piece of rubber, and it leaks. She is very cold. She is also completely on her own and will return to the air above by means of her own intellect, wit, and good judgment. The benthic community she studies in McMurdo Sound is dominated by sponges and starfish. It is often referred to as a sponge mat community. Spicules from sponges long dead carpet the bottom while living sponges in every shape and color grow on top. The little red starfish *Odontaster validus* seems to be everywhere. In this seabed community the animals that are mobile seem to move in slow motion. A primitive feeling dominates this slice of life on the fringe.

Deep-ocean science provides us an opportunity to investigate an isolated and unique biological system. On the abyssal plain, resident species are specialized, and designed to survive in an extraordinary environment. Beneath the ice of McMurdo Sound, one finds biological parallels between its benthic community and that of the isolated abyss. Here, a diving scientist can conduct research in a similar environment, avoiding costly offshore, deep-ocean equipment. Some of these cold-water fauna are not fundamentally different from abyssal creatures found in bottom communities many miles deep. If I had to list my favorite photographic subjects, the soft-bodied members of the zooplankton community that are borne along on under-ice currents would be at the top. "Beautiful Drifters," I like to call them. These gelatinous creatures come in all shapes and sizes, some familiar, some not. One day the water column might be filled with a particular species, the next day another. You never know from dive to dive which interesting

75  A large jellyfish, *Desmonema glaciale*, drifts beneath 8 ft (2.5 m) of sea ice in McMurdo Sound.

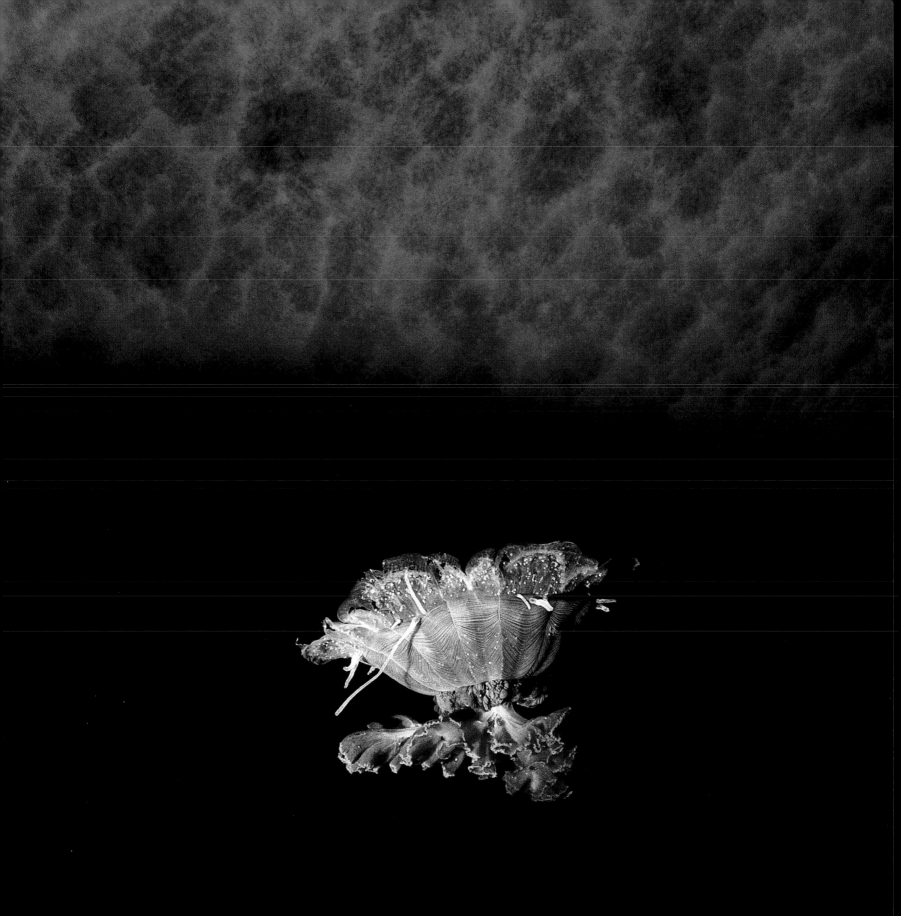

zooplanktons might drift into view. Photographing these creatures has its own special set of challenges. It is quite dark beneath the ice, requiring an underwater strobe to light an animal as it drifts by. Other drifters in the background tend to catch some of the light emitted from a strobe.

These are the stars and planets of my own little dreamscape. These animals look to me like organic space stations, galactic travelers, suspended in some galaxy far, far, away. In reality, most large zooplanktons are senior predators in this inner-space soup of life. Large jellyfish feed on a wide variety of animals that swim or drift into their many-tentacled embrace. Ctenophores, commonly called comb jellies, are little more than stomachs with mouths, voracious predators of all things organic. They filter nutrients from the water column. Ctenophores have eight rows of Cilia -- hairlike structures, placed along the meridian of each body plate. The cilia are fused together at the base, but swing free, like the teeth of a comb. The cilia beat steadily to propel the animal forward. They also refract the light from a strobe, and all the colors of the rainbow sweep rhythmically along the animal's crystal-clear body. Some of the largest jellyfish I have ever seen have been in Antarctic waters. I have seen jellyfish drifting beneath the sea-ice that dwarf a human diver; their tentacles reaching down nearly 30feet from the body. Each tentacle is armed with thousands of stinging cells that capture prey. The tentacles are basically arms that deliver prey directly into the animal's mouth. In some species the tentacles form a physical barrier suspended below the animal in the water column like a spider's web. Any prey bumping into this curtain of tentacles is instantly attacked by the stinging cells. If this was a tropical ocean and divers were not protected by cold-water suits, a jellyfish this large would give one pause. Divers in the Antarctic, however, cover every square inch of their skin with some type of rubber, except around the mask and lips. If you suffer from underwater arachnophobia, a rare disorder for sure, then the orange sea spider is not for you. It was something special to the benthic ecologist I was with when he collected it. It was a rare specimen, *Dodecolopoda mawsoni*, the largest sea spider, measuring about 15 inches across. At the time, only four other specimens had been found. Other smaller species are often seen crawling around with their oversized proboscises, probing for prey.

The Antarctic is my favorite place to dive. On days before the summer season kicked in, I have measured 1000 feet of lateral visibility underwater, the clearest I have seen anywhere on earth. It is like diving in a glass of ice-cold gin, and for me, an intoxicating experience of the best kind.

77  Diving scientists decompress before surfacing through their entry hole in 8 ft (2.5 m) of sea ice, McMurdo Sound.

78 and 79  Divers enter McMurdo Sound through a Weddell seal's breathing hole at Hutton Cliffs, Ross Island.

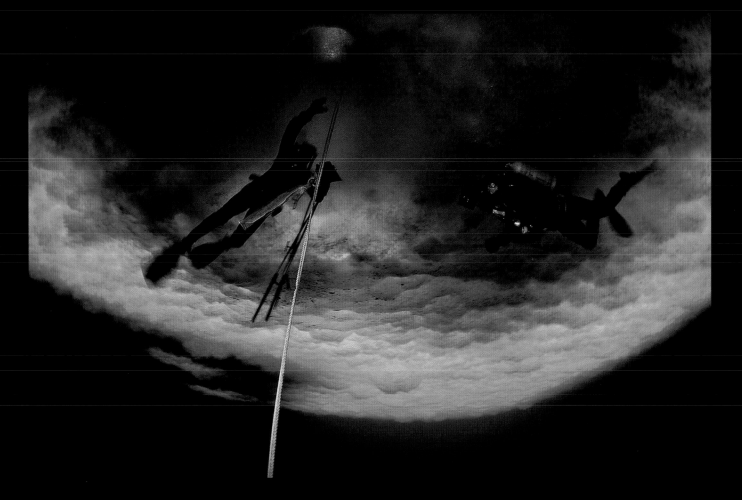

McMurdo Sound

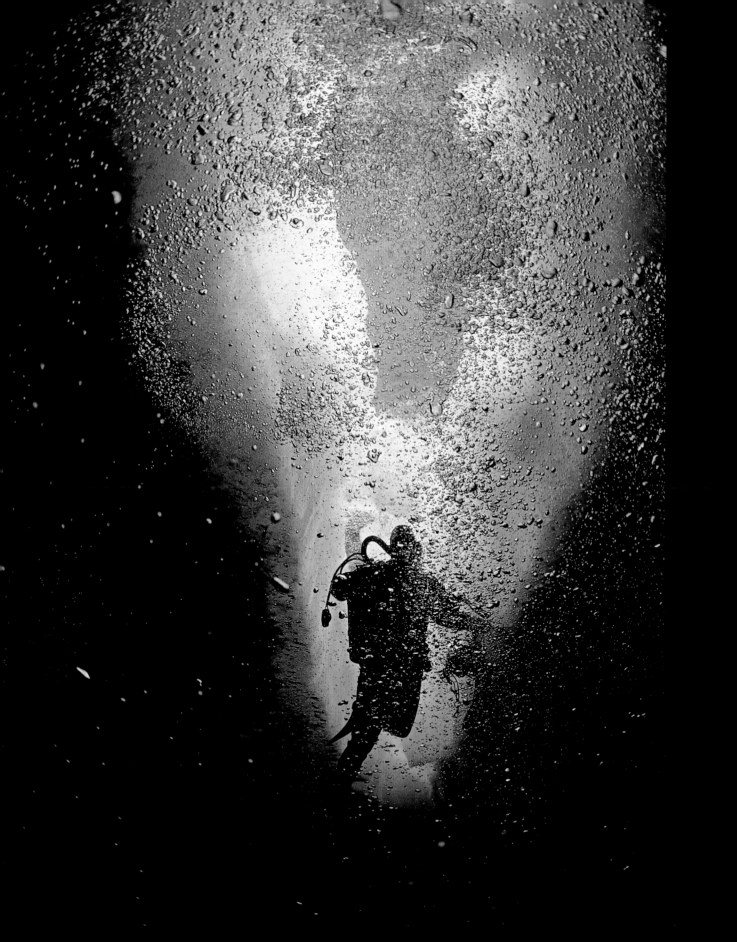

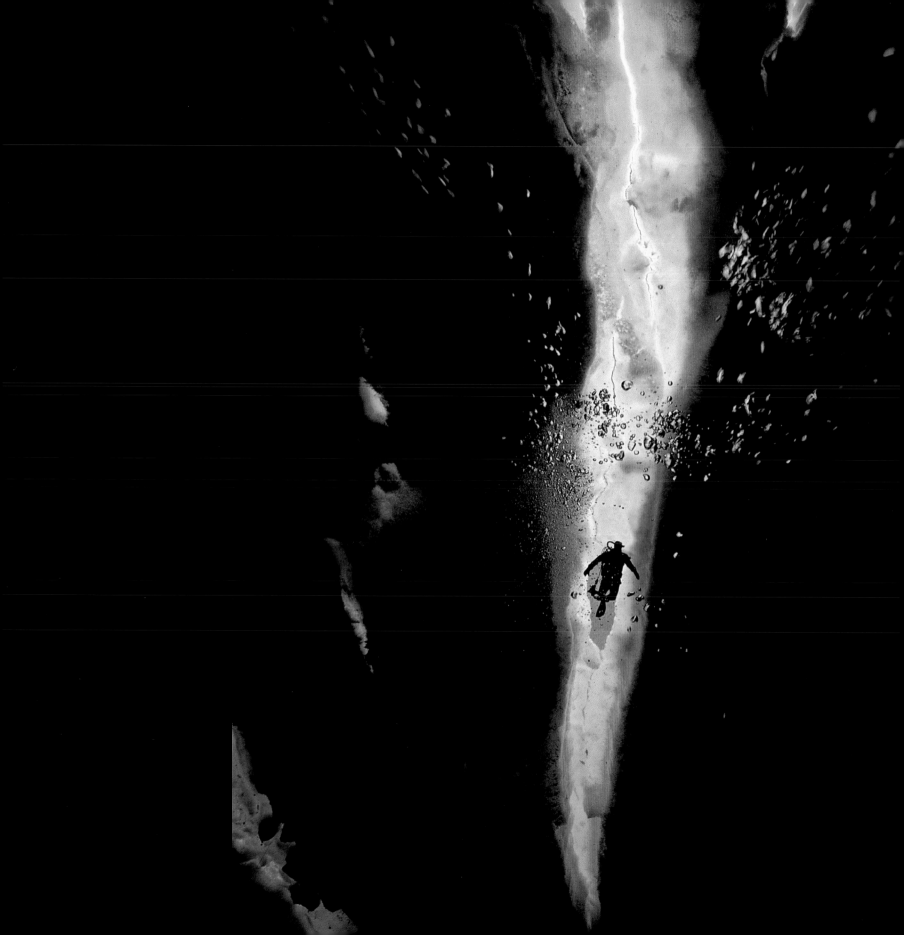

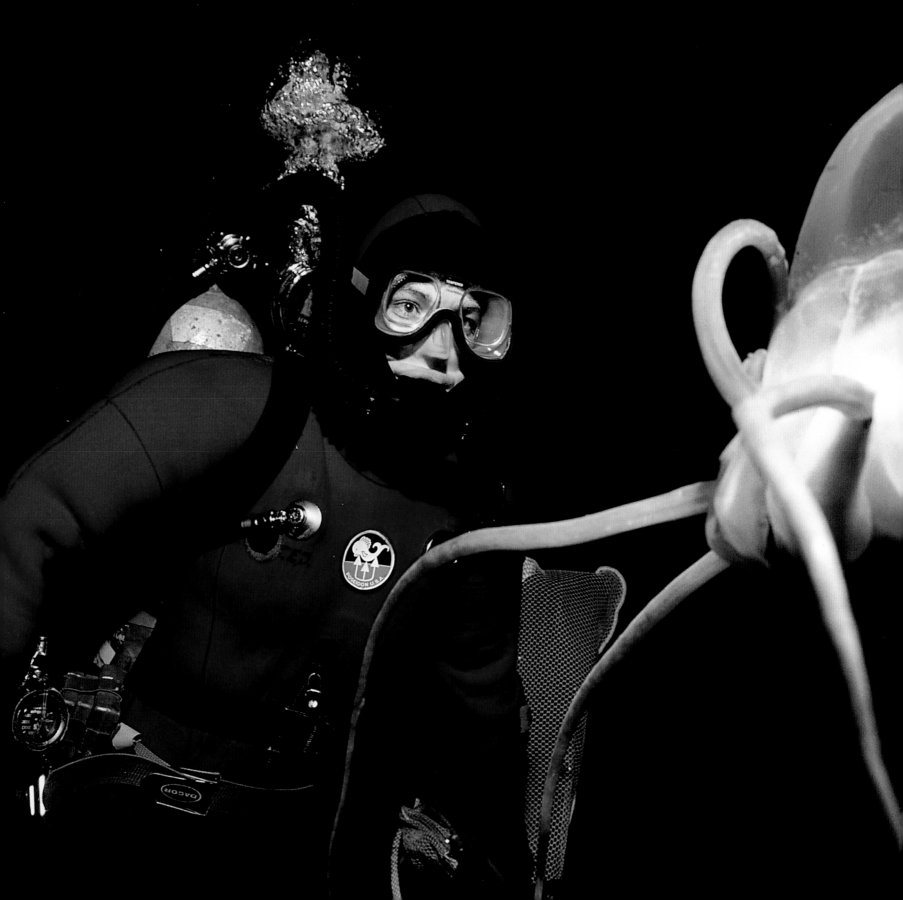

# Beautiful
# swimmers

## Scientist and jellyfish

80-81 Diving biologist, Terrie Klinger observing
a helmet jellyfish, *Periphylla periphylla*,
in McMurdo Sound.

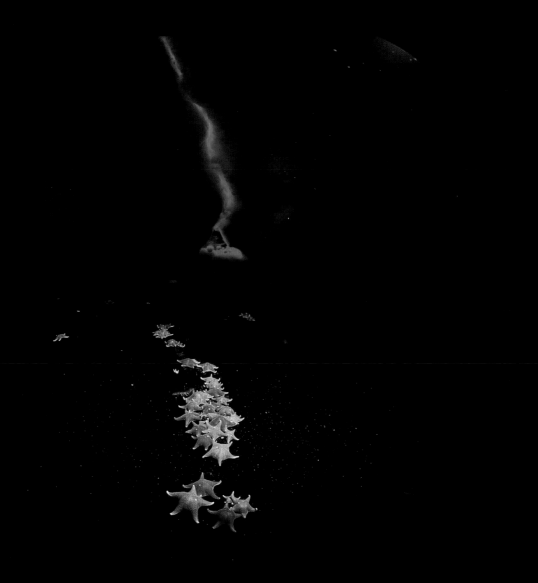

82  A small line-up of the small red starfish, *Odontaster validus*, at Hutton Cliffs, McMurdo Sound.

83  Helmet jellyfish, *Periphylla periphylla*, a pelagic species, is often swept near shore by intruding ocean currents.

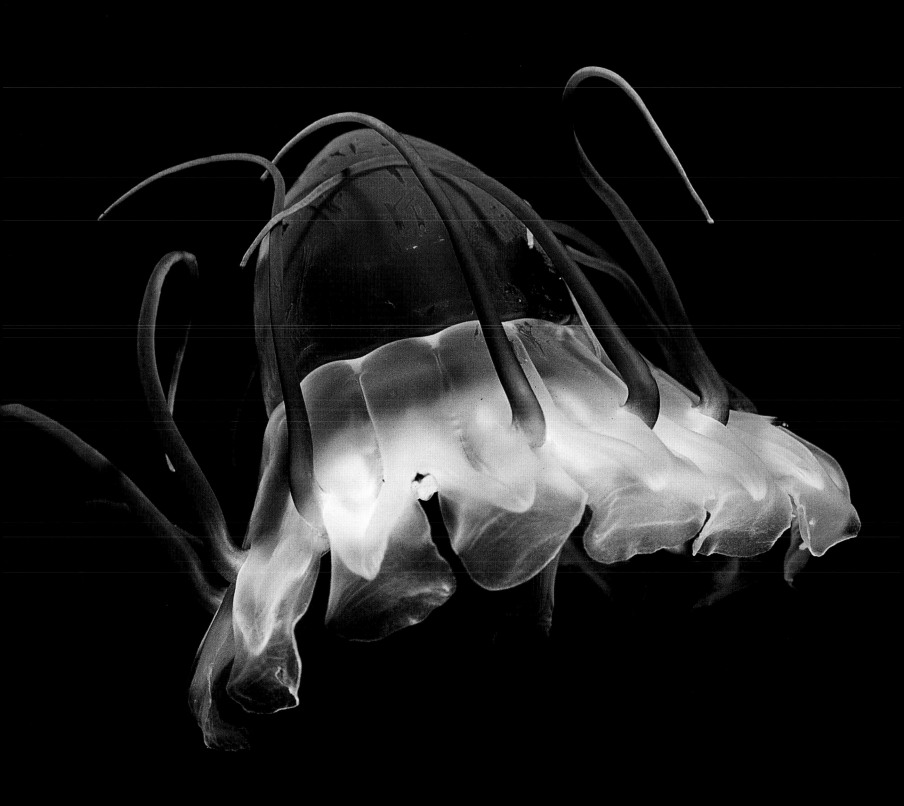

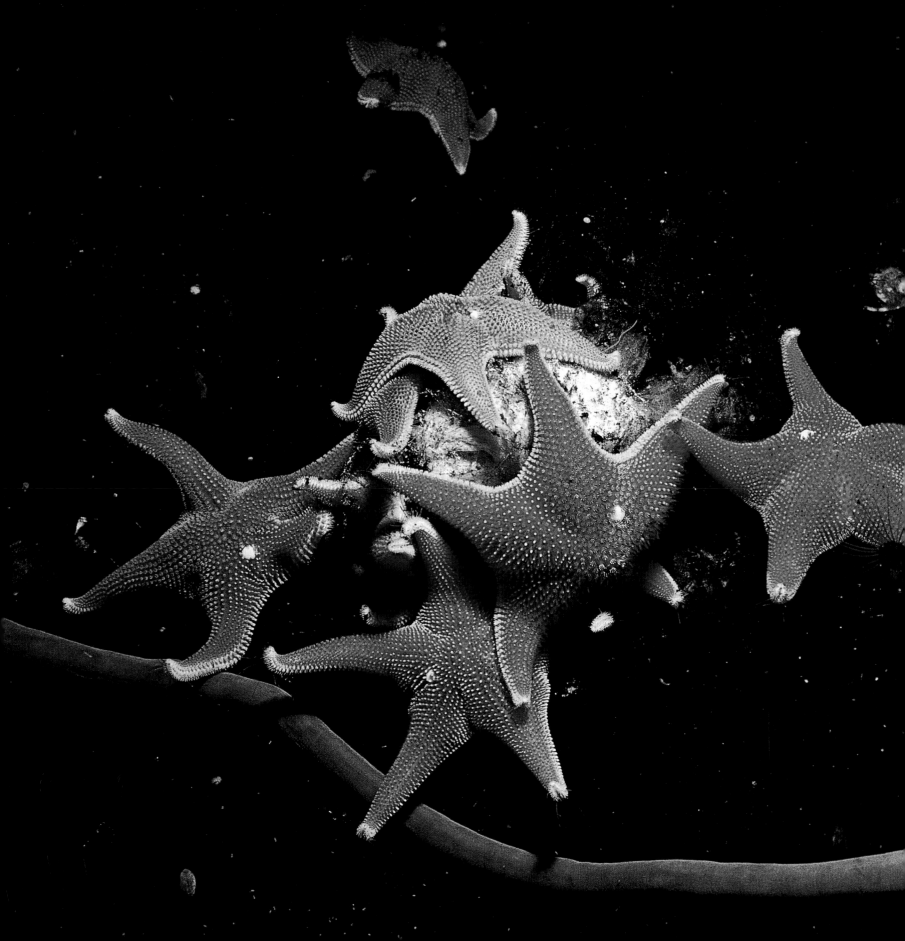

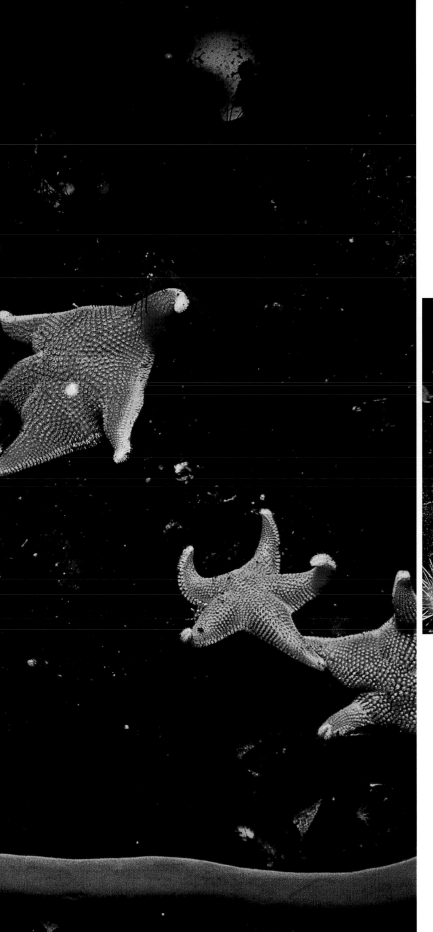

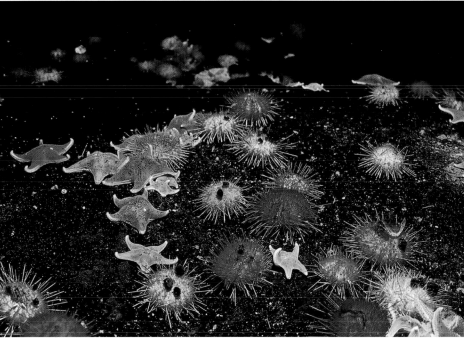

84-85  Starfish attack a small sponge, McMurdo Sound.

85 Starfish and sea urchins crawl along volcano cinder
bottom. Hutton Cliffs, Ross Island.

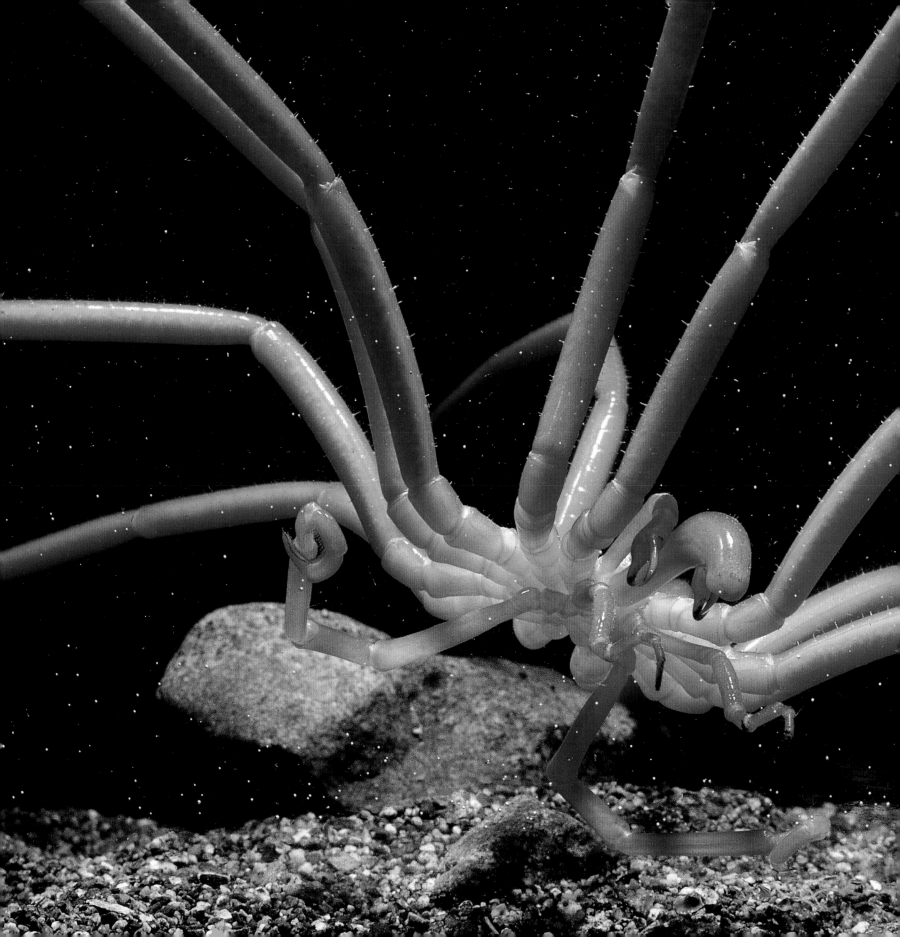

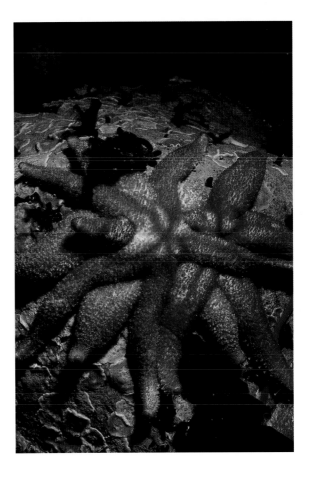

86-87  The largest and rarest of sea spiders,
*Dodecolopoda mawsoni*, from Antarctic Peninsula
waters.

87  Starfish compete for food.

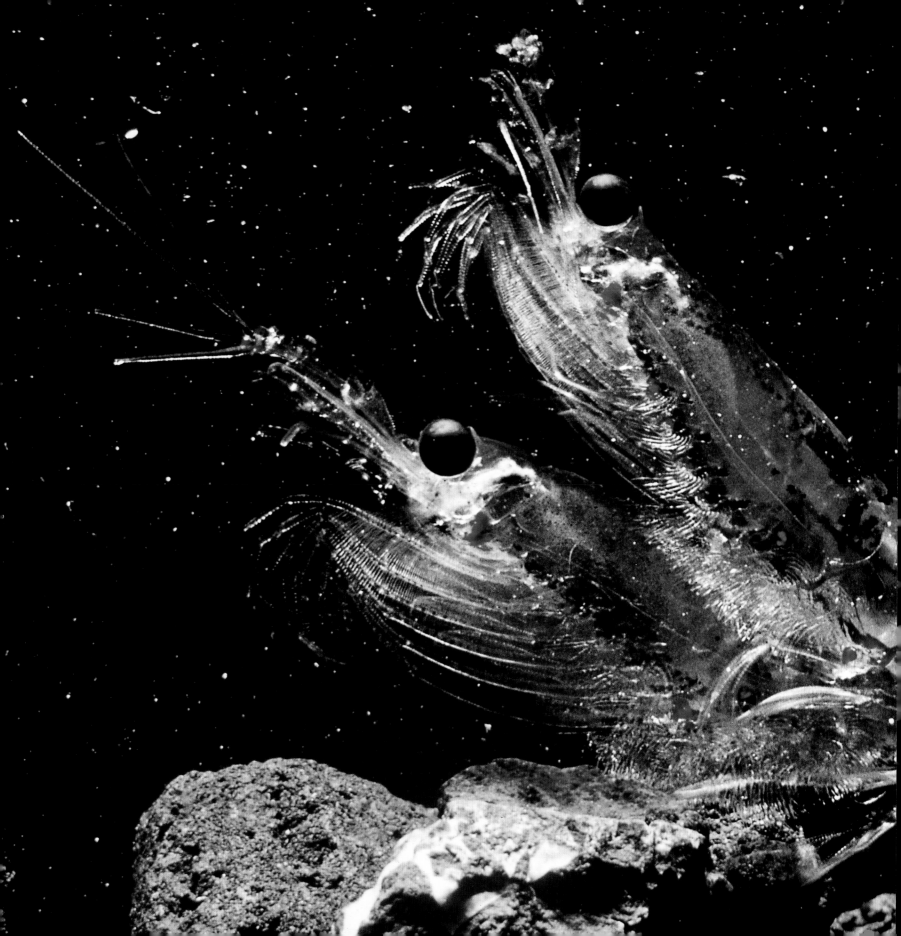

88-89  Krill, *Euphausia Superba*, is
considered the primary member of the
Antarctic marine food chain.

...SOFT-BODIED MEMBERS
OF THE ZOOPLANKTON COMMUNITY
IN ANTARCTICA ARE BORN

ON UNDER-ICE CURRENTS;

# I CALL THEM
# BEAUTIFUL DRIFTERS.

91  A pelagic holothurian dances in the mid-water darkness beneath Antarctic ice.

92-93  A soft-bodied ctenophore (comb jelly) maneuvers with cilia in an Antarctic Sea.

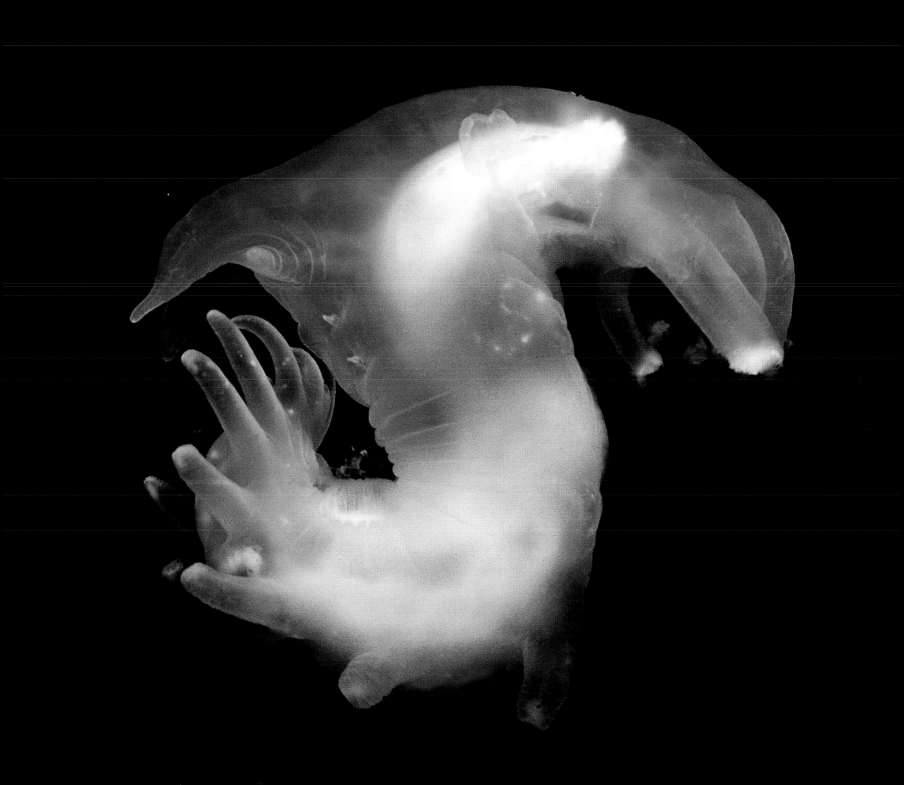

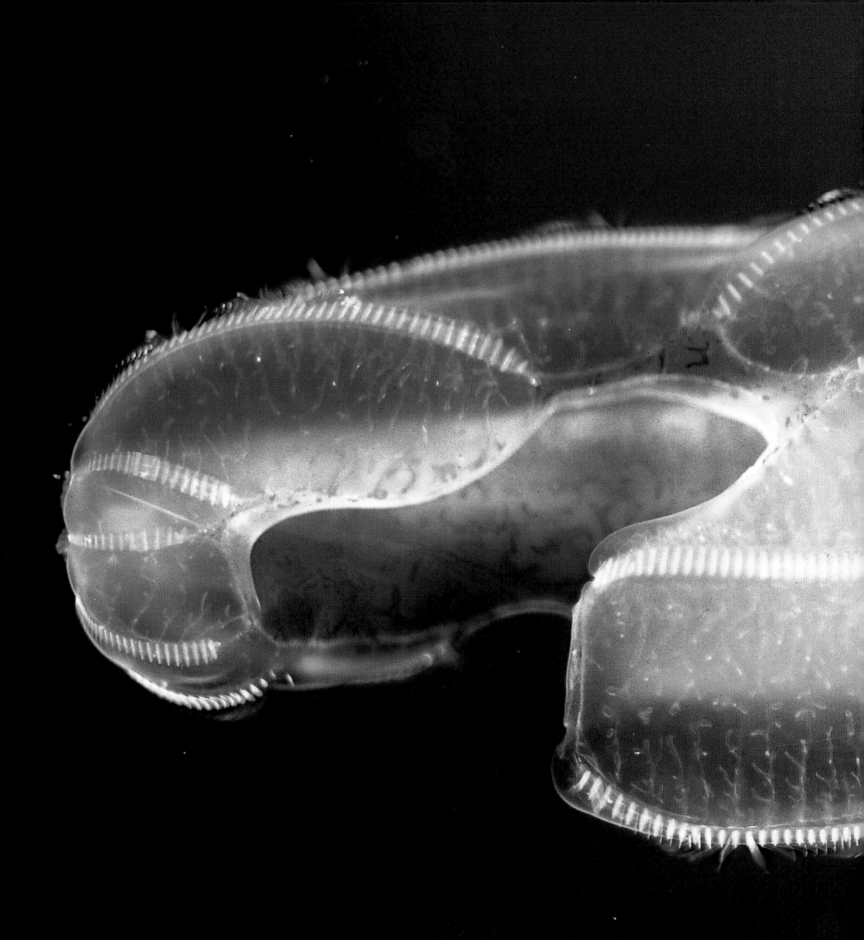

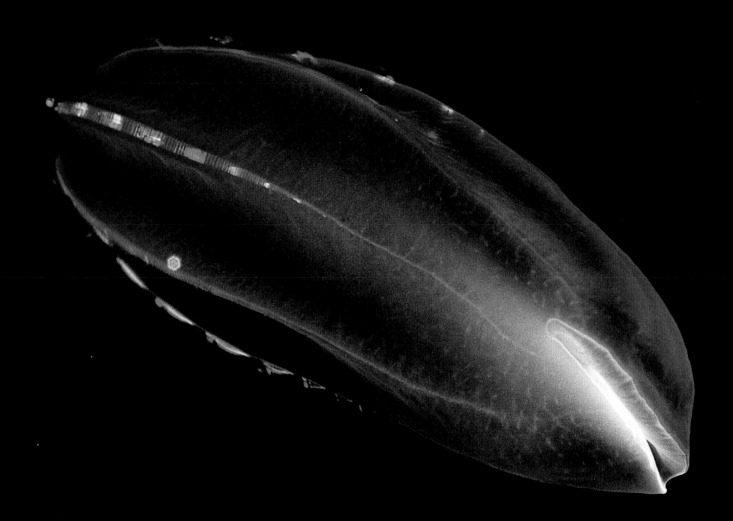

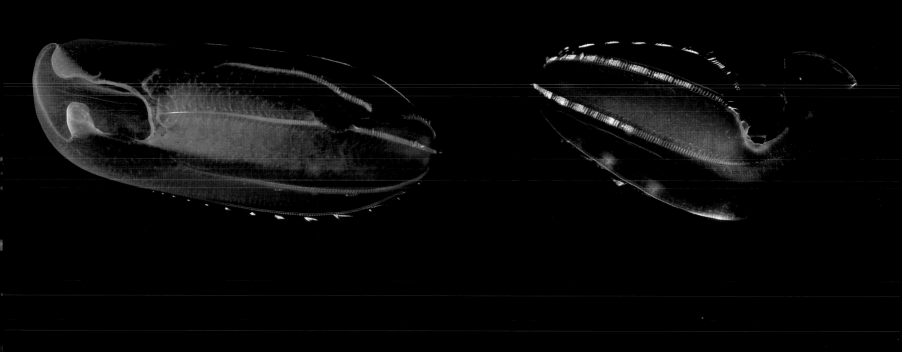

94-95   A leucothea (sp. *Ctenophore*) beneath Antarctic ice.

96 and 97   Plankton eating Beroid ctenophores drift in Antarctic waters.

98-99  Inner-space hitch-hikers,
hyperiid amphipods perch aboard
an Antarctic jellyfish, McMurdo
Sound.

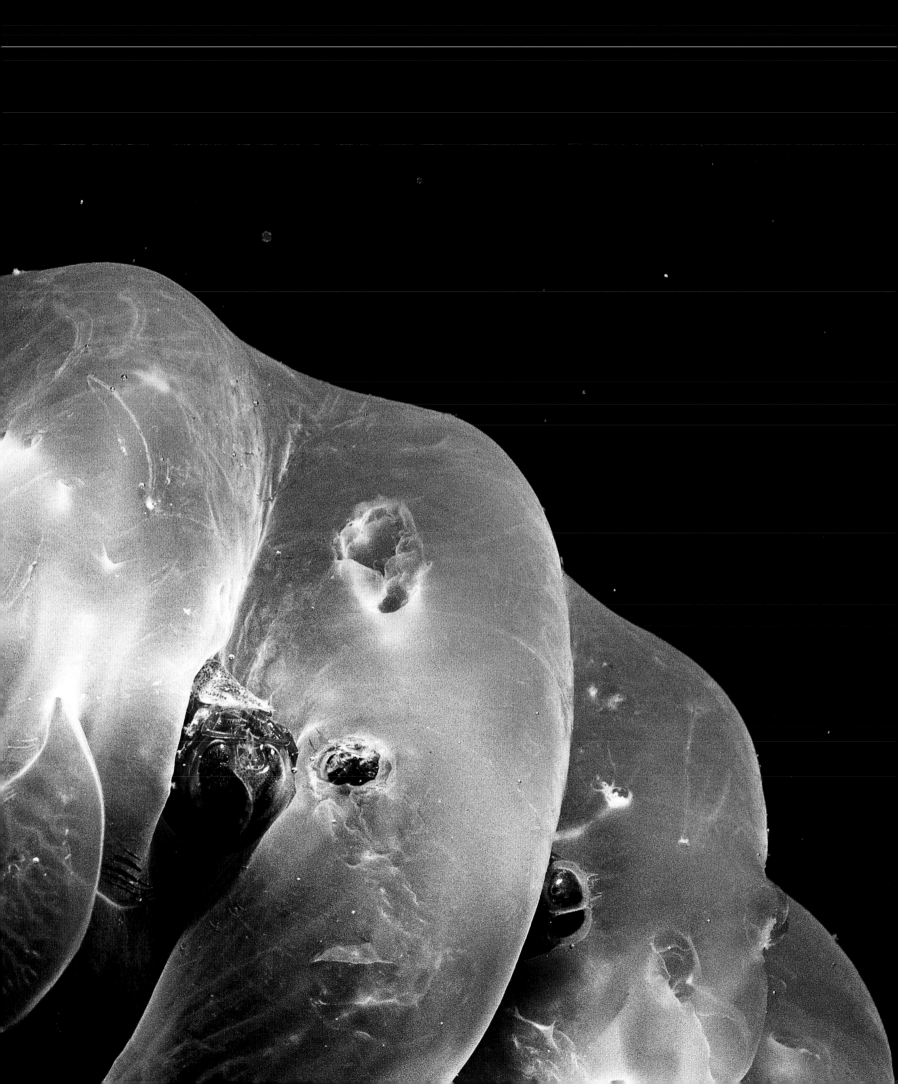

100-101 The soft pleated folds on the
Antarctic jellyfish, *Desmonema glaciale*.

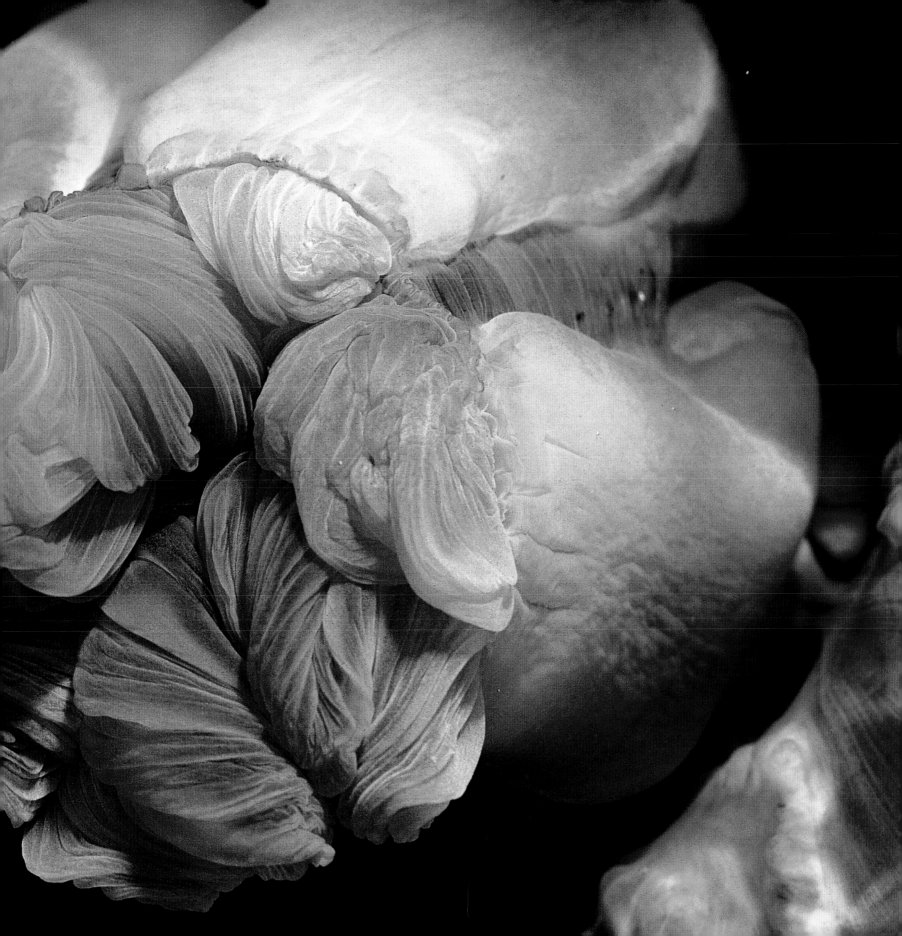

102 and 103 Trachymedusae from Antarctic waters with its marginal tentacles in various swimming positions. Red structure in center of bell is stomach tissue.

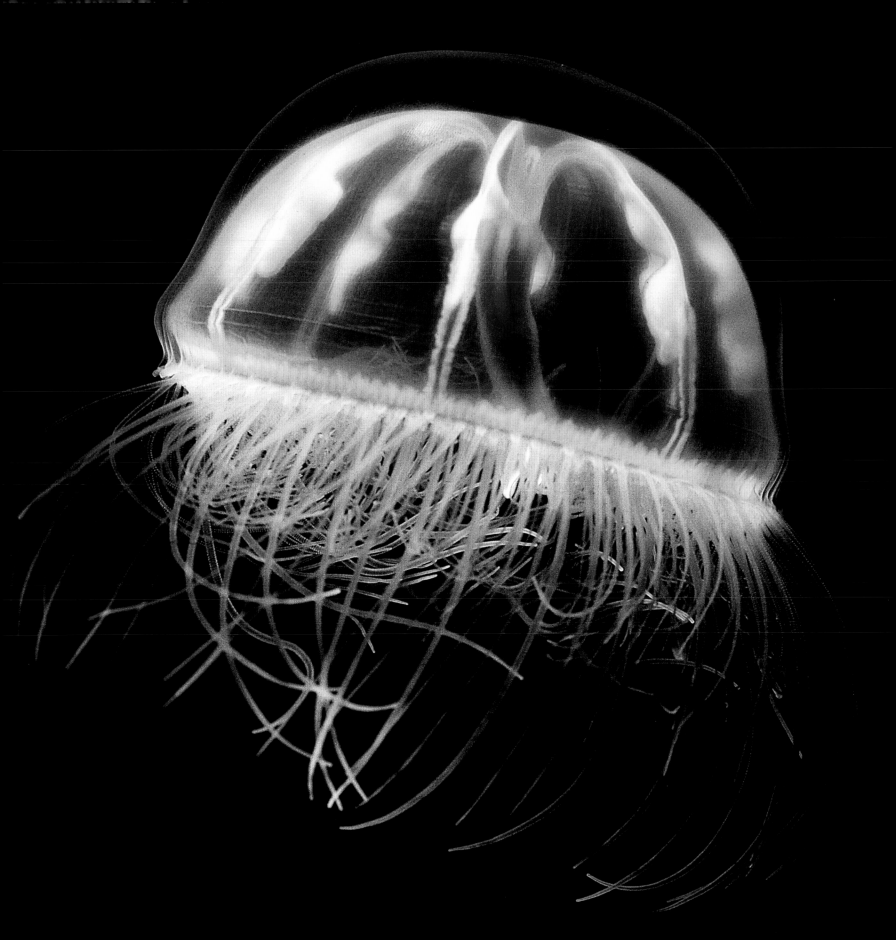

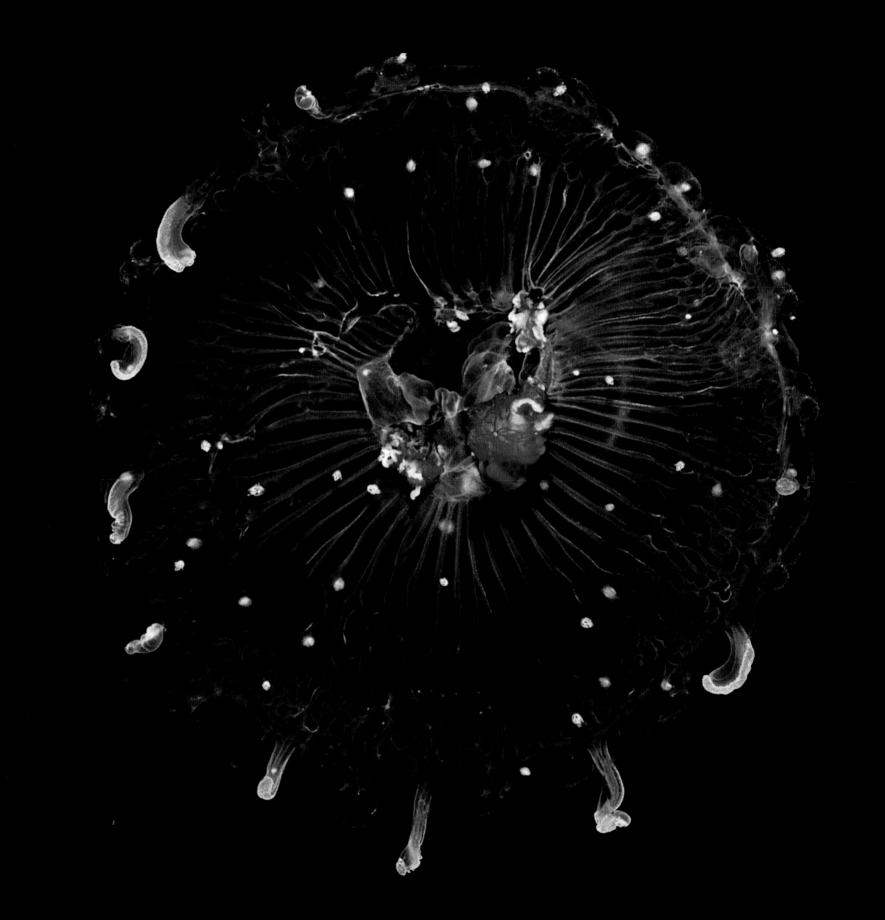

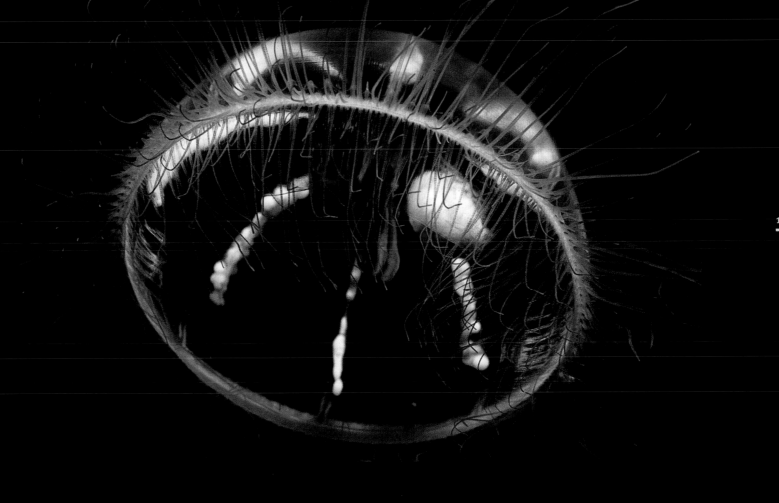

104  Unknown jellyfish species covered with tiny amphipods, McMurdo Sound.

105  Trachymedusae from Antarctic waters. The animal's cilia are refracting the light from my underwater strobe.

106-107  The Antarctic
jellyfish, *Desmonema*
*glaciale* retracts its
tentacles which
can extend to over
16.5 ft (5 m).

108-109  The jellyfish,
*Diplulmaris antarctica*, with
small hitchhiking hyperiid
amphipods on bell.

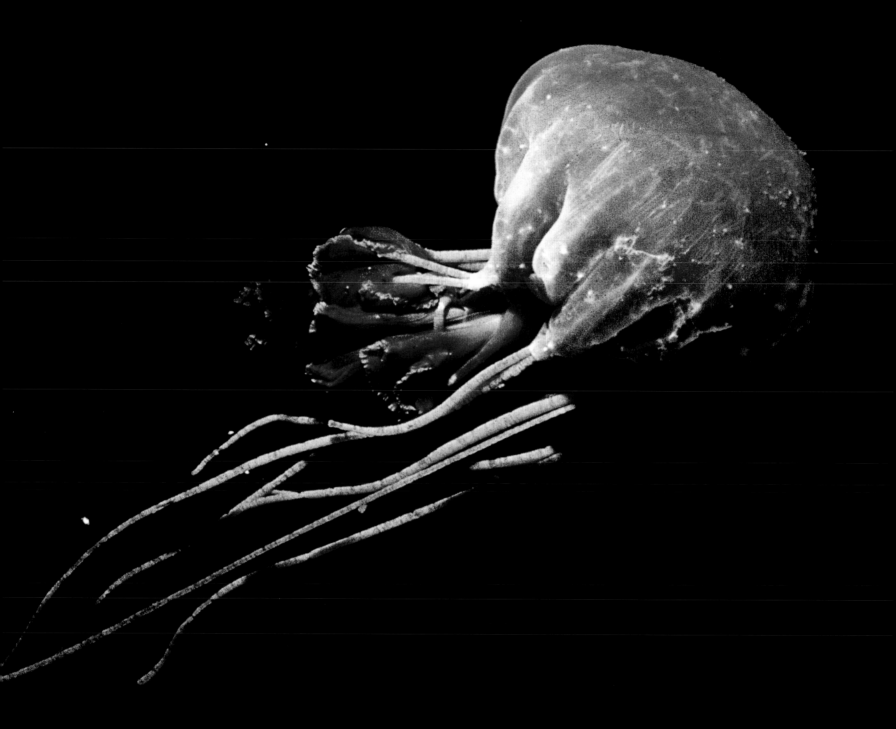

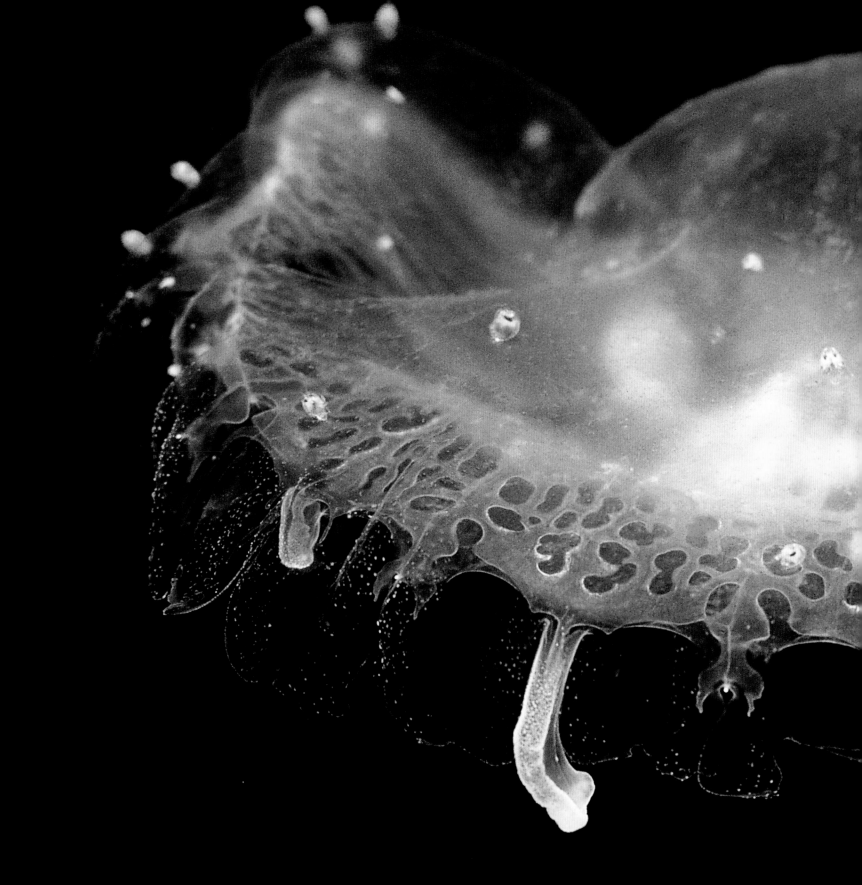

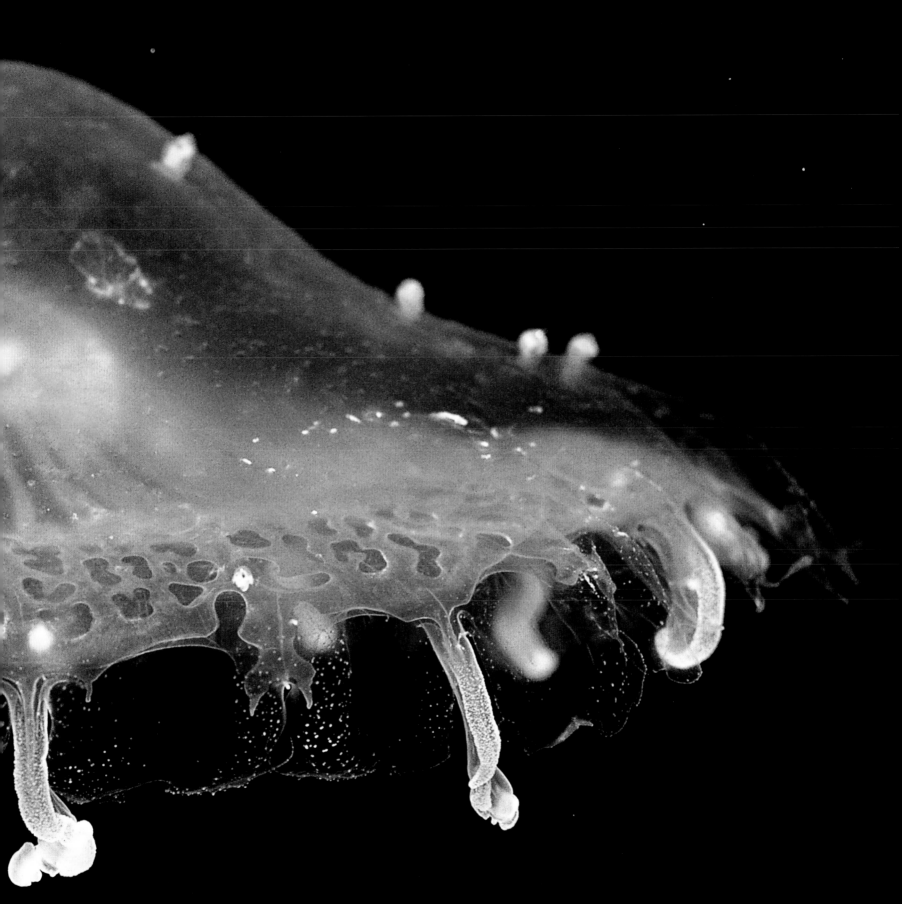

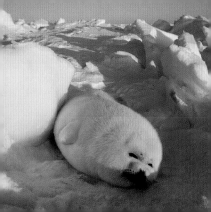

# THE
# ARCTIC

# FROZEN SEA

# THE ARCTIC

## FROZEN SEA

MY FIRST TRIP TO THE ARCTIC WAS IN MID-WINTER. I DIDN'T GET TO SEE MUCH OF THE LOCAL LANDSCAPE BECAUSE THE SUN HAD SET FOR THE SEASON WEEKS BEFORE I ARRIVED IN NOVEMBER.

It was dark all the time. I had gone to Resolute Bay in Canada's Northwest Territories to photograph a diving project. Divers pieced together an acrylic sphere weighted down with eight tons of iron ingots on the bay floor, a stone's throw from shore. It was called Sub-Igloo. It was billed as the "first diver-assembled manned station in the Arctic," but there wasn't much manning going on nor was there much for any man to do once they were inside. It was wet and damp and condensation lined the upper hemisphere, limiting visibility unless it was constantly wiped away. Sub-Igloo, which looked like a huge bubble sitting on the bottom barely, held two wet divers who entered via a hatch in the floor. The couple of times I went inside, I couldn't decide if I felt more comfortable inside, or back out in the freezing water.

The best part of the expedition was the opportunity to photograph invertebrate fauna in the water column and on the bottom of an Arctic bay in mid-winter.

It was also an opportunity to test new diving technologies; the most important of which was a new dive suit I had recently purchased. For all of my polar diving in Antarctica while in the Navy, I had used only wet suits. I remember these experiences as being cold beyond belief. My new suit was called the Uni-Suit, and in it, a diver remained dry. Poseidon Diving Systems, a Swedish company, developed this suit made of neoprene just like my wetsuits, but the neck and wrists had water and air tight seals. You entered the suit through a zipper sewn into the neoprene that was also water and air tight. An inlet valve had a hose that was connected to the air tank. This allowed you to introduce air into the suit for buoyancy control and thermal regulation. An outlet valve allowed you to purge excess air as you ascended to the surface. This technology changed cold-water diving for me forever. For the first time in my diving career, I was actually insulated from the freezing water around me. The only exposed skin was on my face, around my mask and mouthpiece. It was revolutionary and allowed me to work in relative comfort in 0°C water for the first time in my career.

The Arctic is not a continent like the Antarctic, and not so easily defined as to where it begins and ends as a

110  A baby harp seal rests on the sea ice of the Gulf of St. Lawrence waiting for its mother to return.

113  A female polar bear stands erect to better scan her frozen world.

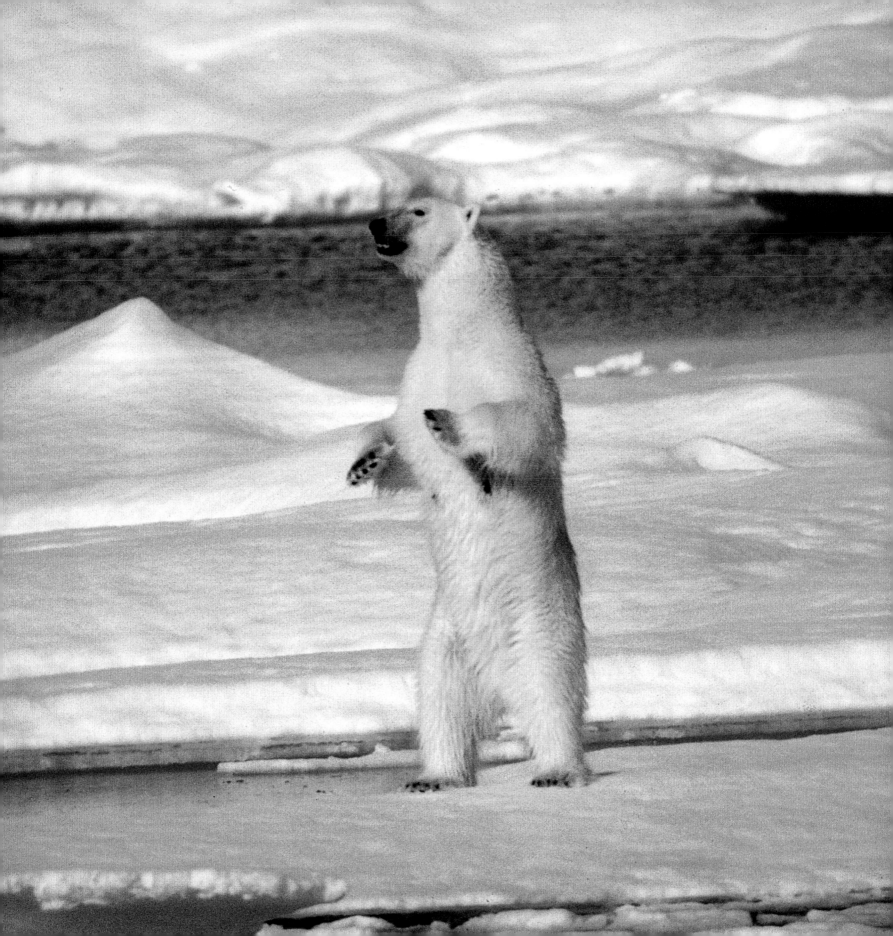

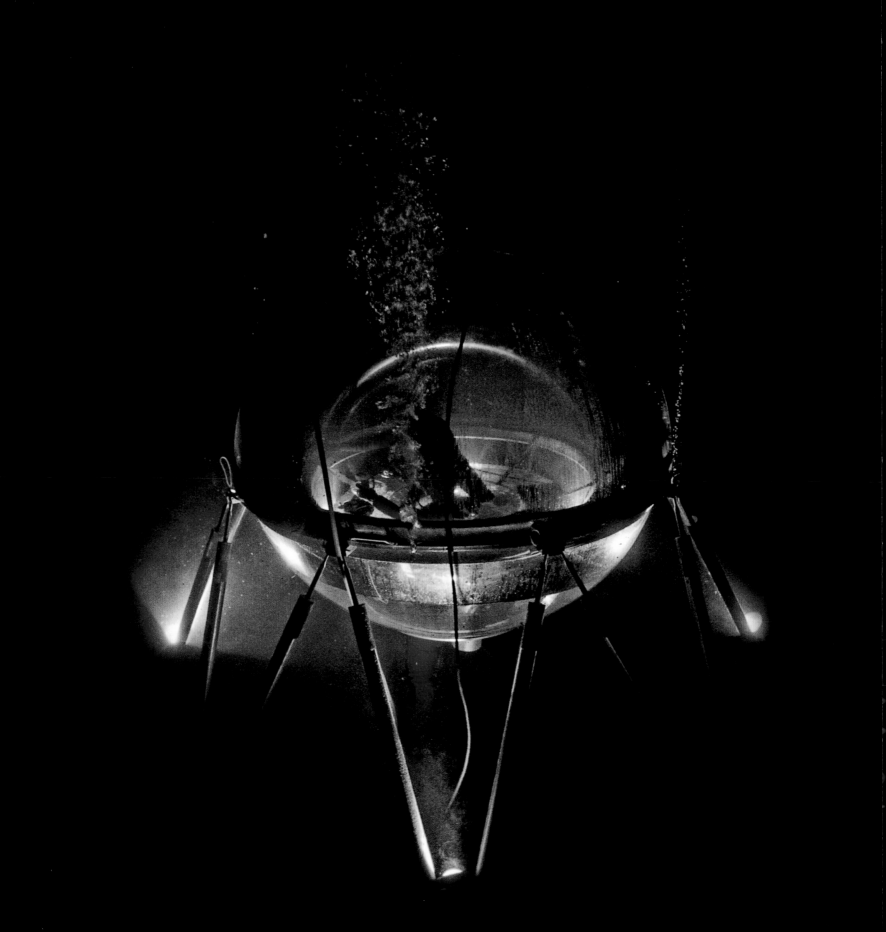

114 Sub-Igloo, Underwater Observation Platform, Resolute Bay, NWT, Canada.

115 left  Portable heated dive huts on sea ice, Resolute Bay, NWT, Canada.

115 right  Diving MD, Joe MacInnis, preparing to dive, Resolute Bay, NWT, Canada.

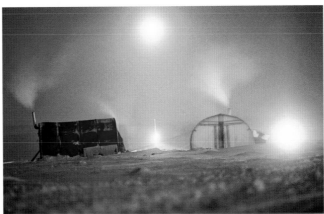 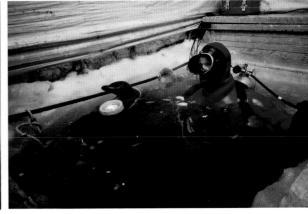

continent would be. Any area that lies above the northern limit where trees grow is considered Arctic. Any area in the north where the midsummer temperature remains below 10°C can be called Arctic. Over half of the region happens to be ocean: the Arctic Ocean along with many seas, including the Barents Sea, the Greenland Sea, the Norwegian Sea, the Kara Sea, the Laptev Sea, the East Siberian Sea, the Beaufort Sea and the Chukchi Sea. Most of Greenland lies north of the Arctic Circle, as do parts of Sweden, Russia, Canada, the U.S., and Norway.

The word Arctic comes from the Greek word Arktos, which refers to a constellation in the Northern sky called Ursa Major, or the Great Bear (also called the Big Dipper). There also happens to be a great bear of the Arctic. It is the polar bear. The polar bear's scientific name, *Ursus maritimes*, means sea bear. It is unique among bear species in that it is considered a marine mammal,

because of its close association with Arctic waters. Polar bears are strong swimmers and can make brief, shallow dives from the surface while stalking prey.

All bears are revered in some way by the indigenous human cultures they share their world with. They are powerful, intelligent creatures and have always garnered great respect from those who know them best. Polar bears are no exception. Standing on their hind legs then can reach 8.5 ft (2.5 m) and weigh as much as 1320 lbs (600 kg). The Inuit call the polar bear Nanuk and refer to it in their poetry as Pihoqahiak, "the ever-wandering one." Bear biologists from the Norwegian Polar Institute have tracked a female polar bear that walked and swam over 620 miles 1000 km during a recent spring/summer migration in the Barents Sea.

Polar bears prey mostly on ringed seals, common found around the Arctic basin. They also eat walrus.

Walrus have always fascinated me. Scientifically, they are classified as Pinnipeds, the order which includes the true seals, sea lions, and fur seals. But walrus distinguish themselves from the others by, among other things, their odd appearance. They are the largest "seal" I have ever seen, except maybe for male elephant seals I have photographed in the Antarctic. They live only in Arctic waters and there is only one walrus species. This single species is divided into Atlantic and Pacific subspecies, and they are spread randomly around the Arctic basin. The Pacific walrus is found mostly in the Bering and Chukchi Seas. All of my walrus photographs were taken in the Chukchi Sea, north of the Bering Straits.

I first saw a live walrus in a zoo somewhere. I was impressed by its hugeness. Even more than by its size, I was intrigued by the walrus' face. No other Pinniped has such a, well, funny face. This fact and this face were not lost on Lewis Carroll, who celebrated the walrus' unusual appearance in his classic book, Alice in Wonderland. The walrus' appearance is dominated by its teeth, commonly called tusks. Found in both the male and female, then extend out from the big whiskered face. Consider the walrus' scientific name, *Odobenus rosmarus*. It means "tooth-walking seahorse". If that description by an early observer doesn't conjure up a humorous image in your mind, nothing will. They don't walk on their two long tusks, but they do use them to help pull their enormous bodies out of the water and onto the ice. The tusks, which are merely upper canine teeth that grew and grew, are the walrus' ice ax, a simple lever they use to gain a "toothhold" on the ice and haul out. They also use them to maintain breathing holes in Arctic ice.

Both males and females use their tusks in various social displays. Females defend their young with them; males proclaim their dominance and social rank with sweeping tusk displays, and will also use them in self-defense.

Walrus do not use their tusks to dig up their primary prey species, clams, from the soft sub-strata in which they feed. For this they use their big, funny, whiskered, faces. A walrus just shoves its face into the muddy bottom and forages around. That face is loaded with *vibrissae*, or whiskers, and walrus have more of them than any other Pinniped or land mammal I can think of. *Vibrissae* are sensory organs; seals use them to detect unseen fish prey in the water column around them. Walrus use them to find clams in the mud. That big whimsical face with those oversized lips is nothing more than a fleshy pump, searching for and excavating clams from the mud, and sucking the tender parts from the shell. Walrus prey on other bottom species including fish, octopus, and worms. On rare occasions, walrus have even been observed eating seals, although the circumstances under which a walrus would resort to capturing a seal are not fully understood.

Not much is known about walrus behavior underwater. I would guess that I have about as many first-hand underwater observations as anyone. When I was given the opportunity to photograph walrus nearly thirty years ago, I knew that my childhood hero, Jacques Cousteau, had been there before me. He and his entourage had been in the Chukchi Sea a year or so earlier, and had failed to obtain a single under-

water photograph of walrus. They never even saw one underwater. I didn't know what his methods had been, but if he couldn't photograph walrus underwater, could I? This question haunted me in the field. In the end, I did photograph walrus underwater, but the pictures did not come easily. I spent many hours swimming alone in the open water along the fields of ice on which they live. While stalking walrus, I always kept and eye out for polar bears. From what I had heard, polar bears, if they so desire, will just come up to you, without hesitation, and eat you. . . .

On July 29, 1977 I photographed my first walrus underwater. It was one of the most beautiful days I have ever spent on, in, near or around the ice. There was just the lightest of breezes as we left the ship and once in among the pack ice there was not a ripple anywhere, not a whisper of wind. The sea shimmered like a mirror and not a molecule of water was disturbed. I was swimming alone, about 85 ft (25 m) from the *Zodiac* when I saw a pair of walrus coming more or less toward me in a fairly large expanse of open water. I swam madly to place myself along their path and slipped underwater when they were approximately 35 ft (10 m) away. All I remember is two walruses coming right at me, turning slightly away only at the very last moment. They seemed curious as they approached, but once I started framing them in my viewfinder, my movements probably startled them. The strobe did too, as I could see their bodies jerk in response to the flash. I remember that I only got two pictures; one with flash and one without, and that the pair were fairly close as they passed quickly from right to left. Then it was over. They were gone. I felt fairly certain that I had a photo-

graph or two, but one never knows for sure. But on that beautiful windless day I became the very first person to photograph walrus underwater in their natural habitat. This incredible encounter took me some time to recover from. I sat in the *Zodiac* in disbelief, happy and hoping that my camera was set properly. It was.

During another underwater walrus encounter, I was on the receiving end of a threat display. I had dropped beneath an ice floe that had a group of walrus on it. On the surface, our boat frightened about half the animals into the water. One large male swam down directly toward me where I was waiting at about a 35 ft (10 m) depth. I remember clicking away with my Nikonos camera and finally having to push the walrus away with both hands. The entire group was in the water by then, and I had to push another walrus' face away with the camera. First there was a mild (not violent or rapid) tusk thrust directed at my camera and me. I could feel myself being pushed down deeper by the walrus, but I kept my face pressed to the viewfinder and continued to photograph. I might possibly have been in their way--not blocking the only exit, but in front of where they wanted to go. The walrus just kept slowly swimming and pushing me down with him. It lasted only a few seconds but it seemed like a long time underwater.

I observed this "mild tusk thrust" on other occasions underwater. It never developed into any gesture I could describe as overtly aggressive. It was just a little mild body language telling me, " Hey pal, you're in my way. And who and what are you, anyway?"

Compared to all other Pinnipeds, walrus have tiny eyes. I am not a walrus optometrist but I don't think

they see well, especially in air. Hang around an aggregation of walrus on an ice floe and one fact becomes clear right away: as long as you remain downwind you can approach close enough to almost touch one. The very second they smell you, they will all spill off the floe into the water gesturing with their tusks and snorting and vocalizing their displeasure at your presence or at being disturbed. In air, it seems that they can't see you until they smell you.

This downwind approach to a group of walrus is not lost on one of their chief enemies, the polar bear. Polar bears are pretty good at catching Arctic Pinnipeds. I had the good fortune to witness a polar bear stalk and chase a group of walrus, but the outcome was not at all what I imagined it would be.

The bear made a long water stalk, swimming about 300 yards to a downwind position and then turned back towards two groups of walrus scattered on two different floes. From my position in the *Zodiac*, I saw him crawl out behind the first group and give chase to the second group to my right. He seemed slightly tentative at first, and did not rush madly forward as I expected. The walrus were scattering. All the females and calves of both groups were in the water , but the big males remained and were swaying their tusks back and forth, slowly backing into the water, vocalizing loudly with a guttural bellow. Once the first group wass in the water the bear just stopped and looked at them. He seemed to half climb and half swim for a moment onto the floe toward the second group, but once again it was not a mad dash. The big, white bear slowly walked toward the remaining males and at one point, just stopped and looked around. The bear seemed slightly intimidated by the walrus, and the walrus didn't appear to be overwhelmed by the bear, especially the big-tusked, swaying males who were the last to leave the floe. In the end, the bear just walked over to the edge of the floe and watched as the walrus swam steadily away, backwards, with their eyes on the bear.

I really thought I was going to get some fantastic images of a polar bear attacking and eating a walrus, but that was just my hopeful imagination at work and little else. The bear didn't rush at the walrus with carefree abandon. I don't think any polar bear in his right mind would take on a 2000-pound, tusk-swinging, bellowing, male walrus. As happens so often in nature, this well-adapted predatory bear of the high Arctic had another plan. A better plan, really. From this frantic event he had created, with walrus stampeding toward the safety of the surrounding water, he was hoping for just one sick, confused, young, dumb, or crushed calf to be left behind. He would attack and eat it without hesitation. It did not happen this time, but I'm sure it happens often enough to make this a common event whenever walrus and polar bears meet.

Walrus are very social animals; they like the touch and feel of fellow walrus. When they haul out on the ice to rest they don't do it alone, but in large, dense groups. Science calls this "positive thigmotaxic behavior." I have seen no Pinniped so determined to engage in "positive thigmotaxic behavior" as the walrus. Elephant seals haul out in dense piles but not to the extent that walrus do. From an aerial viewpoint it is easy to see thousands of walrus bunched onto one floe, acres of brown blobs in big social piles. I was often surprised

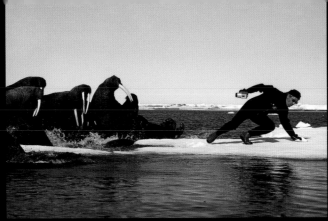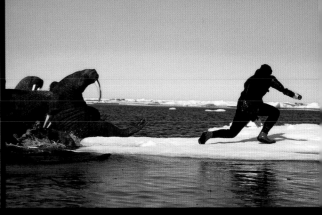

119 left and right  Walrus and walrus scientist on the run.

by how many walrus could fit on one small piece of pack-ice. It seemed at times, that if one more walrus climbed on, the floe had to tip over. I never saw it, but I wouldn't be surprised if it happens. The need to touch another member of your species is a powerful one and basic to survival. Walrus understand the simple, basic comfort derived from having another beside you as you sleep. Touch is a potent sense and one we often fail to understand. Not the walrus. They are absolutely, positively, thigmotaxic about it. My last evening with the walrus is the one I most like to remember. It was in the Arctic summer when the sun takes forever to set. The sky was a brilliant orange and it stayed that way for over an hour. The air was thick with the distant sounds of walrus. All of a sudden, just a few feet in front of my rubber boat, the stillness was broken by a single gray whale surfacing among the scattered floes. Rising for a quick breath to where it saw the orange light from below, the whale descended again with a great whoosh. I could hear its back scraping along the gnarled underside of a near-by ice floe. Then it was gone. All that was left was the warm vapor of its breath hanging in the still air above me. In the wake of the gray whale's whoosh, the walrus sounds returned, mostly calm grunts, enormous brown bodies being shifted, a plea here and there for more room; the click-clack of walrus tusks meeting each other in a polite spar. I remember feeling pretty good with the assignment and myself. Click-clack. I was almost certain that in my quest for an underwater image of this elusive animal I had bested my childhood hero. Click-clack. Click-clack.

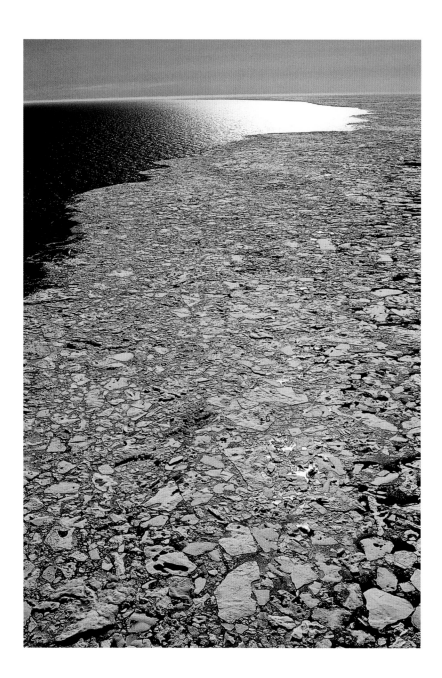

120  At the edge of a frozen Chukchi Sea a brief summer arrives.

121  U.S. Coast Guard ice-breaker *Glacier* navigates through summer sea ice in the Chukchi Sea.

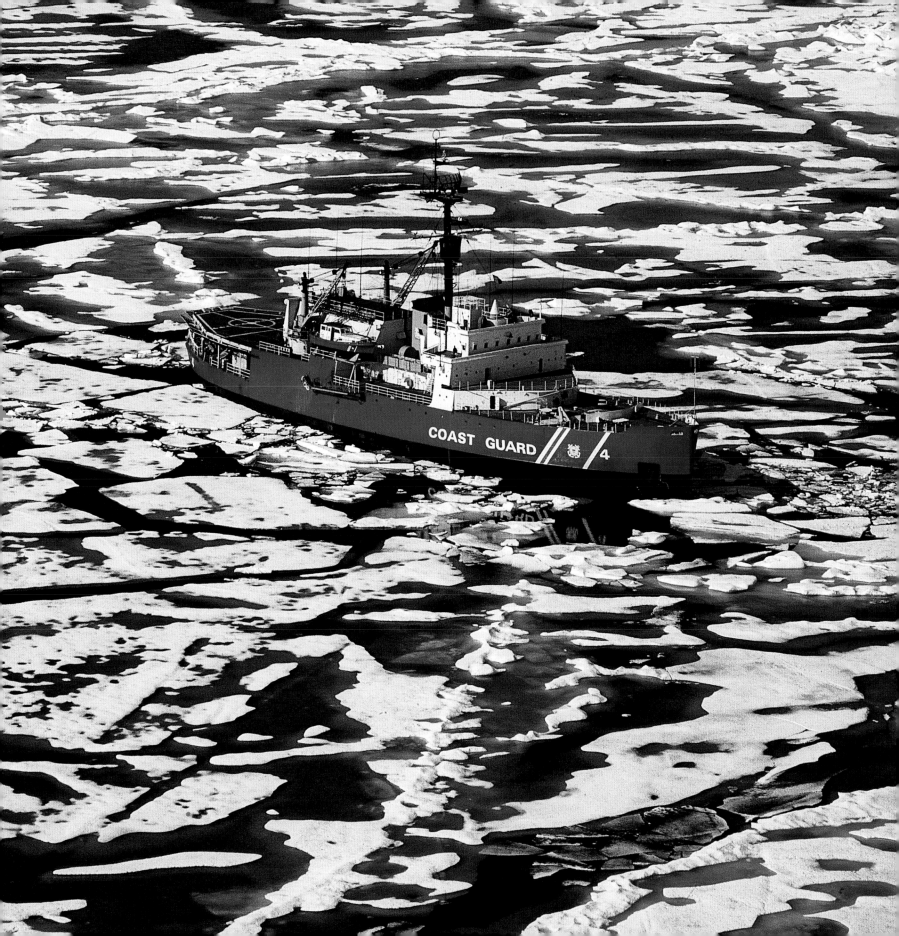

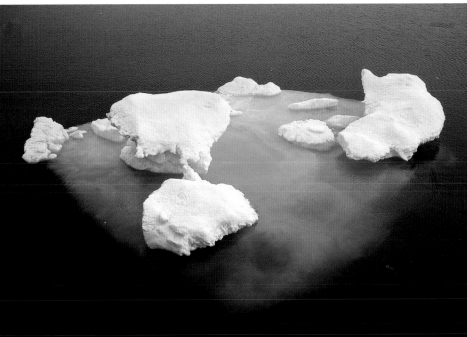

122-123 and 123  Ice Patterns and small floating berg,
Chukchi Sea.

124-125  Aerial views of the Chukchi Sea thawing
during the summer reveal beautiful patterns,
such as the open lead shown here.

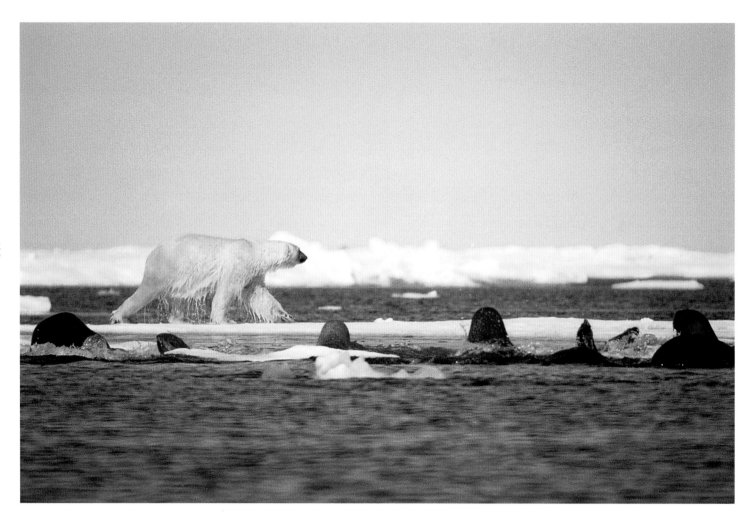

126  A polar bear on an ice-floe where adult walrus were resting. After a long water stalk the bear was hoping to surprise a naïve or confused juvenile and successfully attack it.

127  Adult polar bear with the remains of a walrus calf he had killed.

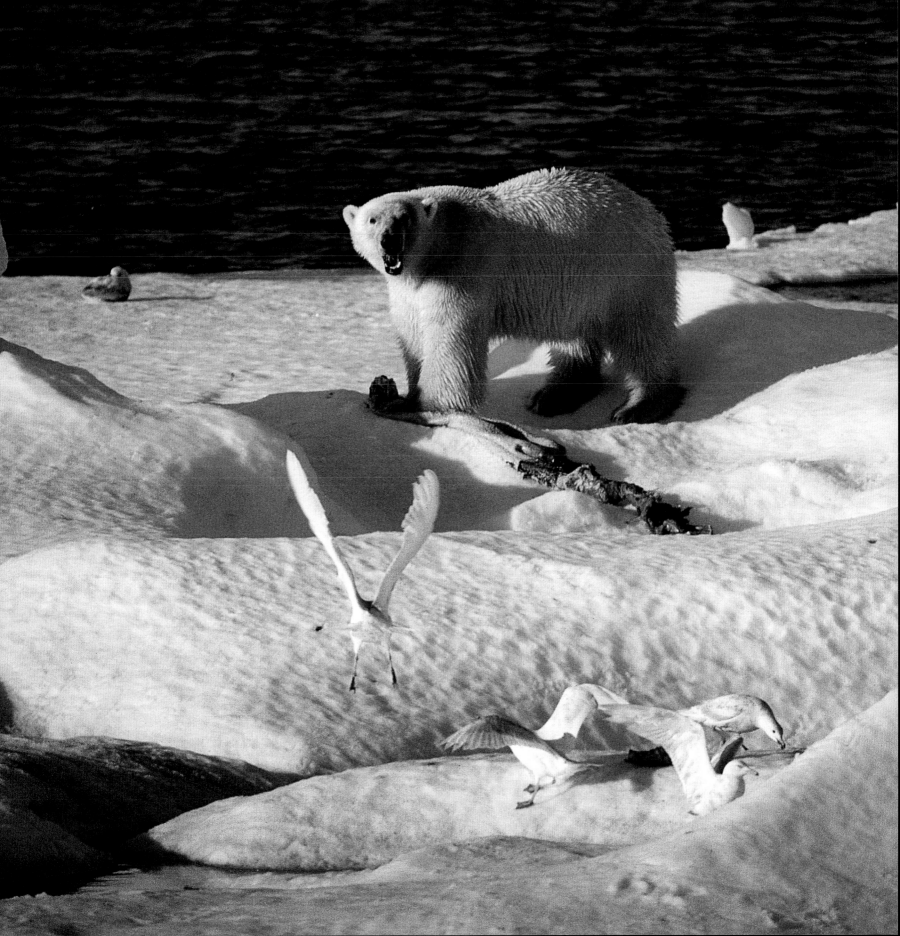

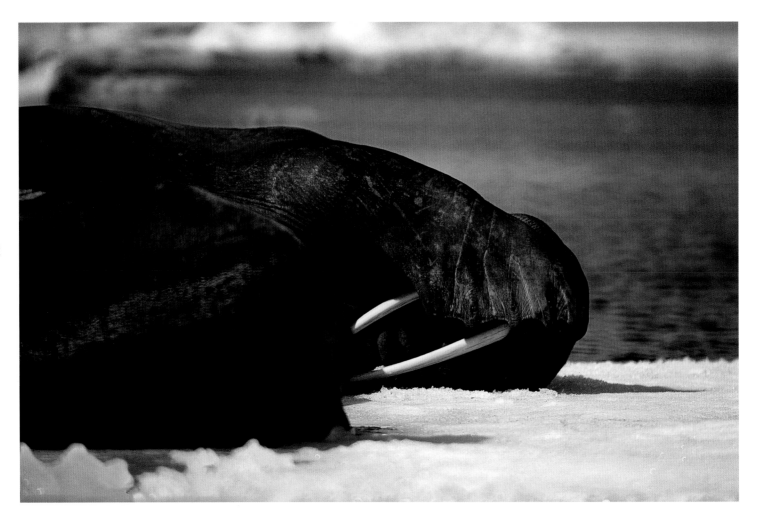

128  A resting walrus shields its eyes from the sun with flipper.

129  Walrus always haul out onto the sea ice in groups, resting up against each other in a big
social huddles, Chukchi Sea.

130-131  Big is Beautiful; an adult walrus "sitting up" while others sleep.

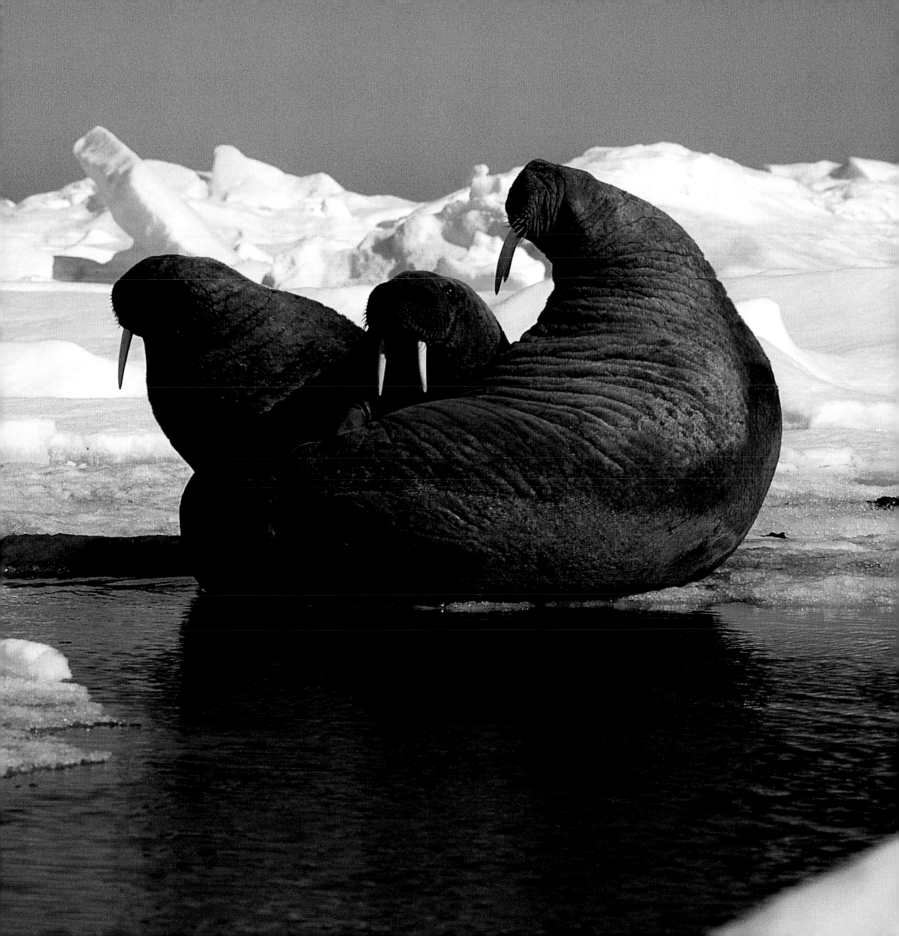

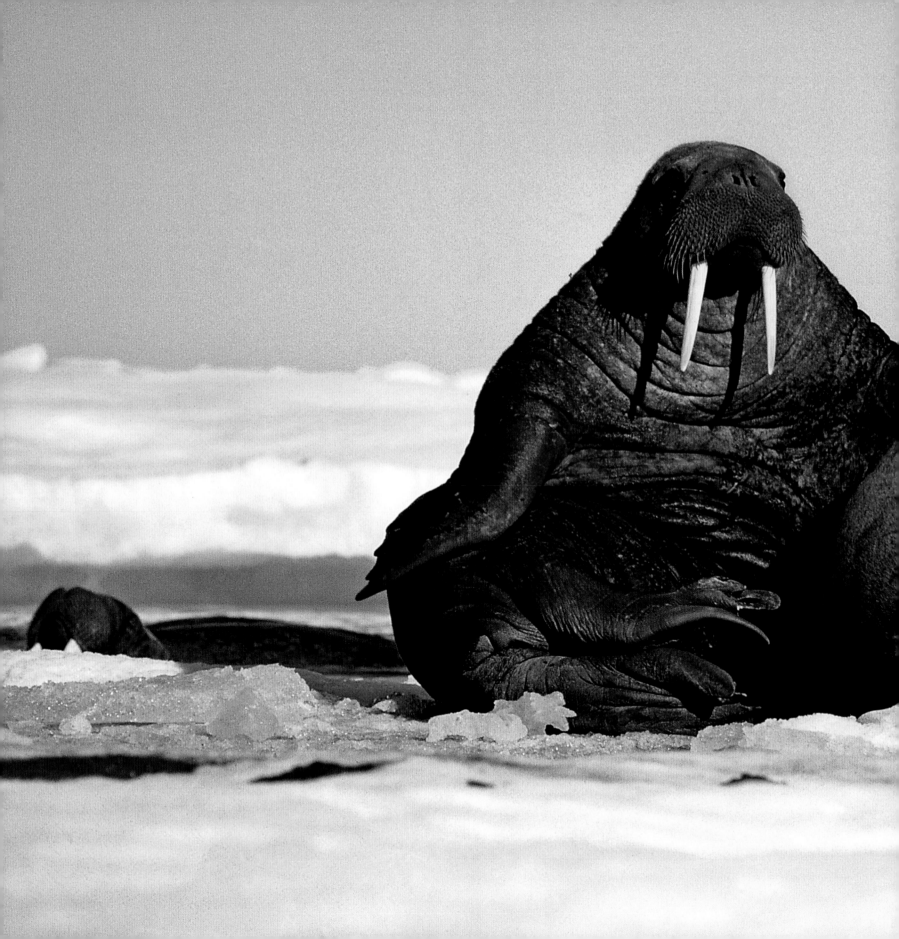

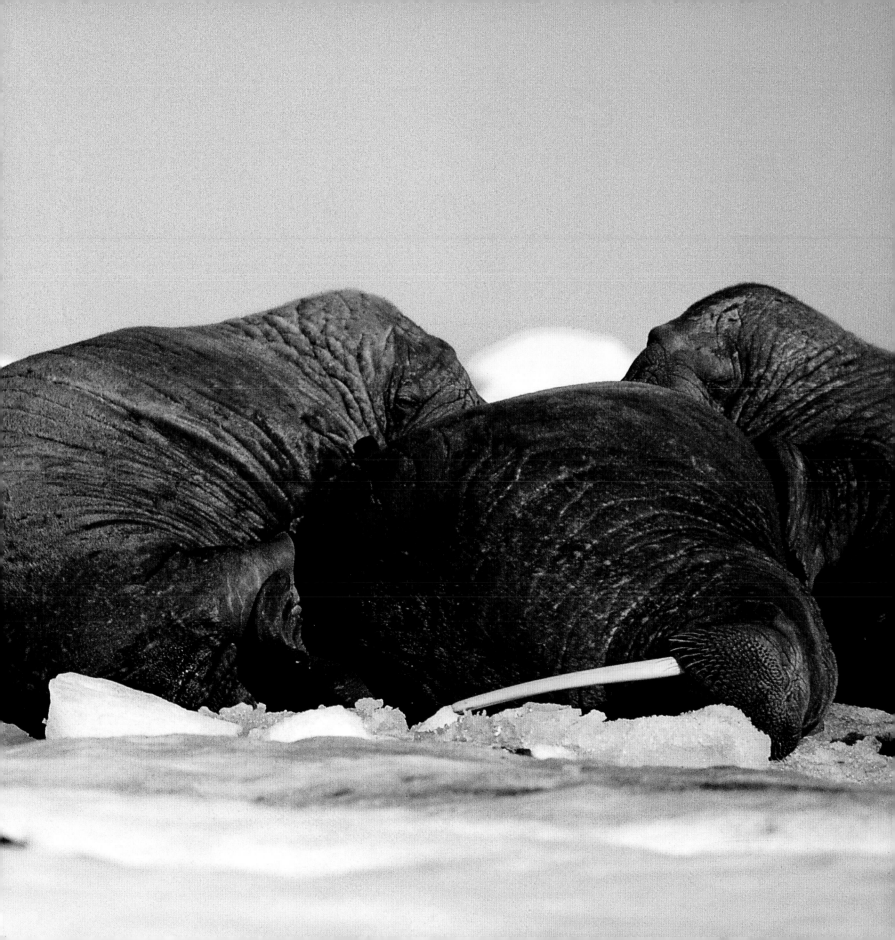

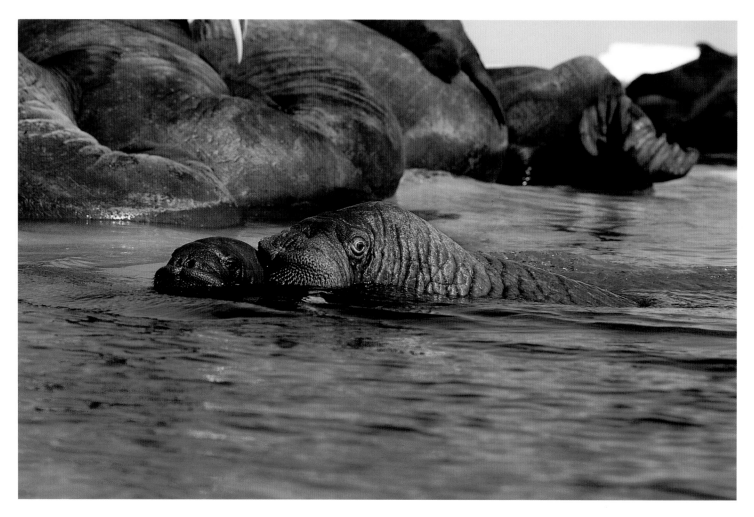

132  A walrus mother pushes her calf behind her as she spots me.

133  A walrus mother and calf (behind) look at me.

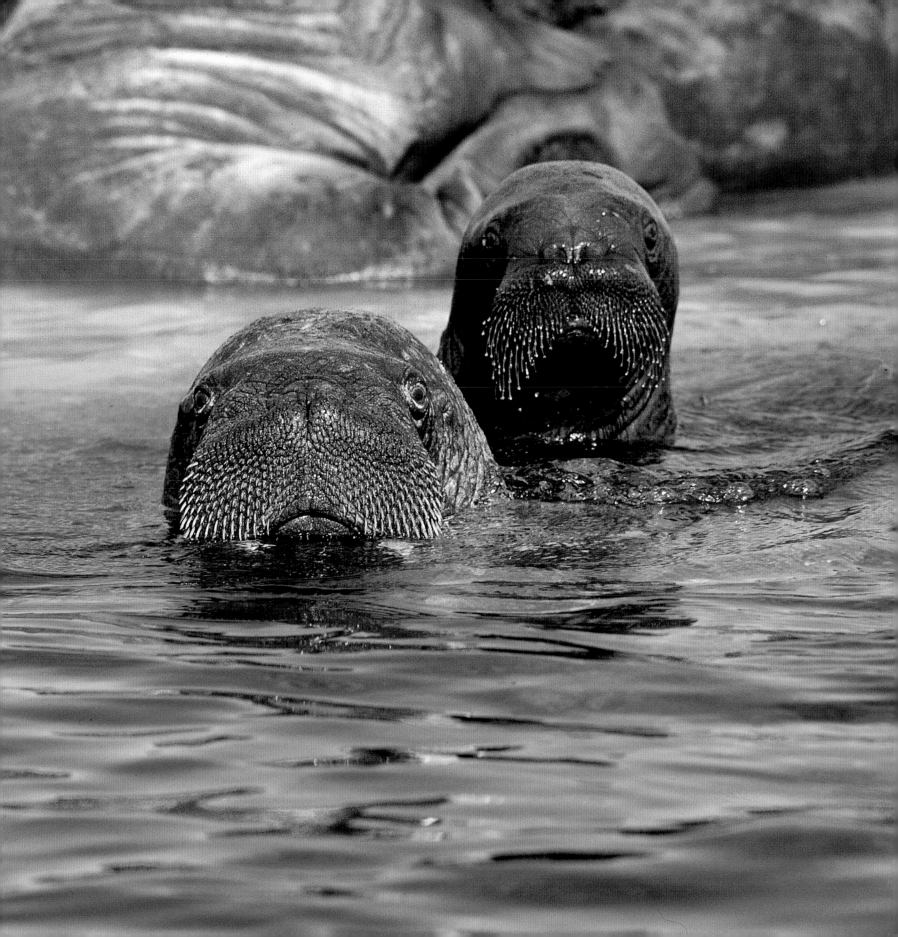

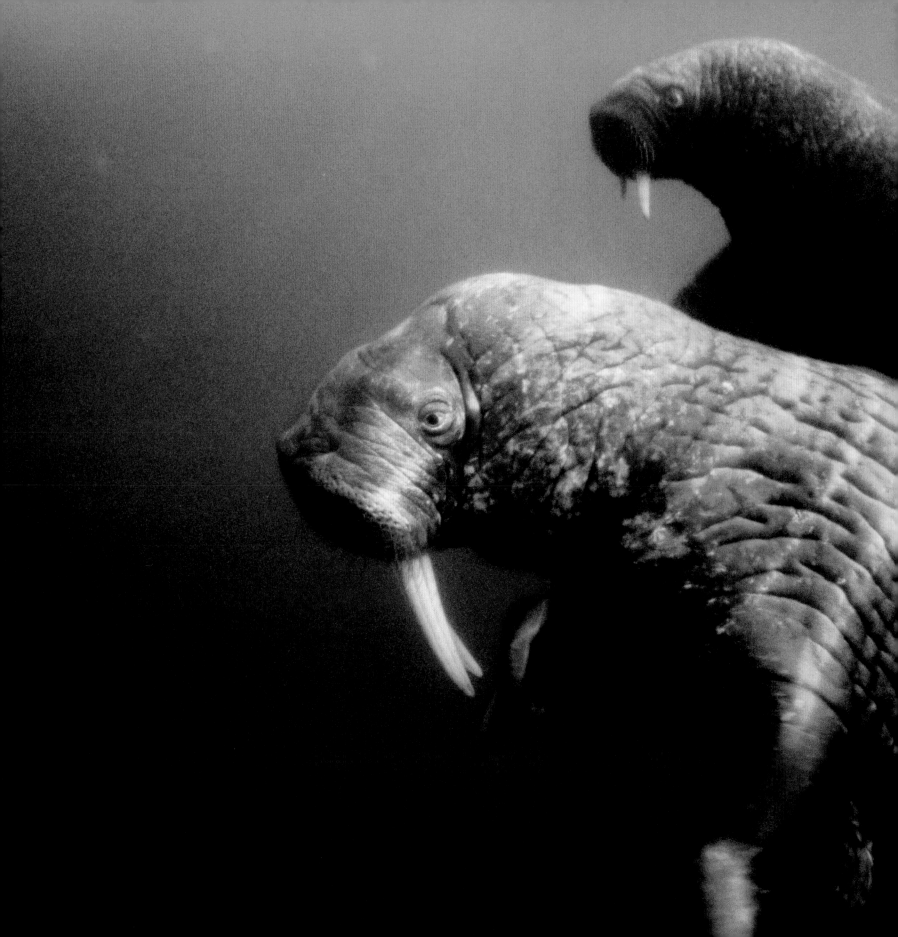

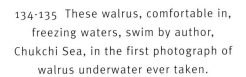

134-135 These walrus, comfortable in, freezing waters, swim by author, Chukchi Sea, in the first photograph of walrus underwater ever taken.

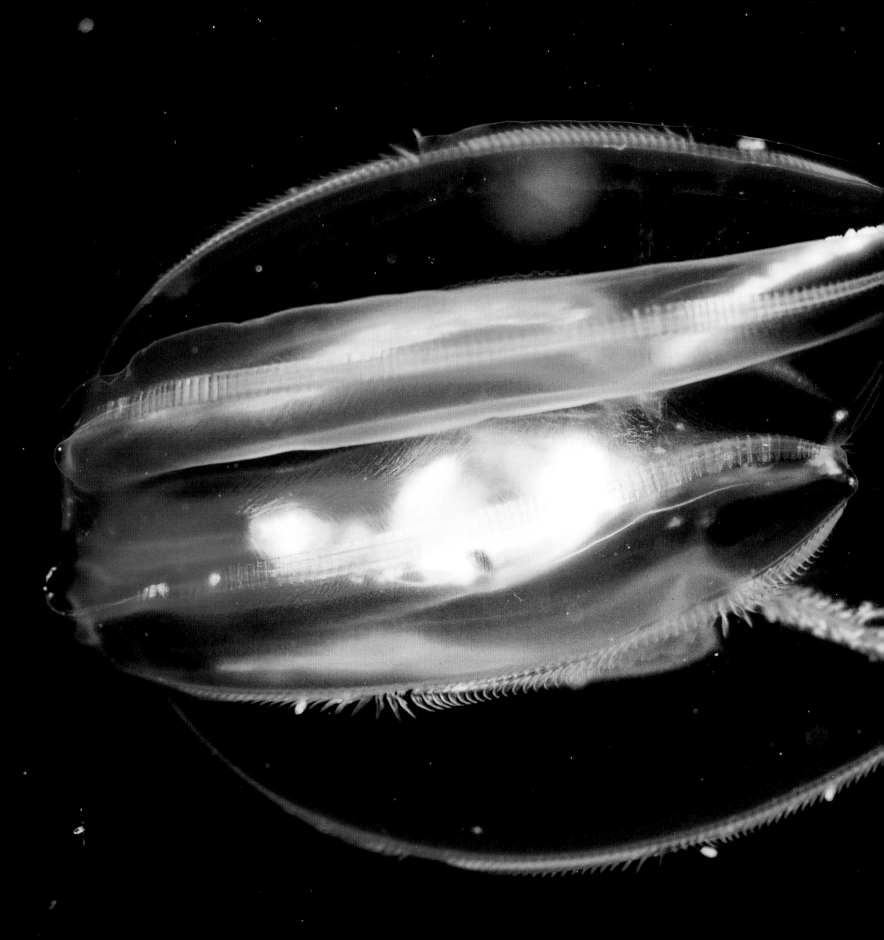

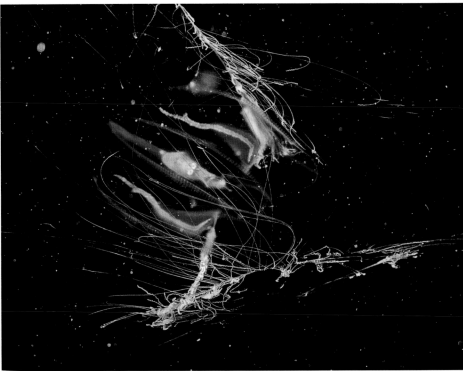

136-137 and 137  Cydippid comb jellys are ctenophores. Extended tentacles are used to capture other zooplankton species like copepods and small crustaceans.

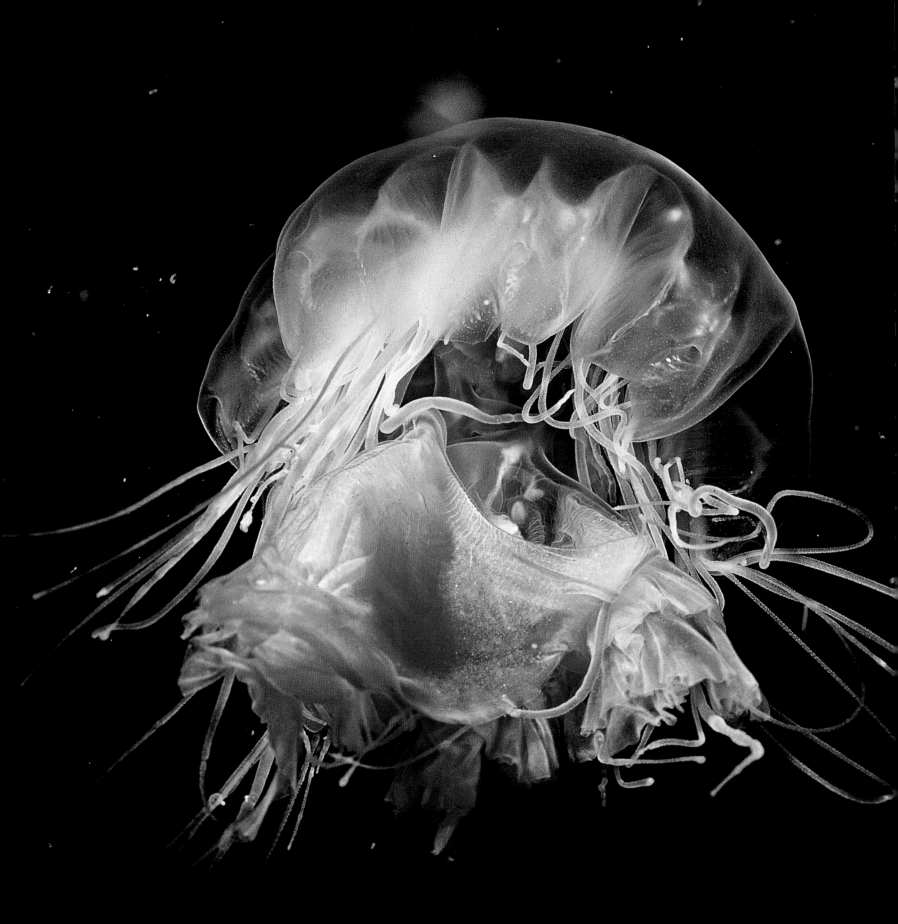

138  Lion's mane Jellyfish, *Cyanea capillata*, Resolute Bay, NWT, Canada.

# HARP SEALS

## THE ICE FROM BELOW

MUCH OF MY WORK HAS OFTEN BEEN CHARACTERIZED BY THE SPECIAL EFFORT IT TAKES JUST TO BE IN A CERTAIN PLACE, AT A CERTAIN TIME, TO SEE THE ANIMAL I WANT TO PHOTOGRAPH. I'VE NEVER WANTED TO PHOTOGRAPH THE ORDINARY, THE COMMONPLACE, OR WHAT MANY UNDERWATER PHOTOGRAPHERS SEEM TO WANT TO DO, CORAL REEFS.

My interest is in doing something new, photographing an animal in a way no one has before. Working beneath the shifting sea ice of the Gulf of St. Lawrence, photographing harp seals, typifies this kind of effort. One might think that it is one of the craziest things I've ever done, but it isn't. It has had its crazy moments though.

Once, after finishing a late dive, my assistant, Bora Merdsoy and I ascended to the slushy lead we had entered through an hour before. I held my hand above my head to push through the slush. Much to my surprise the slush did not give way; the lead had frozen solid. We were trapped. With a rapidly diminishing tank of air and the thought of being cut off from the world above, my internal alarm bell started to clang away.

The next few minutes of that dive are forever imprinted in my brain. I remember looking at my pressure gauge and trying to calculate in my mind exactly how much time I had left with 500 psi of air remaining in my tank. I remember saying to myself, calm down, slow down, and don't panic. I forced myself to take slow, deep breaths instead of too many shallow ones. We started to move along our now frozen ceiling of ice looking for a way out. I descended to about 23 ft (7 m) and scanned the length of the lead for the brightest spot, thinking that might be where the ice was thinnest. I ascended to a bright spot and started bashing my underwater housing against the ice. Bora was swinging off his tanks to bash his way through when my arm managed to poke a hole through a piece of yielding slush. I kept punching the hole and pushing aside pieces of ice to make it large enough to pass through. As I crawled out onto the sea ice and spit out my mouthpiece, I looked across at the orange sun setting behind a pressure ridge. It was the most beautiful sunset I had ever seen, and I don't remember taking a sweeter breath of air, ever.

In the early 1970s the hunt for the white-coated harp seal pups in the Gulf of St Lawrence was

141 Harp seal pup on ice, Gulf of St. Lawrence.

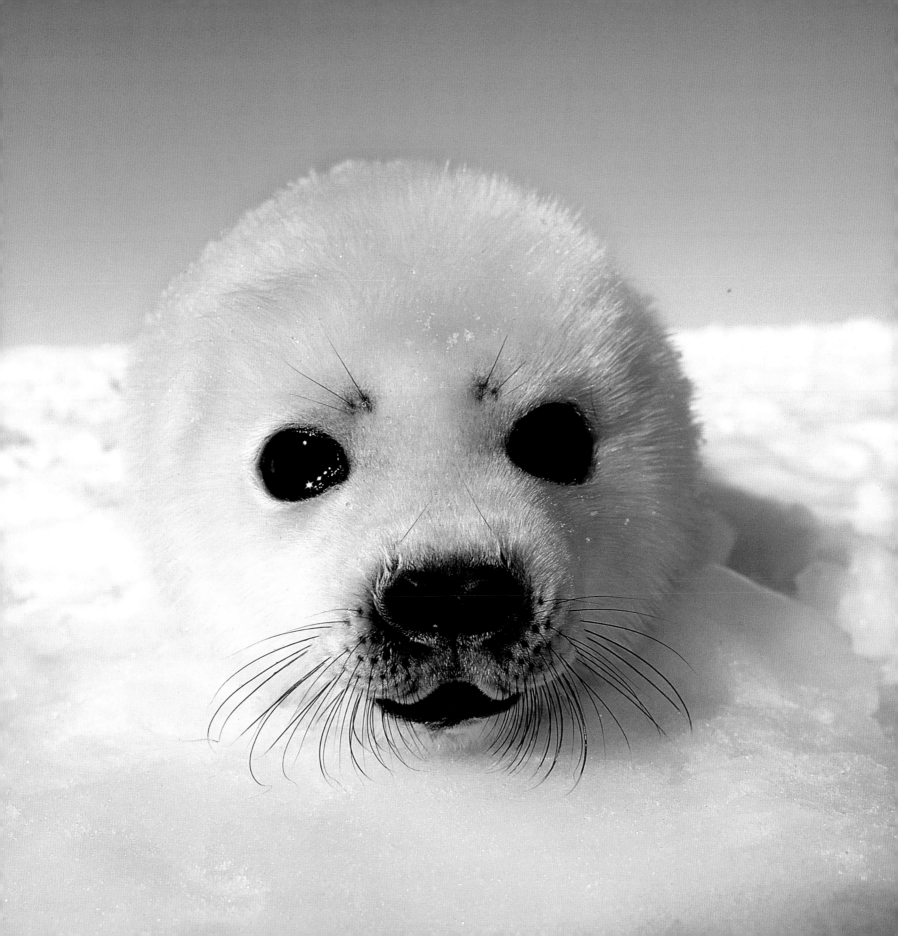

beginning to attract international attention. At the time there were only a few decent photographs of harp seals and no one had ever photographed them underwater. I went to Bob Gilka, Director of Photography at the National Geographic at the time, and talked him into letting me attempt a story on harp seals. I proposed the story with marine mammal biologist David Lavigne from the University of Guelph in Ontario, Canada as the writer. In the budget, Gilka allowed for only twenty-five hours of helicopter time and warned me about using any more. Helicopters are very expensive to operate and flight hours can build up rapidly, especially when searching for wildlife. When Bob Gilka asked you to not exceed twenty-five hours, you didn't. I found a diving assistant who had cold-water diving experience, Bora Merdsoy, at Dalhousie University in Nova Scotia. In March of 1975 we left for the Magdalen Islands, located in the middle of the frozen Gulf of St. Lawrence. The harp seal photographs here are all from that trip and ended up being one of six cover stories I have done for the Geographic. These were the first underwater photographs of harp seals ever taken.

Harp seals are found in the North Atlantic and Arctic Oceans from northern Russia, to Newfoundland and the Gulf of St. Lawrence. For several species of Arctic seals, harp seals included, life is defined by ice. For a seal, the icy polar world

we often characterize as harsh, frigid, and inhospitable, is home. They are never very far from sea ice, and harp seal migrations coincide with its formation. As the Arctic Ocean begins to freeze in the fall harp seals begin their journey south, staying just ahead of the frozen ocean's edge. By mid-to-late October they reach northern Labrador and by mid-December the Strait of Belle Isle. One group heads into the Gulf of St. Lawrence and he other to the east coast of Newfoundland. Many harp seals give birth on the sea ice around or near the Magdalen Islands.

One of the most fascinating biological facts in nature is how some marine mammal females delay the implantation of a developing embryo. A few land mammals do it, but ice-breeding seals have taken it to new heights. A female harp seal can delay implanting the small embryo on the uterine wall until conditions are just right. The developing new embryo simply stops growing. It goes into a state of limbo before birth, and just waits. For harp seal embryos, the wait can be as long as two and one half months. The delay holds off the birth until a proper sea-ice platform has frozen solid. On some unknown cue, the embryo-in-waiting continues its journey towards full fetal maturation. It eventually leaves the warm mammalian womb, and is born on a frozen stage, surrounded by ice and freezing water its entire life: home sweet home.

143 Harp seal, *Phoca groenlandica*, curious about the author swims toward camera.

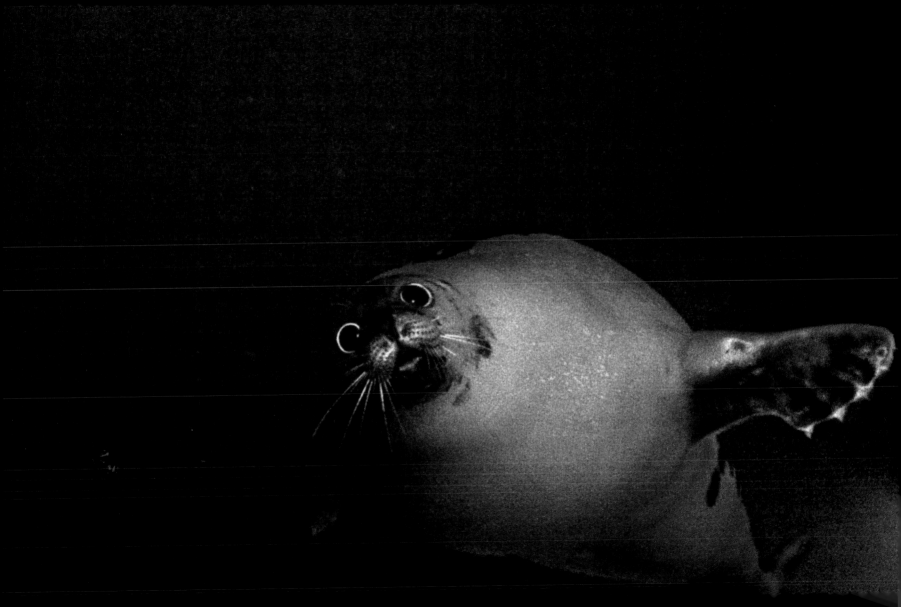

144  Harp seals rest on sea ice near their breathing hole.

145  A sleeping harp seal pup awaits its mother's return.

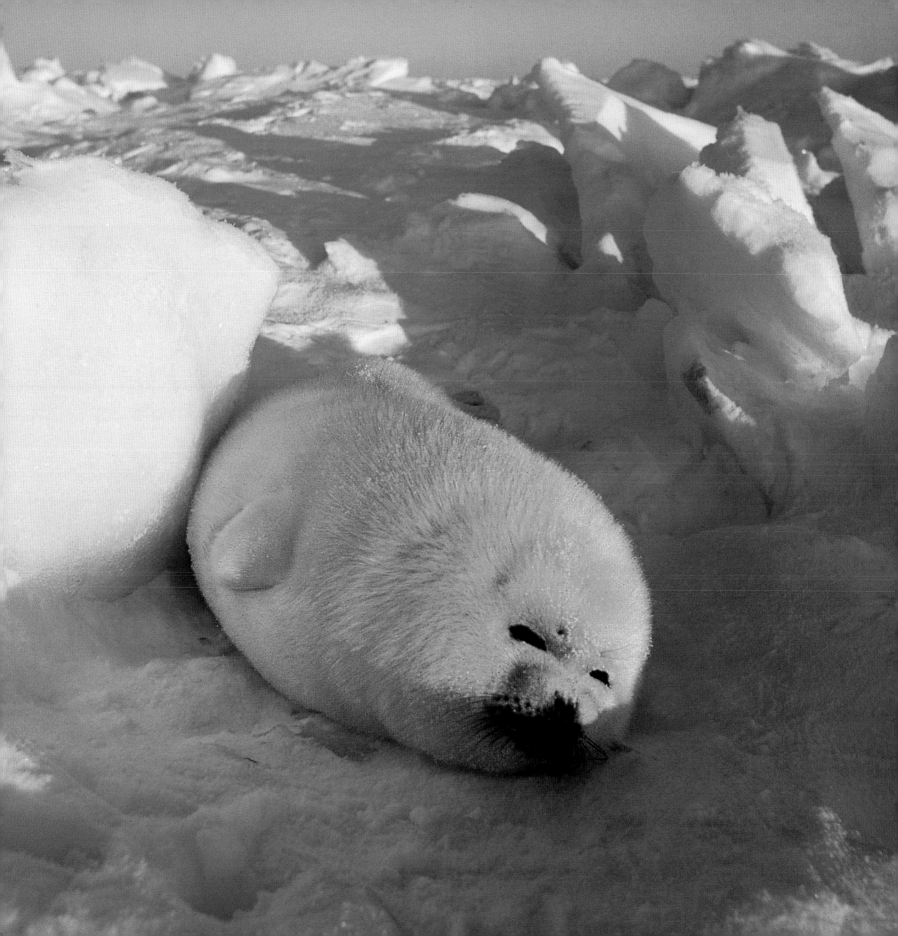

# THE SEAL'S WORLD

## FROM BELOW

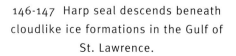

146-147 Harp seal descends beneath cloudlike ice formations in the Gulf of St. Lawrence.

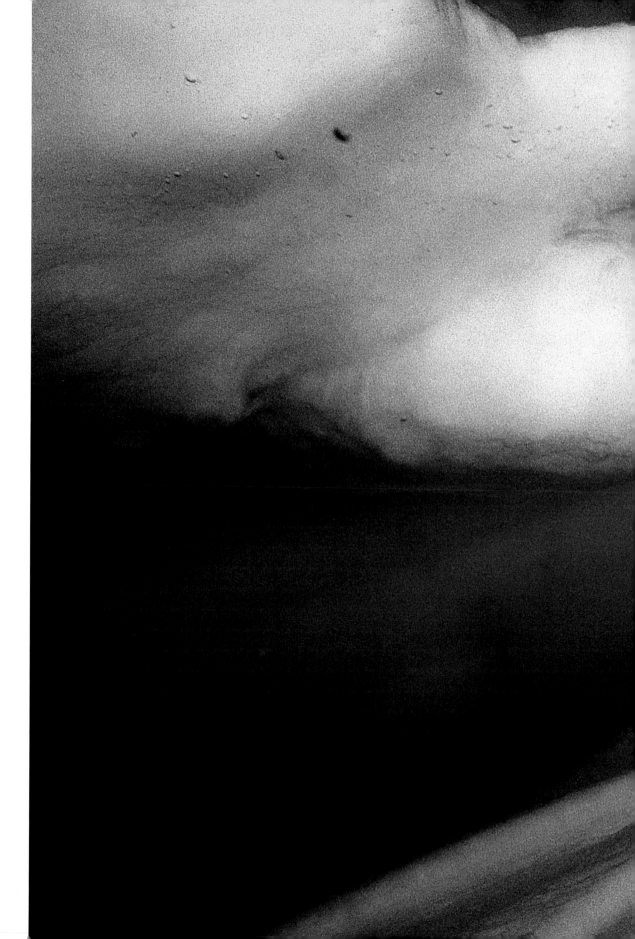

148

148-149 Wind, current and
tide create a complicated
assemblage of pressure
ridges and ice formations
beneath the surface.
A harp seal glides through
the ice structure, Gulf of
St. Lawrence.

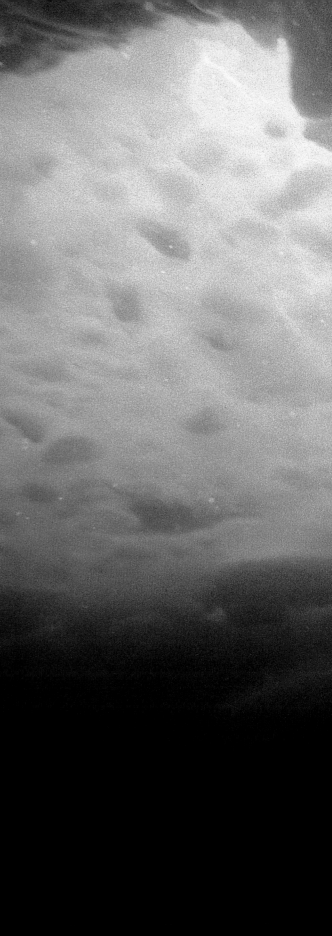

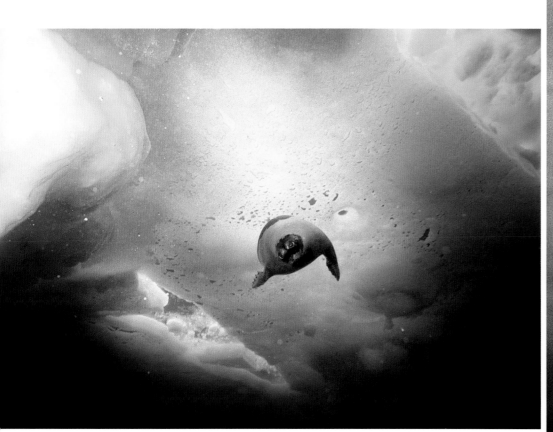

150 and 150-151  Harp seals often seem curious about
any alien mammal swimming in their icy world.

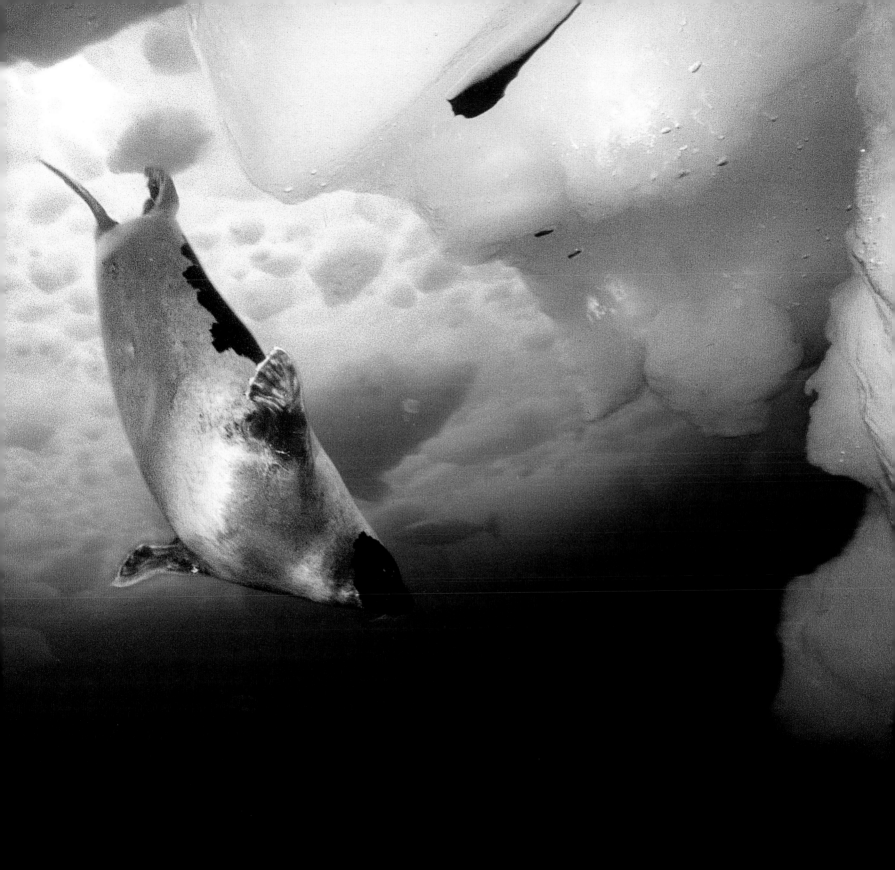

# Harp seals

*Pagophilus groenlandicus*

152-153 With rays of sunlight descending from
above, a harp seal swims down into the
darkened depths of the Gulf of St. Lawrence.

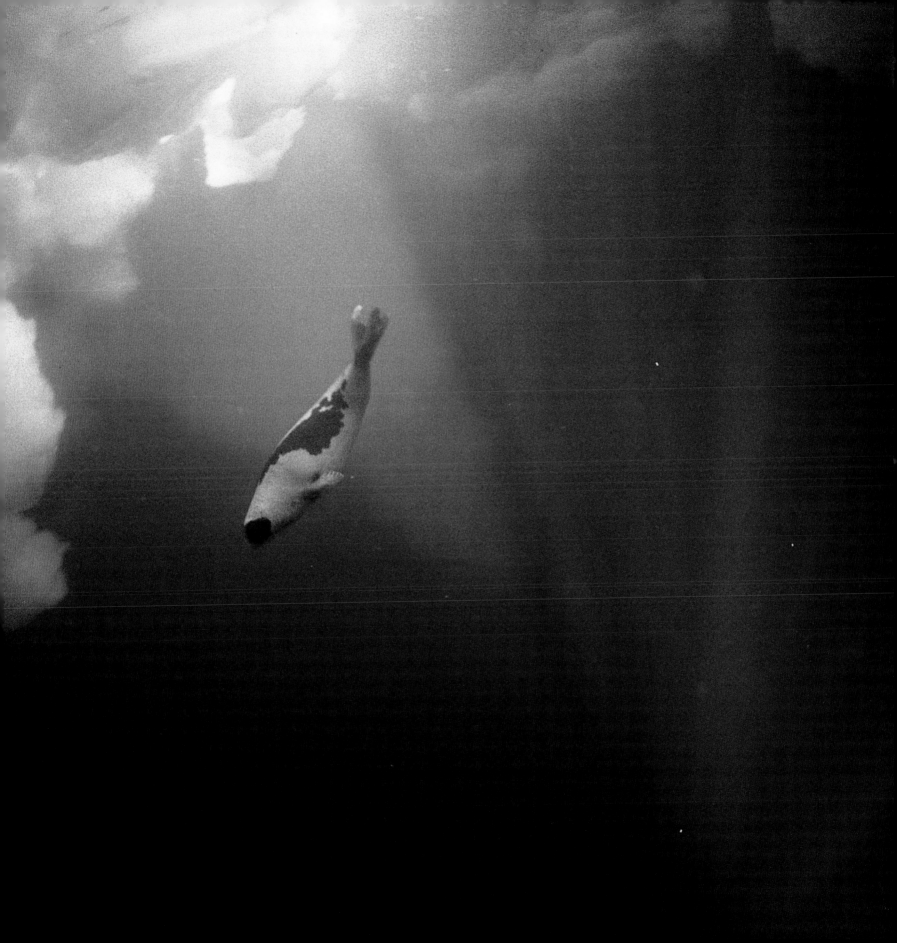

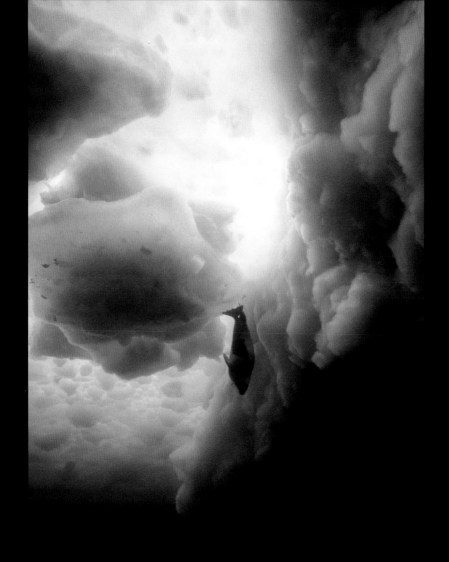

154  A harp seal swims straight down along a vertical wall of ice, its breathing hole above.

155 ˚Two courting seals (male above) beneath slush-filled lead in sea ice, Gulf of St. Lawrence.

157  A curious *groenlandicus* glides past author underwater. Seals' eyes are adapted for life in a cold dark often murky environment

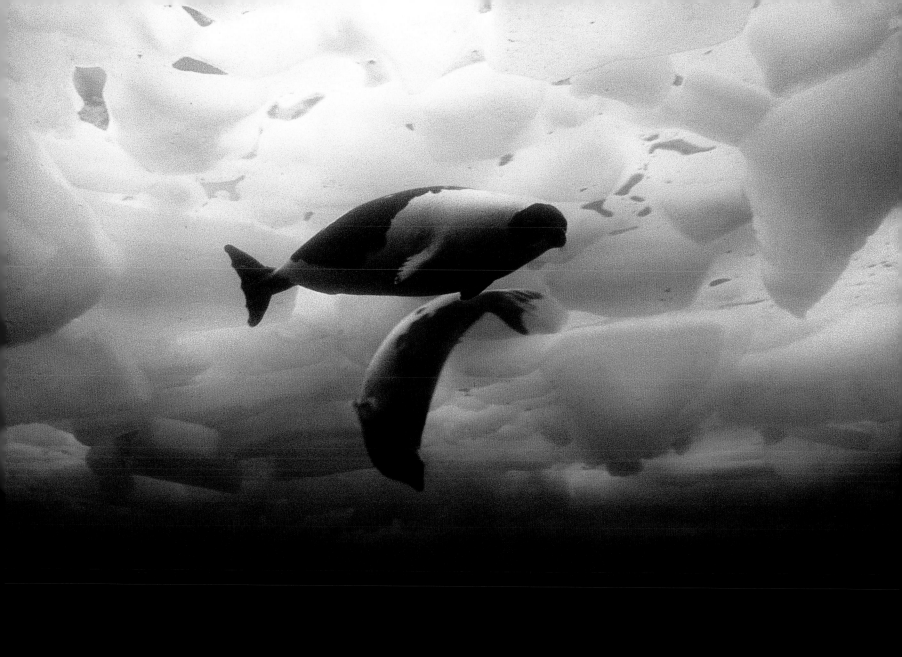

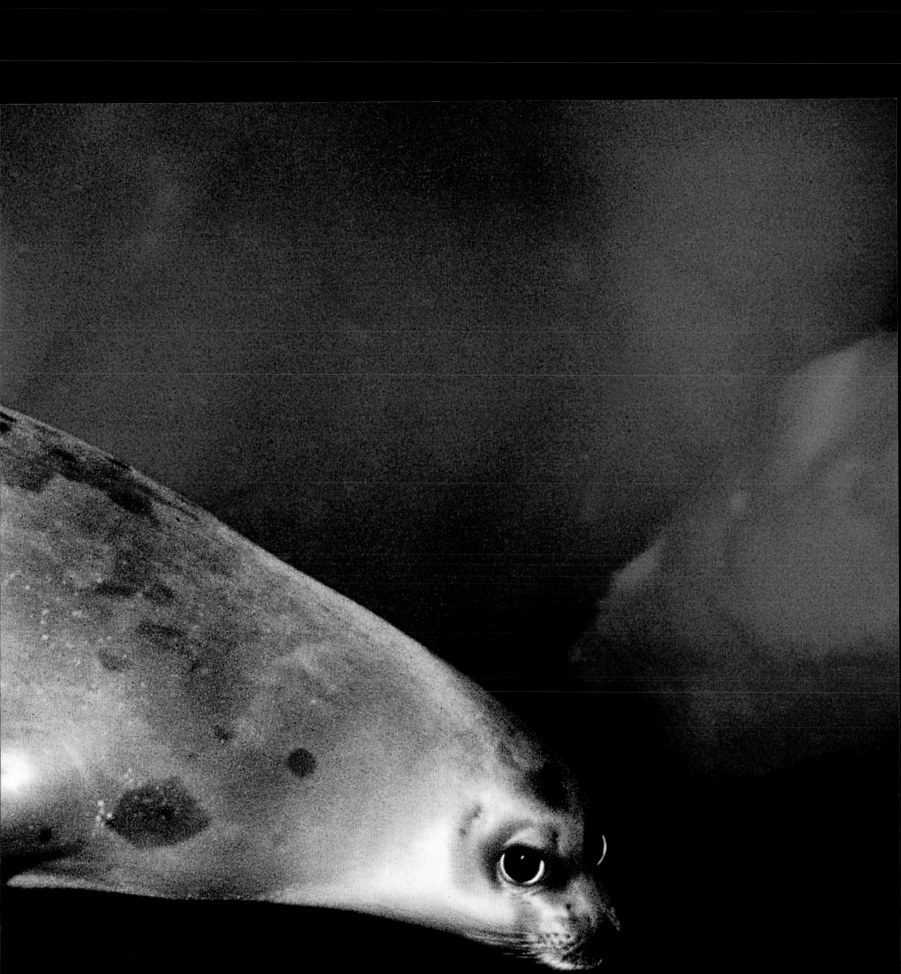

# SHARKS

## BRIEF ENCOUNTERS

# SHARKS

## BRIEF ENCOUNTERS

IF I HAD TO CHARACTERIZE MANY OF OUR DIVES AT BIKINI ATOLL I ONLY HAVE TO MENTION ONE SPECIES, *CARCHARHINUS AMBLYRHYNCHOS*, THE GRAY REEF SHARK.

Carcharhinidae are aptly named requiem sharks, and this family includes some of the most dangerous species: The tiger, Galápagos, oceanic whitetip, and silky, to name a few. In Bikini, the gray reef seemed to be ubiquitous. Many of our dives were on isolated reef patches scattered across the lagoon floor. Some of the patches were acres big, some were small; but all had gray reef sharks. More often than not the sharks were circling around us before the last diver in reached the bottom. Sometimes they seemed to quickly satisfy their curiosity and leave after a few minutes. On many occasions, however, we had to make a swift and clumsy exit from water.

One time on the outer reef slope we never even got to the bottom. I had just fallen into the water from the boat to begin my descent when I saw Eric, my dive assistant, looking excitedly at something behind me. I turned and saw what looked like a scene from the movie, "The Wizard of Oz," when the witch's fleet of monkeys flies over the castle wall. It seemed like every gray reef shark in the atoll was swimming up the reef slope toward us, leering. Needless to say, that was on of those swift and clumsy exits.

There were just too many to keep track of: at least twenty were circling us with more on the way, and no big coral heads to back into for cover. If a gray reef shark is swimming around you, it's best to keep track of it.

I should know. Thirty years ago a gray Reef shark attacked me. Most sharks attack with hunger as their prime motivation. The gray reef's aggressive behavior has sometimes been categorized as territorial. The problem is knowing where their property line begins and where it ends.

It was late in the afternoon, sometime around 3PM. We had just anchored our boat for the day in the western Caroline Islands. I was hot and wanted to go for a swim. For some reason, I chose my large dive flippers instead of the smaller snorkel-

158 Tiger shark with dead albatross chick in its mouth, French Frigate Shoals.

161 Great white shark swims through school of fish, Australia.

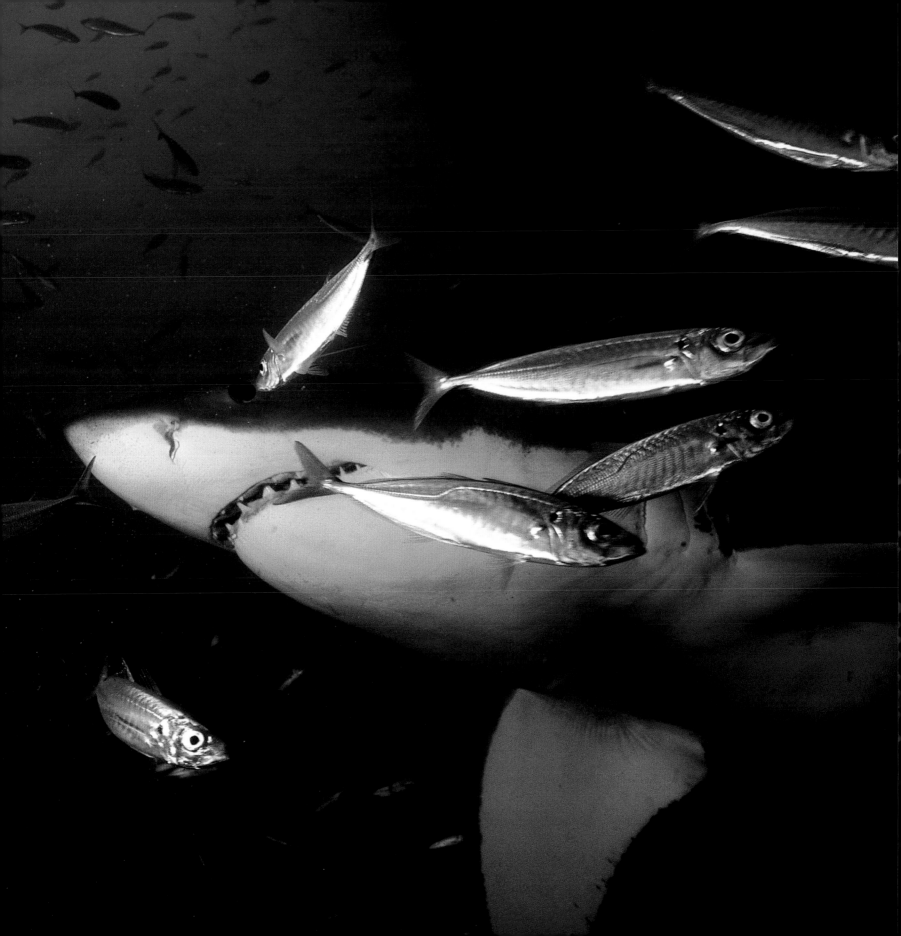

ing flippers I routinely put on. This decision may have saved my life or at the very least, saved a limb. I snorkeled around ending up about a 330 ft (100 m) from the boat. I was alone. I had just left the bottom, and was spiraling upward for more air when I saw the shark. It was coming up at me at an angle from the bottom. It was a blur but I knew it was a shark. From the moment I first saw it to the time it struck me seemed like less than a second. It went for my head. I only had time to put my left hand in front of my face and turn my head away. It bit my left hand, and as it moved forward it knocked off my dive mask.

Without it, I was blind underwater. I don't remember feeling any pain associated with the bite itself. What I remember most was the force of the impact. It felt like a torpedo had hit me, so powerful and strong that it took me a few seconds to recover. I started swimming on my back toward the boat.

I was doing a frantic backstroke and kicking with my big fins. As soon as I dipped my left hand back in the water I noticed the blood -- a thick cloud of it. So did the shark. Every time I took a stroke with my left hand, another cloud of blood formed. I saw the shark's dorsal fin swimming up my wake toward me.

Then, it disappeared. Without my facemask it was pointless to look underwater for the shark. I just swam as fast as I could. Seconds later, another blow, this time on my shoulder. The shark had gone ahead of me and turned around. It had come at me with its open mouth and raked my right

shoulder. It was at that moment that I wondered if I was going to make it. I started to think about all sorts of things. Just like close-call accounts I had read about somewhere, that quick, little movie of my life started to play inside my head. I remember thinking about Brownie, the dog I had as a kid. I thought about my mother. I thought about my girlfriend, Jane. I thought of my boss at National Geographic, Bob Gilka. I remember feeling bad that I wasn't going to be able to finish this assignment.

I had been screaming the word "shark" as loud as I could as I swam toward the boat. Bill Otey, a crewman onboard, heard and saw me and knew I was in trouble. He climbed into a small dingy and rowed toward me as I swam across the lagoon. I saw the dingy and flew into it. I think I actually flew. There was not a moment where I was trying to climb into the dingy; I simply launched myself over the gunwale and into the boat in one continuous movement. And then it was over.

It took some reconstructive surgery and a couple of months of rehabilitation for my hand before I picked up an underwater camera again. My right shoulder and left hand have scars that remind me of that day, but I was more than a little lucky. I have always been thankful that gray reef sharks don't get very big like, say, a tiger shark, in which case I wouldn't be here.

All of my images of gray reef sharks were taken after my shark incident. Because of this experience, I suspect I am more cautious than most when sharks are around. I'll admit I lost my cool

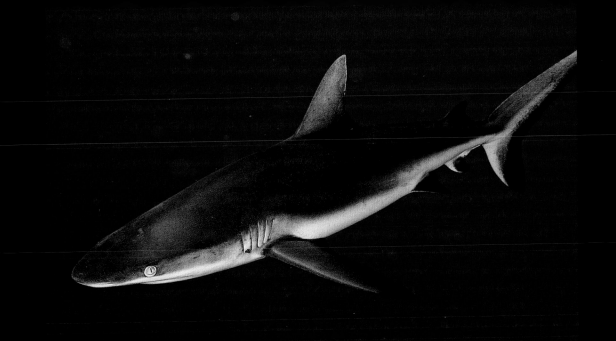

163  A gray reef shark like this one at Bikini Atoll once attacked me while I was snorkeling in Micronesia.

once underwater off Argentina following a group of Fitz Roy dolphins. I was looking through the wide-angle lens in my underwater housing. All of a sudden my brain told me that the animal gulping mouthfuls of anchovy in front of me was not a dolphin, but a shark. I exited the water immediately. I wish I had stayed. I was following dolphins and had never seen a shark there in weeks of diving. But when my mind morphed that dolphin into a shark, I was caught off guard and completely taken aback. By the way, I am still waiting for the gold medal I earned when I broke the Pacific backstroke record, swimming for the boat in that uninhabited lagoon in the Caroline Islands.

At Bikini and Rongelap Atolls, where I have logged hundreds of hours underwater with sharks, the abundance of a top predator like the gray reef shark seems to me a good indicator for the overall health of the local marine environment. In spite of the nuclear nightmare that descended on this region, its marine world has recovered and is alive and well; if just try to keep track of all those sharks, you'll see this.

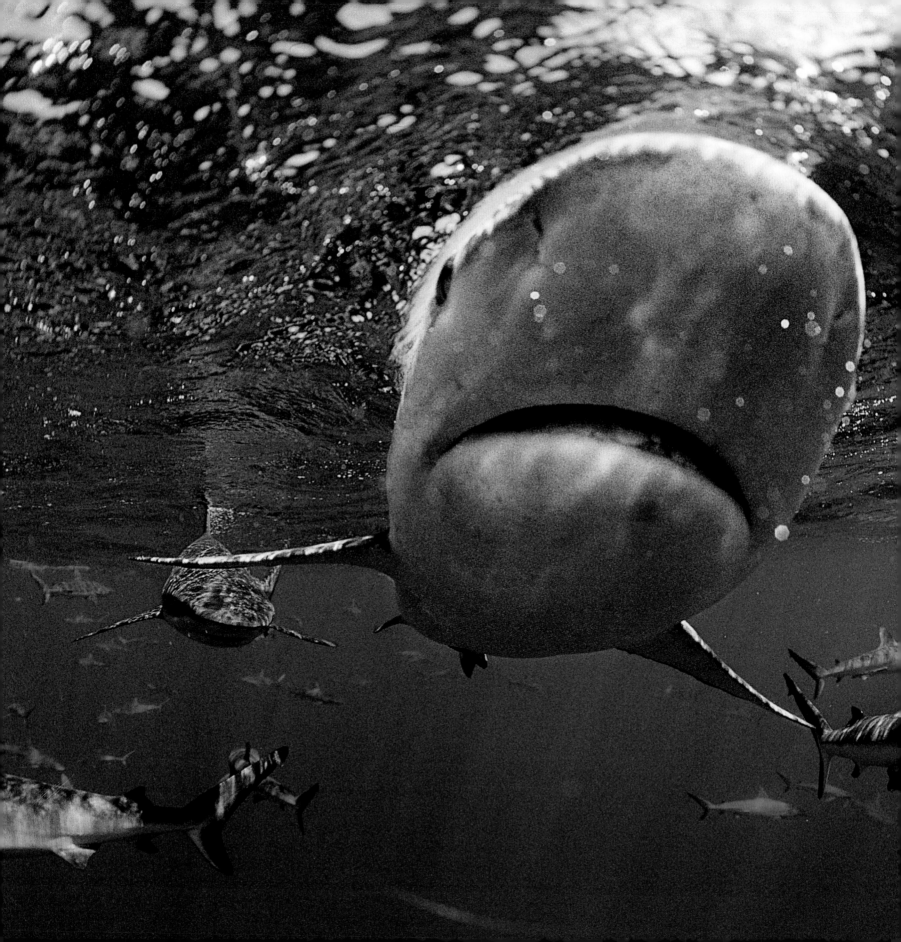

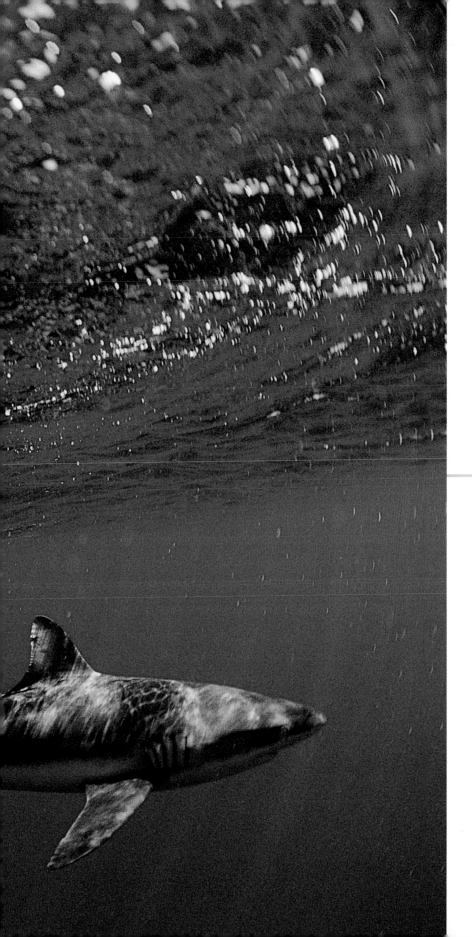

# UNDERWATER NIGHTMARE

## GRAY REEFS ON THE PROWL

164-165  Looking behind my boat with a remote camera, as gray reef sharks follow. Though they are not man-eaters, their aggressive behavior places this species on the most-dangerous list.

166-167  During World War II many helpless military pilots and shipwreck survivors floating at risk on the Pacific saw their fate swimming swiftly toward them underwater as they drift vulnerable and helpless.

168-169  A slow shutter speed helps evoke the swiftness this gray reef shark, a fast predator, as it streaks by the camera, Bikini Atoll.

170-171  A blue shark, photographed in the Gulf of Maine. This species migrates great distances in the Atlantic using the Gulf Stream to cross the Atlantic to Europe and Africa.

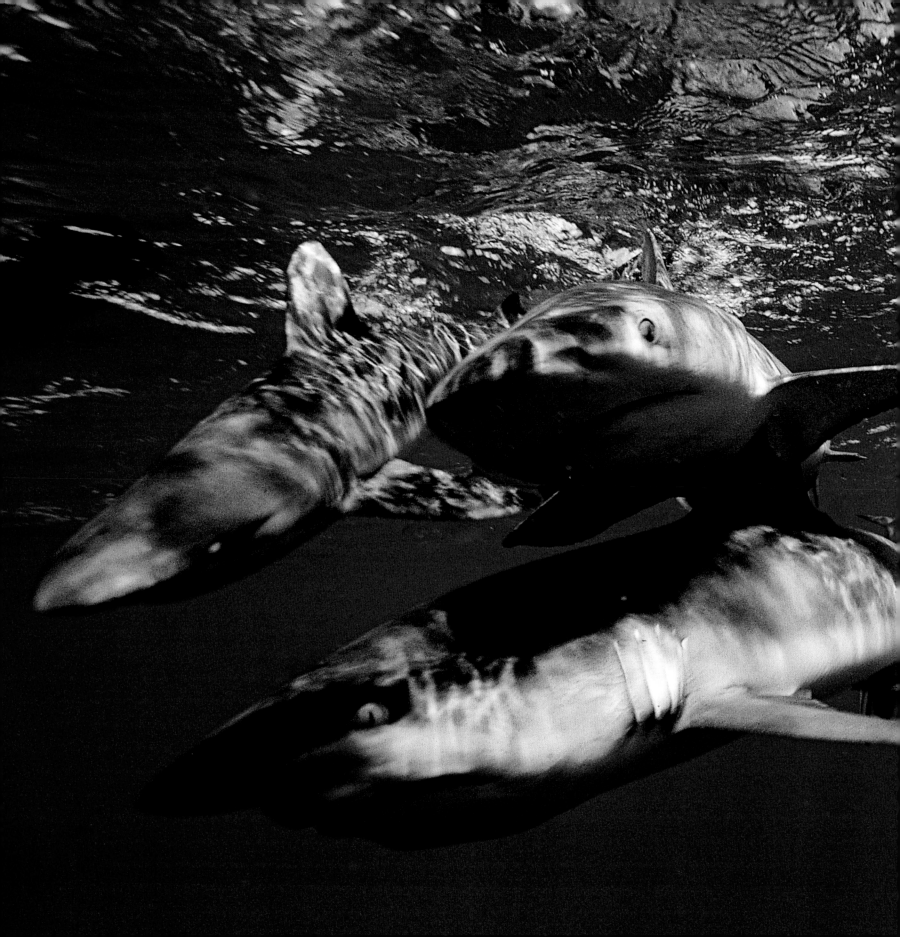

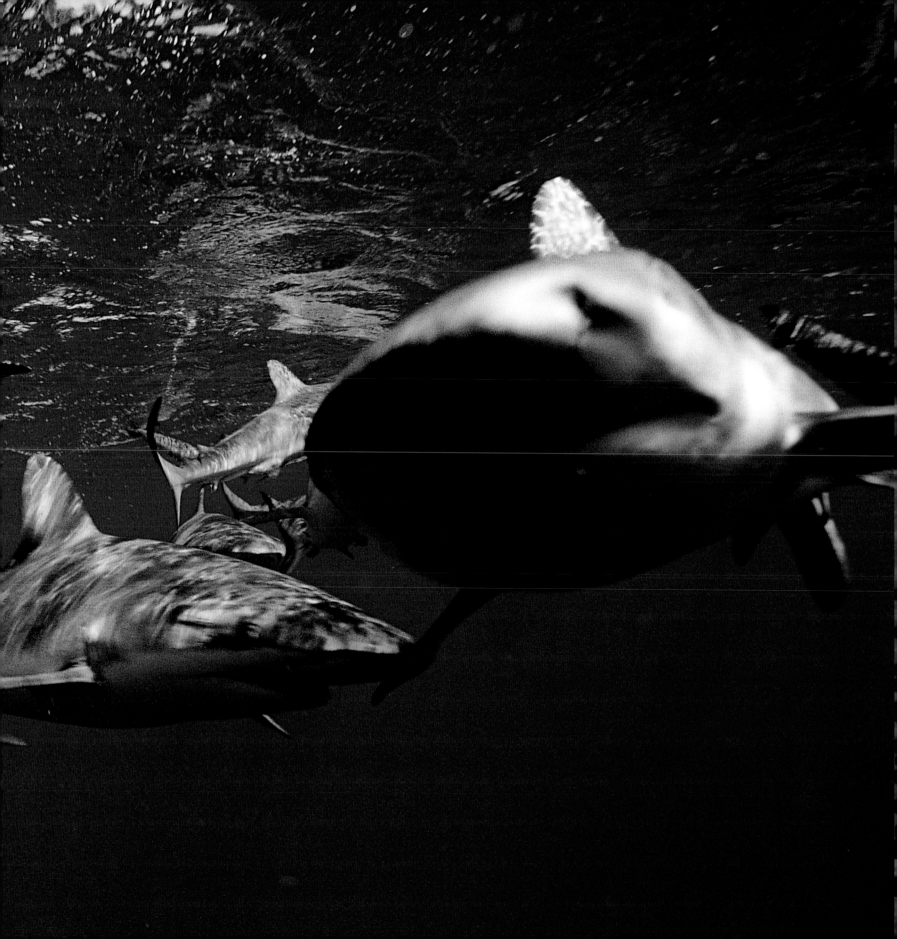

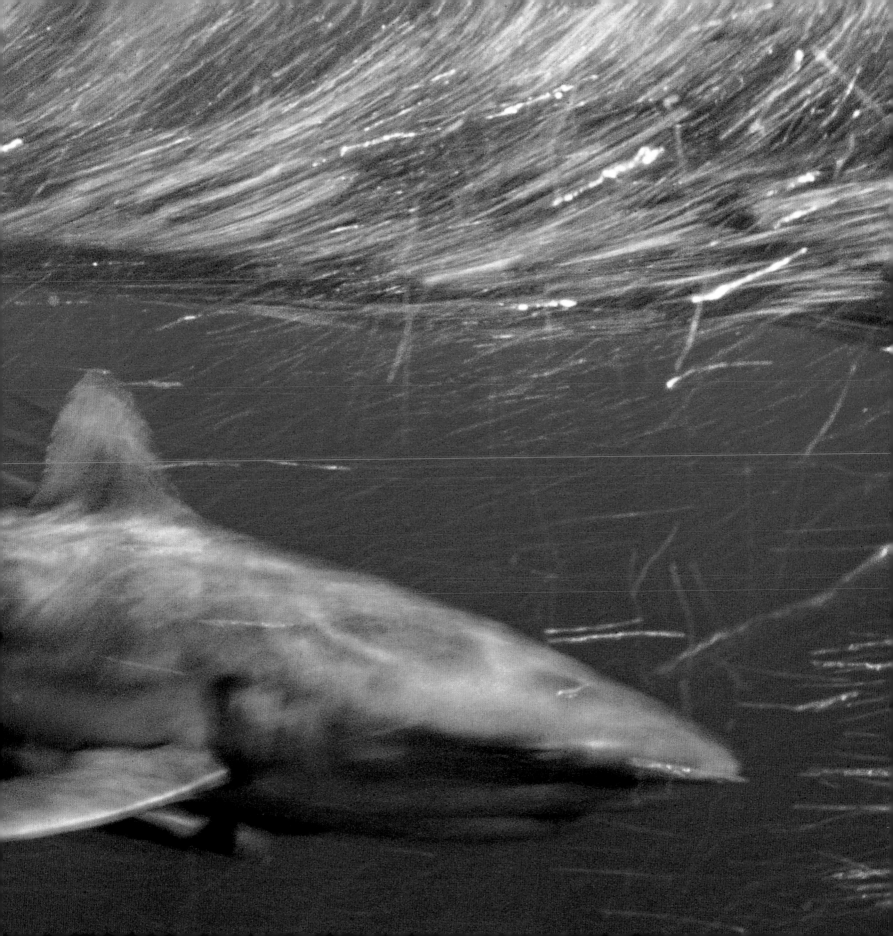

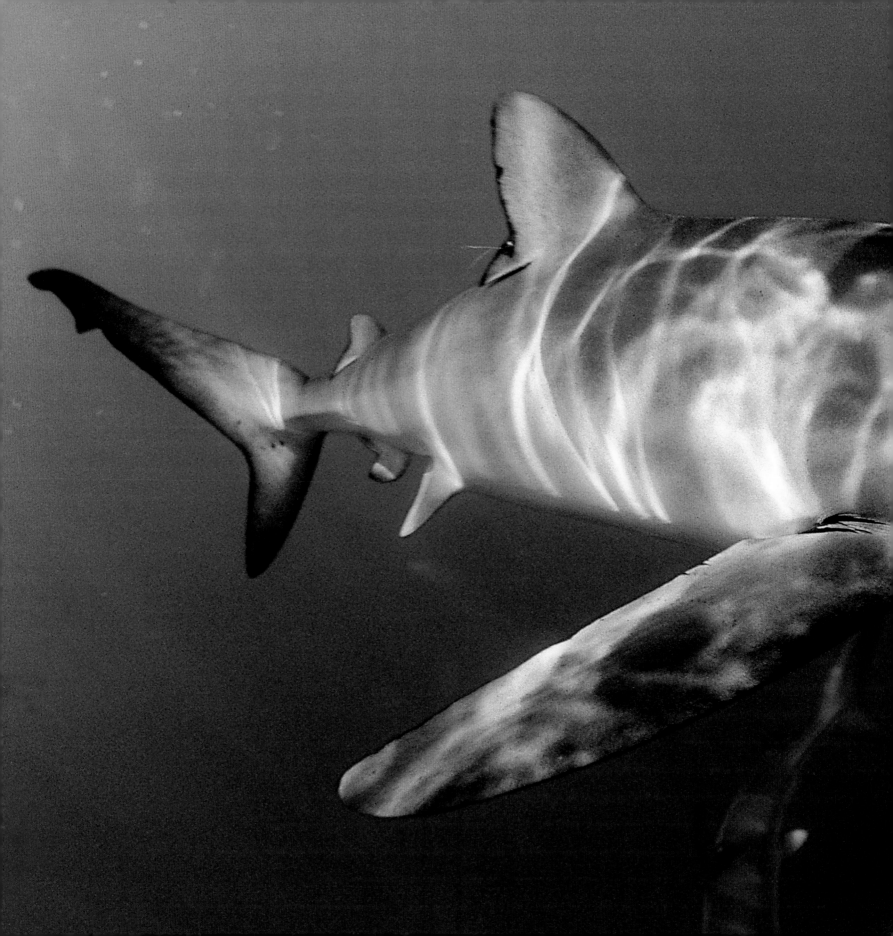

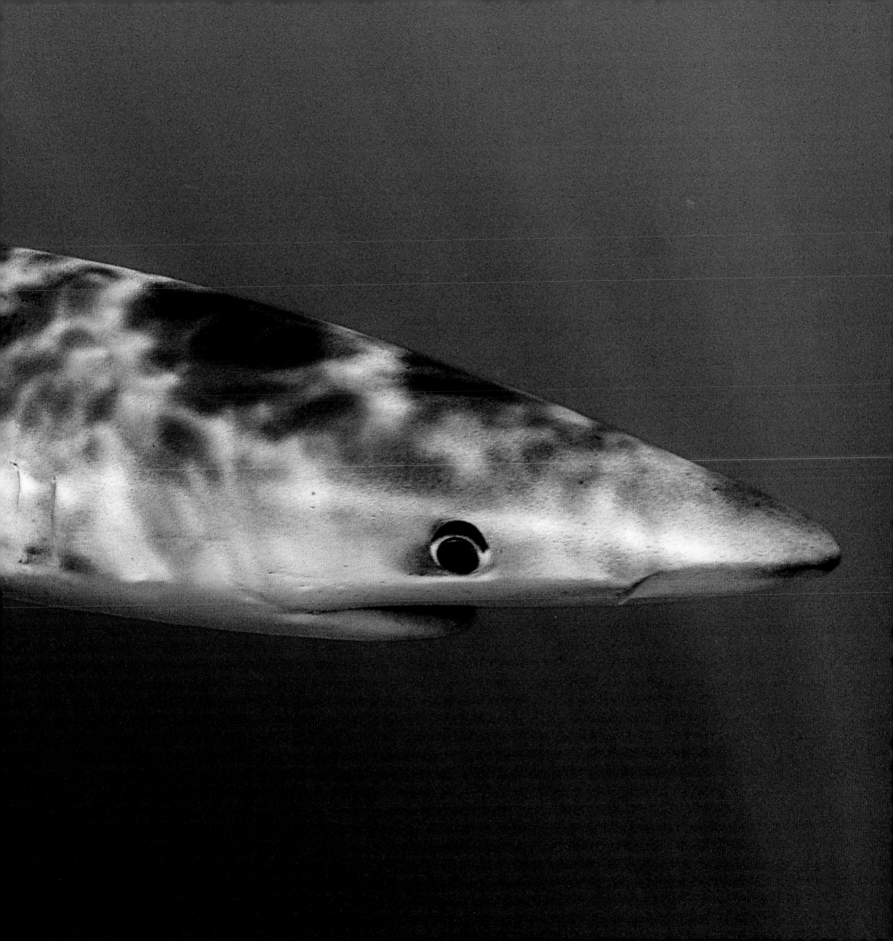

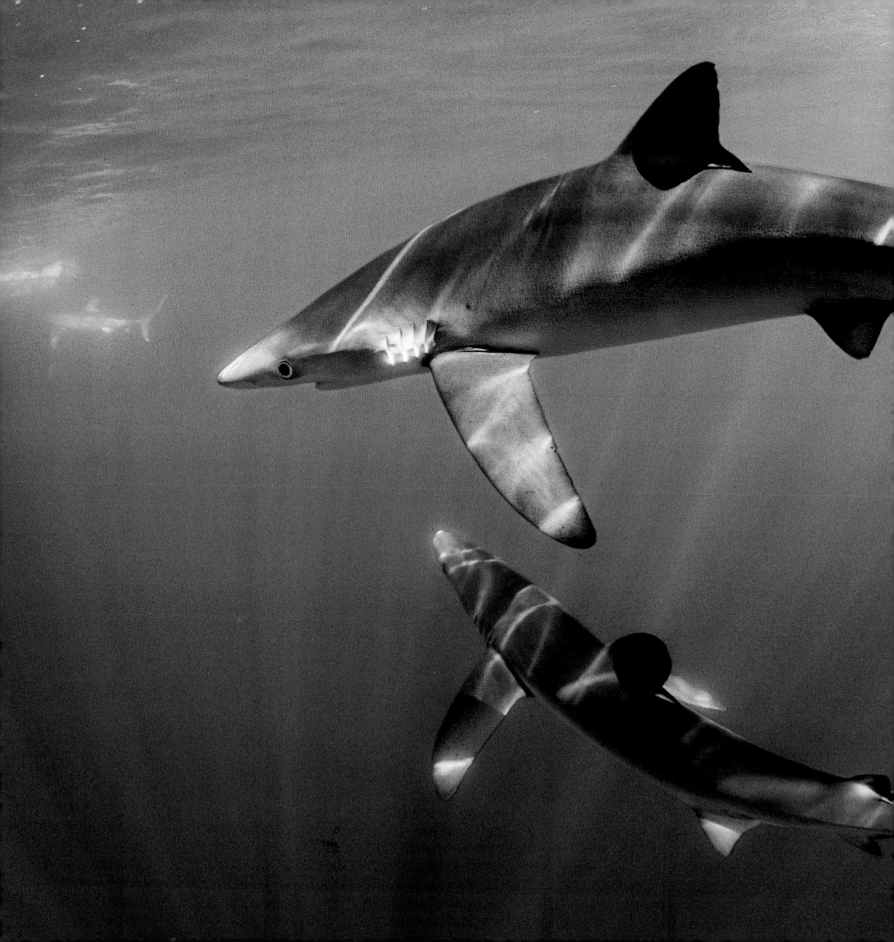

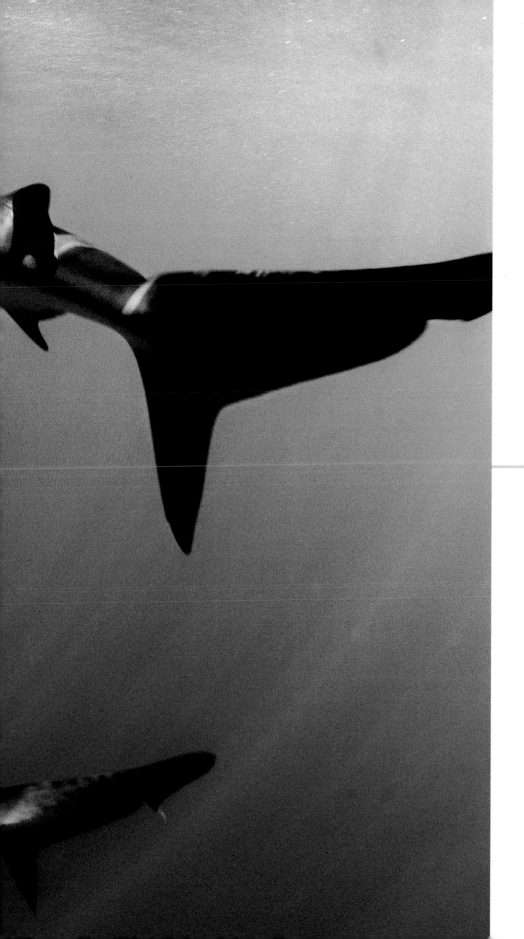

172-173  Blue sharks are known
to migrate great distances throughout
their range.

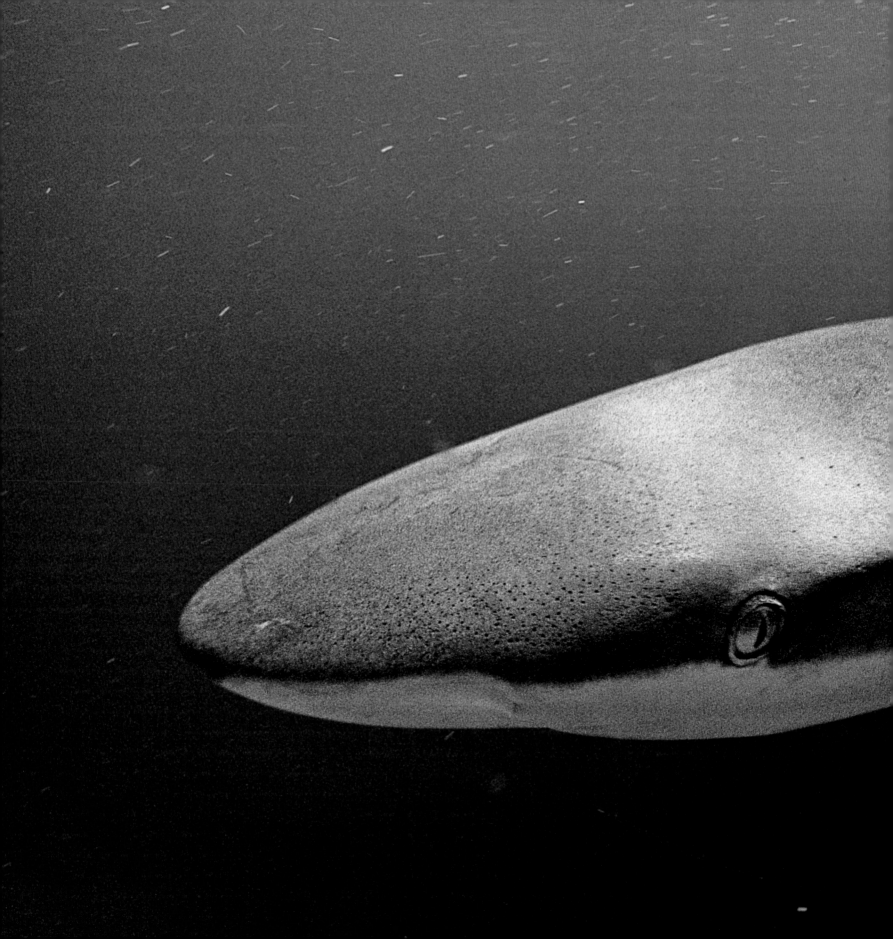

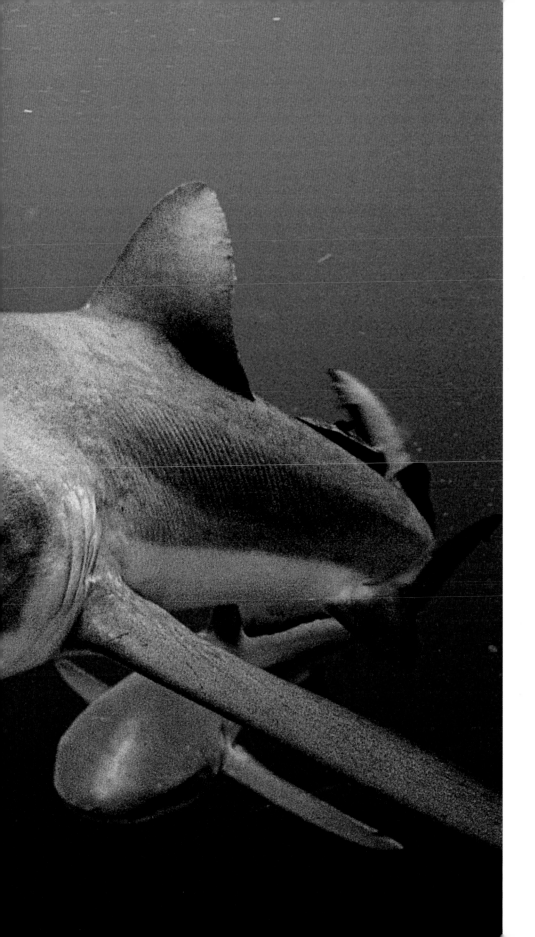

174-175 Gray reef sharks are
extremely sensitive to any unusual
sound or vibration produced by
distressed fish.

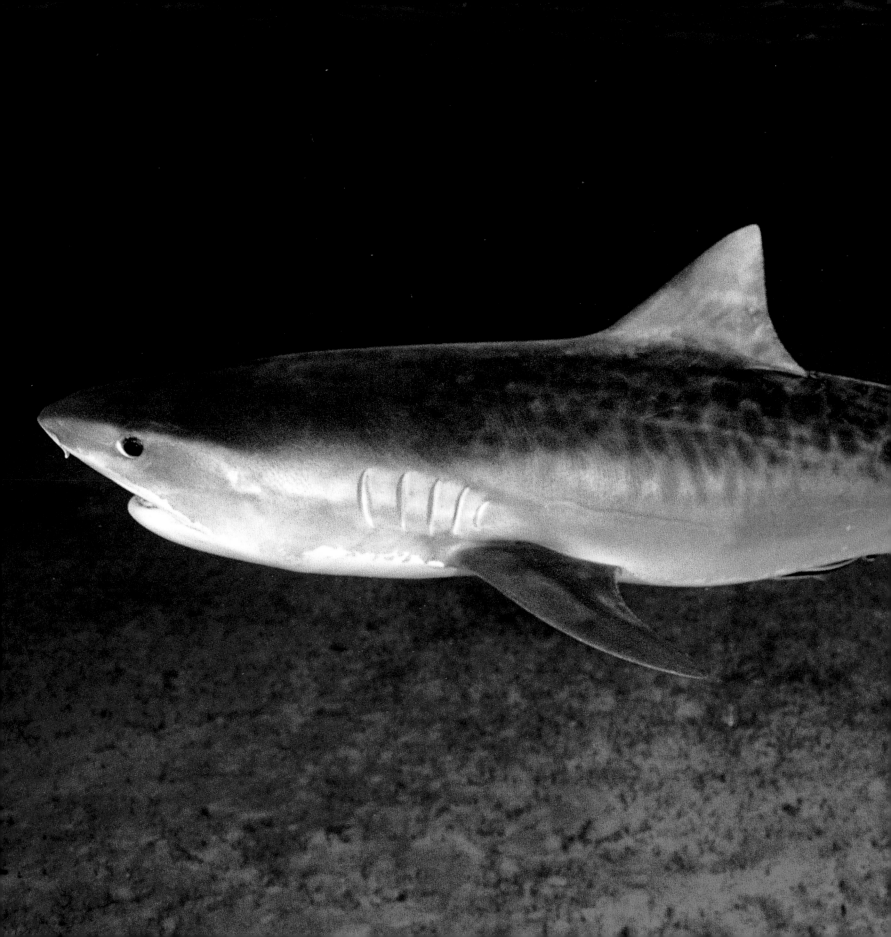

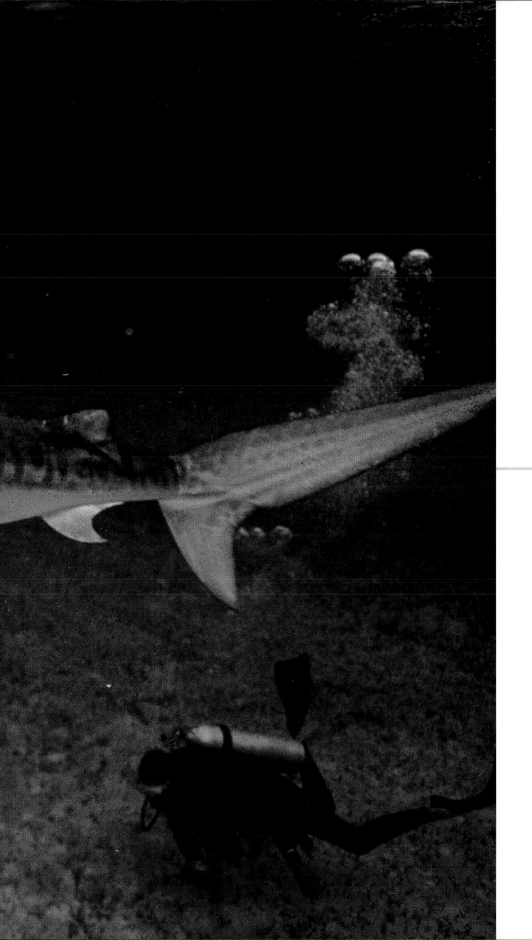

 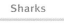

176-177 Tiger shark, Bahamas.

178-179  Often considered the most
voracious marine predator, the Great
white shark, Australia.

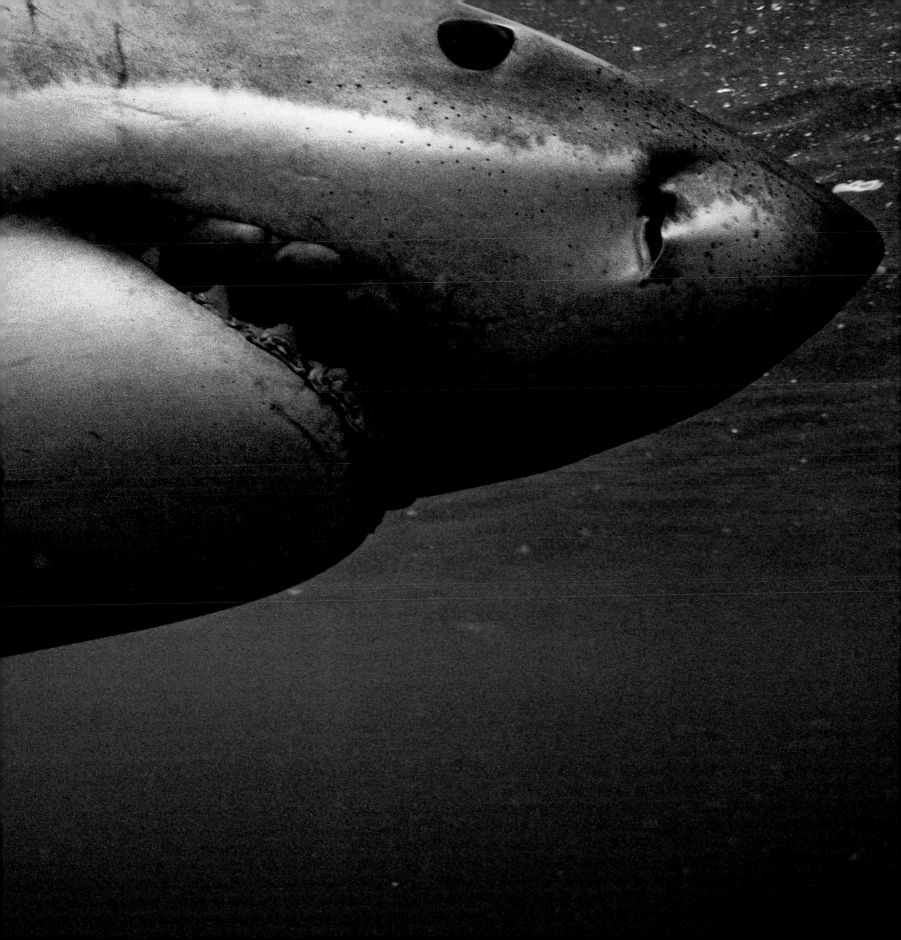

# THE UNFORGIVING SEA

## TIGER SHARKS AND ALBATROSS

S OOTY TERNS WHEELED AND SHRIEKED OVER THE BLUE-GREEN WATERS. FROM AN ANCHORED BOAT I SCANNED THE SHORE OF EAST ISLAND FOR ALBATROSS CHICKS. Two species of albatross use French Frigate Shoals, a far-away spit of sand of the northwest of the Hawaiian Islands, for nesting; Laysan (*Diomedea immutabilis*) and black-footed albatross (*Diomedea nigripes*) I was not here for birds though; I was here to photograph sharks. Albatross, the largest of seabirds, spend most of their lives at sea, coming ashore only to nest on remote oceanic islands around the globe. During the months of June and July, tiger sharks come close to shore at French Frigate Shoals. Their presence here coincides with the first flights of young albatross chicks at about eight weeks after hatching. It is a time when the separate worlds of bird and fish come together. It was just after dawn and with the rising sun come rising winds. The albatross chicks, finally ready to fledge, stretched their wings skyward into the early morning breeze. They hopped up and down off the crest of their nesting beach into near flight. As the winds increased one could feel the excitement of thirty or forty albatross chicks stretching their wings and facing the rising sun. It was time. This was the day of their first flights into the wild blue yonder and over the eastern horizon. They seemed oblivious to the triangular fins breaking the surface, slowly cruising by the beach, just a few yards from shore.

For many of the chicks, the blue yonder ended up be-ing the warm shallow waters within thirty yards of shore-a place that would prove wilder than they could have imagined. A huge, swift-swimming predator lurked just beneath the surface, waiting for a less than perfect effort at solo flight. Tiger sharks are classified as one of the most dangerous sharks on earth, known to eat just about anything of animal origin, dead or alive, that comes their way, including humans. Surprisingly, tiger sharks only targeted albatross chicks and ignored their other known prey species, green sea turtles and Hawaiian monk seals swimming near by. That June morning was a fairly typical one for observing albatross chicks and tiger sharks. Between 6:45 and 9:45 AM, thirty-nine albatross fledglings began their first flights. In the first hour five of the sixteen fledglings that lifted off the beach were attacked and killed. During the next hour, between 7:45 and 8:45 there were eighteen flights with ten attacks and only two albatross killed and eaten. In the next hour I only saw five young albatross leave East Island. They all flew beyond the sharks patrol area and over the horizon. Tiger sharks made attack runs on sixteen chicks that morning. Seven chicks were attacked and eaten and nine managed to escape. Thirty-two in all survived and flew away. The albatross chicks that took flight and stumbled to near shore waters would sit on the surface and rest, preen their wings and shake water from their heads. They seemed unaware of the danger beneath them. For some chicks, the struggle was brief. They simply landed in the

181 left  Shark meets bird at French frigate Shoals, NW Hawaiian Islands.

181 right  The moment of truth. This was the albatross chick's first flight.

 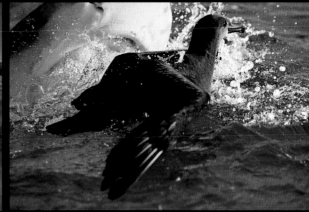

wrong place at the wrong time and were taken by a shark in a microsecond. Many of these successful attacks started and ended before I could even raise my camera to take a photograph. The tiger shark attacks were not always so efficient. A shark would line up an attack and miss the chicks by several feet. In that moment, some chicks would take off and survive. The shark would wheel around underwater looking for the albatross it had missed. If the chicks had taken off, one very large shark with a strange knob in front of its dorsal fin would often slam into our small Boston Whaler, or attack the outboard motor's propeller. This was somewhat discouraging since I wanted to dive with the Tigers to photograph this underwater action. But based on the behavior of this particular shark, I decided to take all of my underwater photographs with a remote camera system on a pole. It should be noted that my underwater photographs of an albatross chicks in a

tiger shark's mouth were all made using a dead bird found floating in the water around the island. Getting a camera in front of an attack on a live bird to document this behavior underwater was impossible.  Many albatross chicks stayed on the water even after a near brush with death. They would flap their wings and look down into the clear water as if they were trying to figure what just happened. The chicks appeared slightly confused-- not fully aware of the danger they were in. Some chicks faced off admirably with their pursuers. As they looked into the open jaws filled with rows of white triangular teeth, they would make feeble pecking motions toward the fourteen-foot predator. In the next second, they were in the Tiger shark's jaws, dragged underwater, and swallowed whole. The only physical evidence remaining were a few feathers drifting in the water, and bits and pieces of flesh being picked up by swooping terns.

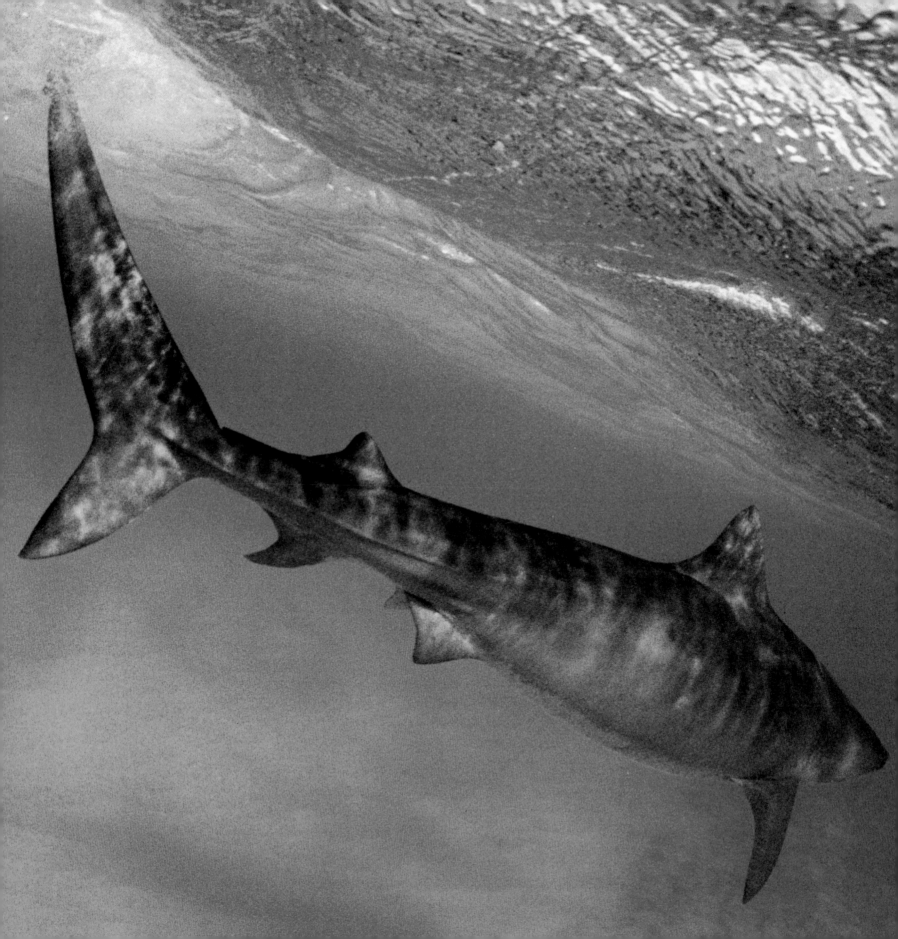

# The hunt
## The shadow below

182-183  Tiger shark patrols for unsuspecting albatross chicks.

183  The tiger shark begins its stalk an unsuspecting albatross chick.

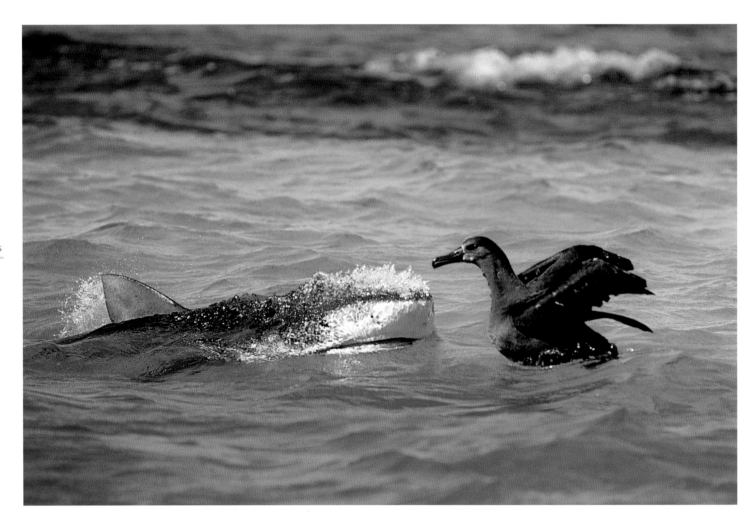

184  The albatross chick suspects something wrong and begins to take flight.

185  The chick is knocked aside while attempting to escape.

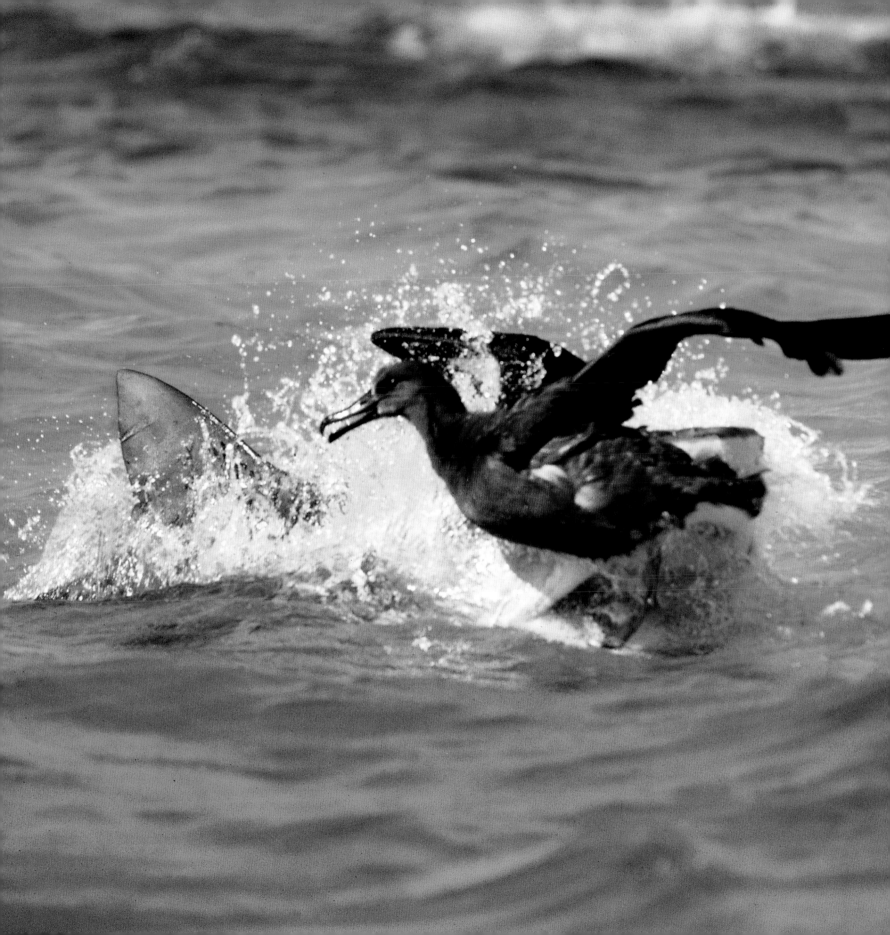

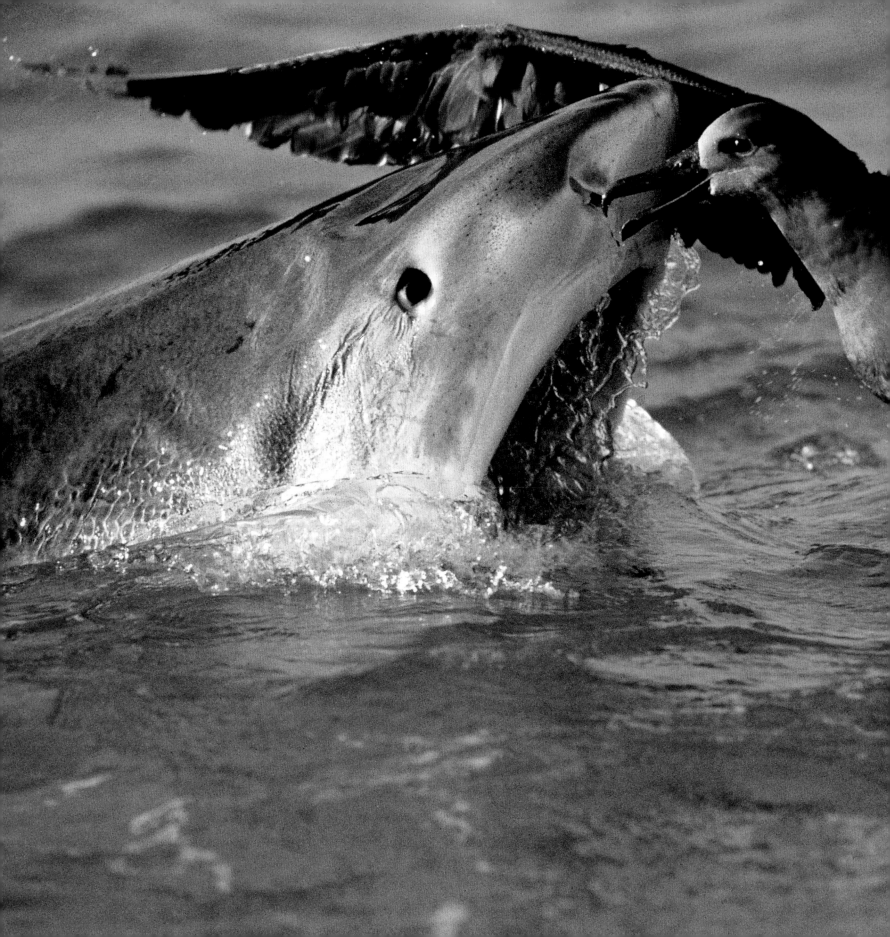

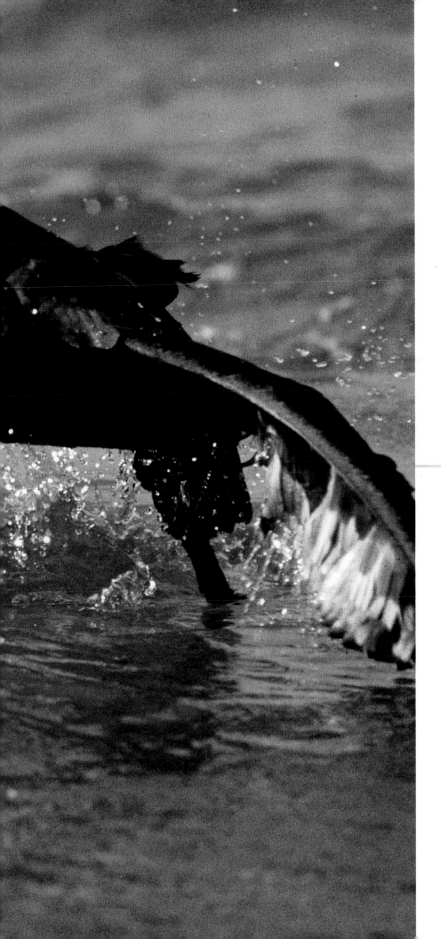

# The extreme
# predator
## The naïve prey

186-187  Tiger sharks kill less than half
of the albatross chicks they attack,
most get away as this one did. Reacting
to something underwater this chick
saved itself from instant death with
only a fraction of a second to spare.

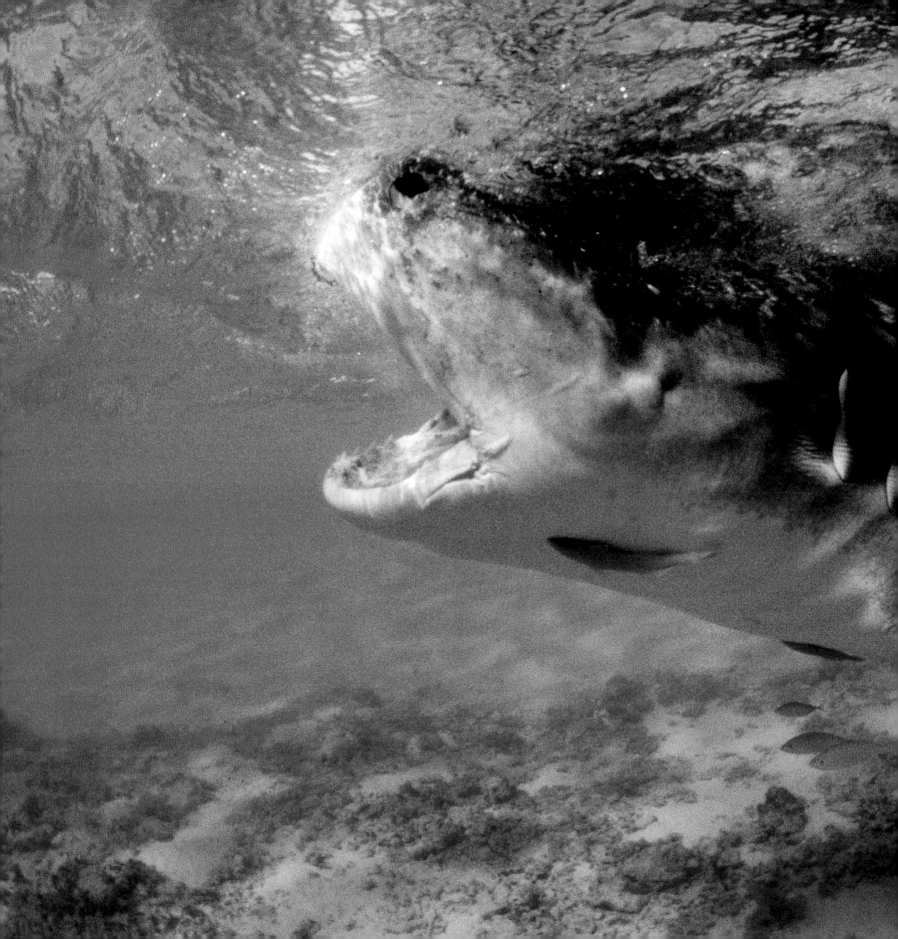

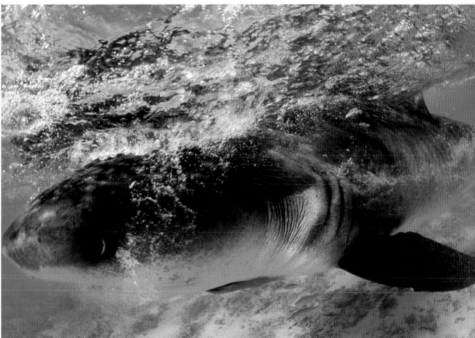

188-189 and 189 The powerful predator looks for a chick that has taken flight. After missing its avian prey, this particular shark would often attack our boat, its mouth wide open in optimistic anticipation.

190 and 191  With one powerful lunge the shark would instantly swallow the chick, leaving
only feathers drifting to the bottom.

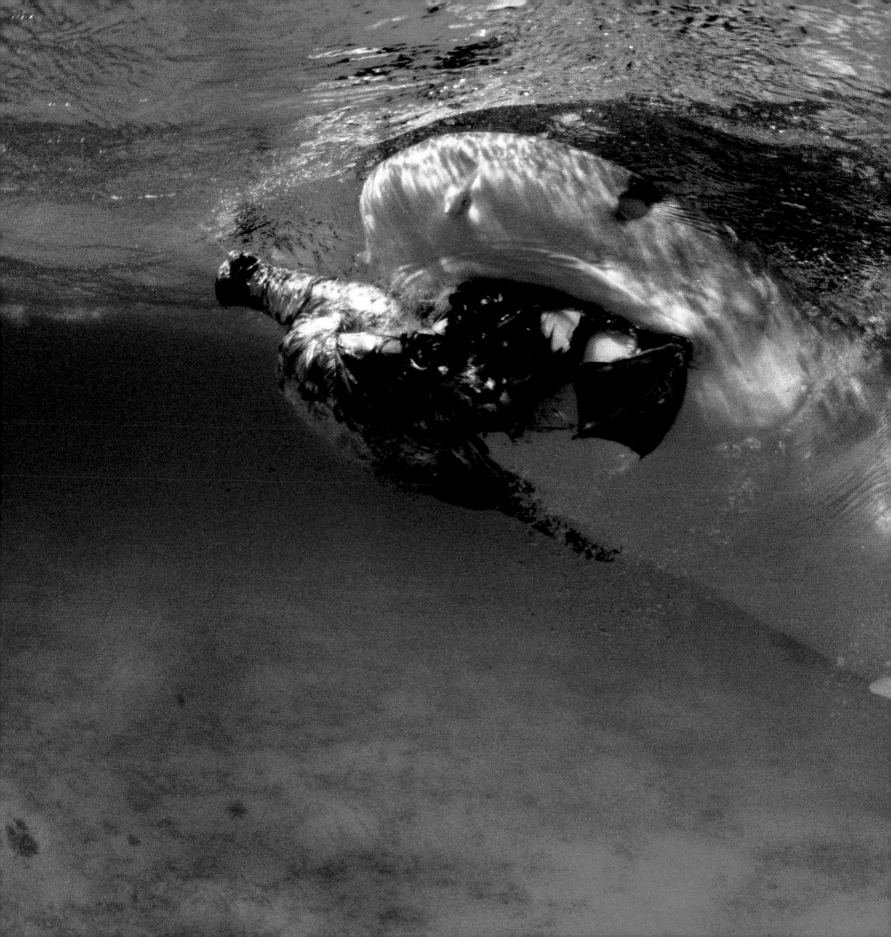

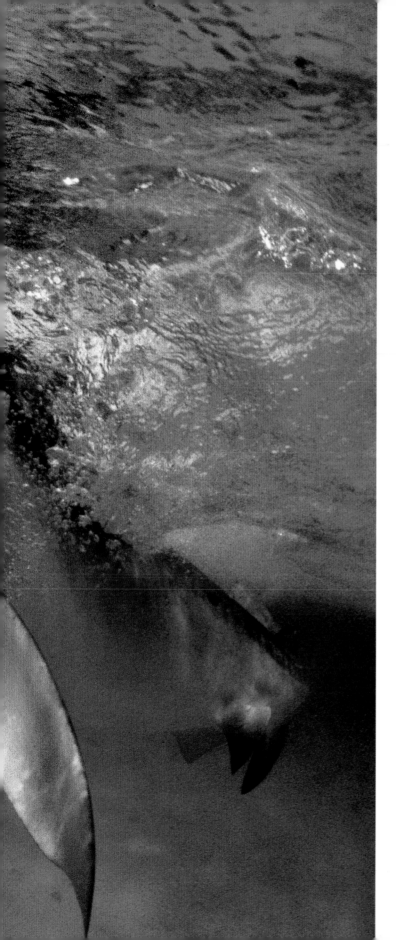

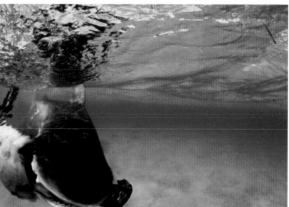

192-193 and 193  A tiger shark with dead bird in its
mouth, about to swallow it whole.

194 and 194-195  Role reversal; Shark eats bird.

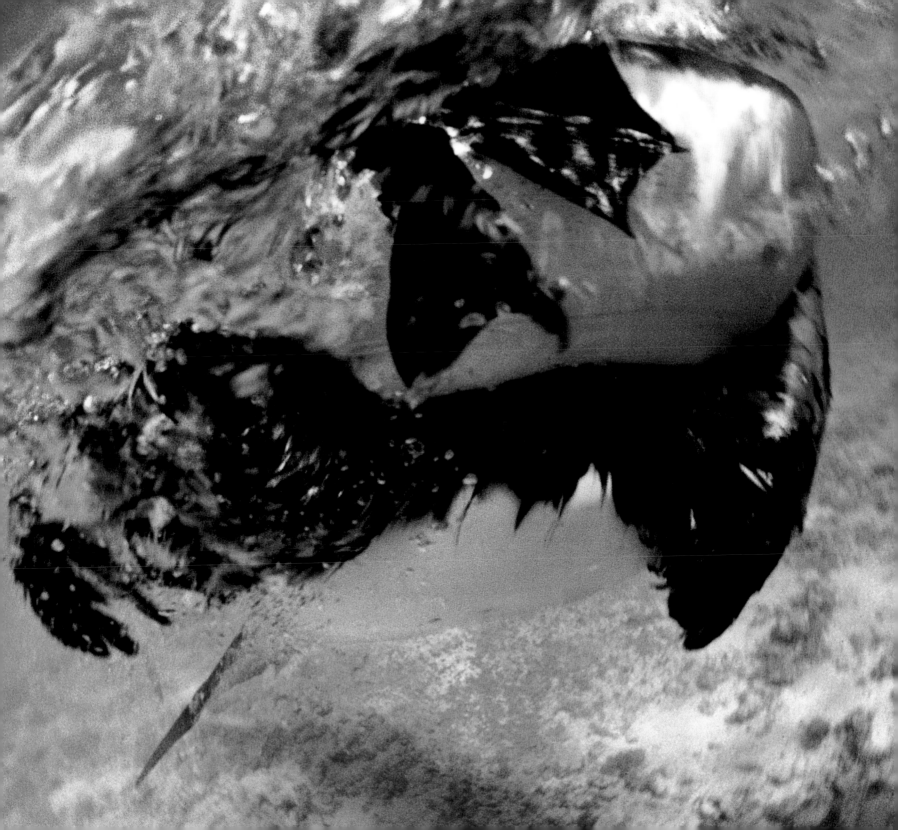

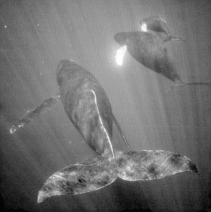

# MARINE MAMMALS

## MINDS IN THE WATERS

# MARINE MAMMALS

## MINDS IN THE WATERS

•

I N THE LATE 1960S, AFTER EARLY SUC-
CESS PHOTOGRAPHING SEALS IN ANTARCTICA,
I STARTED TO PHOTOGRAPH MARINE MAM-
MALS; WHALES, SEALS AND DOLPHINS. I FO-
CUSED MY EFFORTS ON THESE MAMMALS NOT
IN ONE REGION BUT ALL AROUND THE WORLD.

After the first dozen years this work came to-
gether in the publication of my very first book, *Wake
of the Whale*, written by Ken Brower and published in
1979 by David Brower of Friends of the Earth, who
was Ken's father. Many of my images from this peri-
od are of animals never before photographed under-
water. Many photographers have swum in my wake
since, and I like to think my work here inspired
some of their efforts.

Much of what I try to do with animals takes
time, lots of time. My goal is to immerse myself in an
animal's realm so that so I can extract from those
moments a new image, or a new insight into behav-
ior heretofore unseen. I become the creature I pur-
sue, at least in theory. I try to blend in, go slowly, go
quietly, in the hopes that my subject will forget I'm
even there, and interact with its own kind or anoth-
er species in a natural way. Sometimes it works.

The air chamber of an inflatable boat has a
unique resonance and produces a wonderful sound
from anything it comes in contact with. Since the
bottom of the chamber is immersed in the sea,
sounds you normally could not hear from the sur-
face are transmitted and amplified; even sounds
produced by marine mammals. So many times I have
heard wonderful echoes from below vibrate
through the rubber hull I've been sitting on. In the
course of my photographic career, I have spent days,
weeks, months, maybe even years, sitting in small
rubber boats, looking and listening for the animals
I pursue.

Southern Argentina's Patagonian coast is a place
where dry, desolate desert meets the sea. If you look
hard and wait long enough on shore, you will see
many desert species unique to this region. Offshore,
on the clear green waters of Golfo Nuevo, if you look
hard and wait long enough, you will see a southern
right whale (*Eubalena australis*).

There was a light breeze blowing offshore mak-
ing tiny waves that lapped softly at the rubber hull
of our inflatable boat. We waited in the stillness of
the empty sea until the quiet was suddenly broken

196  Humpback whale mother and calf with male escort in foreground closest to camera in Hawaii.

199  Humpback whale eclipses the sun above.

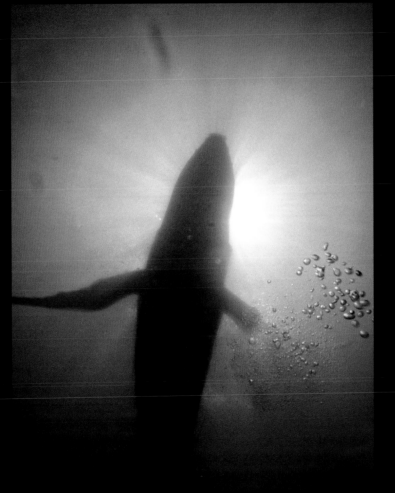

by a loud woosh. A large whale surfaced nearby. A small population of southern right whales comes to these waters every spring to give birth and nurture their young. They also come to mate. With a mature right whale measuring about forty-five feet long and weighing several tons, courtship between whales is often hot and heavy in the truest sense of the phrase. Slipping into the water with only simple snorkeling gear and a camera, I began one of the most interesting quests of my photographic career.

Southern right whales were the first whales I ever saw and attempted to photograph underwater. Since no one that I knew of had done this kind of work before me, I could only wonder to myself about the wisdom of such an exercise. I wondered if, after it passed by, the whale would know where I was relative to its enormous tail. I wondered if it would care. The underwater visibility was about 85 ft (25 m), so I would be seen for sure. Would the whale graciously share this remote bay with me or was I about to do something dangerous and reckless? Even with all of these questions racing around in my head, my gut told me that swimming with these right whales would be safe. It was.

As it turned out, they always seemed to know exactly where I was and avoided striking me with their enormous flukes. There, making photographs next to a 50 ft (15 m) whale, the great flank moving past me like an underwater freight train, I never once felt I was in danger. As the whale's tail approached it would, without fail, slowly lift up and over my head, and the whale would swim on. As it moved away the

cavitation produced by the powerful movement of its tail would gently toss me around in the water column. What a wonderful sensation, to be rocking gently in the wake of a whale. I wanted to feel that again and again, and I did.

I spent weeks swimming with these whales, never being able to get close enough for the kind of image I wanted to make, watching them keep their distance at a pace I could not match. And then one day that all changed. They seemed to gain some confidence that I was not there to harm them in any way. They stopped swimming so fast. There were occasions when, after a whale had passed by it would stop, turn around and swim directly back for a look at me. I finally started to have the moments with these whales I had hoped for.

A right whale's eye is roughly the size of a large grapefruit. Being locked in a giant whale's inquisitive gaze is something I will never forget. I still wonder what they might have been thinking at the time.

Once, after several such encounters with these graceful animals, I ever so gently touched a tail with my finger, just a tiny feel. The whale instantly reacted to this soft touch by thrashing its fluke and swimming out of sight.

One of my favorite photographs, taken just below and behind the tail of a southern right whale, took me weeks to do. Try as I might, I could not get the full frame image I wanted. I worked patiently, day after day, week after week. Finally, with one encounter, everything changed. I was following in the wake of a particular whale, a large female. We were

swimming in a shallow bay, only 50 ft (15 m) deep. The sun was bright and I could see the sandy bottom below us. She was keeping her distance as usual, effortlessly swimming just beyond where I wanted her to be. Suddenly, for some unknown reason, she simply stopped swimming and let me approach within a few feet. The photograph I had imagined unfolded before me. I swam right up to the trailing edge of her giant fluke and started to take pictures. I took as many frames as I could before running out of film. The water was clear, the light was just right and the southern right whale posed. Everything just came together that beautiful morning.

I realized long ago that the silent world of the sea, as it is often described, is anything but. The ocean is filled with noise. Imagine yourself on vacation on the island of Maui, Hawaii. The morning air is filled with the fragrance of tropical flowers, and gentle waves are breaking on a small reef offshore. If you are like me, you want to get in an early morning swim before the beach begins its daily population explosion. Swimming just beneath the surface, you will hear the ebb and flow of coral reef life. You can hear shrimp snapping, parrot fish crunching, waves swishing. You can also hear the song of humpback whales. It will be very faint near shore and one must listen carefully, but it is there.

The whales singing this song could be and probably are, many miles away. Acoustical properties of the sea are such that sound travels in all directions farther and faster than it does in air. I have heard a humpback whale singing just a few feet away while photographing in the deep blue waters that surround the Hawaiian Islands. There, the sound is very loud. You feel it as well as hear it. It resonates through the water column all around you and vibrates through your body. It is a beautiful sound and can only be described as a song. It has high notes, low notes and everything in between. It is haunting and mysterious. It is eerie and unlike any earthly sound you have ever heard.

Large questions loom on scientific horizons surrounding the humpbacks singing. Why do they do it? I suspect that the song has an important social purpose. During the humpbacks' seasonal visit to Hawaii from Alaskan waters, researchers tell us they are all singing the same song. And what I find most amazing is, researchers have learned that the song changes each year. Is there a single whale or group of whales that compose the new song? If so, what, if any, would be the social status of those whale-song composers within the large group of migrating whales? Is the composition a collective effort with many whales contributing a musical section here and there until it sounds right? If their song is so clearly repeated over and over and then another one sung the next year, just what are they communicating to each other? While waiting for all these answers, I simply enjoy the concert.

During the summer months off the Canadian province of Newfoundland, humpback whales migrate to inshore waters to feed. The western Atlantic waters were once among the most productive in the world. When I was there several years ago, the

humpbacks were feeding primarily on schools of capelin and herring, both migratory small fish, about six inches long. The humpbacks' arrival to these waters was no accident. With the coming of capelin and herring inshore to Newfoundland's coast, the humpback whales are never far behind.

Humpback whales were not the only species waiting for the big capelin schools. The famous Newfoundland codfish were also waiting for capelin.

Newfoundland was once synonymous with the word: cod. For many generations Newfoundlanders earned their livelihood from these cold, unforgiving northern waters and it has made them a tough, proud people. Many a Newfoundlander still looks seaward, privately evoking the memory of a husband, son, brother, father, grandfather, lost to these frigid sub-Arctic waters in pursuit of cod. The island's economy and social life were built around the cod fishery. It is hard to imagine Newfoundlanders without a cod fishery, but that is their current reality. Because of over fishing by foreign fleets and federal mismanagement, the cod fishery, for now, is closed to Newfoundlanders.

I once sat on a Newfoundland cliff overlooking a tidal rip and watched humpbacks feed on capelin that were swimming near the shore. It was early evening and the light was beginning to fade. The whales would disappear in the tidal rip for several seconds underwater and powerfully break the surface, mouths agape. Their huge mouths would almost always be full of capelin.

Day turned to dusk and it became too dark to photograph. It was a rare moment for me to be able to put cameras aside and just look. I remember being amazed at how distended and large the whale's mouth became when filled with water and fish. I remember the few lucky fish that got away, silver flashes glistening in the setting sun spilling back into the sea. I remember a group of young boys playing on the beach; their happy voices seemed to mimic the swooping seagulls diving for the fish that the whales had momentarily stunned. I remember the red sky, the first few stars, and the inevitable night darkening the seascape.

I stayed long after dark, after I could no longer see. I could hear the whales breathing, I could hear them feeding, I could hear them leaping from the water and splashing back into the sea. It was a unique gift, to be without the burden of sight, to simply enjoy the sounds of nature. It was an evening I'll never forget. I sat for a long time just listening and thinking; thinking about the night sky above me filled with planets and stars. I thought about the humpback whales feeding below me. Sitting in the dark on that beach I understood that I recognized a new and powerful way to experience the natural world around me. In a sense, I had a new vision. Since that evening in Newfoundland, sitting in the dark, I've learned to just stop and listen, listen to the music of what's all around me, even when it can't be seen.

203 Pilot whales, swimming in a large social group, descend to feed in deep waters off Hawaii.

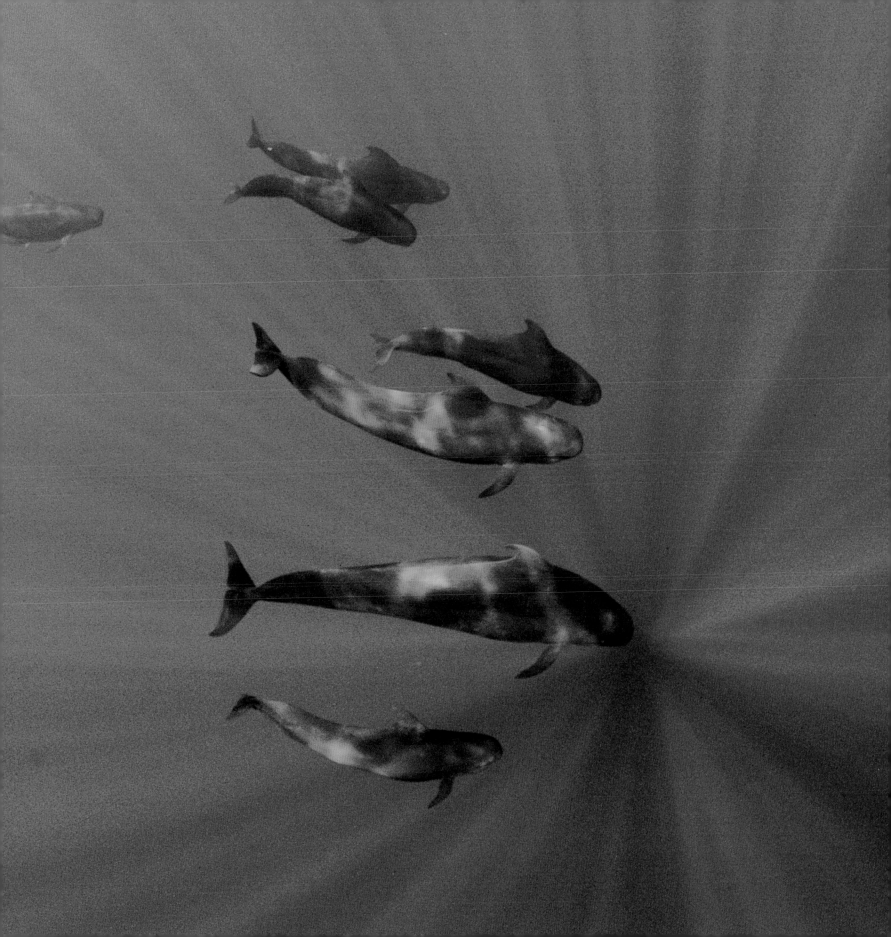

# GENTLE GIANTS

204-205 Humpback whales often
become entrapped in fishing gear, as
this one did off Newfoundland. Later
released, it swam away with a radio
tag. Whenever I swam too close,
it would bob its head up and down
in warning.

206-207 Humpback whales have long,
mostly white pectoral fins.

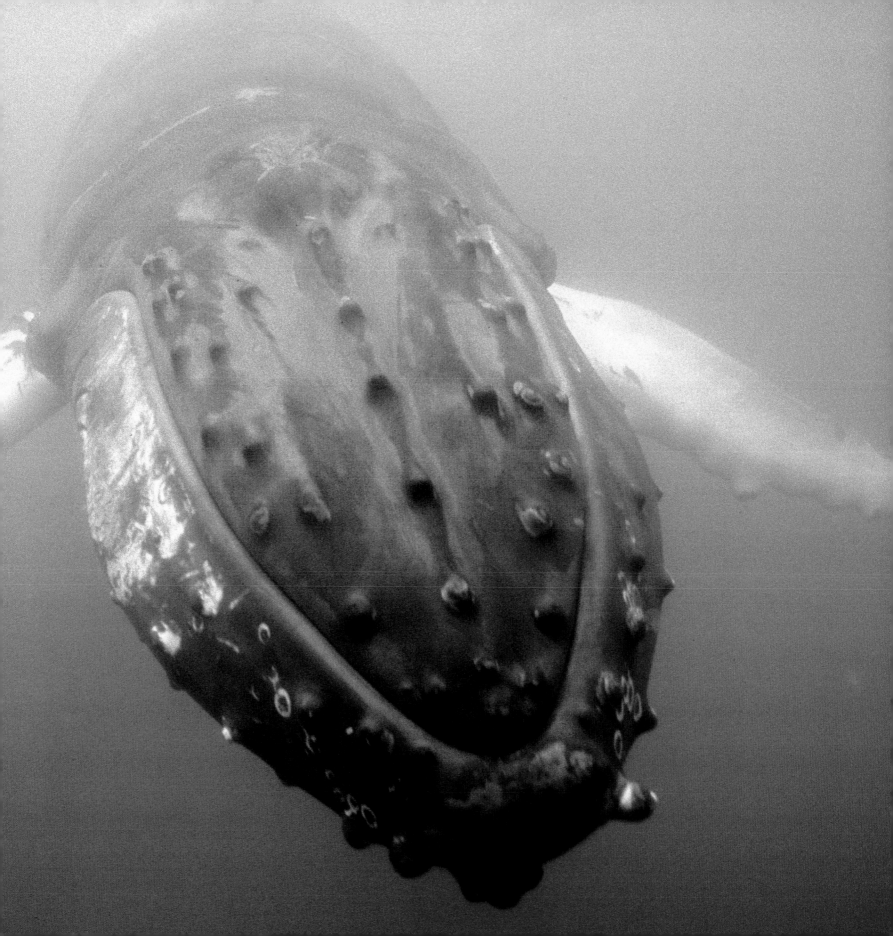

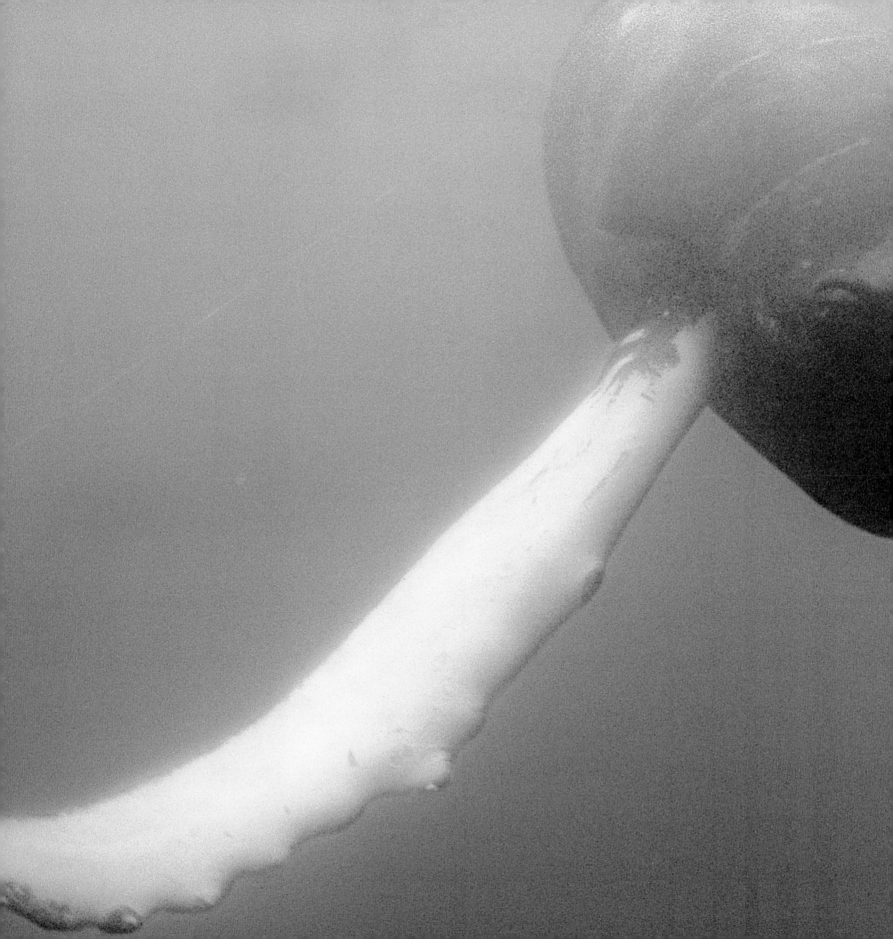

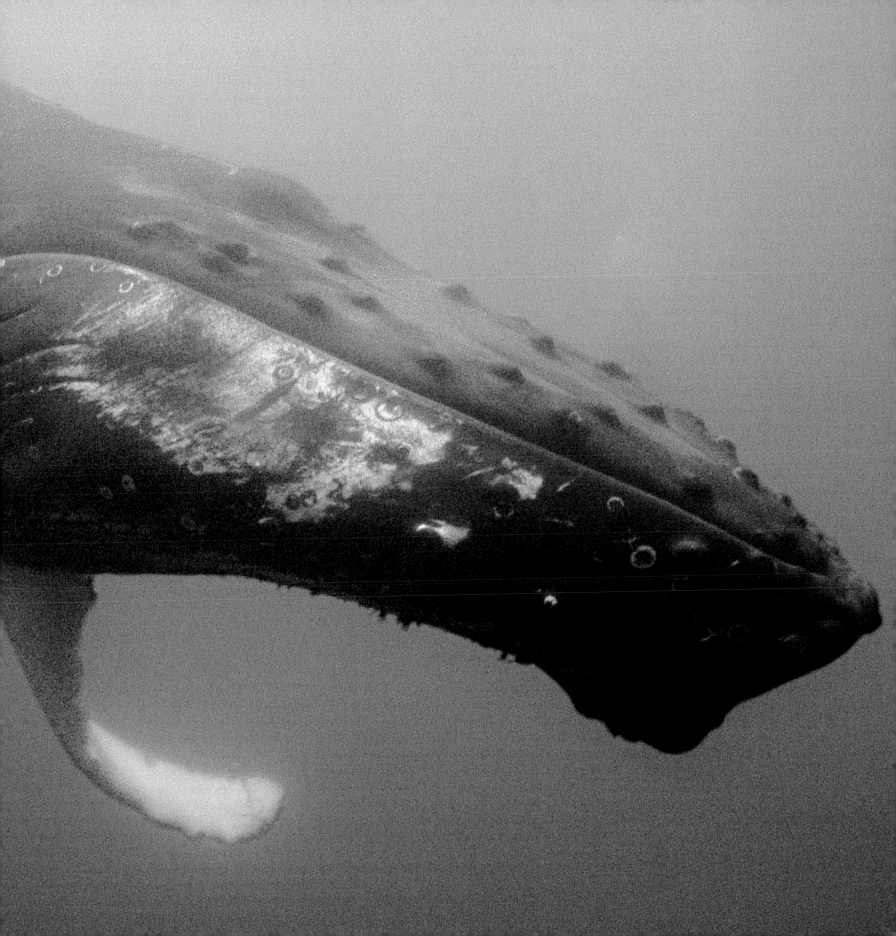

208-209  Swimming in the wake of
a southern right whale. This is one
of the most memorable moments I
have ever had underwater.

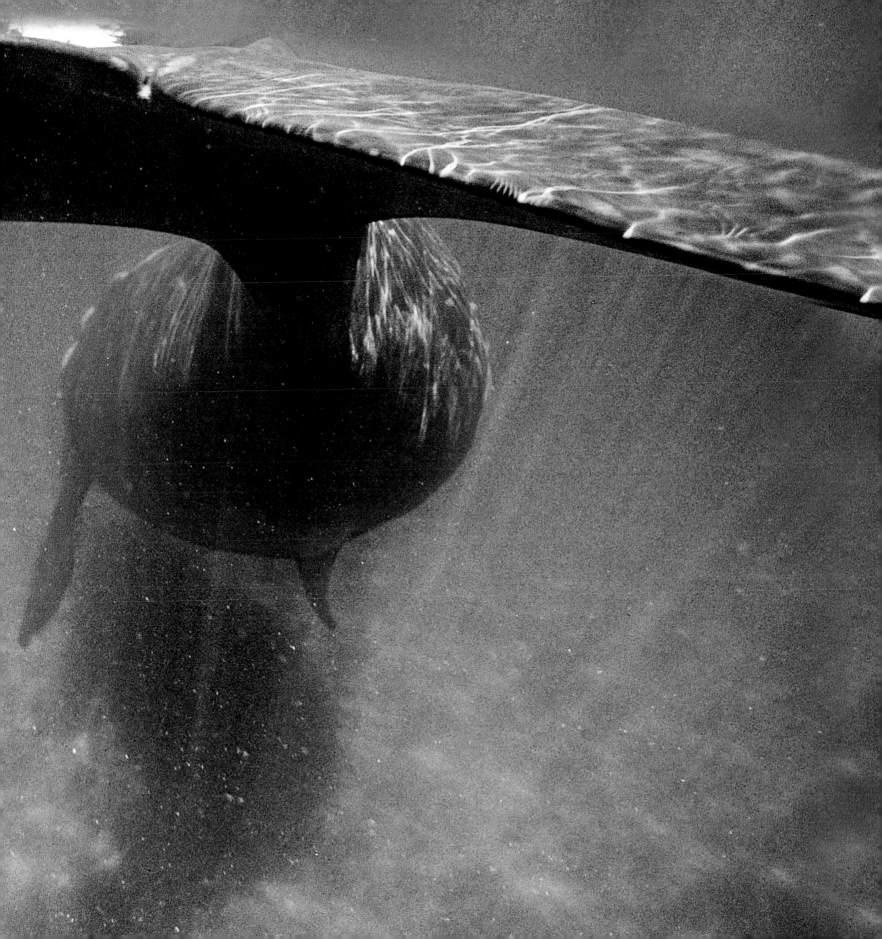

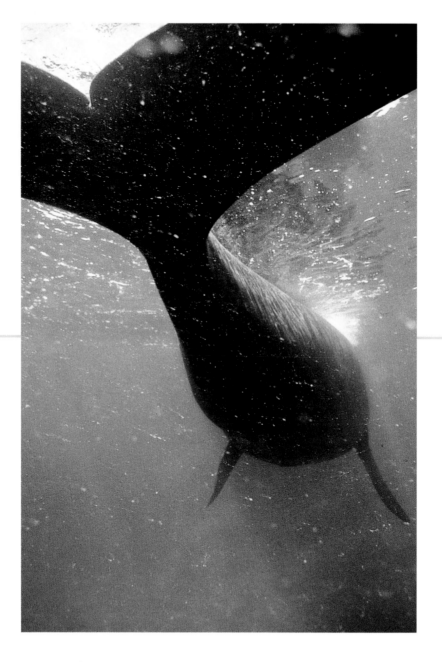

210  After two weeks of trying to get close enough to take this photograph this southern right whale finally let me swim beneath her enormous fluke to make this image.

211  A right whale rises with callosities visible as a white pattern.

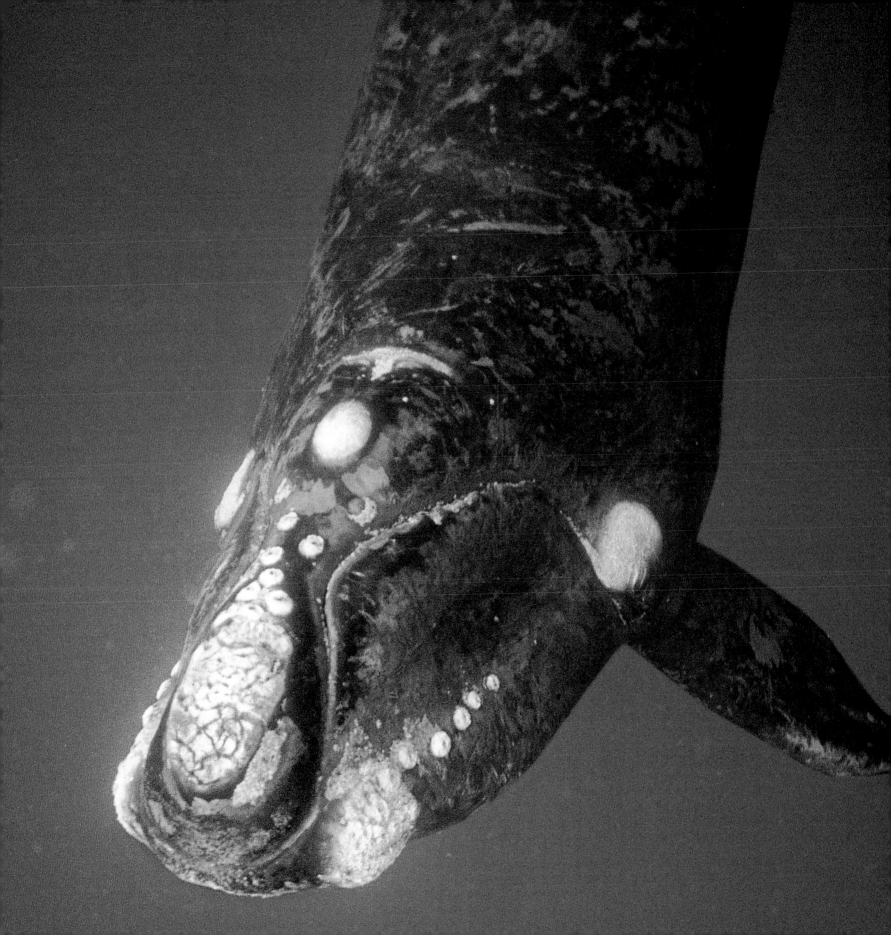

# MAN MEETS
## WHALE

212-213  Diver Andreas Pruna swims
near a southern right whale in
Argentinian waters.

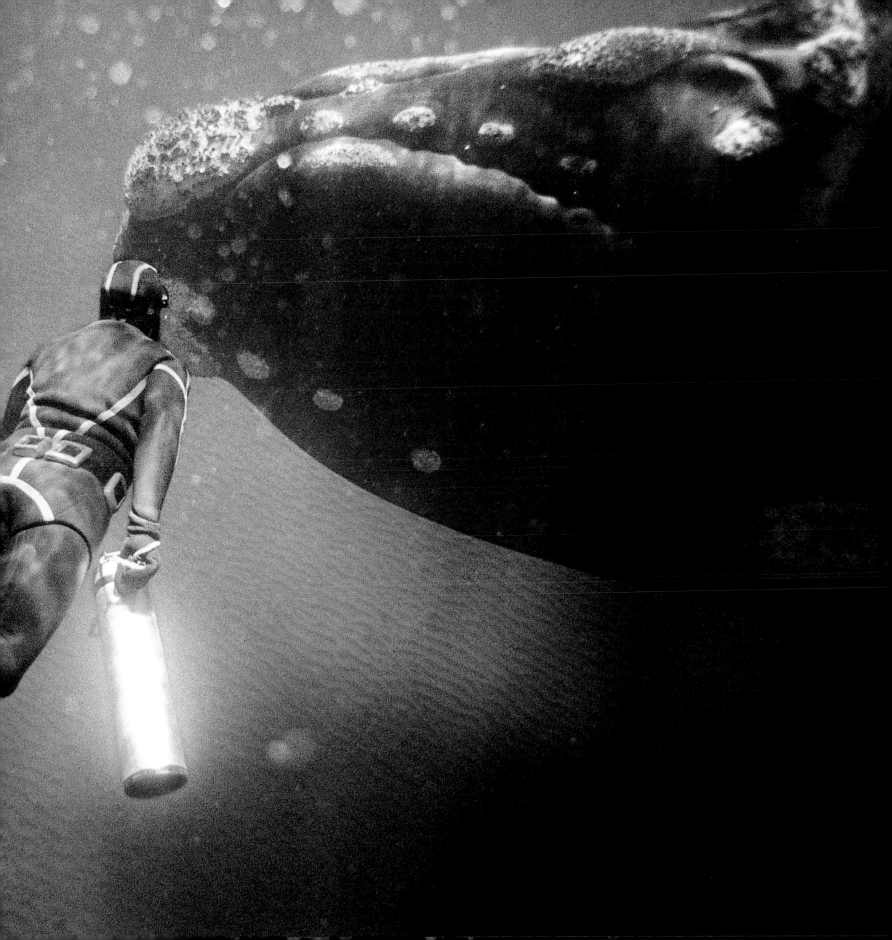

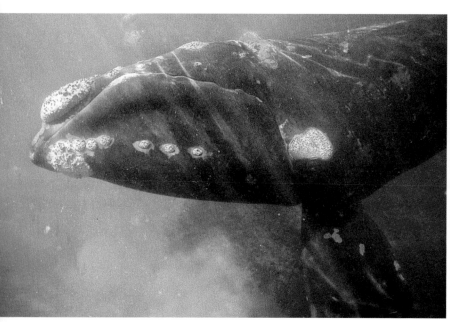

214 and 214-215 Southern right whales are born
with an individual pattern called callosities which
makes it possible to identify individual whales.

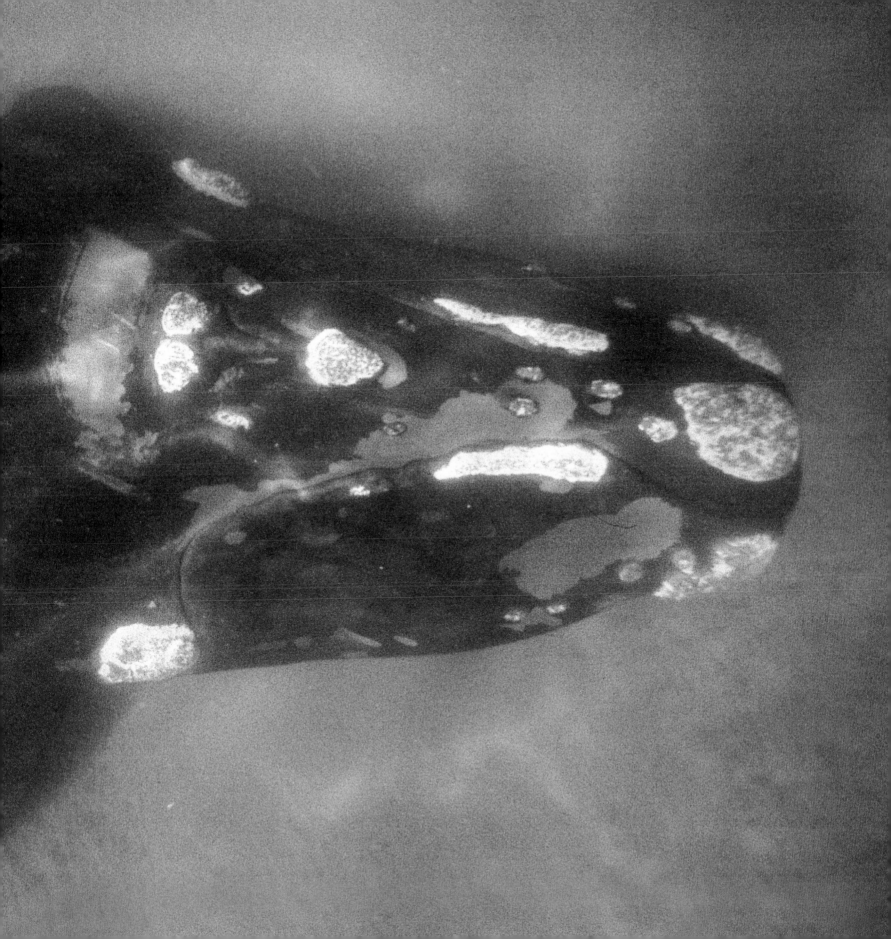

# GIANT TRAVELERS

## HUMPBACK WHALES

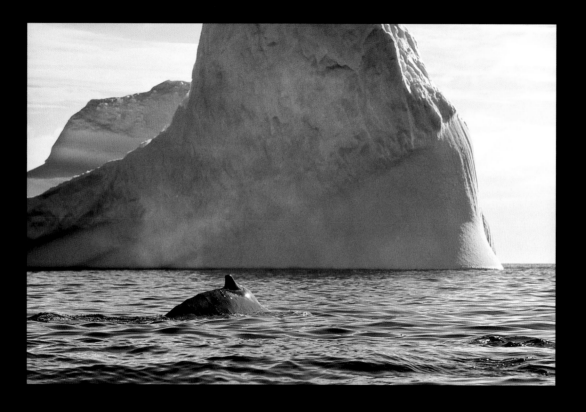

216  A humpback whale in Antarctic waters near a large iceberg.

217  A humpback whale surfaces close to my small rubber boat in Newfoundland as it begins a deep dive.

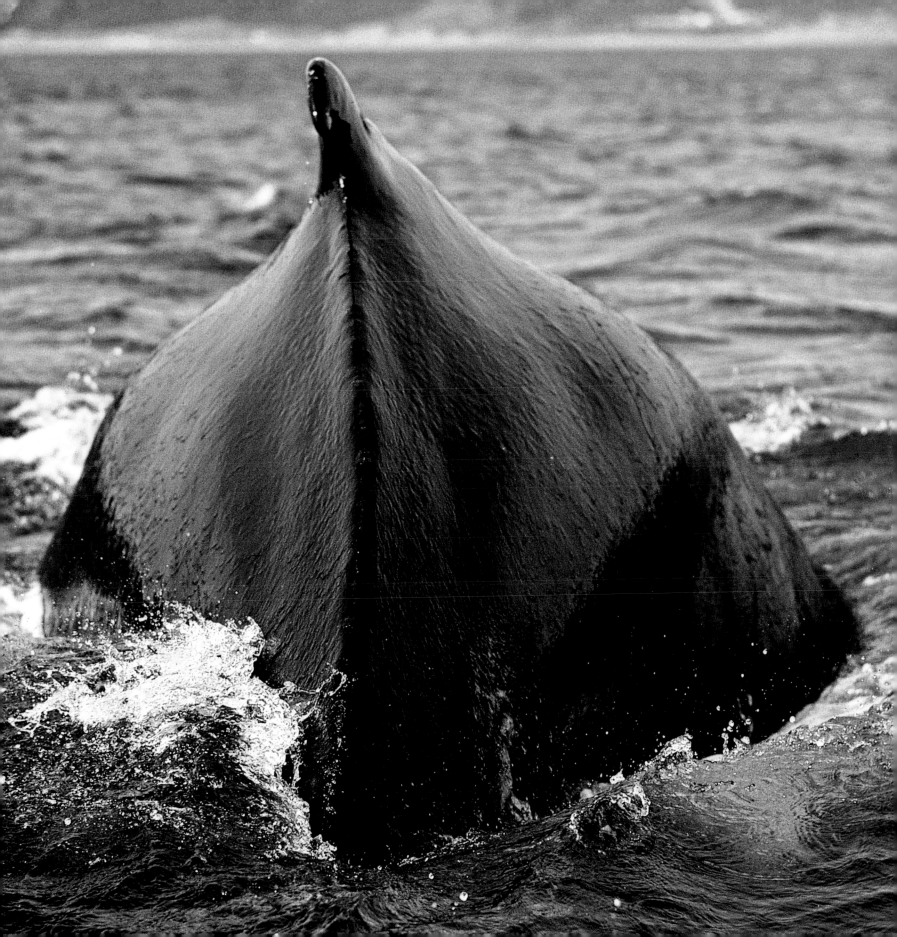

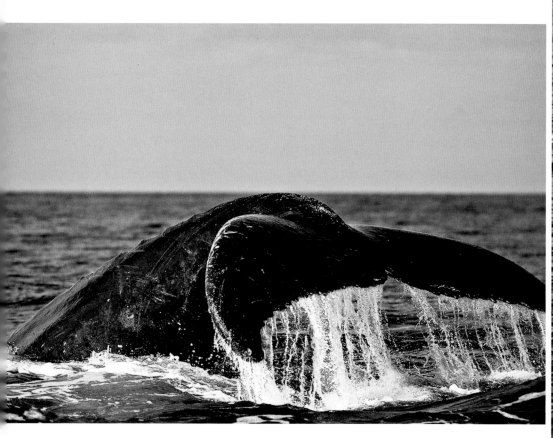

218  Sea water dripping from its fluke, a humpback whale dives to deep waters off Hawaii.

218-219  Fin whale and birds feeding on krill in upwelling off Grand Manan Island, Gulf of Maine.

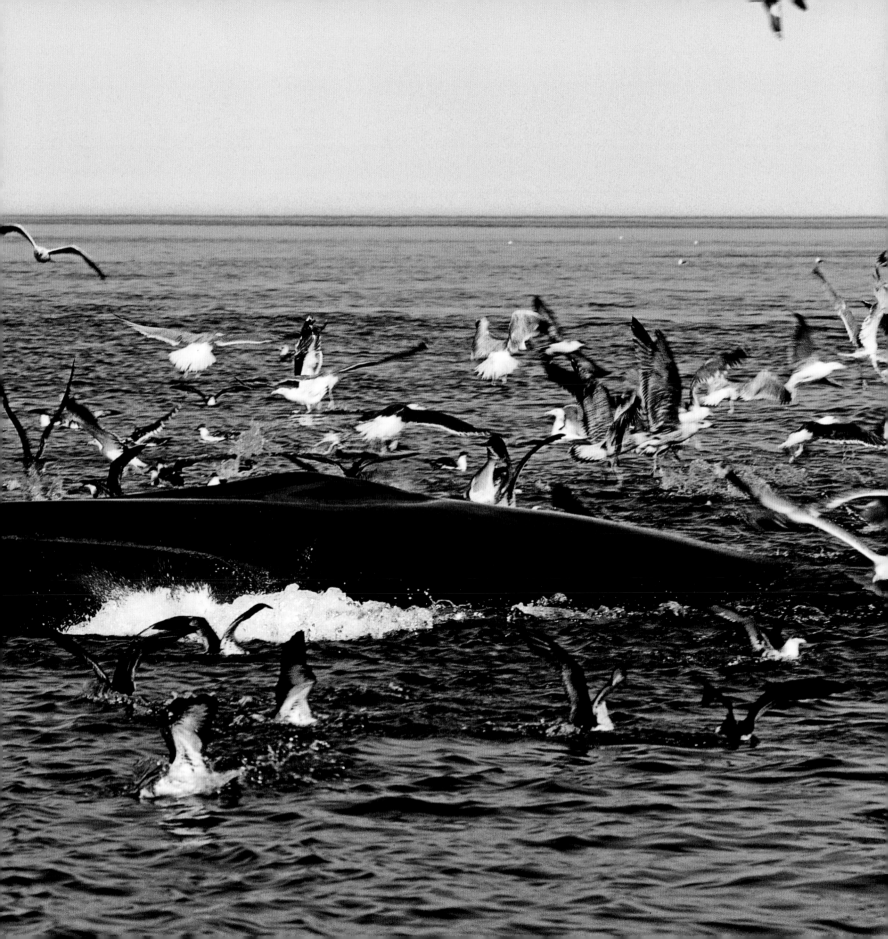

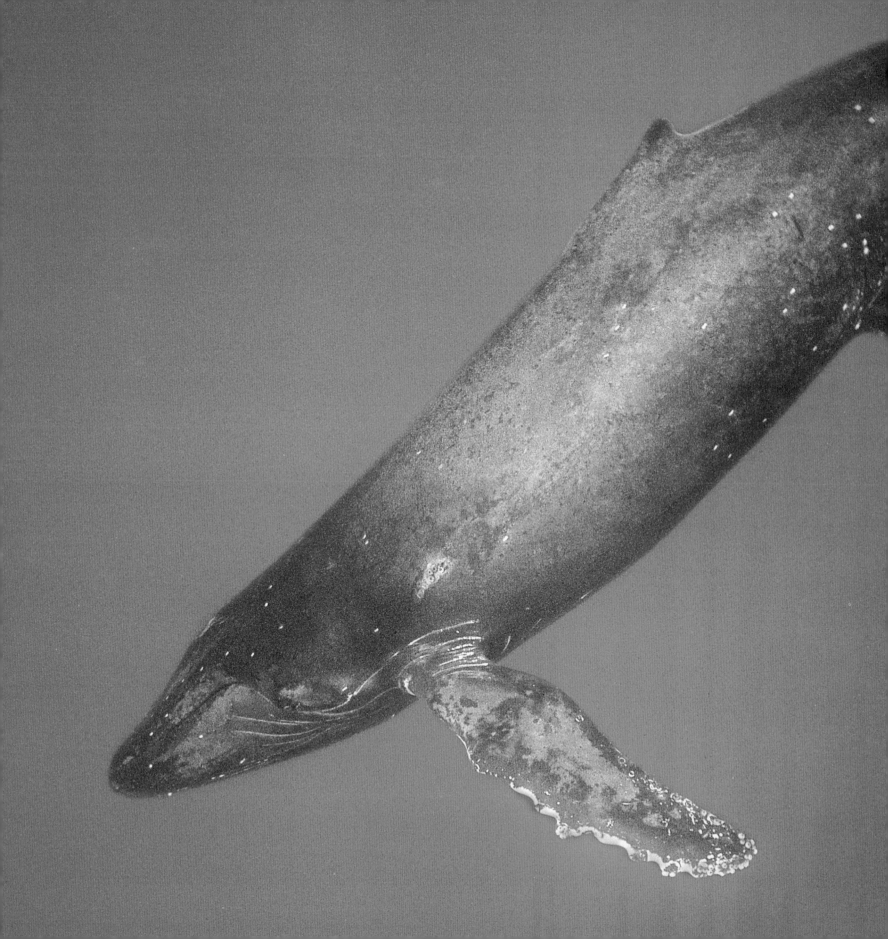

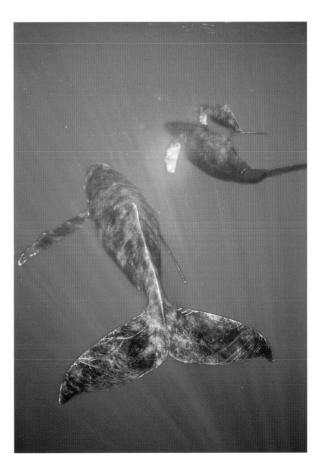

220-221  Humpback whales in Hawaiian waters.

221  A humpback mother and newborn
calf with escort.

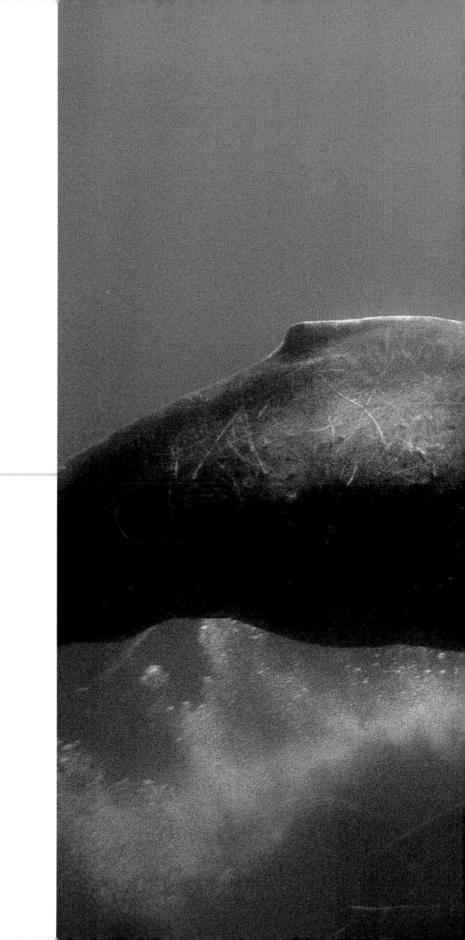

222-223 Humpback whales
emitting bubbles off Hawaii.

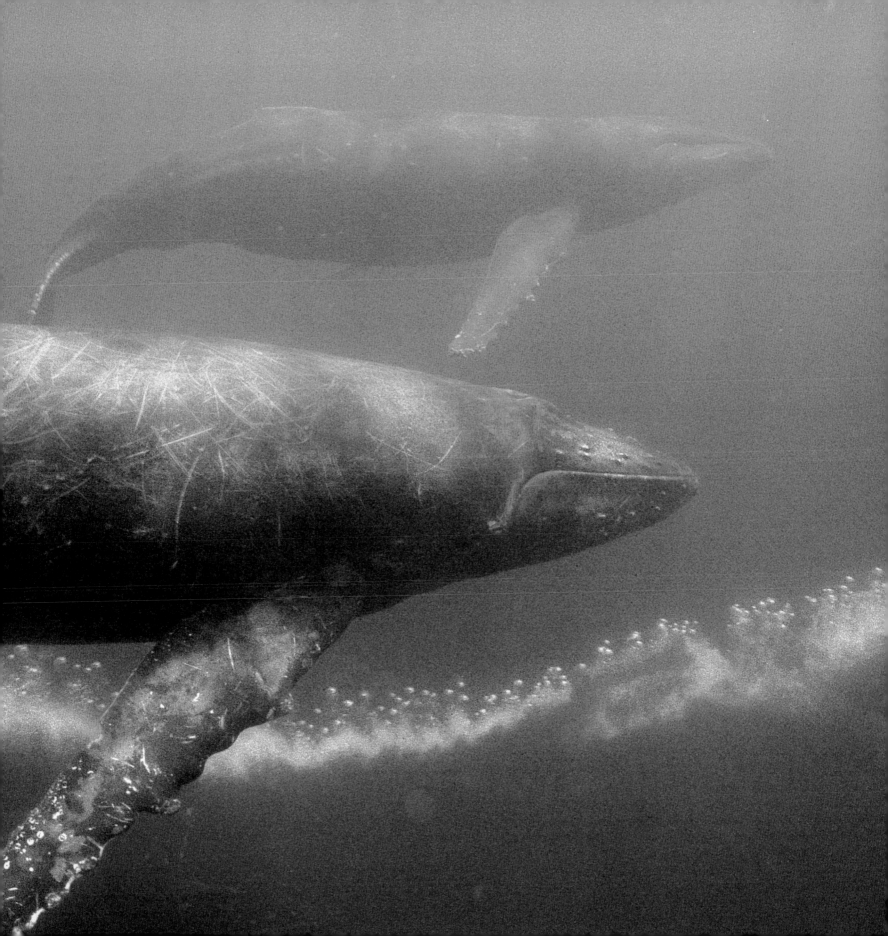

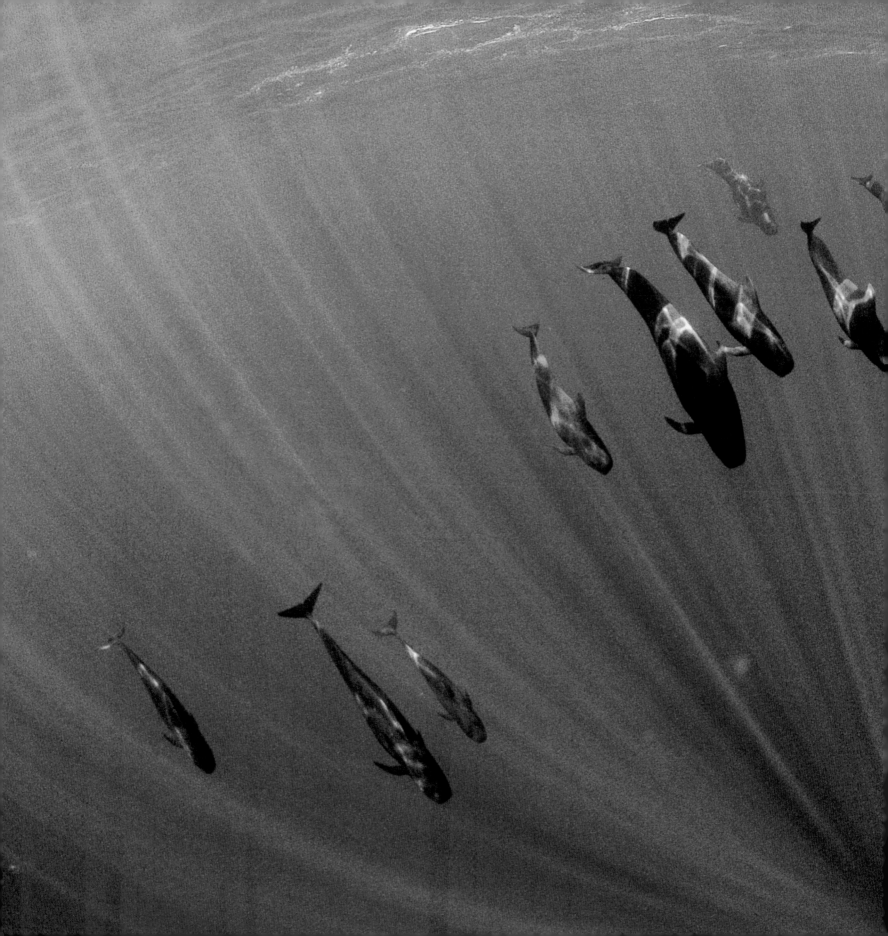

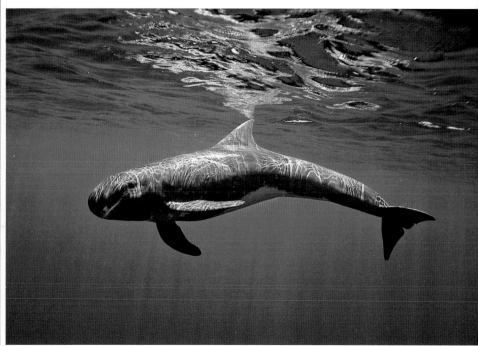

224-225  Short-finned pilot whales travel in a large
social groups, Hawaii.

225  Pygmy killer whale off Hawaii. This large dolphin is
often confused with other species but underwater their
rounded head and aggressive behavior make them
easily to identify.

226-227 A pygmy killer
whale off Hawaii swims
right up to the author.

228-229 A short-finned
pilot whale mother with
nursing calf beneath,
Hawaii.

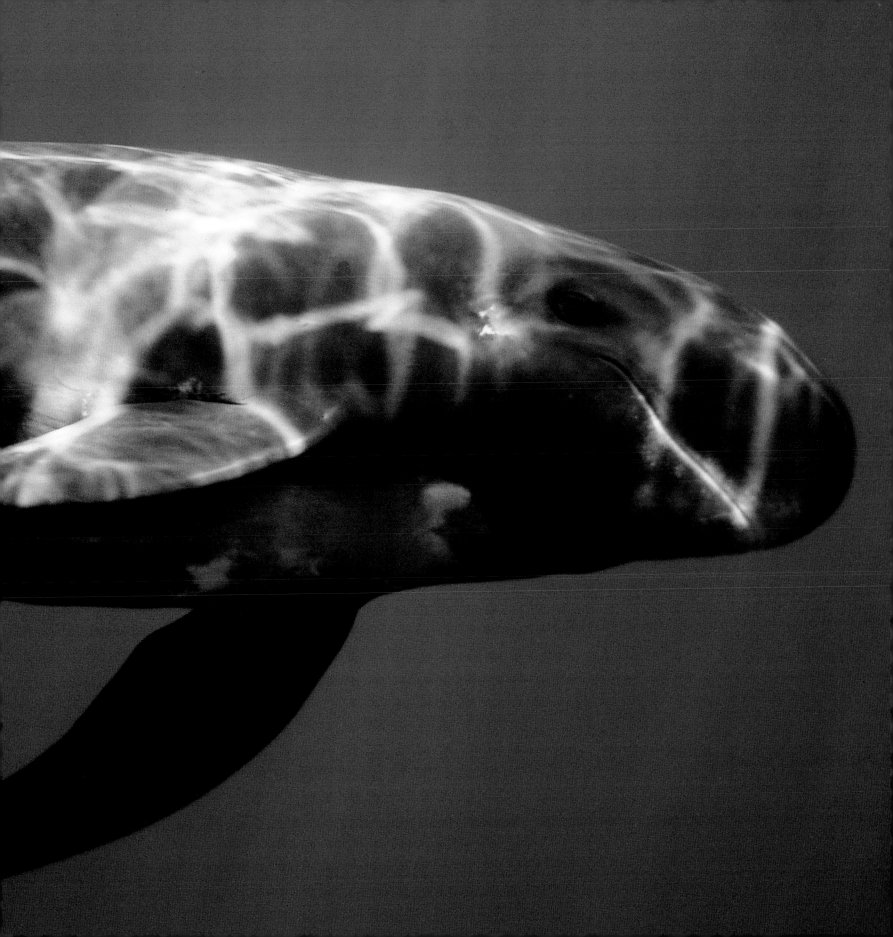

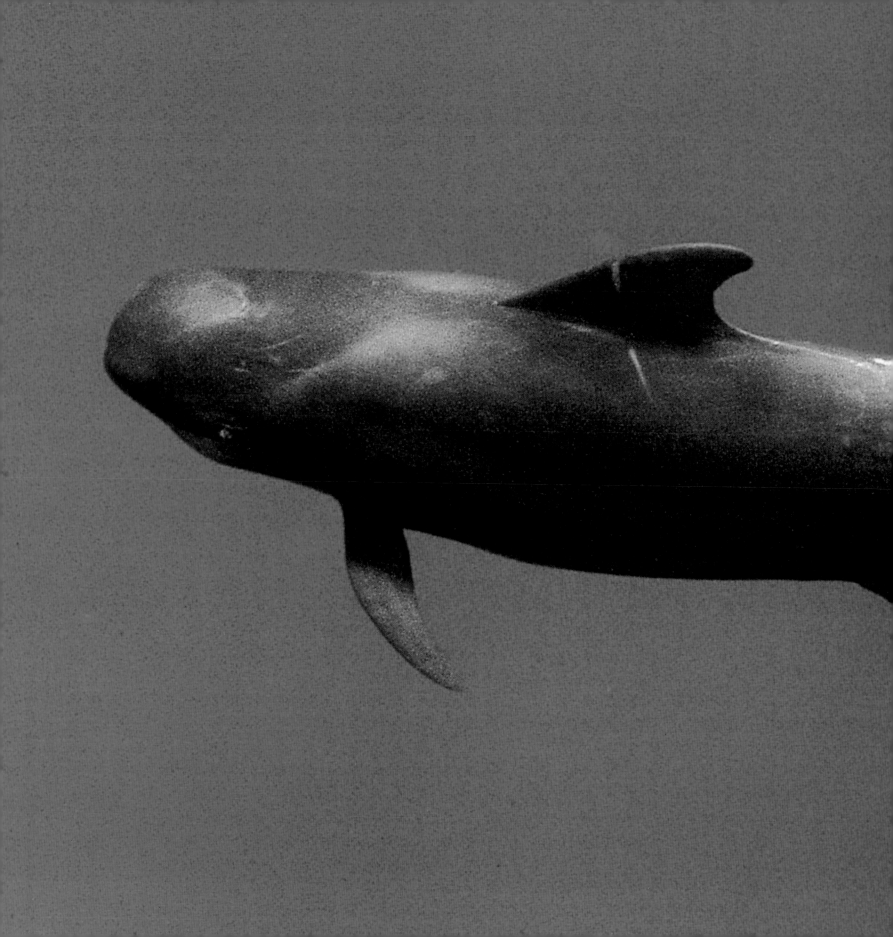

# DOLPHINS

## OCEAN SPIRITS

"THERE IS SOMETHING SPECIAL ABOUT THE OCEAN WORLD, A CERTAIN ALLURE, LIKE A SONG THAT CALLS TO ME. I CAN'T REALLY EXPLAIN THIS ATTRACTION; IT'S JUST THERE, INSIDE -- A PART OF WHO I AM. Whenever I am in a boat and beneath me is clear, blue, oceanic water, the song is loudest. No tropical marine environment holds my attention the way the offshore pelagic realm does. It is a featureless seascape with no visible bottom, no reef, and no fish. It is empty and seemingly void of life. It is a world that reluctantly gives up its secrets. Shafts of sunlight penetrate the surface waters angling downward, illuminating nothing. Searching this empty blue vault day after day can be a frustrating and humbling experience. Hour after hour one looks at nothing. When something does appear it's more like a magician's act. Where a second before the ocean was empty, suddenly something materializes. My whole life as a professional underwater photographer has centered around one unwavering truth: I must be in the right place at the right time. The oceans cover two-thirds of the earth's surface. It is a world laden with mysteries and secrets that are only grudgingly revealed and brought to light. It is a multi-dimensional environment. A marine creature has many options for eluding a photographer. Unlike a terrestrial mammal, a marine mammal can swim beneath you, or over you, and it can chose which side to swim around you. Dolphins can use their extraordinary acoustical abilities to figure out who you are and where you are long before they actually see you with their eyes, and much longer before you ever see them.

Spotted dolphins exist throughout the tropical Pacific. But here in this featureless ocean far offshore they are elusive and hard to find. To photograph them, I tried to place myself in the right chunk of ocean at the right time. Sometimes this works; often it doesn't. Looking at these photographs now, it is easy to overlook the effort that went into their making. Days, sometimes weeks, would go by before I might have an image on film I wanted to take home. It is always a frustrating undertaking but for some unexplained reason it's what I love to do, and I've been told I do it best. I do not know if dolphins are intelligent. I am often asked for my opinion though, and I feel the question is irrelevant and misses the point. No other marine creature seems so well adapted to their world as dolphins are. No other marine animal seems so at one with the sea and such a master of that environment. Dolphins do have a complicated language that they can transmit over great distances underwater. They live in both large and small social groups and seem to have a well-developed social hierarchy that each individual respects. Traveling the open ocean as they do, it is in their best interest to maintain

231 Pantropical spotted dolphin breaches off Hawaii.

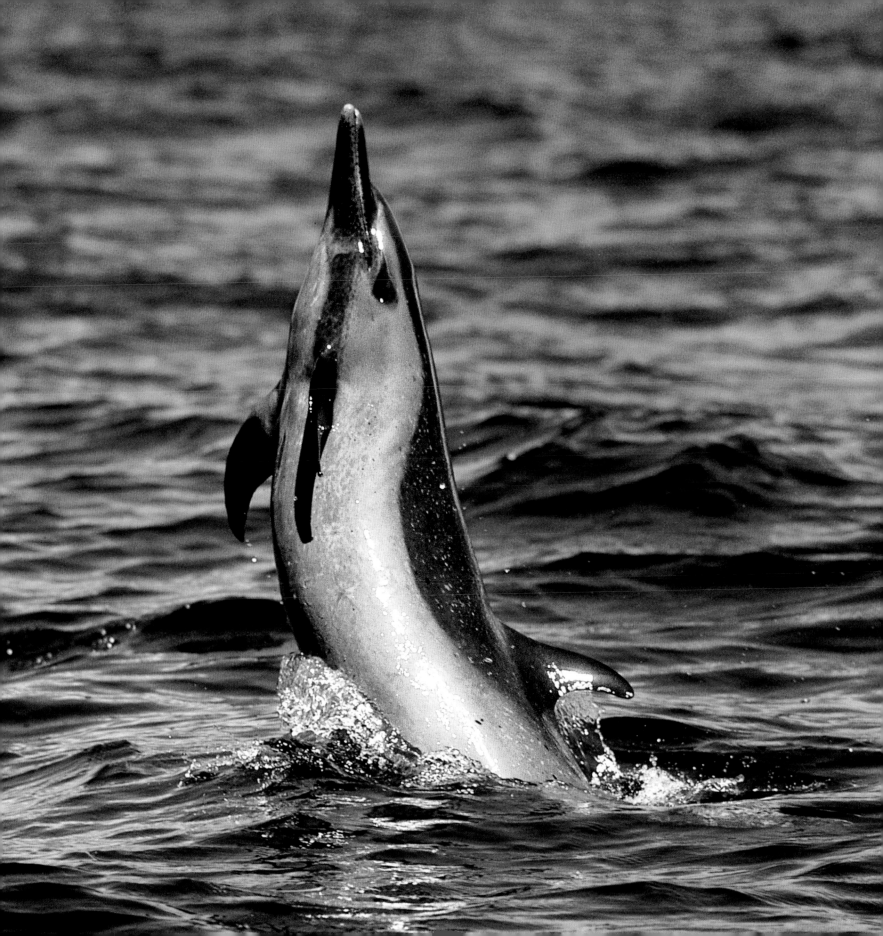

this social group as best they can. Unlike the dolphins you might see in oceanaria, wild dolphins have to feed themselves and are superb hunters. They swim through many miles of ocean each day in their quest for prey. They are born, nurtured, and live their entire lives in the gravity-free world of the open sea, never settling down on any object anchored to earth. They embody the very word motion with their endless, effortless swimming and leaping. I don't know if dolphins desire, strive for, or possess intelligence. I do know that they express curiosity. When a whale or a dolphin swims by me it's not looking at my toes, it's looking me right in the eye, or even better, the big eye of my camera dome. What is it thinking about when it encounters this clumsy, obviously inferior "marine mammal" dangling from the ceiling of its watery world? Who knows? Once, a pilot whale and her calf swam beneath me. It was a moment in the wild I will never forget. It was a dark and gray day; the light underwater was marginal for underwater photography. When the mother and calf approached, the sun suddenly came out and the ocean around me filled with light. Then the calf rolled over, swam beneath its mother and began to nurse.

Dusky dolphins surround and feed on large schools of anchovy. You can spot this event across the water by a flock of birds frantically trying to get their share. For the longest time I wanted to be at the center of a feeding frenzy. So many times I would race to

a frenzy, only to find that by the time I arrived, everything was gone -- dolphins, fish and birds; hunters and prey had moved on, the ocean was green and empty. All that remained were the silver scales of unlucky anchovies, gently falling to the bottom of the sea. While underwater with a group of dusky dolphins, I often witnessed a moment when they would suddenly all take off swimming in the same direction. If I followed them long enough, I found that they ended up at a school of anchovy another group had found. This, to me, is evidence of a sophisticated language through which that they can transmit ideas over great distances underwater. Once they had surrounded the school of fish, they seemed to share different jobs. Some would hang motionless in the water, casually eating anchovy, while the others would swim around to keep the fish in a tight ball. Integrating such teamwork into a feeding strategy in a challenging environment helps achieve a simple goal, survival of their species. I guess you could call this a measure of their intelligence, but I'll leave that discussion to those doing the measuring. The actual taking of a fish was almost impossible to see in real time as it happened; it just took place in a fraction of a second. Later looking at my film, I could see that the dolphin would target and swim after individual fish within the large school, and take one at a time instead of just swimming through the school with their mouths open.

233 Pantropical spotted dolphins, *Stenella attenuata*, in a social group off Hawaii. These dolphins will surface and dive synchronously.

234-235 Fitz Roy dolphins, *Delphinus fitzroyi*, sprint toward a feeding opportunity off Argentina.
Dolphins are able to communicate over great distances underwater alerting other dolphins to a feeding opportunity.

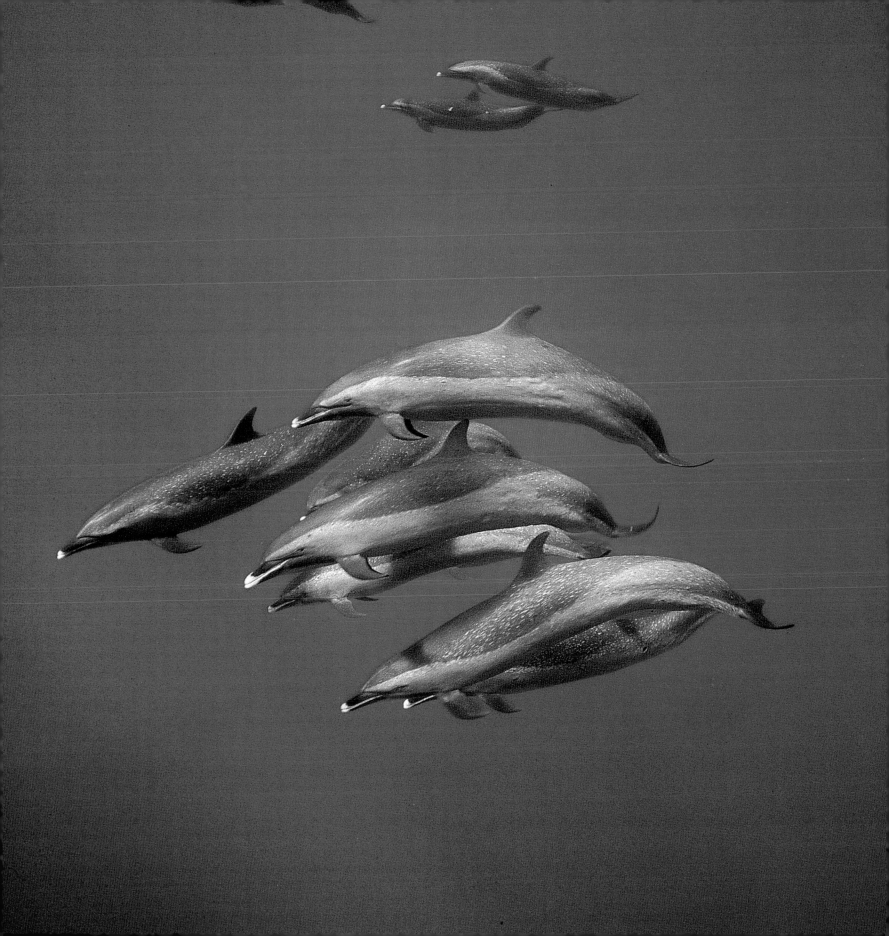

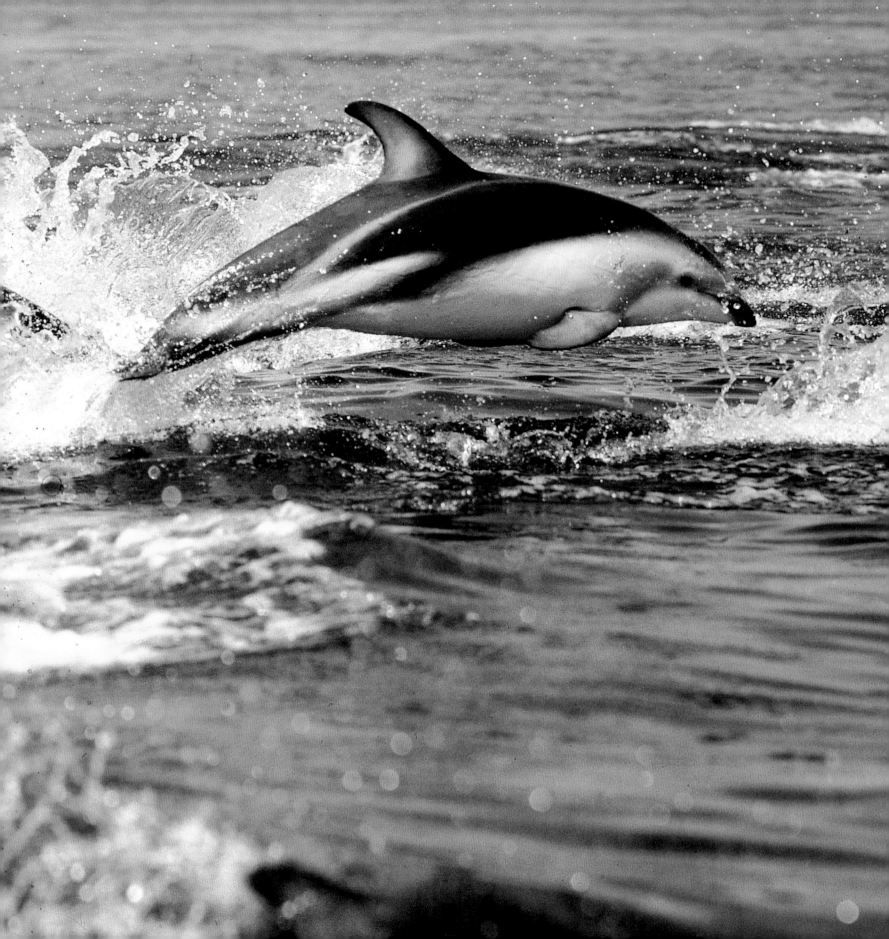

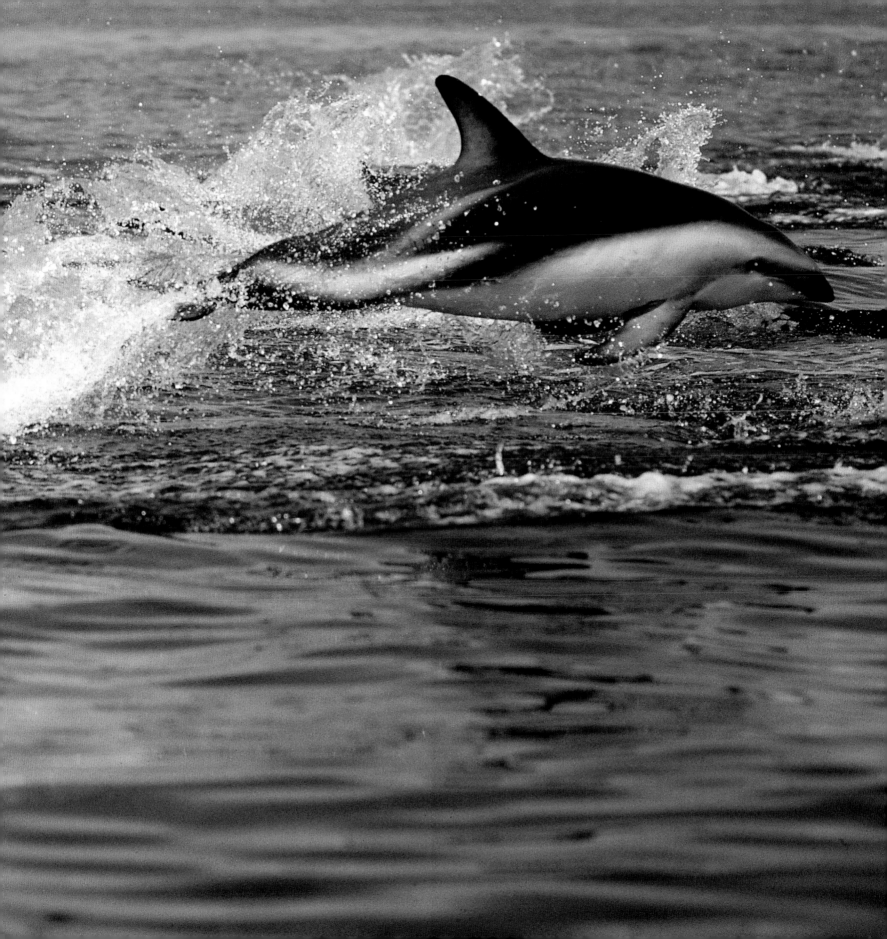

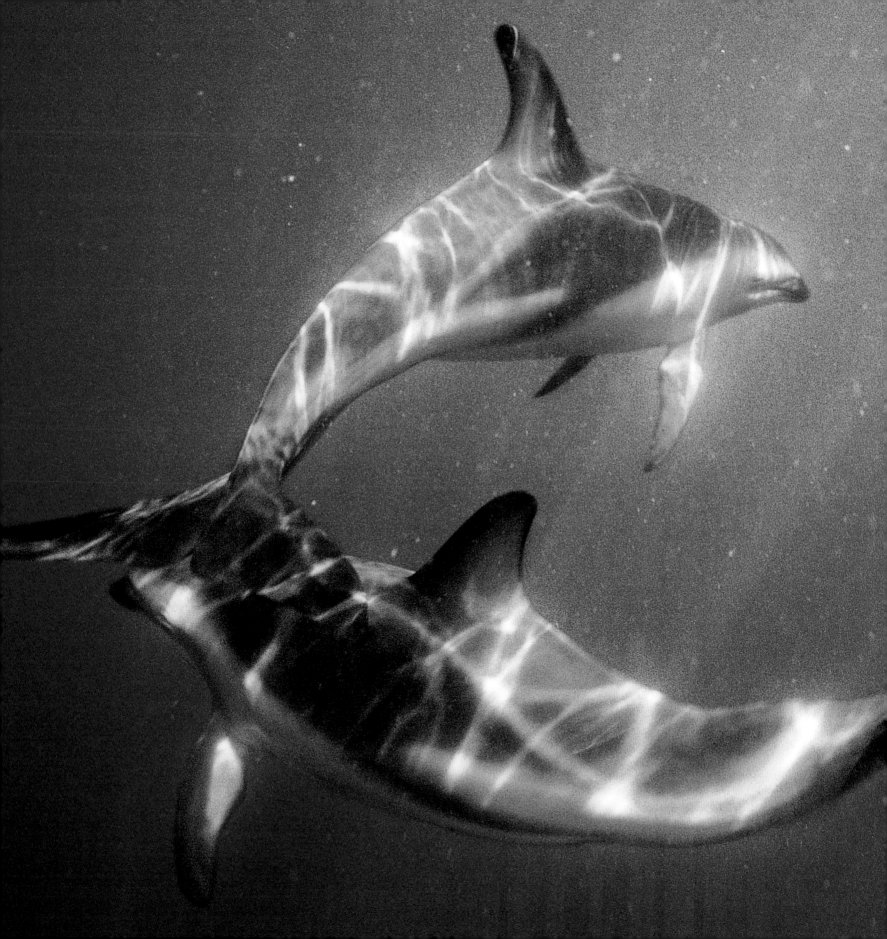

# FITZ ROY DOLPHIN

## DOLPHINS WITH A CAPTAIN'S NAME

236-237  Fitz Roy dolphins herd anchovy into a tight ball off Argentina.

237  Fitz Roy dolphins switch from herders to feeders as they skillfully contain the school of anchovy that has no possible escape.

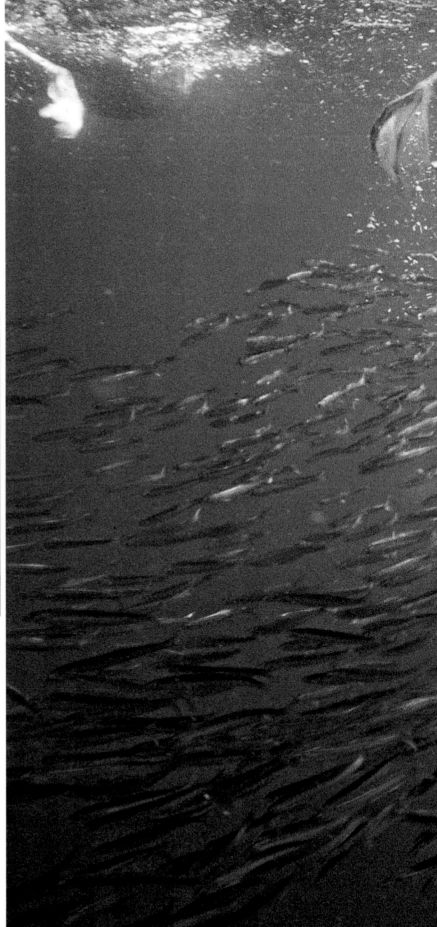

238 and 238-239  Fitz Roy dolphins feed on the anchovy school they have collectively herded. Birds attack the fish from above.

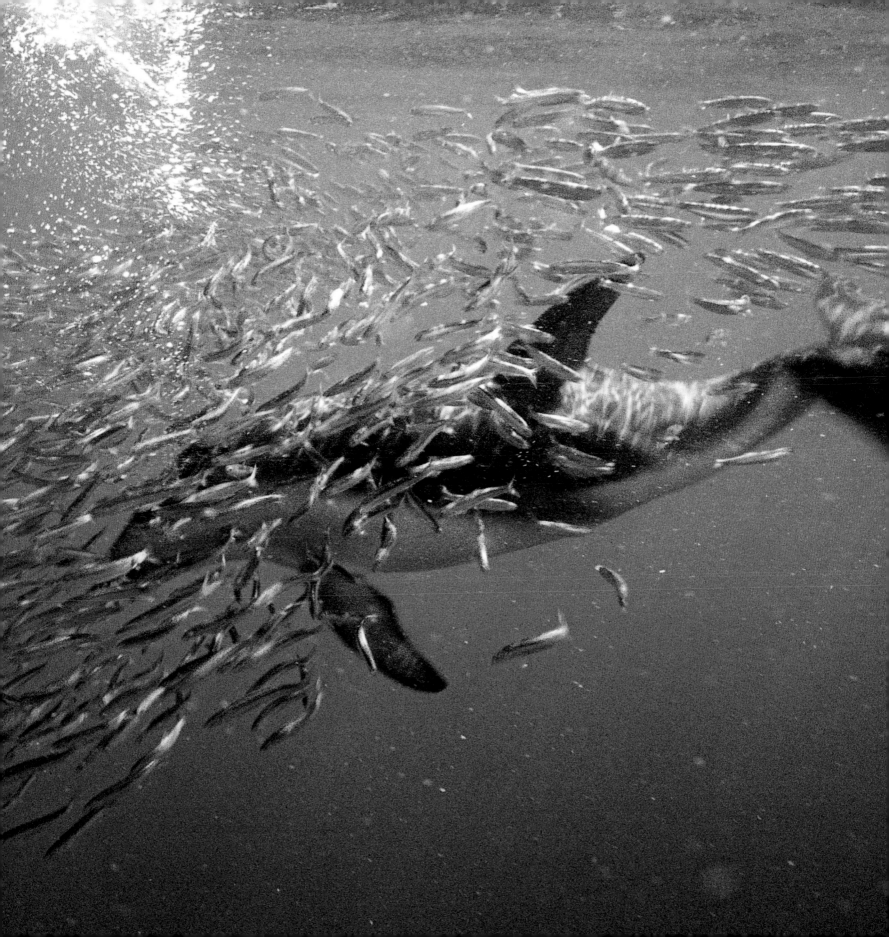

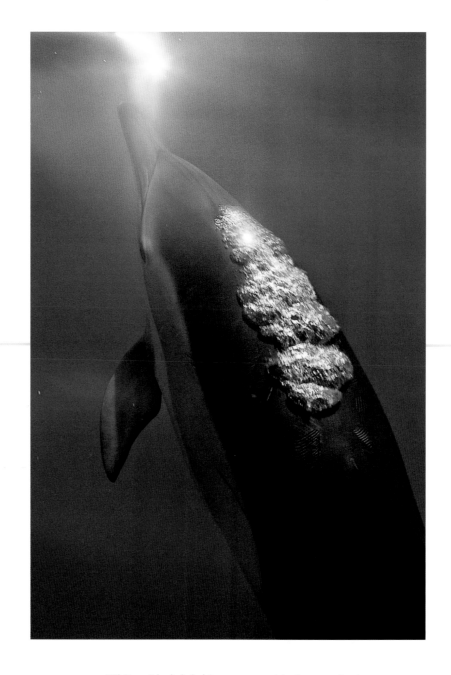

240  White-sided dolphin a moment before surfacing.

241  Fitz Roy dolphins off Argentina. One dolphin's blowhole is clearly
visible as it surfaces for a quick breath.

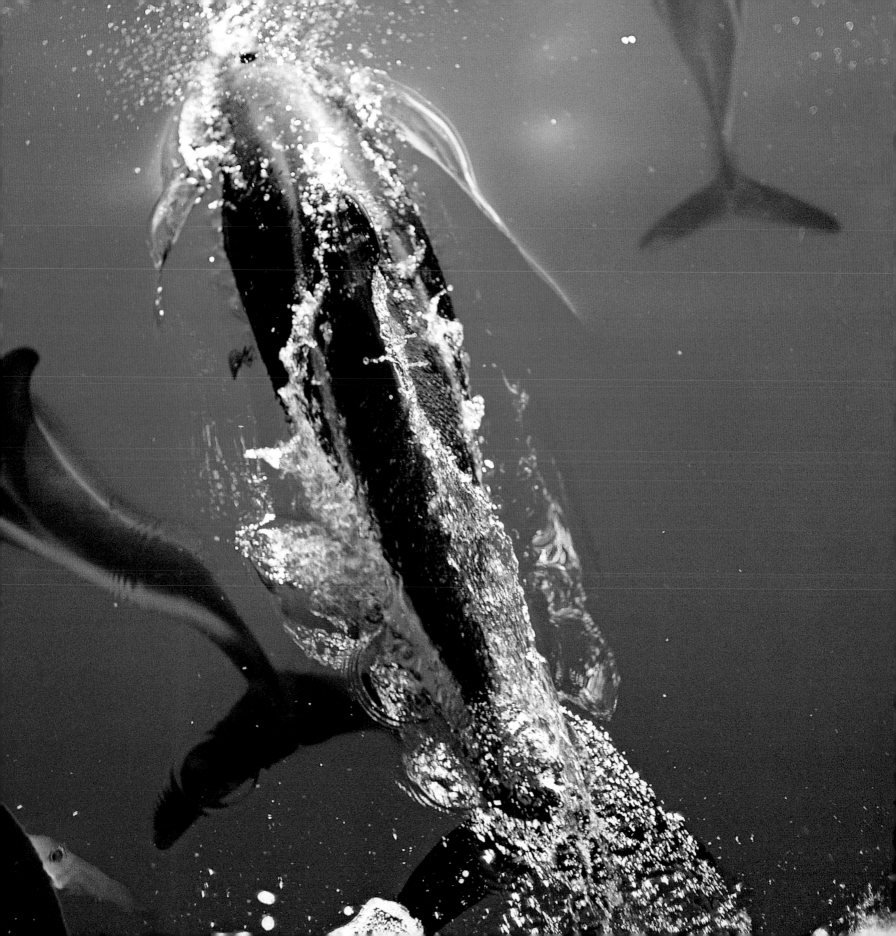

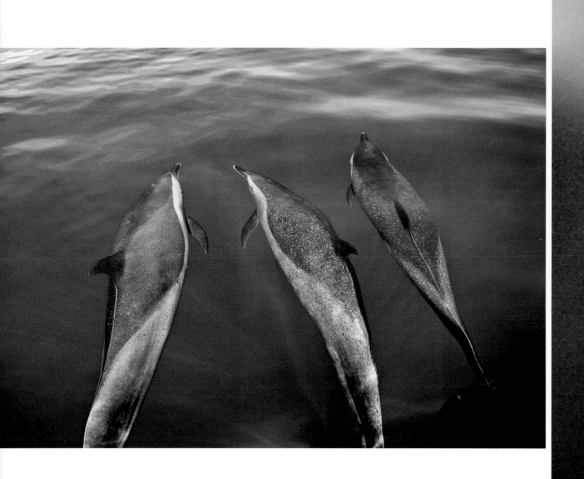

242 and 242-243  Pantropical spotted dolphins,
*Stenella attenuata*, swim below the surface off Hawaii.

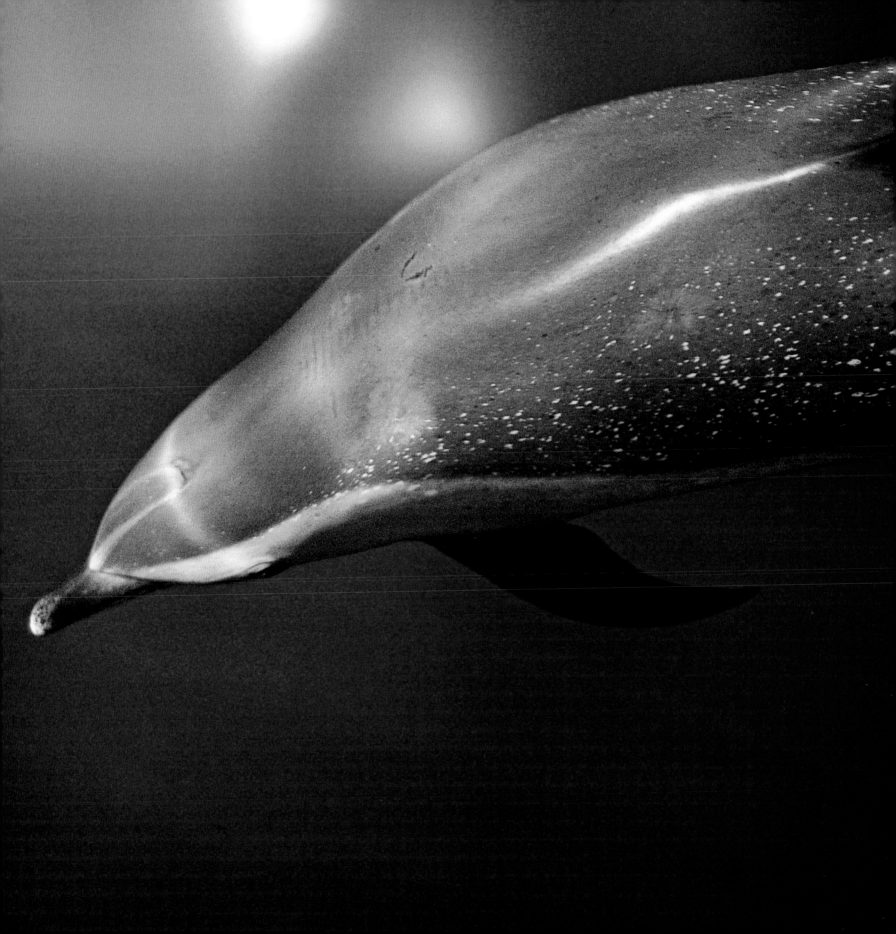

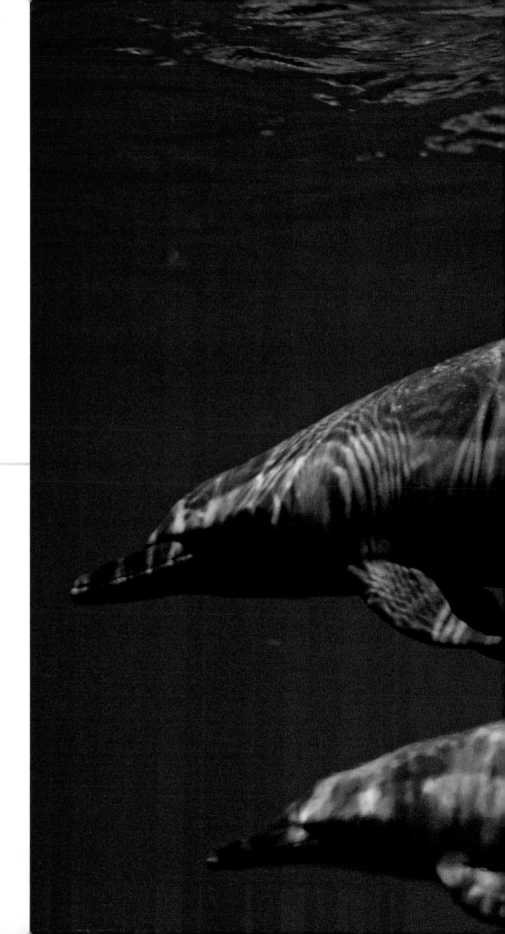

# SPOTTED DOLPHINS

## LIFE IN PERPETUAL MOTION

244-245  Spotted dolphins swim past the
author off Hawaii.

246-247  A pantropical spotted dolphin
investigates the author.

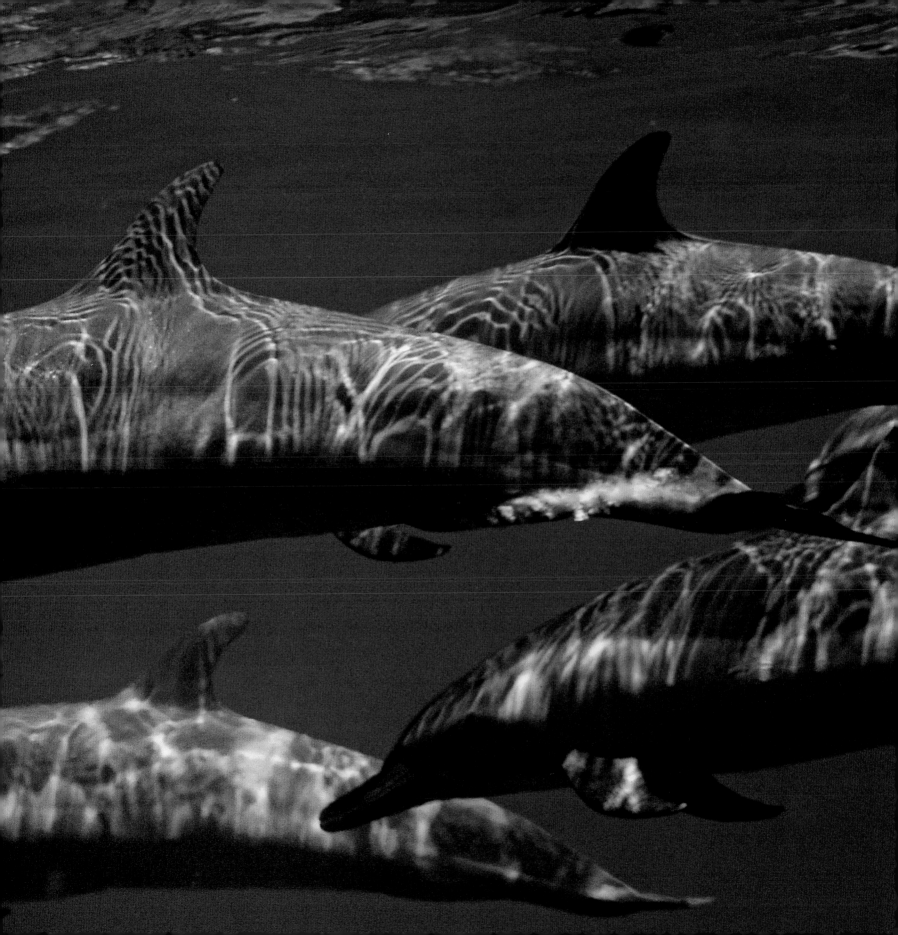

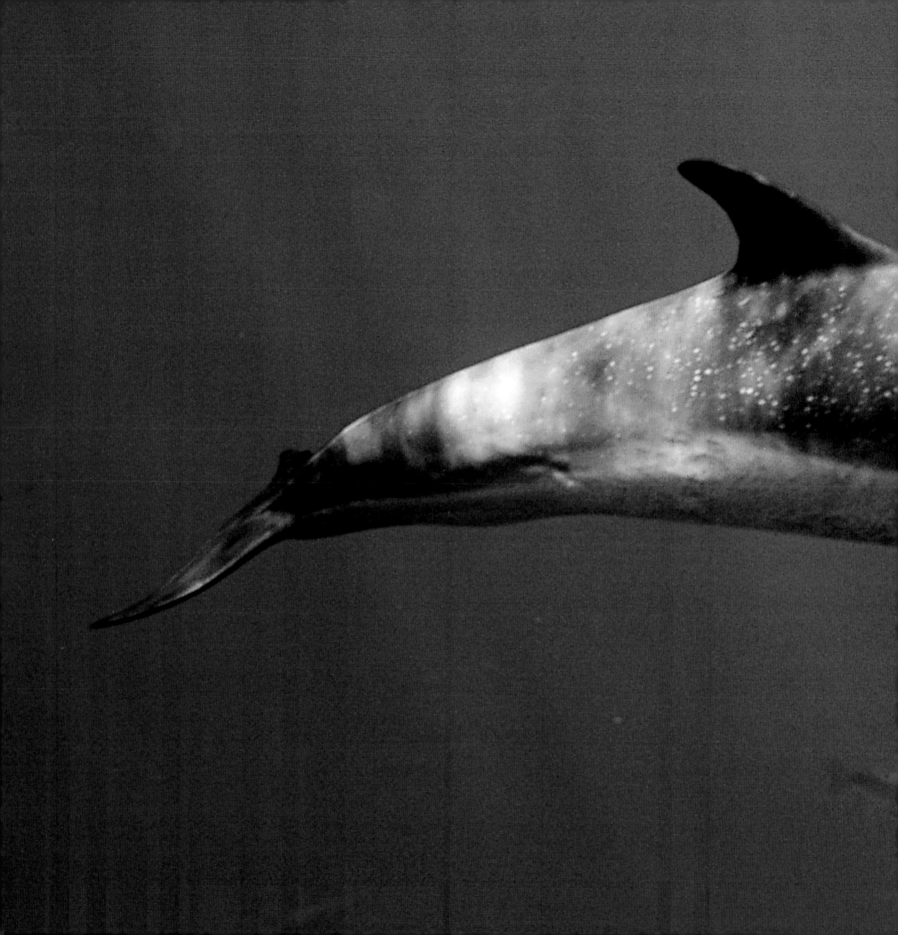

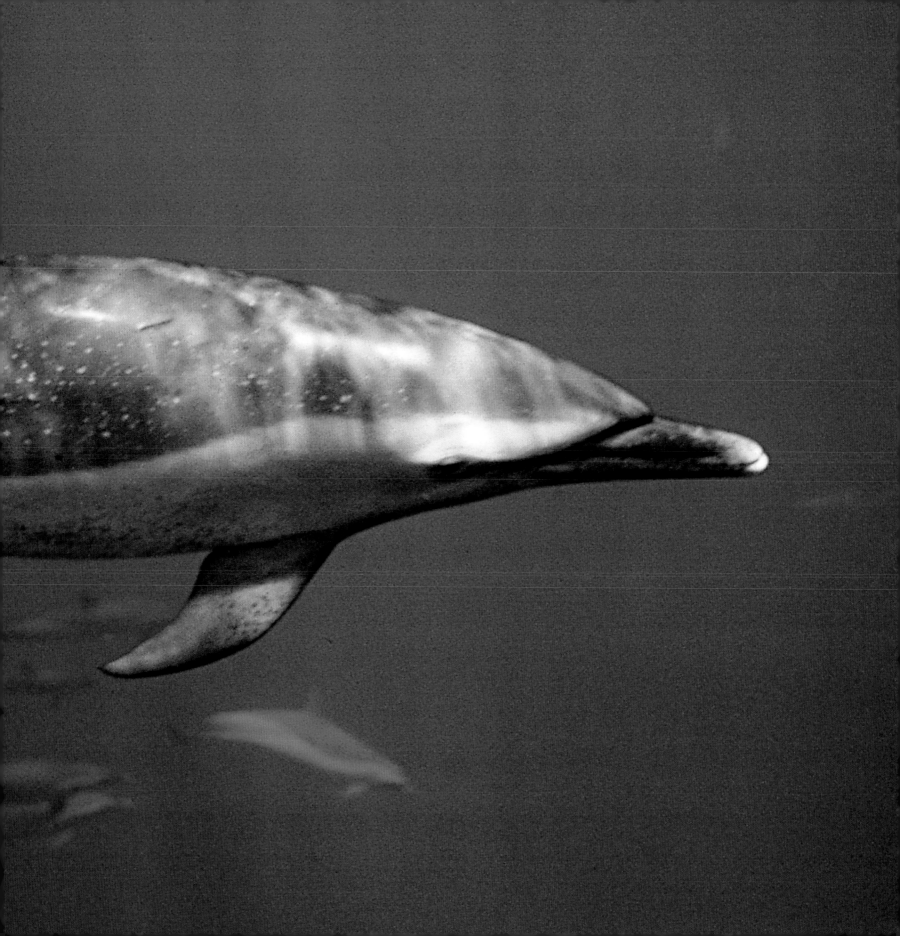

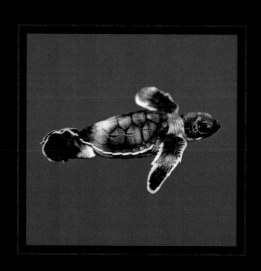

# SEA TURTLES

## BLUE ANGELS

# SEA TURTLES

## BLUE ANGELS

As Aesop would have us believe, turtles are slow moving, ungainly reptiles. His popular fable, the tortoise and the hare is all about a land tortoise racing a rabbit through the countryside. The tortoise ends up the surprise victor with the message being how a slow and steady strategy and a dash of perseverance can win the day and the race. Aesop did not know about sea turtles. Sea turtles are impressive swimmers. They sprint through their underwater world with bursts of speed and impressive maneuvers that would make any bigheaded hare drop its fuzzy jaw in awe. They have developed this swiftness underwater to avoid being eaten by predators. Sea turtles also swim through sand.

Imagine what it might be like being buried six body lengths down in sand on a remote turtle-nesting beach somewhere in the tropics. The nest your mother dug for you has been a safe, warm, moist, out of sight haven. You break through your "egg case," and now have to get yourself up through the compacted sand you have been buried in for over two months. You are only an inch or so long. How do you do that? You swim.

Sea turtle hatchlings are frenetic, compulsive swimmers. Their first swim is through these sands that have hid their presence from the world above. Once hatched they begin a hazardous journey through sand and sea to reach some relative safety offshore, beyond the waves and beyond the chaos of their natal beach and the near shore environment.

I once observed an entire nest of olive ridley hatchlings emerge from their haven. I was lying on a beach in Costa Rica at sunrise, watching the sun's rays strike the tops of curling waves splashing shoreward. In front of me there was a slight depression in the flat surface of sand. I noticed some movement so I stayed and watched. Almost imperceptibly, tiny grains of sand started to stir and tumble to the middle of the depression. The sand was collapsing down and inward within a small circle. Suddenly, there was a small head poking up. Then a tiny flipper. A second turtle emerged, then another and another. The sand suddenly collapsed into a small shaft filled with a mass of frantic sea turtle hatchlings "swimming" toward the surface. Hatchlings were popping up like popcorn, crawling over their nest-mates, struggling to get up and onto the beach. And as

248  Black green sea turtle hatchling.

251  Olive ridley hatchlings emerge into the light from the sands of Costa Rica.

they first emerged from the sand they moved their flippers as they would in the sea, with swim-like strokes. They flailed and flapped in the medium that surrounded them, sand, levering their way through it as if sand were water.

I saw maybe eighty-seven hatchlings emerge from this one nest that morning, a beautiful and rare sight in daylight. The gods were with me as I photographed and watched, almost laughing at my good luck.

The hatchlings took frequent and well deserved breaks. Some poked only their tiny noses out through the interface of sand and sky before resting to take their first sweet breath of pure beach air. But almost as soon as they stopped to rest, they started up again, headed off directly and without much hesitation towards the water's edge -- a sea turtle "no man's land."

Scientists warn us that only a painfully small percentage of hatchlings make it to adulthood. I do realize that if all the hatchlings that emerged from nests had made it to adulthood I would have bumped into a few more underwater over the course of my career, but until that morning, I didn't realize how truthful this warning really is. The gods were not with the baby turtles that day, but the frigate birds were. One by one, each and every olive ridley sea turtle hatchling I saw swim up out of the sand to crawl down the beach disappeared before my very eyes like tiny grains of sand thrown to the wind. In what appeared to be an effortless exercise, a small group of frigate birds swooped down and plucked young turtles from the beach. Frigate birds are supreme flyers and skilled predators with razor sharp vision and a keen sense for any feeding opportunity that emerges. Not a single turtle hatchling made it to the water's edge that morning, not one.

Months later, hundreds of miles north along a Pacific beach in Mexico, I photographed underwater baby sea turtles that were swimming beyond the surf line. They were black green hatchlings and the water was blue and clear. They swam with steady purpose, away from beach and pounding surf. After resting for a few seconds at the surface, they would dive straight down, level off at about 10 ft (3 m), and swim seaward.

The frigate bird experience and images were still in my mind as I dove down and began following these tiny black sea turtles. I realized how lucky they were to have come this far. A creature with so low a survival rate is almost an ephemeral object; here one second, gone the next. It seems as if everybody with a set of teeth or a beak is waiting along the beach, in the air, at water's edge, in the surf, out on the big open sea, waiting to eat it. I wanted somehow to evoke this "ephemerality" with my camera. I did so by slowing the shutter speed and having the tiny turtles move through the frame as I swam above them. To me, the images I made that day capture the delicate, extraordinary character of hatchlings that have made it to sea. They are tiny sea angels swimming in a great blue heaven.

253 Mating olive ridley sea turtles, *Lepidochelys oliveacea*, off Costa Rica.

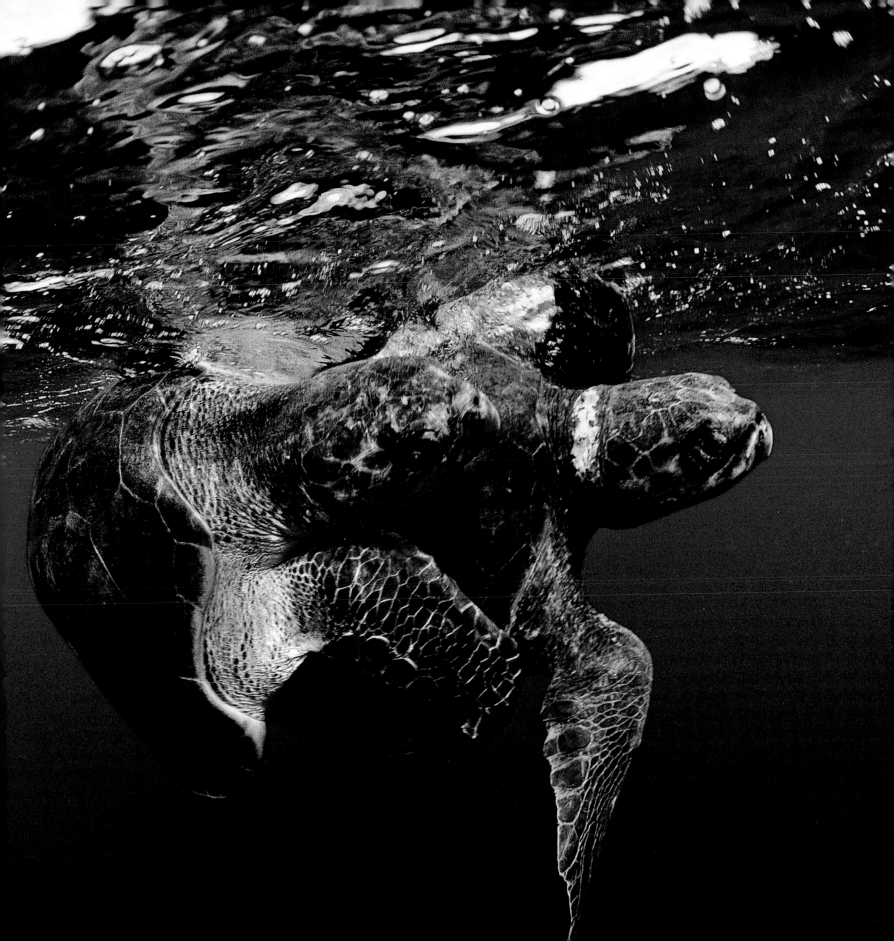

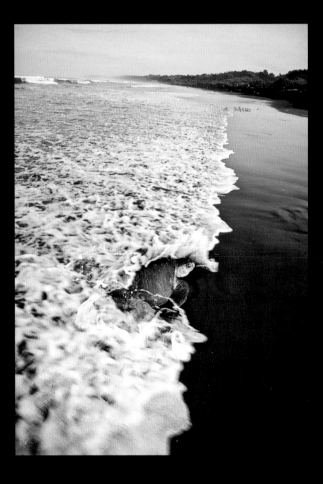

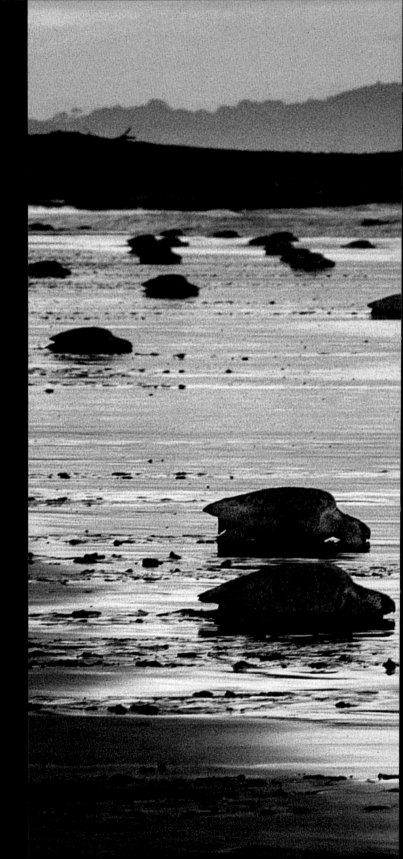

254 and 254-255  At a sea turtle nesting beach in
Costa Rica, olive ridley females emerge from the sea
to dig their nests.

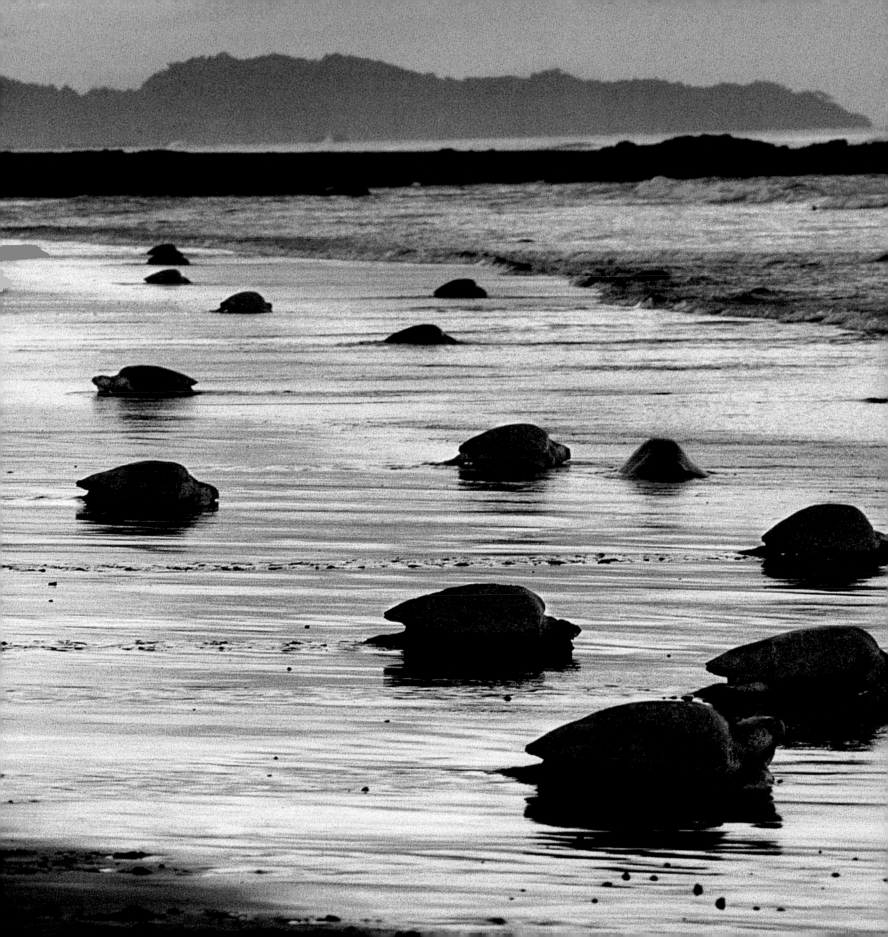

# The long journey home

256-257  Only the female ever returns
to dry land and the beach where she
hatched. Resting after hauling herself
up the beach at sunset, this olive ridley
sea turtle will dig her nest and lay the
eggs she carries inside herself.

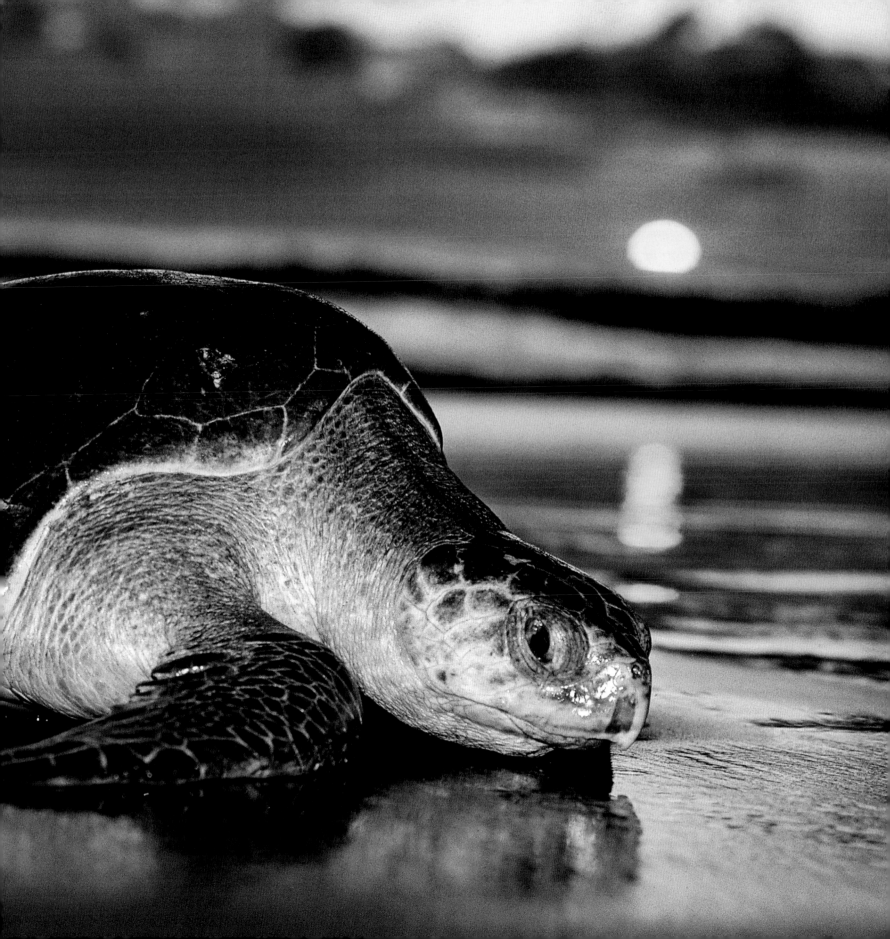

258  A female olive ridley turtle looks for a nest site, Costa Rica. Females carry over a hundred ping-pong-ball-sized eggs.

259  An olive ridley hatchling crawls toward the safety of the Pacific Ocean.

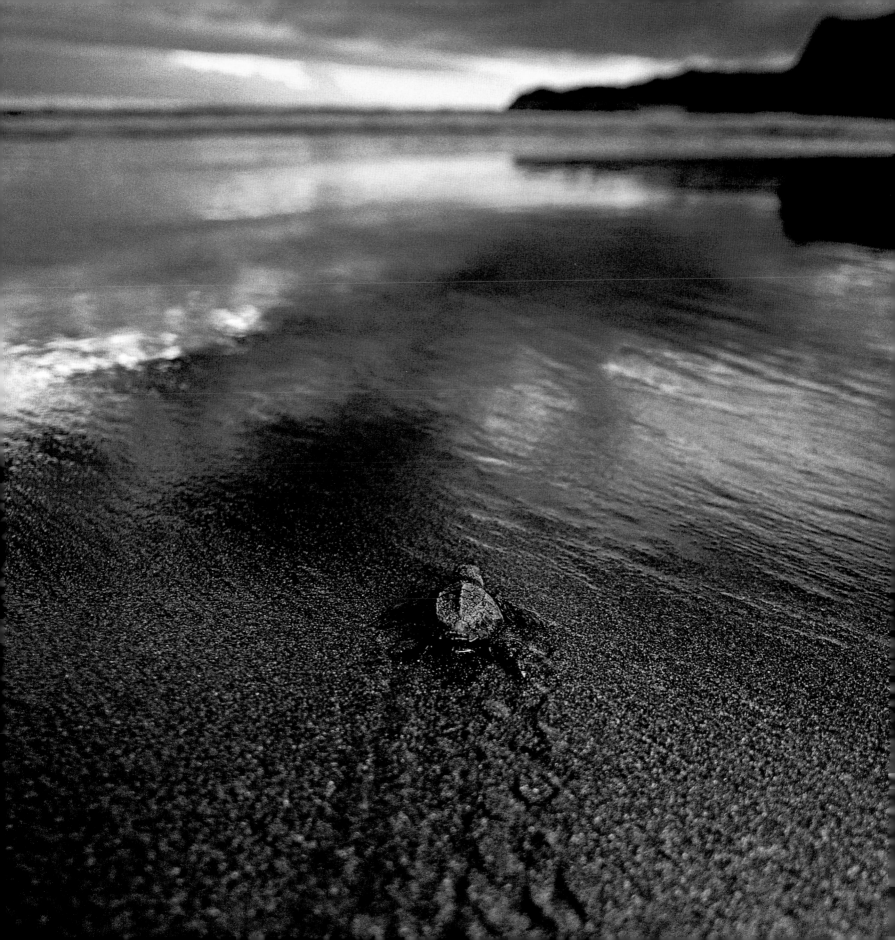

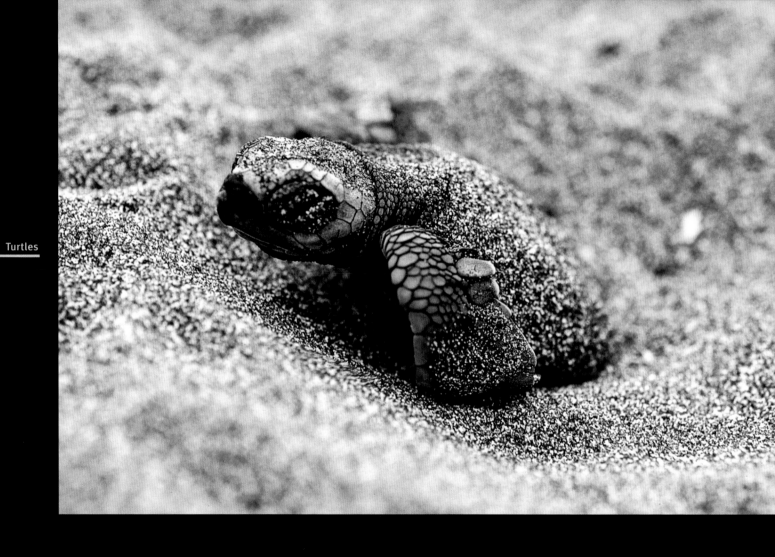

260 and 261  Olive ridley hatchlings emerge from their nest site on an uninhabited beach in Costa Rica. Breaking out of their shell and swimming up through the sands that have hid and protected them for over two months they now begin their most perilous journey to the sea.

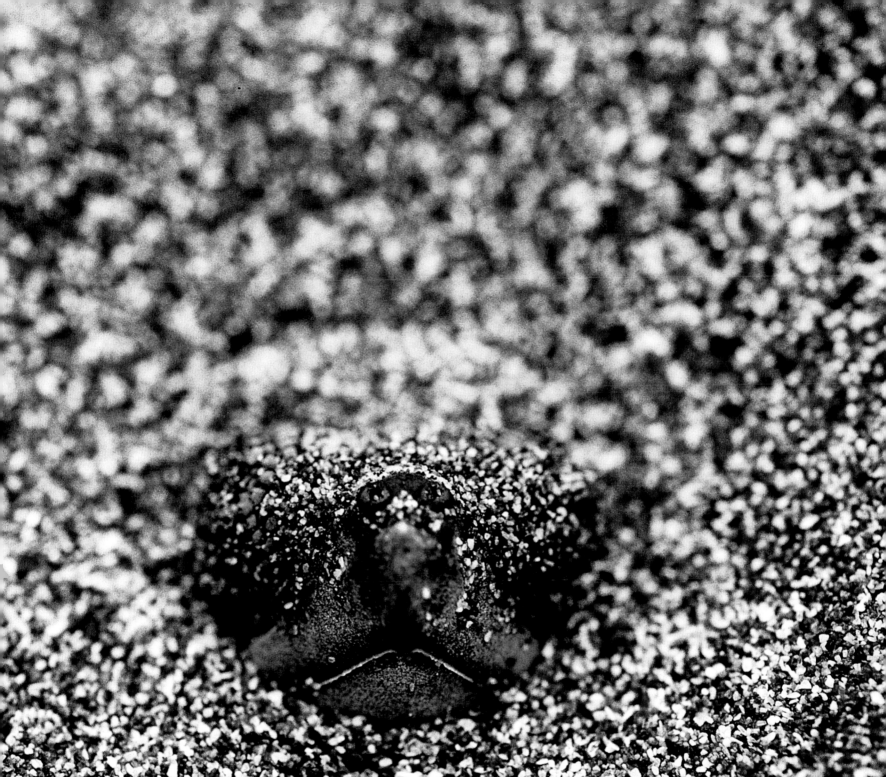

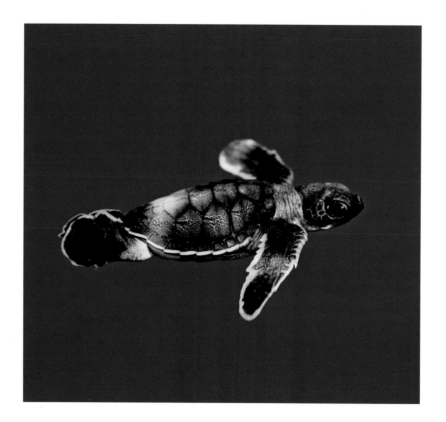

262  Black green sea turtle hatchling - my Blue Angel.

263  An olive ridley hatchling struggles to flip over and head toward the ocean after emerging.

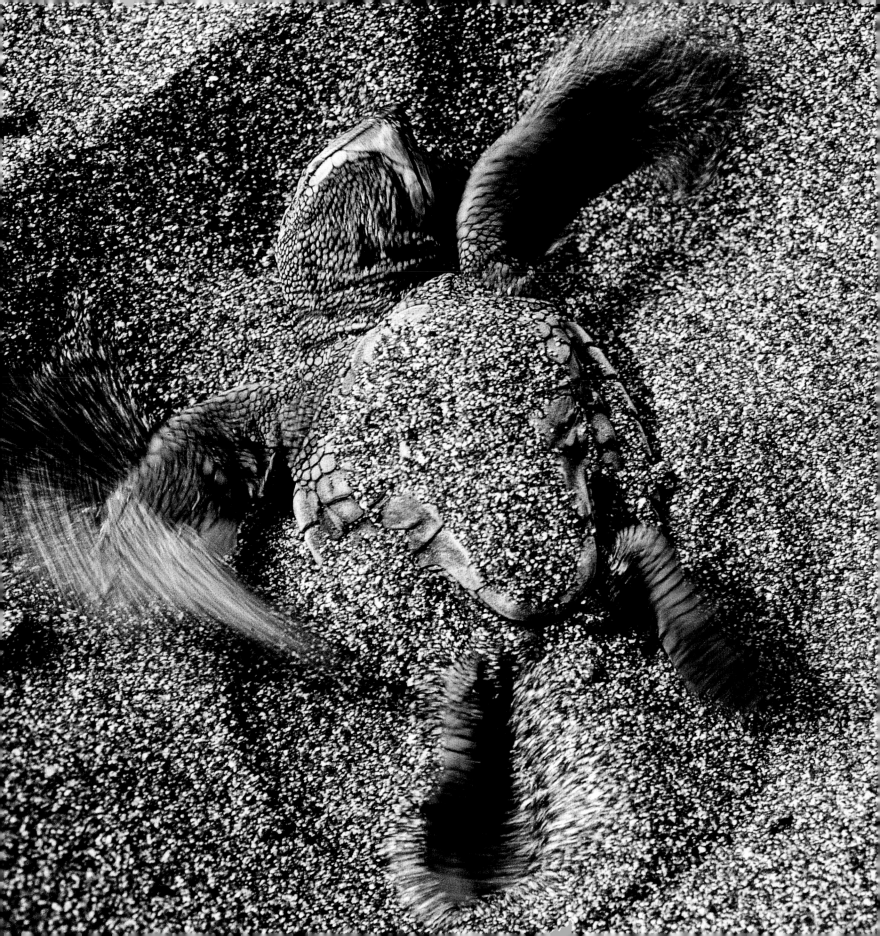

# LIVING IN TWO WORLDS
## TURTLES OF LAND AND SEA

264  Green turtles share a small sandy islet to bask with monk seals,
NW Hawaiian Islands.

264-265  Green sea turtle, *Chelonia mydas*, swims off Grand Cayman Island.

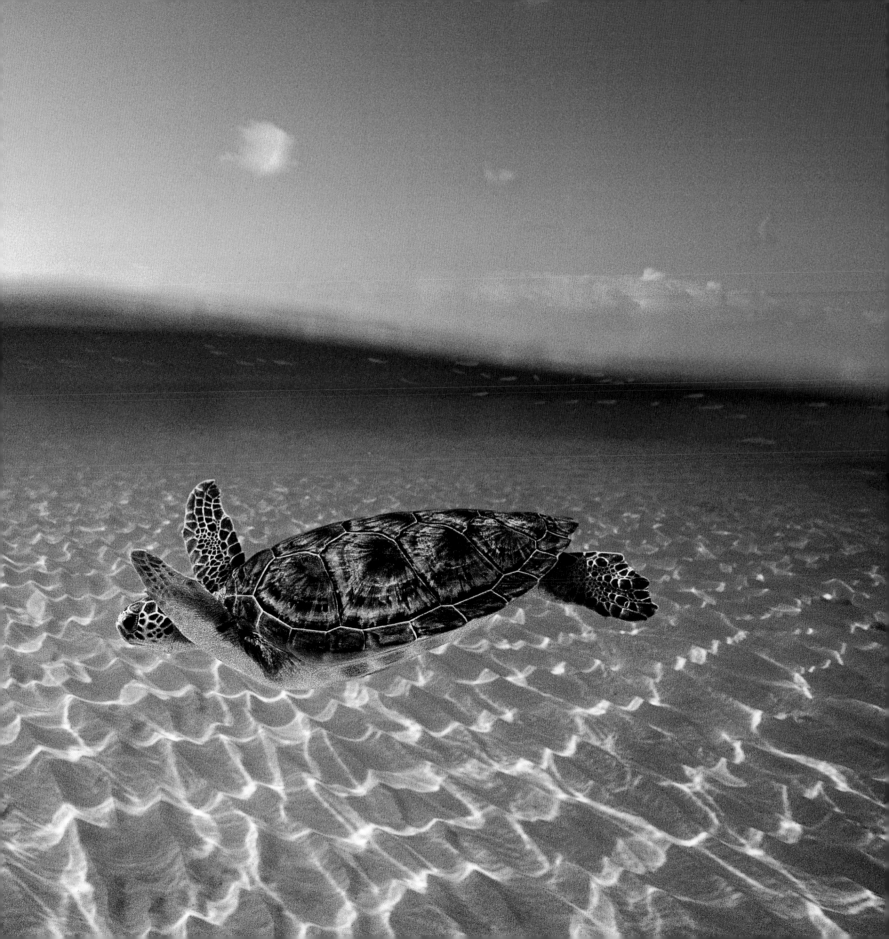

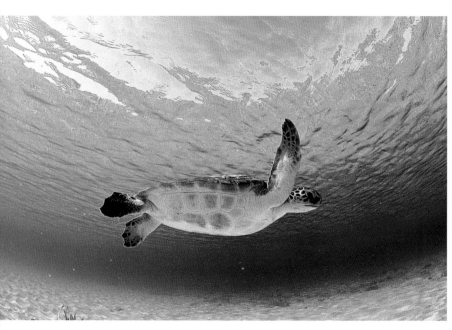

266 and 266-267  Green sea turtles swim near me, off Grand Cayman Island.

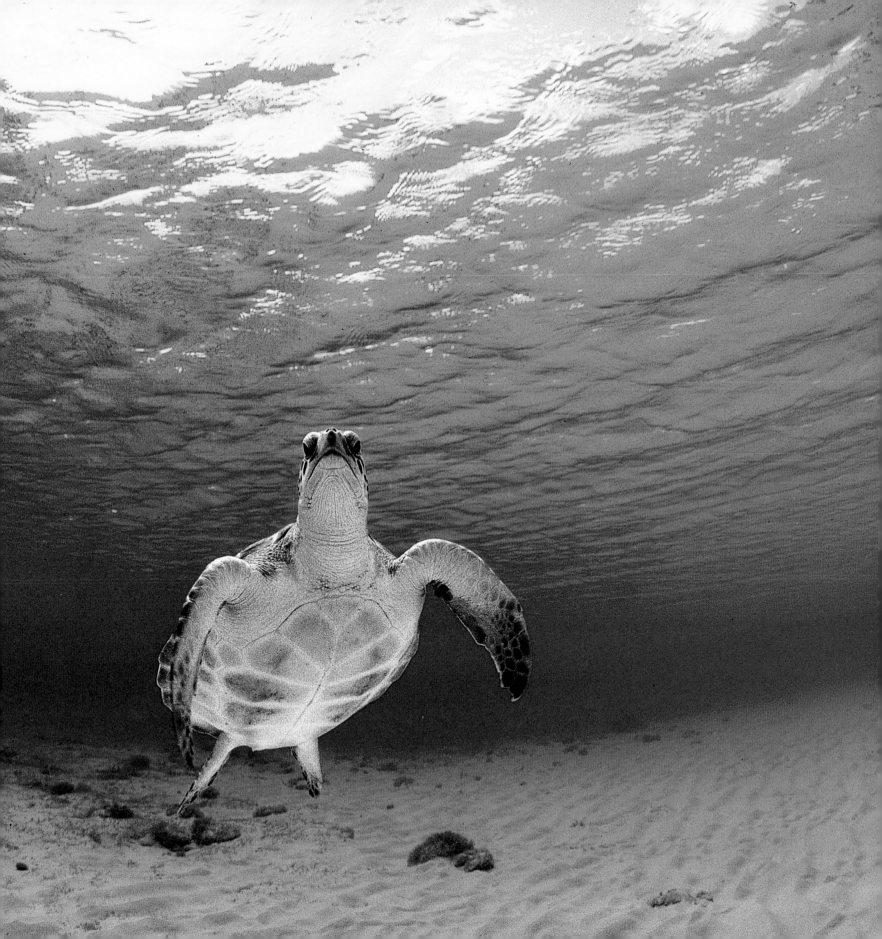

268-269  A hawksbill turtle,
*Eretmochelys imbricata*, swims
above a Caribbean reef.
The species' shells are so in
demand in making jewelry and hair
ornaments that its numbers and
survival are threatened.

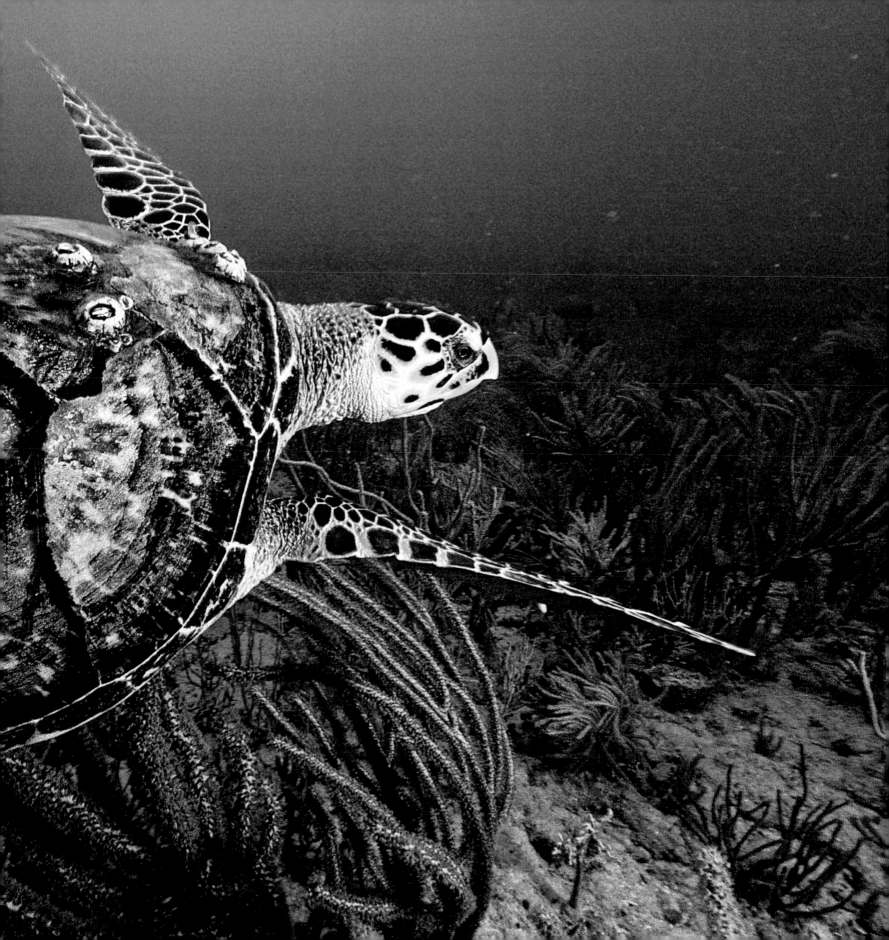

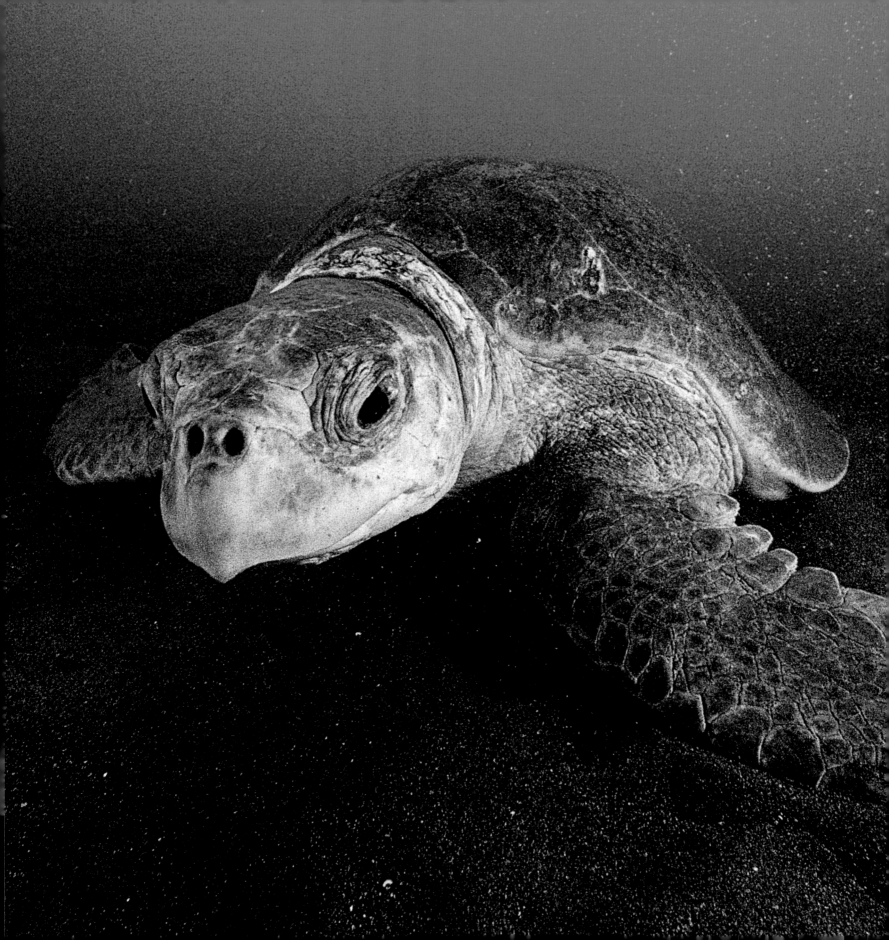

270-271  Lady in Waiting. A female olive ridley turtle 65 ft (20 m) underwater waits off her nesting beach for some unknown cue that will bring her ashore to nest with thousands of other females in a mass nesting instinct that the local Costa Ricans called *arribada*.

272-273  Mating olive ridley sea
turtles off Costa Rica. Mating
usually occurs offshore of the
nesting beach. Females can store
male sperm for use throughout the
breeding season.

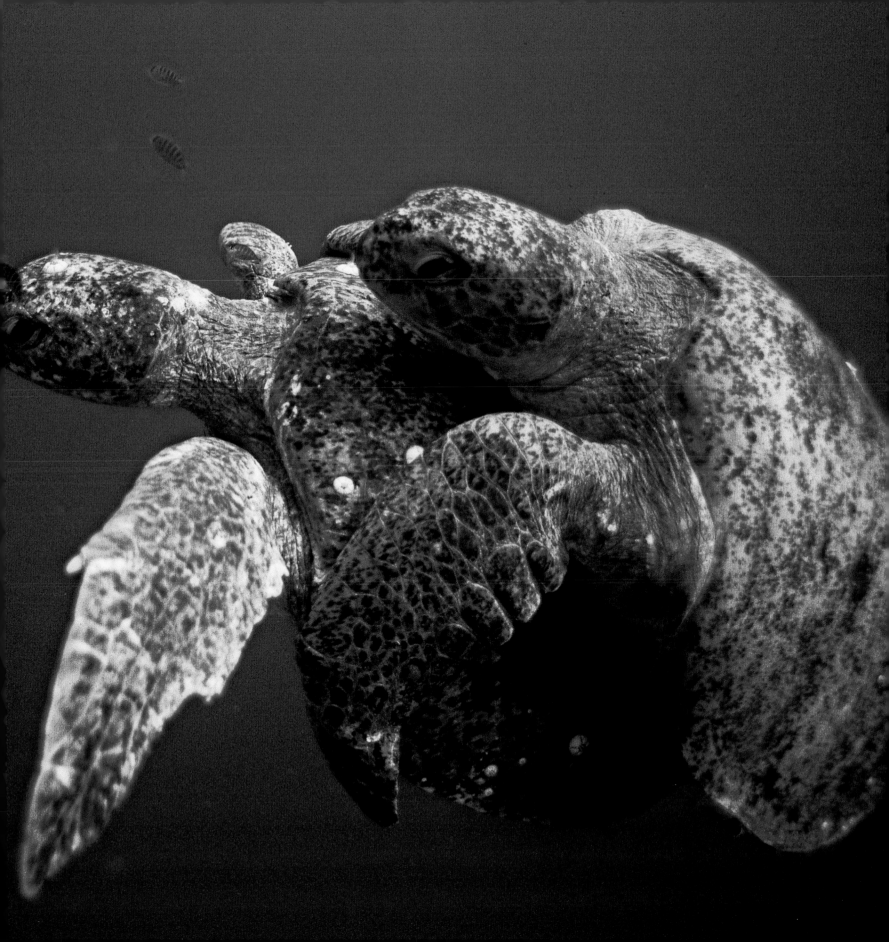

# Sea turtles mating

274-275 Olive ridley sea turtles come together off their nesting beach in Costa Rica. The female (right) is larger and the male, clasped to her carapace, rides along and mates.

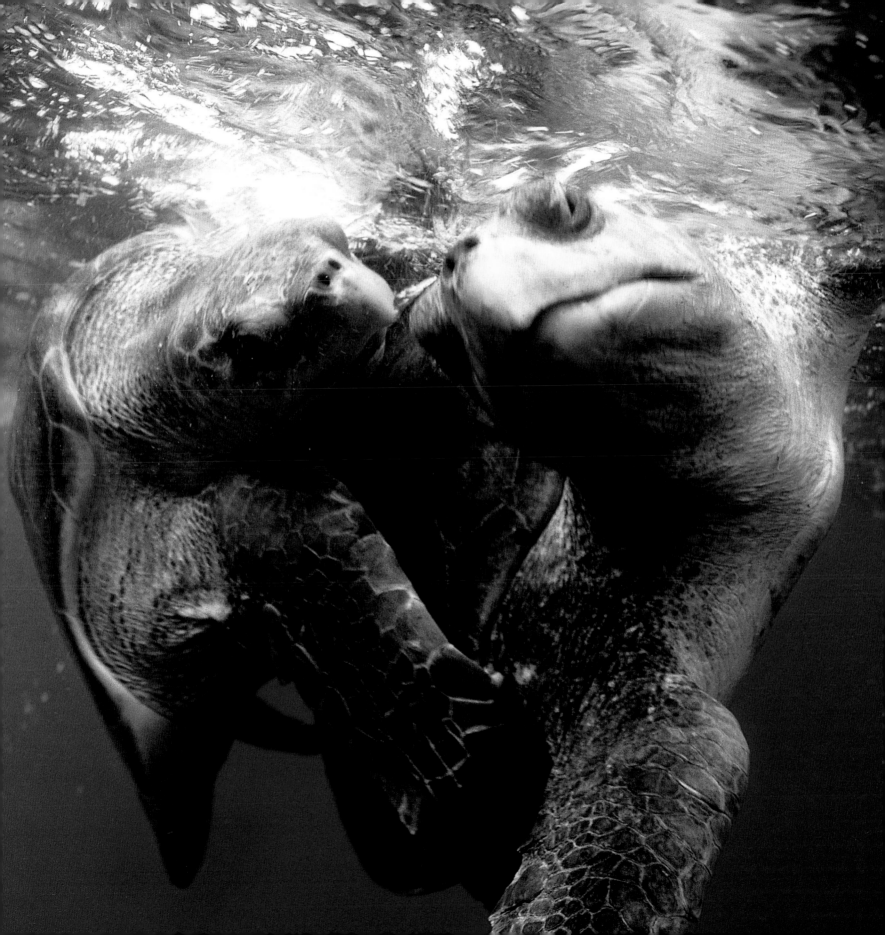

# THE GULF OF MAINE

## BRINGING DARK WATERS INTO THE LIGHT

I N THE WESTERN ATLANTIC, ALONG THE NORTHEASTERN SHORES OF THE U.S. AND EASTERN CANADA, THERE IS A BODY OF WATER CALLED THE GULF OF MAINE.

It is a biologically unique marine region with a surface area of about 37,200 sq. miles (60,000 sq. km). The Gulf of Maine is encircled by the Maine coast to the west and north, the Canadian province of Nova Scotia to the northeast, and the outstretched arm of Cape Cod to the south. It is a distinct body of water almost entirely enclosed by these land masses and their submarine extensions. Its nearness to the warm waters of the Gulf Stream, its broad expanse of glacially carved basins and channels, and the seasonally extreme water temperatures, makes this "sea within a sea," a unique and valuable bio-geographical region. The Gulf of Maine is best known by the fisherman who harvest its waters, the scientists who study its mysteries, and the divers who swim its depths. Historically the Gulf is one of America's most productive fishing grounds. Early interest in Gulf fishery contributed significantly to the settlement of North America. From offshore trawling, to lobstering, to fishing for cod, the Gulf has supported valuable fisheries for the region's inhabitants for two centuries. Over-fishing in the Gulf

of Maine has recently forced US and Canadian authorities to restrict the annual catch of ground fish.

In Downeast Maine where my home state meets the Canadian province of New Brunswick is one of my favorite dive spots in all the Atlantic, Passamaquoddy Bay and the Bay of Fundy. In some parts of the Bay of Fundy the water may rise and fall as much as 46 ft (14 m) each day. Diving in these conditions is both challenging and rewarding. The Bay's invertebrate community, especially animals that filter nutrients from the water column like shellfish and sponges realize, great benefit from living there. The tides are huge and so is the nutrient load they bring in. The submerged walls and outcroppings are covered in a complex and colorful community of benthic life: starfish, sponges, tunicates, gorgonians, hydroids and many other species. Water is a dynamic medium. No two waves lap upon any shore the same way, or in the same place. A school of fish is like the sea, ever changing, as fluid in motion as the medium they swim through. In English the word "school" means an institution for teaching and learning. It is also the word used to describe a group of like species of fish that are swimming or feeding together. A school of fish can be a group of ten or a group of tens of thousands of individuals.

276  Swallow Tail Lighthouse, Grand Manan, Gulf of Maine.

279  Gray seal, *Halichoerus grypus*, about to touch the author with its whiskers, *(vibrissae)*. Gulf of Maine.

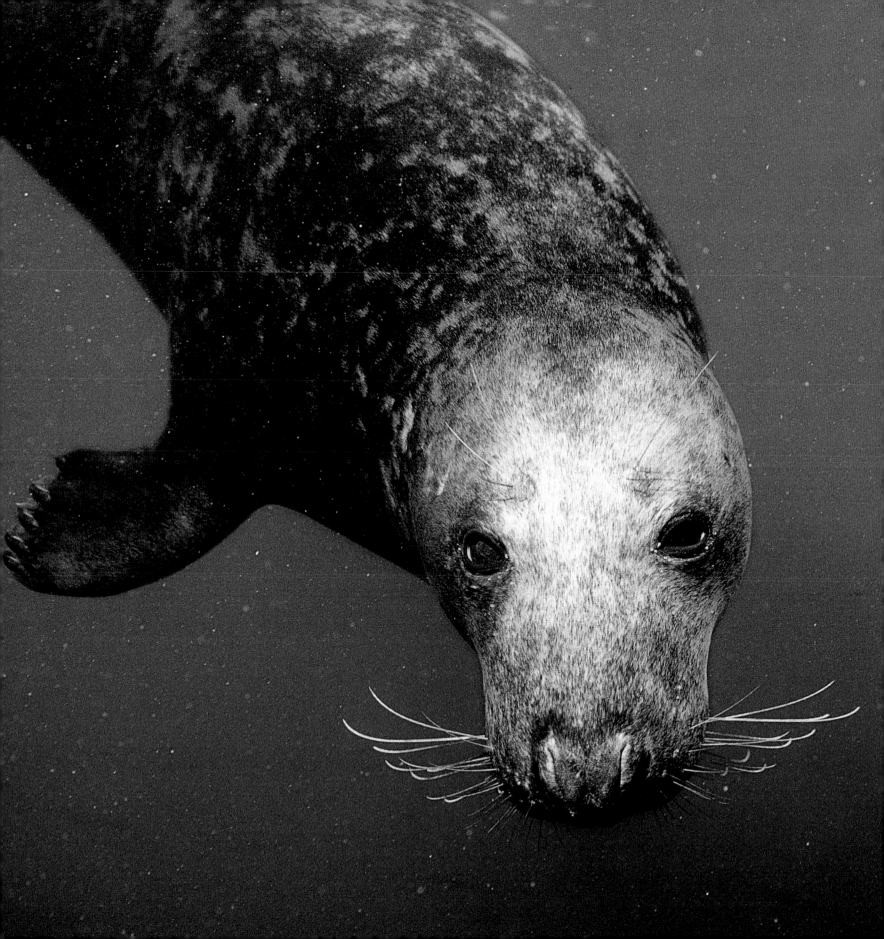

Over the course of my career, I have spent hundreds of hours underwater watching and photographing schools of fish. The number of fish in a school is sometimes beyond what is imaginable. One cannot help but be impressed with how a school comprised of so many individual fish moves as one. Disturb the edge of a school of fish and you create a ripple of silver bodies undulating in reactive concert throughout. It is almost as if the school of fish went to school to learn to move together as they do. The school often looks like some creature unknown to science. The school evolves into another organism, a collection of many individuals with a single purpose, and a life, and a beauty, all its own.

The main purpose for schooling behavior in fish is survival. Large numbers of fish swimming together help ensure survival of the species. Large numbers of fish with identical coloration and contrasting patterns make it more difficult for a predator to single out any one individual during an attack. To be sure, many individuals swimming at the school's margins fall to predation. On the other hand, many of these victims are often weak, old, or disabled individuals that are forfeited along the way for the good of the whole. These unlucky fish are sacrificed for the evolutionary higher claim -- survival of the species.

Atlantic herring are a key species to the Gulf of Maine. The most impressive school of fish I have ever seen was a gigantic school of Atlantic herring; they swim in very large schools made up of thousands, even millions of same-age-class fish. I have seen a herring school swim briefly alongside a boat, their huge numbers darkening the water as far as the eye could

see. I have seen enormous schools of herring represented on the sonar screen of a herring purse seiner. I have seen tons of those very same herring seined and trawled offshore and pumped into a fish hold.

Once while diving offshore in the middle of the Gulf of Maine on an underwater pinnacle called Ammen Rock, a large school of herring eclipsed the sun overhead. It suddenly became a dim dark sea. The school looked like one massive organism, pulsating and shifting this way and that, their silver flanks reflecting back the light from my underwater strobes as each individual fish kept its personal distance from the other fish around it. A million expressionless eyes stared back from the wall of fish above me.

Blue sharks visit the Gulf of Maine during the warm summer months. Blue sharks are the most beautiful of sharks I have seen. They have large black eyes and are named for the cobalt blue color that runs from nose to tail along their dorsal sides and down along their flanks. The blue melts away to a silvery white on their ventral side. Blue sharks are slim and very agile underwater.

Another summer visitor to the Gulf of Maine is the ocean sunfish, often called Mola mola. They are found worldwide in both tropical and temperate seas. An ocean sunfish is truly one of the oddest fish in the sea. They do not have a tailfin like most fish. They are relatively flat and shaped like an oval plate with long fins on the top and bottom placed anteriorly. Between the two fins at the rear where the tailfin should be is a structure called the clavus, which has small rounded projections that assist in maneuvering. They flap their long fins in alternate movements along the ver-

281  An ocean sunfish, *Mola mola*, swims in Casco Bay near Portland, Maine.

282-283  Gulf of Maine waves pound the rocky shore at Biddeford Pool, Maine.

tical axis of their bodies, more or less paddling their way forward. Since they often swim at or near the surface their dorsal fins can be seen moving side to side out of the water. One might think it is a shark until a close inspection reveals this odd looking silvery fish moving slowly just beneath the surface. Their skin is tough and leathery and their flesh is unpalatable. Ocean sunfish are harmless to humans and are not commercially valuable but are often taken as incidental by-catch by various fishing methods. Here in Maine they often become entangled in lobster trap gear and perish. They are known to eat plankton, small fish larvae as well as jellyfish and other gelatinous creatures drifting in the water column. Their bodies can measure over 10 ft (3 m) in length. It is always an exciting moment when you first see one underwater. Their eyes are expressive and as large as tennis balls. They follow your every move as you swim near them. They always seem to swim with their mouths wide-open. They seem unbothered by swimmers and divers and most of the time it is easy to keep up with one.

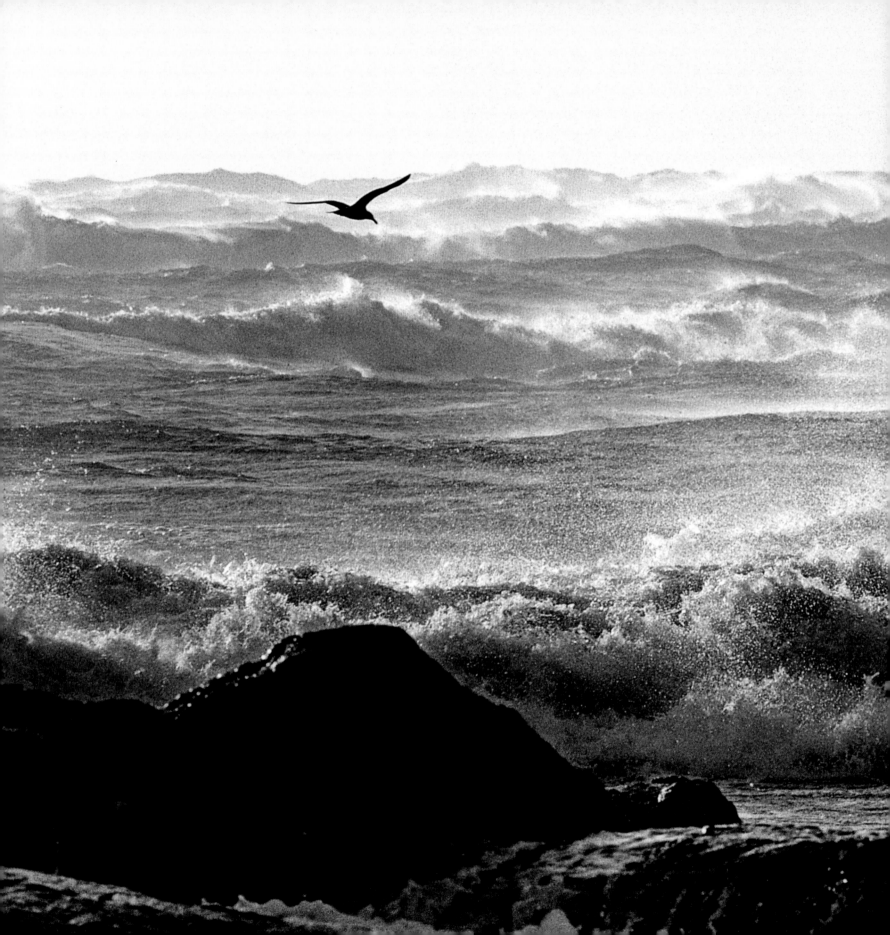

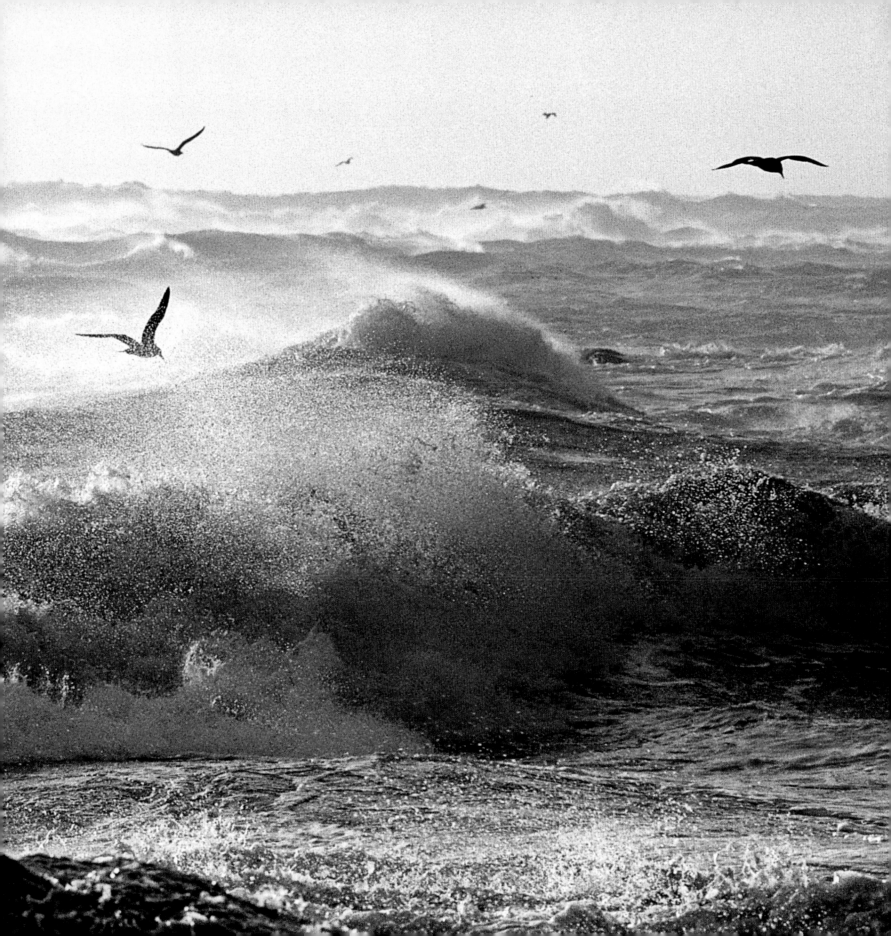

284 and 284-285  The pilot of the research
submersible *Johnson Sea Link*, maneuvers near
Ammen Rock, Gulf of Maine.

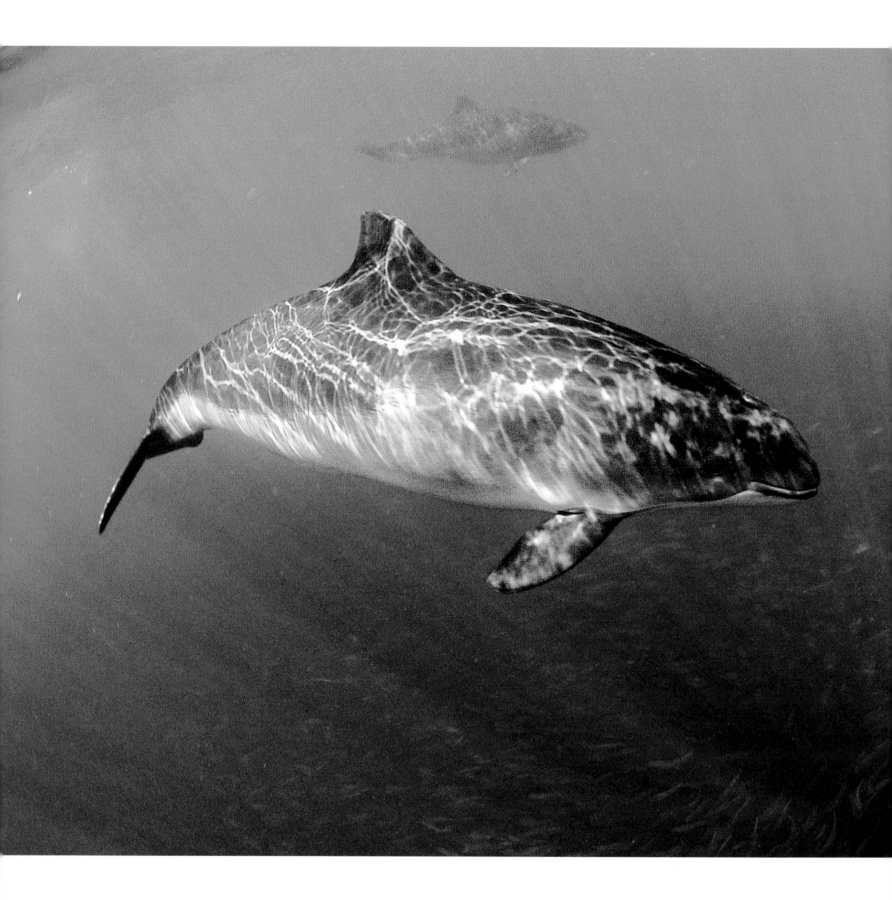

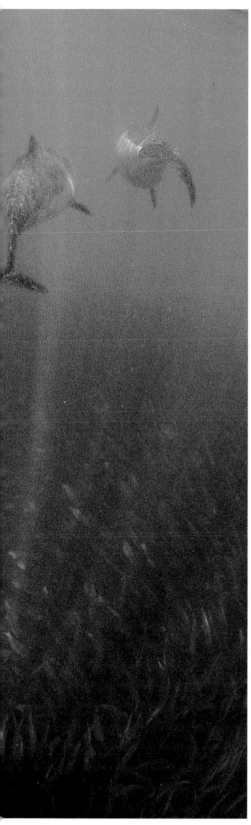

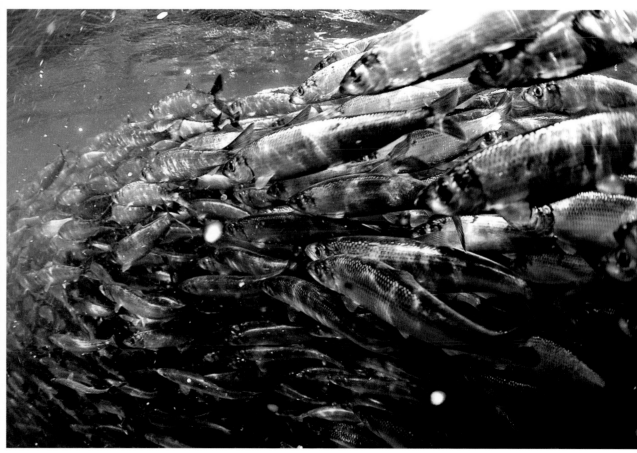

286-287  Harbor porpoise, *Phocoena phocoena*, also known as
herring porpoise, Gulf of Maine.

287  Herring in the Gulf of Maine. Herring, the most important fish
in the North Atlantic, swim in very large schools between their
spawning, feeding, and nursery grounds.

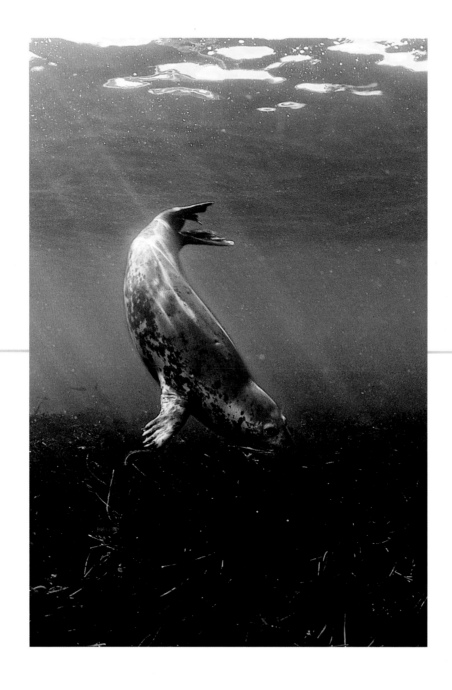

288 and 289  Grey seals, *Halichoerus grypus*, approach the author
underwater, Gulf of Maine.

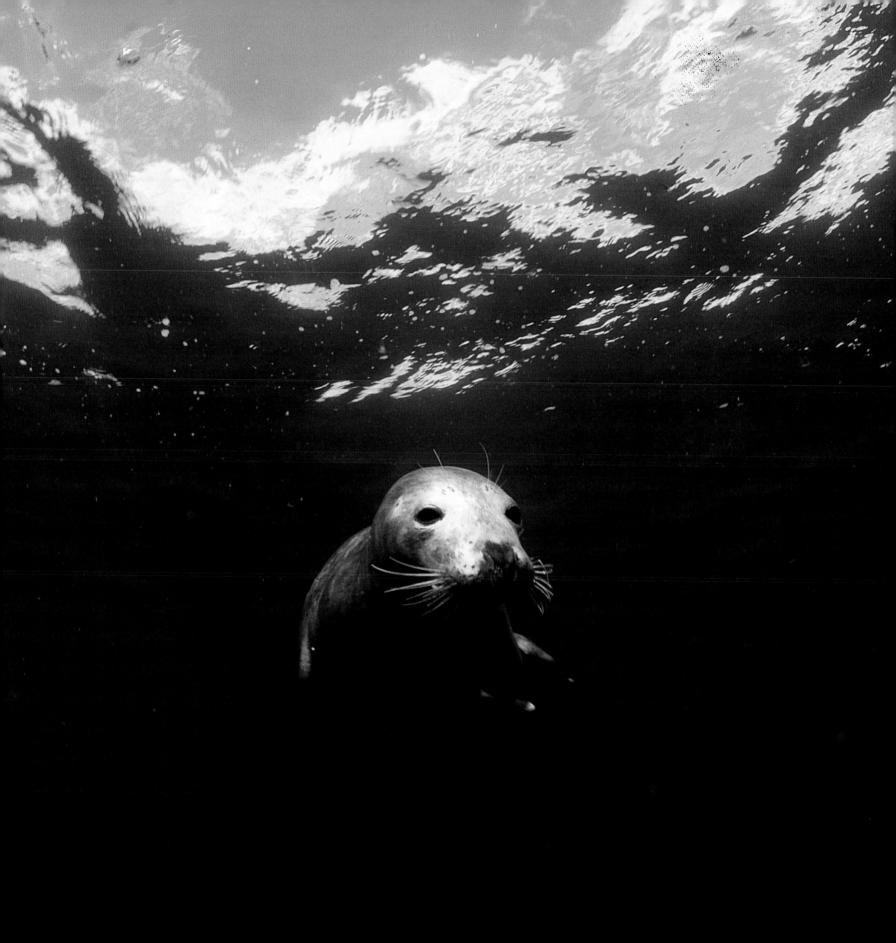

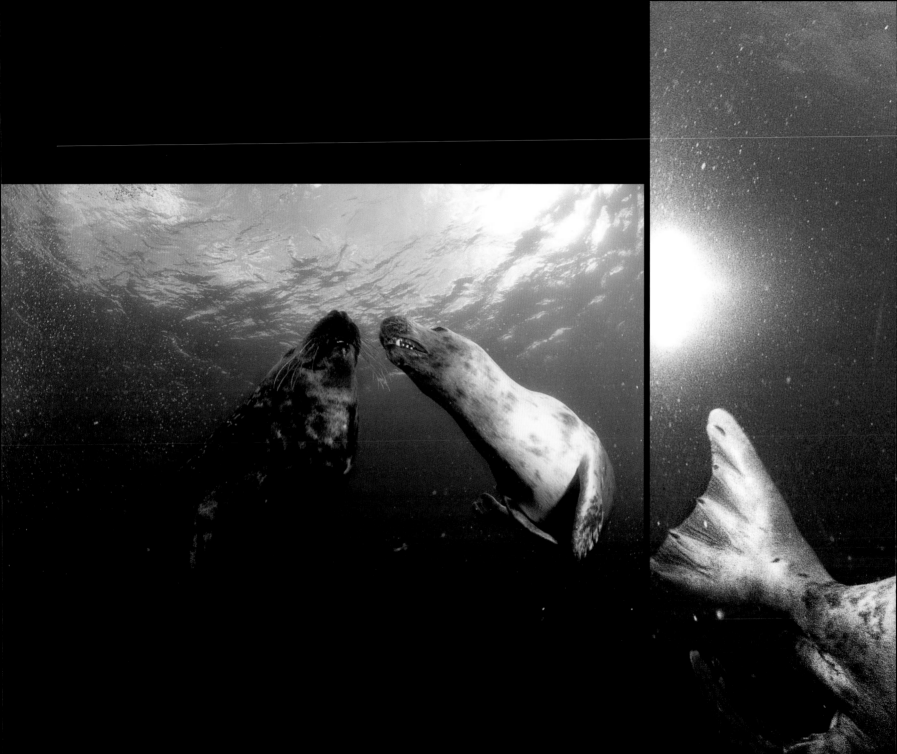

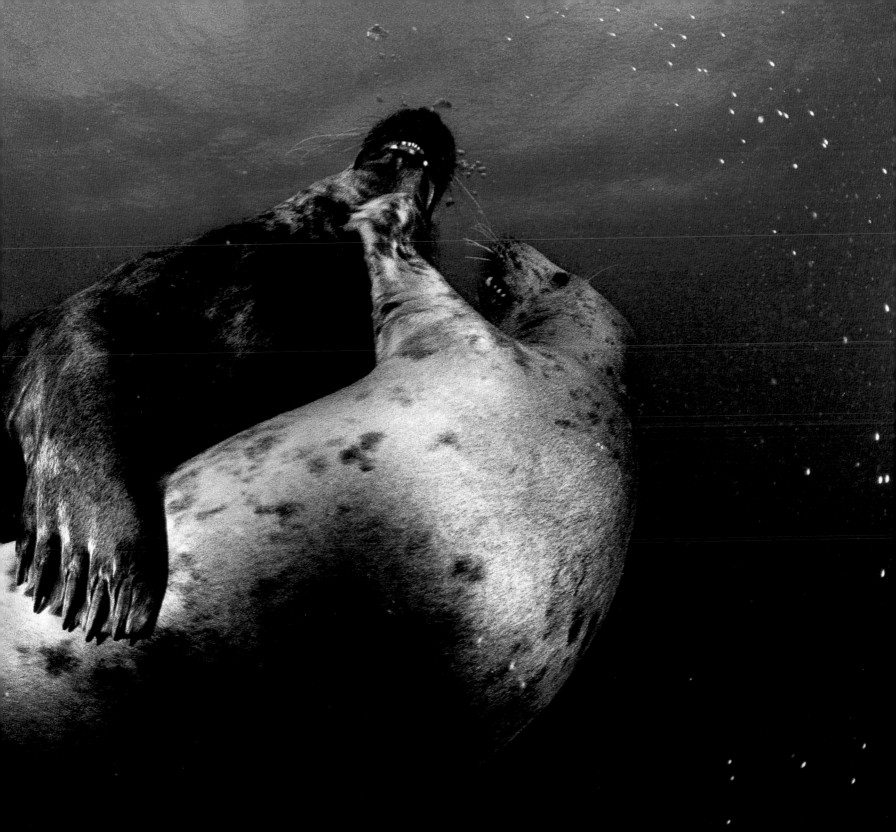

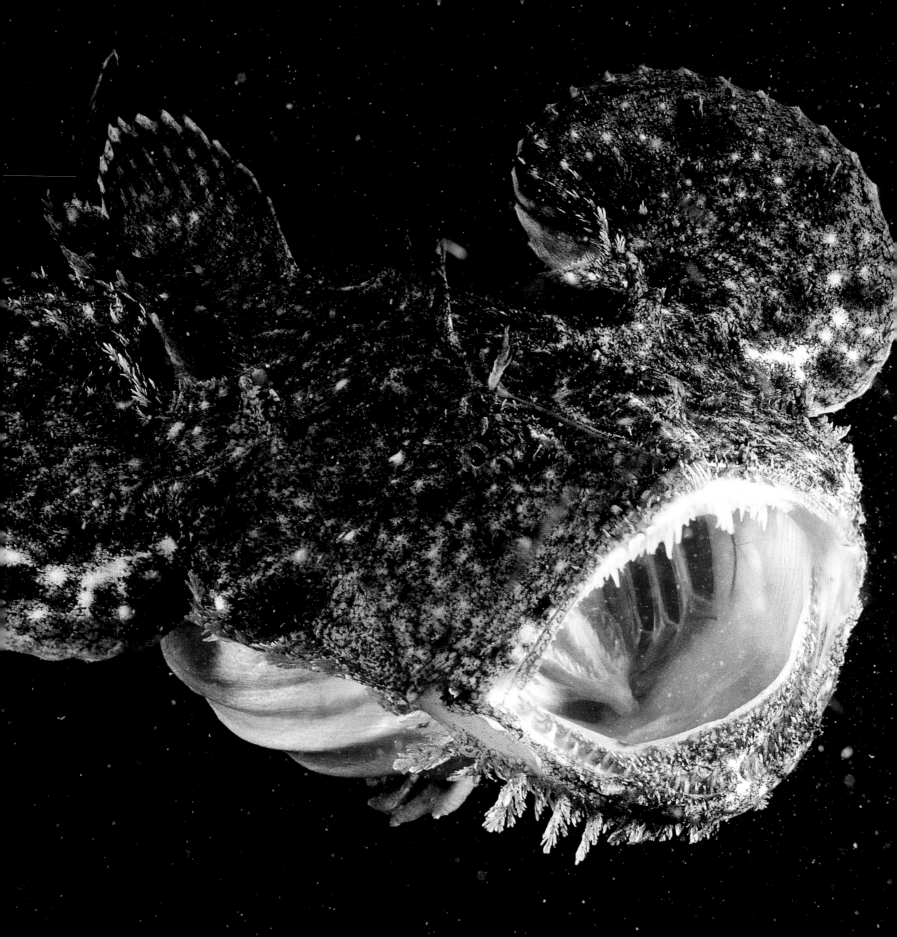

292 The goosefish or monkfish, *Lophius americanus*, is a bottom-dweller using an appendage on its head as a lure to attract
unsuspecting fish.

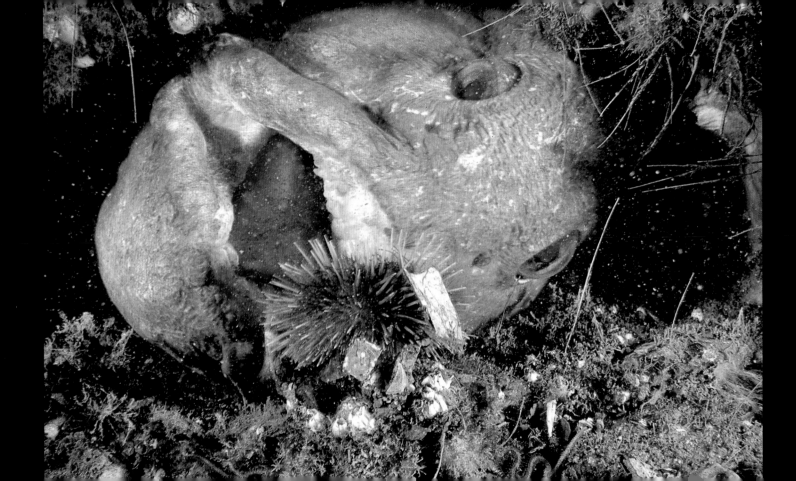

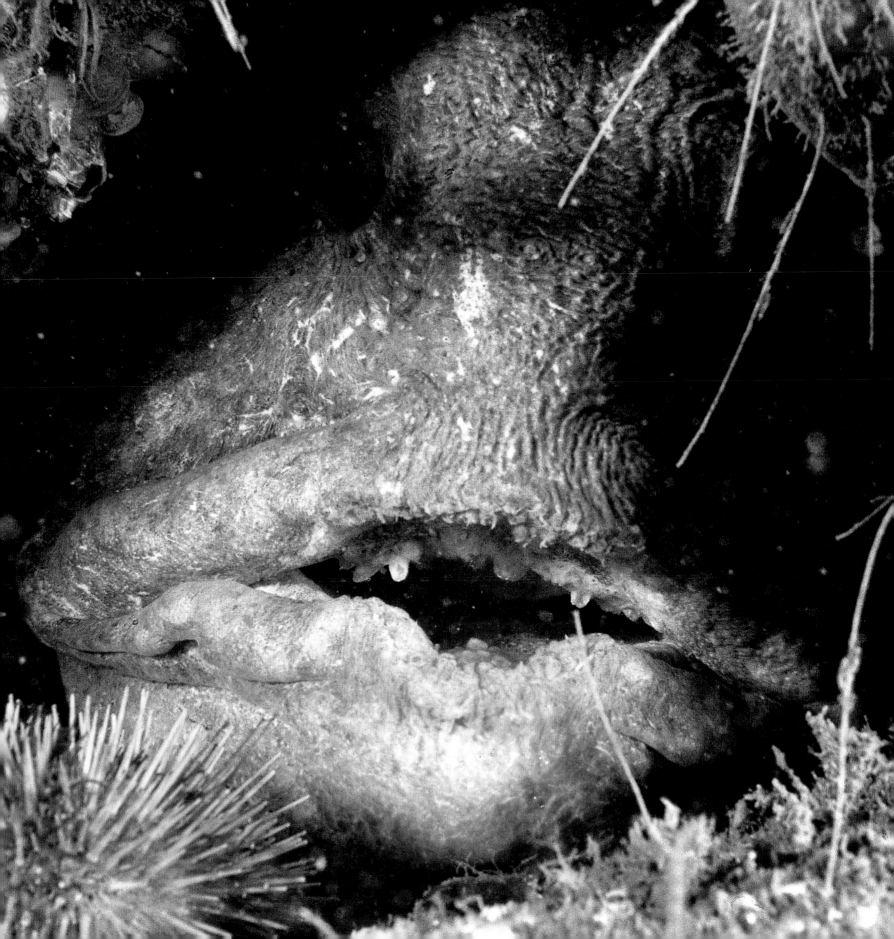

296 and 297  Sea Ravens, *Hemitripterus americanus*, Gulf of Maine. With their fleshy appendages, sea ravens easily blend in with seaweed and other benthic flora to hwelp avoid predators.

298  Winter skate, *Raja ocellata*, Gulf of Maine. This bottom feeder is well camouflaged, blending into the surrounding rocks and algae to avoid predators.

298-299  Rock crab, *Cancer irroratus*, Gulf of Maine.

300  Red-gilled nudibranch *Coryphella browni*, Nudibranchs are shell-less mollusks.

301  Rock gunnel, *Pholis gunnellus*, entwined around orange tunicates, *Halocynthia pyriformis*, Gulf of Maine.

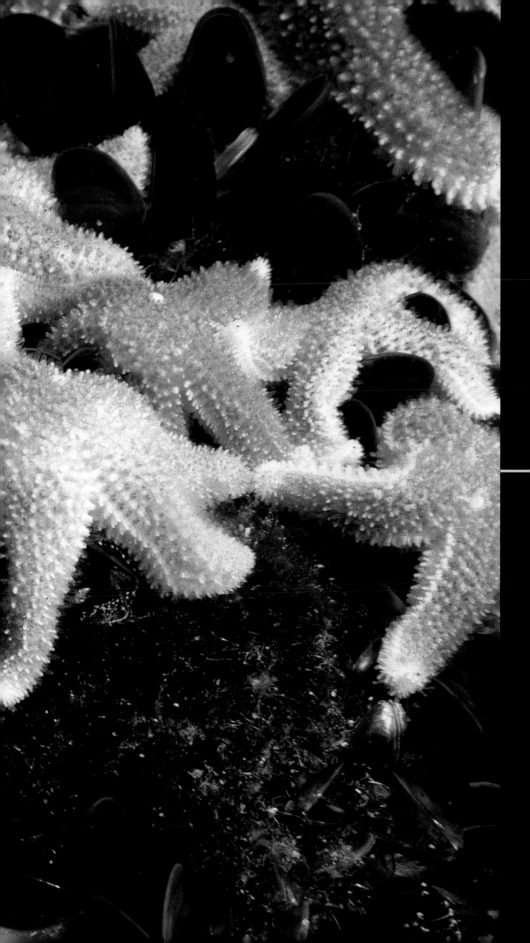

302-303  Forbes sea stars, *Asterias forbesii*, swarming to eat barnacles, Gulf of Maine.

304-305  Stalked tunicates, *Boltenia ovifera*, in a large bed near Eastport Maine. Tunicates are filter feeders filtering nutrients from the water.

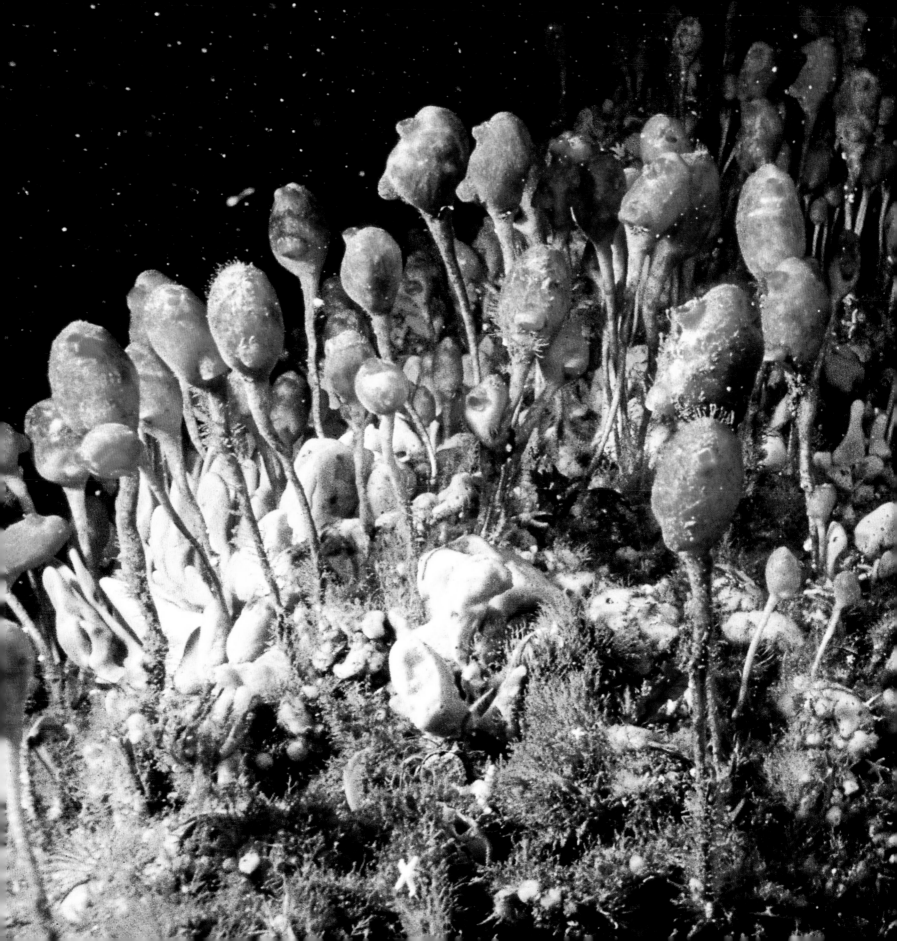

# BIKINI ATOLL

## RETURN TO LIFE

# BIKINI ATOLL

## RETURN TO LIFE

I F YOU WERE TO FLY OVER BIKINI ATOLL IN THE MARSHALL ISLANDS, IT MIGHT LOOK TO YOU LIKE ANY OTHER ISOLATED ATOLL IN THE NORTHERN PACIFIC. YOUR EYES WOULD BE DRAWN TO THE SLOW MOTION OF QUIET WAVES BREAKING ON THE OUTER REEF EDGE.

The lagoon floor would appear an emerald green while the outer reef spills down into the tropical, cobalt blue depths. You would see many submerged coral pinnacles that reach up toward the surface all across the lagoon. You would see green coconut forests on the larger islands, and pristine white beaches and sand bars exposed by the tide. You would see channels, reef flats, the reef front, spur and groove zones, the outer reef slope, and drop-offs. You would see the beautiful necklace of islands, sand and reef that comprise and define an atoll. You would also see Bravo Crater. It is a perfect circle, carved into the sand, over a mile in diameter and filled with water. Where there should be three islands -- Bokbata, Boklokoaton, and Boknejun, flora and fauna and a thriving coral reef, you would see from the air this perfect circle of nothing but deep, blue water. At 6:45 AM on March 1, 1954, an experimental thermonuclear test was conducted at Bikini Atoll. The bomb was one of more than 23 nuclear devices deto-

nated at Bikini between 1946 and 1958. The test was code-named Bravo. The bomb was placed in the northwest corner of the atoll near the three islands of Bokbata, Boklokoaton, and Boknejun. US government scientists thought the yield from the Bravo blast would be somewhere between 3 and 5 megatons--certainly no more than 8 megatons, at least that is what they thought. The Bravo blast turned out to be a thousand times more powerful than the bomb that destroyed Hiroshima. With a yield of 15 megatons, it was the largest nuclear detonation in the history of the U.S. Weapons Testing Program. The Bravo blast was called a mistake. It vaporized the three islands and their surrounding reef. I was eight years old the morning of the Bravo test at Bikini. I can remember my parents watching the black and white television news, and I remember seeing shots of the nuclear cloud over Bikini. I was incapable of understanding what this news really meant, but I remember wondering where all the fish went, and if were they able to hide. Nine years earlier, in July 1946, two atomic tests code-named "Operation Crossroads," were conducted on a fleet of 73-target ships anchored in Bikini Lagoon. Naval analysts were eager to find out what effect an atomic blast would have on an assembled fleet of ships. The doomed vessels had survived

306 WW II U.S. submarine *Pilotfish*, sunk during 1940s atomic-era testing, Bikini Atoll.

309 A concrete bunker on the east side of Bikini Atoll housed instruments used in the thermonuclear test days.

311  Yellowfin goatfish, *Mulloides vanicolensis*, gather at a large coral mound, inside Bukini's lagoon.

312-313  With large coral formations below, the main island of Bikini looms above the waves.

close their thick shells to "hide." Perhaps they survived it all. I don't know about the fish. One wonderful moment, and perhaps my best Bikini memory , occurred underwater one morning near the end of my trip. I was surrounded, completely encircled; by the largest school of bigeye trevally jacks I have ever seen. It was a giant sweeping mass --thousands of individual fish. They eclipsed the sun. My dive assistant Eric Hiner, disappeared from view. He told me later that all he could see of me was a stream of bubbles slowly rising from the top of a swirling carousel of fish. I remember watching all those silver bodies circling, all the eyes on me, a wall of living flesh and muscle, swimming, twitching and glimmering in concert.

In that moment, I was at the epicenter of whirling life, right there at ground zero. I remember thinking for the first time, nature has prevailed, and nature has won. In spite of that mile wide circle in the sand in the northwest corner of Bikini atoll, the ebb and flow of this natural world has somehow survived and managed to triumph.

many World War II naval battles. Their participation in "Operation Crossroads" sealed their fate. The two atomic bombs sank ten major ships: U.S. aircraft carrier *Saratoga*; the Japanese battleship *Nagato* and U.S. battleship *Arkansas*; destroyers *Anderson* and *Lamson*; Japanese cruiser *Sakawa*; transports *Gilliam* and *Carlisle*; and submarines *Apogon* and *Pilotfish*--both Pacific wolf-pack prowlers. Several of these ships had distinguished naval records. The *Saratoga* had survived two torpedo attacks and five kamikaze aircraft. The *Nagato* had been Admiral Yamamoto's flagship during the attack on Pearl Harbor, and was the last Japanese battleship afloat at war's end.

The Bikini Atoll's underwater graveyard of World War II relics provides a rare opportunity for well-trained and experienced divers. It is the only place one can see an entire aircraft carrier underwater. The *Saratoga* sits upright on the lagoon floor, her flight deck at 100 ft, with Helldiver aircraft and 500-lb. bombs on the hangar decks below. She must be one of the largest intact shipwrecks in the world. Divers can carefully explore the *Saratoga's* island and superstructure. A few compartments, including the navigational bridge can still be entered.

The *Nagato*, rests upside down, her giant hull with four screws pointing toward the surface. You can still see the bridge, now crumpled, where Yamamoto must have paced nervously back and forth waiting for the radio transmission from one of his Pearl Harbor pilots.

My favorite wreck dive at Bikini was on the US submarine *Pilotfish*. The boat was submerged for one of the Crossroads tests, and positioned very close to ground zero. She lies upright on the lagoon floor in about 170'

of water. She is smaller than the other wrecks so the scene is more intimate. You see more. You can swim off to one side and get an eerie view of most of the sub's length. There is always a swarm of fish around the sail and the 20mm gun seems to point defiantly towards the surface, as if still poised for incoming aircraft.

Fortunately, the bleak underwater landscape of Bravo Crater does not represent the entire underwater world of Bikini. Possibly one of the most exciting spots I have ever been underwater, Bikini is a place where you can dive unexplored terrain, seeing young reefs and natural life, undisturbed for nearly fifty years. The question I have been asked above all others since my first trip to Bikini is "Do you glow in the dark, Bill?" The question is not a serious one, and the answer is, of course, no, at least not yet. Since the days of weapons testing at Bikini, the contamination once present in the marine environment has been diminished by the exchange of lagoon water with the open Pacific around it. After years of sediment sampling by scientists, it has been determined that there is no current danger from any radioactive element in swimming or diving in Bikini waters.

In several weeks of diving all over Bikini lagoon, I had many rare and wonderful moments with marine creatures big and small, meek and wild. Some of my favorite creatures were the giant clams nestled in the reefs all over the lagoon. Giant clams are fairly abundant and some individuals are extremely big; so big that even in the relative "weightless" conditions underwater they are impossible to budge. I don't know much about the life span or growth rates of giant clams, but I wonder if some of them managed to live through the 23 nuclear tests conducted at Bikini. Clams have only to

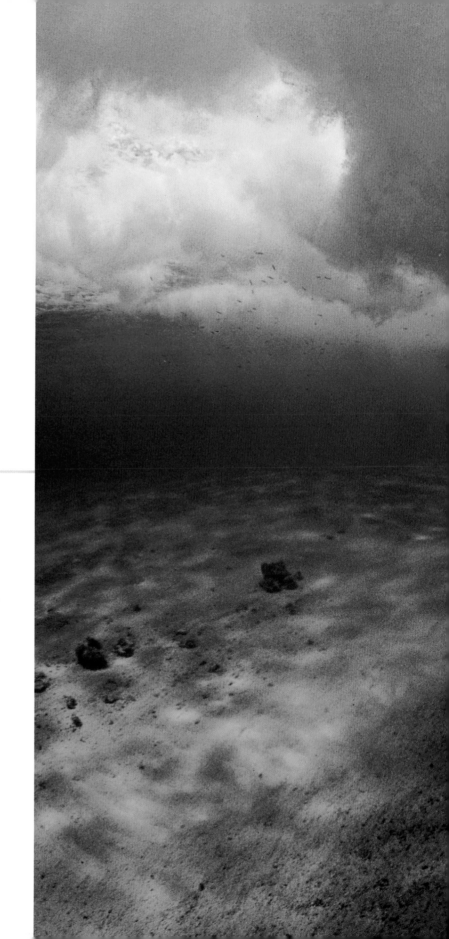

# EDGE OF THE REEF
## WHERE OCEAN MEETS LAGOON

314-315 A wave breaks over a narrow section of barrier reef flat on western edge of Bikin Atoll's main lagoon. Eric Hiner stays below the crashing surf to protect himself from the wave's energy at the surface.

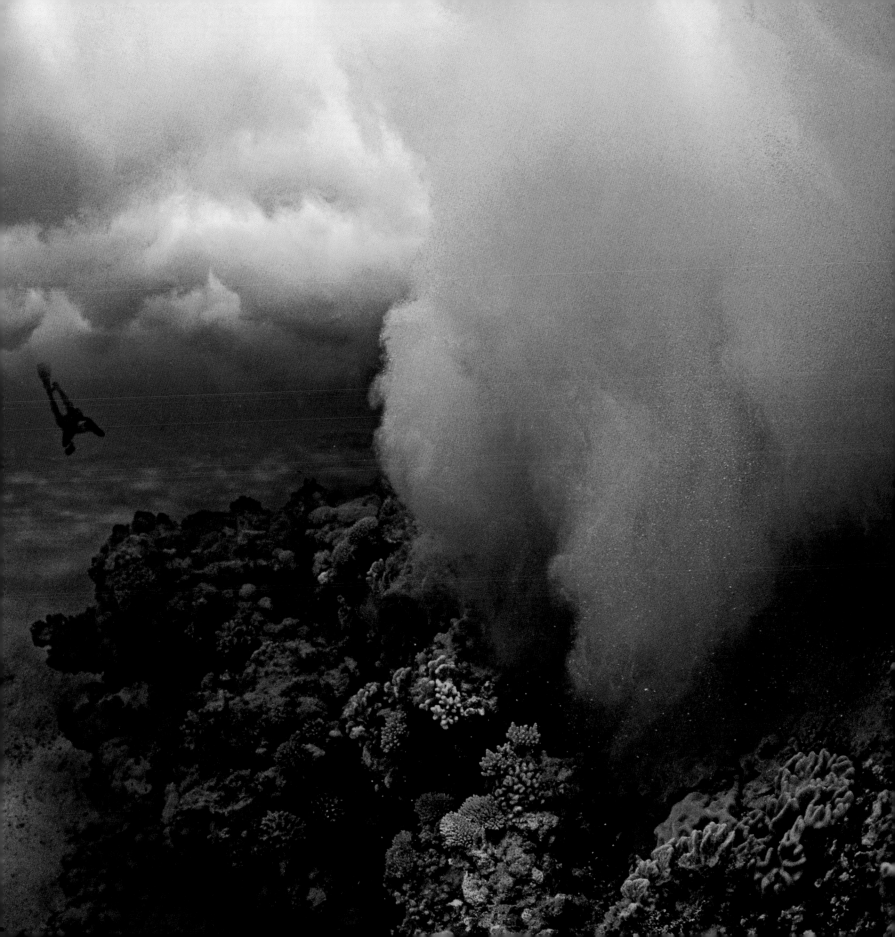

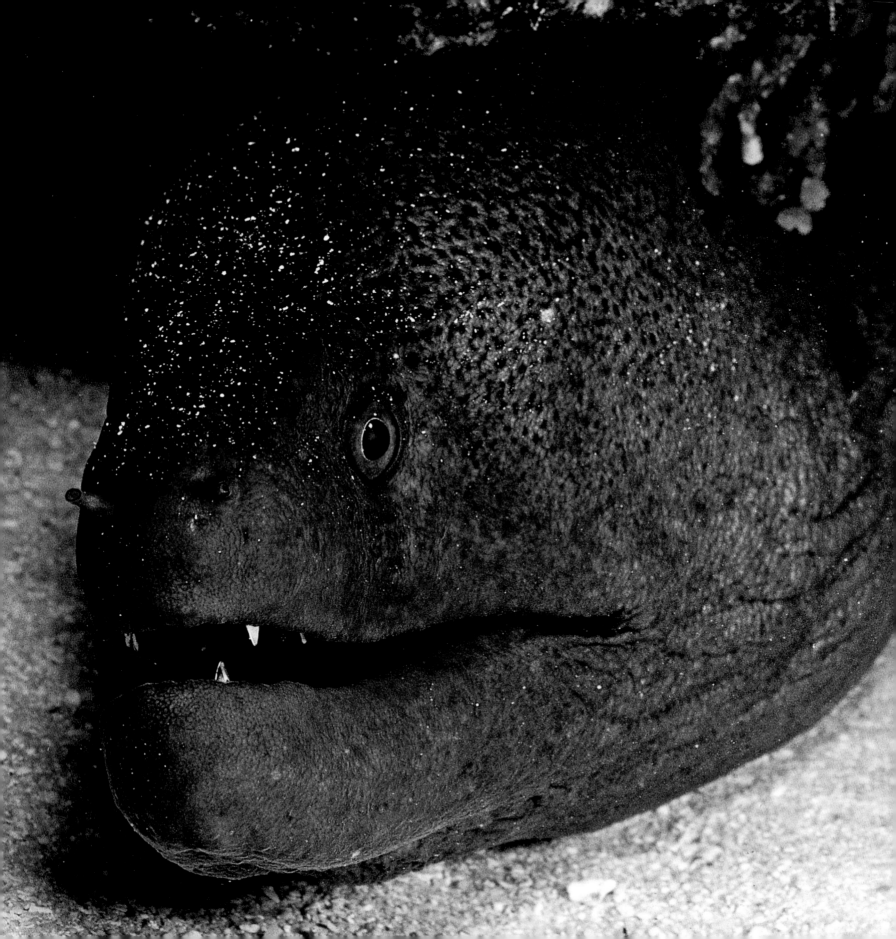

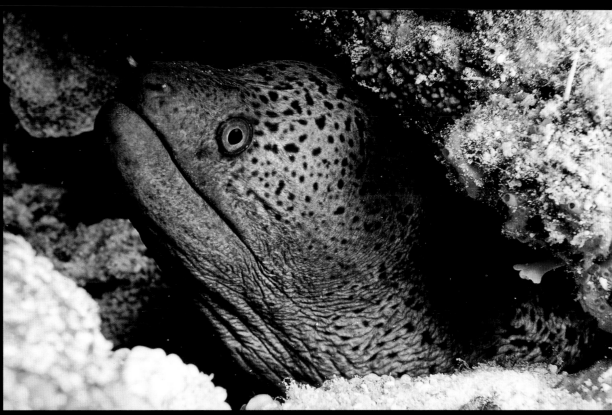

316-317 and 317  Moray eel, *Gymnothorax sp*, emerges from it's coral cave
on the lagoon floor, Bikini Atoll.

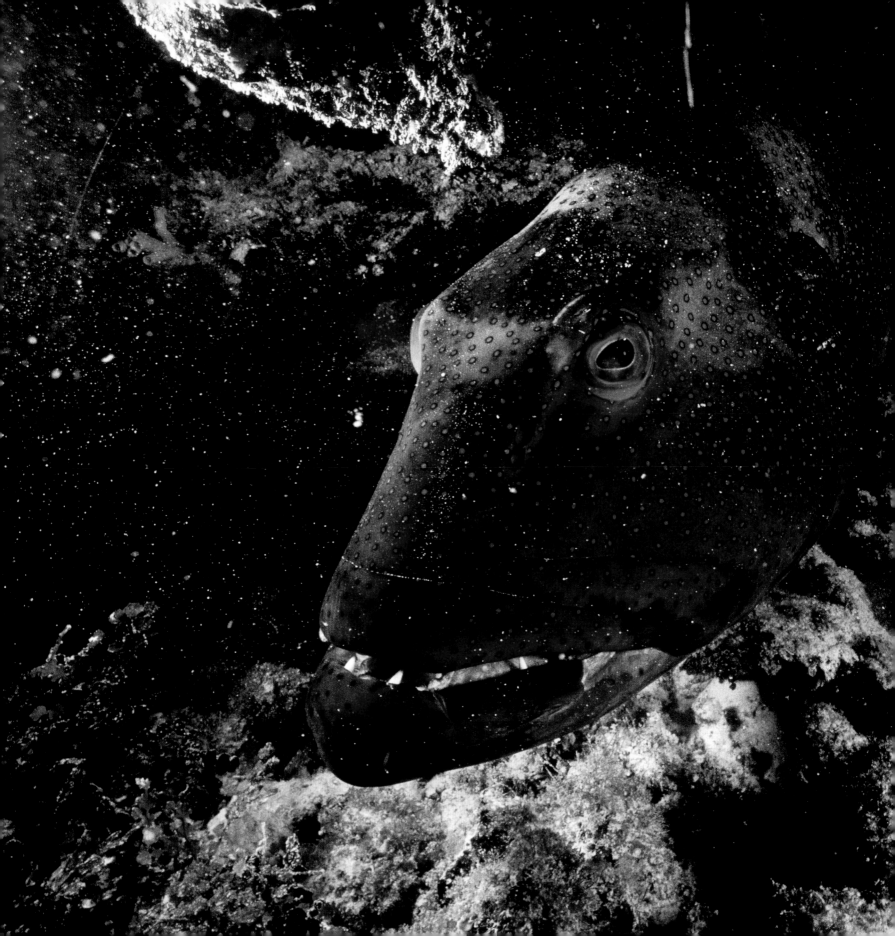

# THE REEF SURVIVES

## NATURE PREVAILS

318-319  A small grouper swims out of its reef
cave, Bikini Atoll.

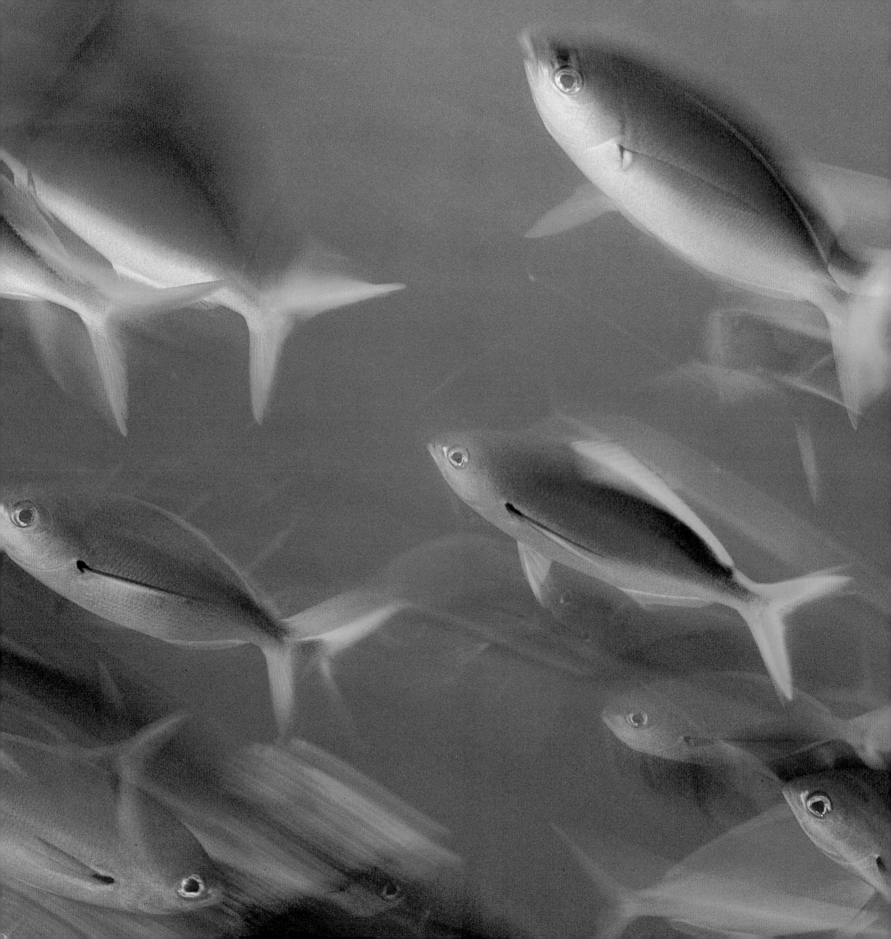

320-321  A school of fusiliers, *Caesio cuning*, swim past the author on the outer reef slope, Bikini Atoll.

322-323 A school of
bigeye trevally jacks,
*Caranx sexfasciatus*, swim
with diver Eric Hiner
along Bikini's outer reef
slope.

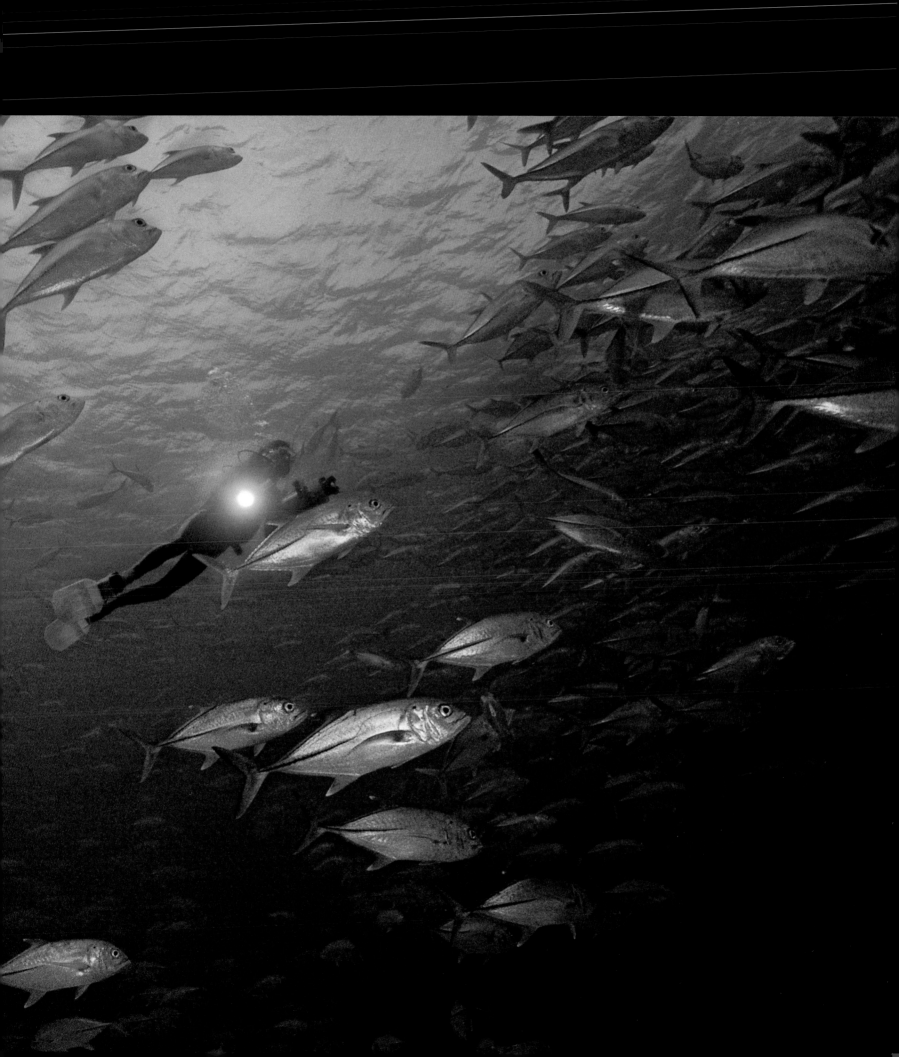

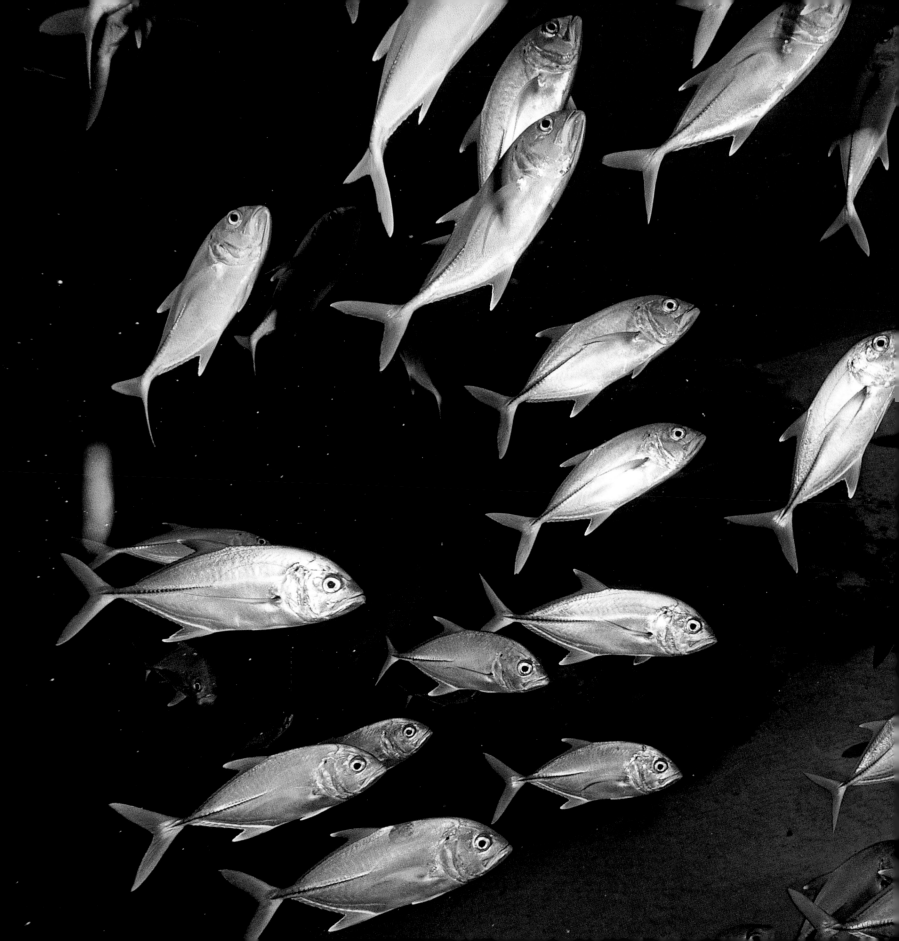

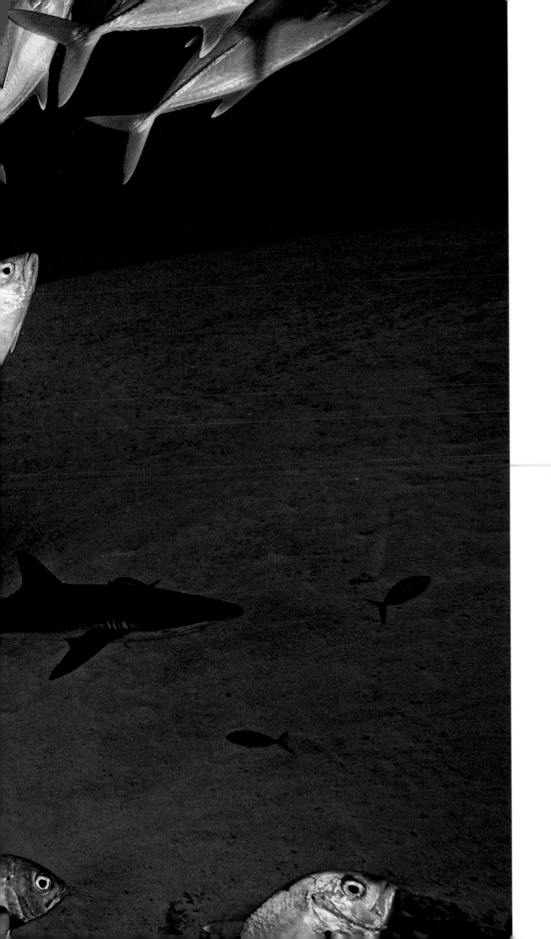

324-325  Bigeye trevally jacks, *Caranx sexfasciatus*, swim above a lurking grey reef shark, Bikini Atoll.

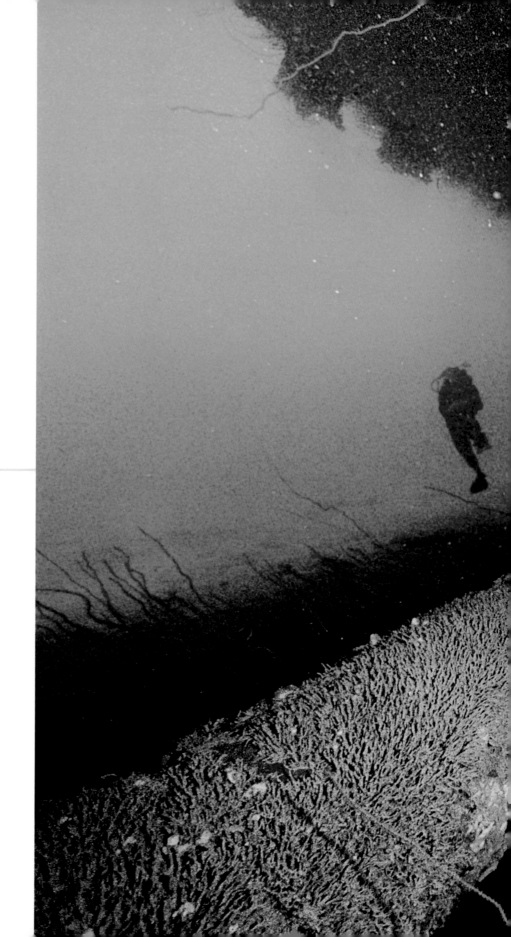

# Nuclear
# Graveyard
## Comes to light

326-327  After being sunk during U.S. Navy
atomic-bomb test, the Japanese battleship
*Nagato* rests upside down on the bed of the
Bikini Atoll lagoon. The *Nagato*, Admiral
Isoroku Yamamoto's flagship during WWII, was
the first battleship to mount 16-inch guns.

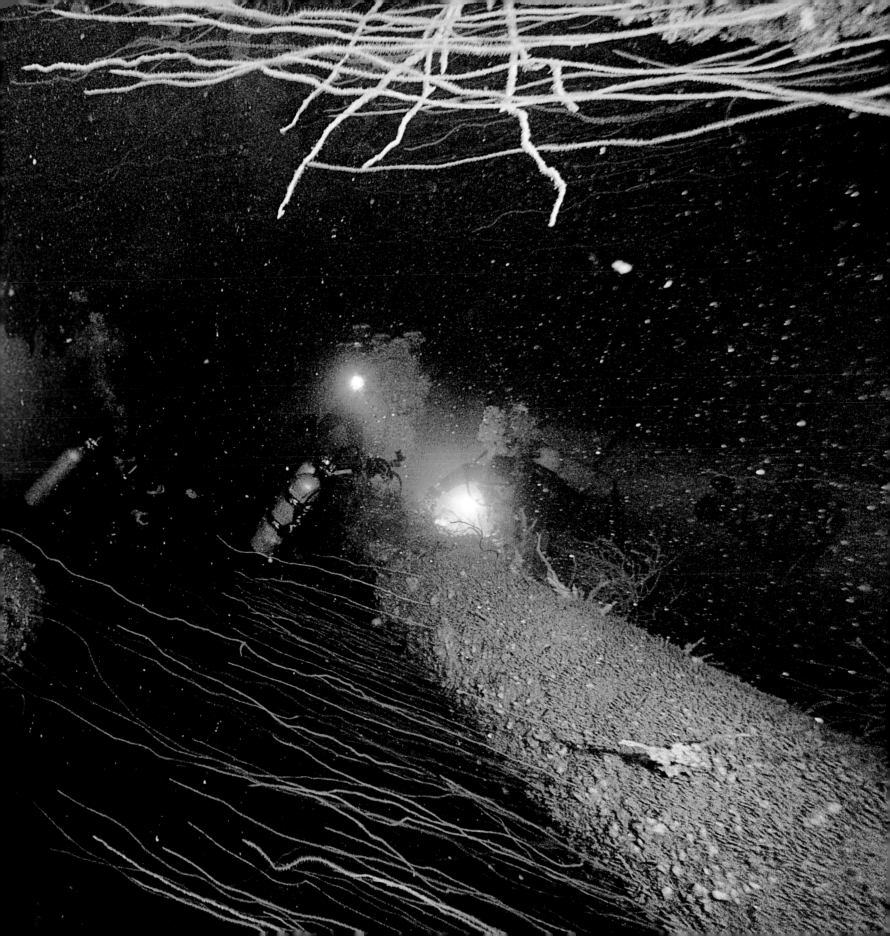

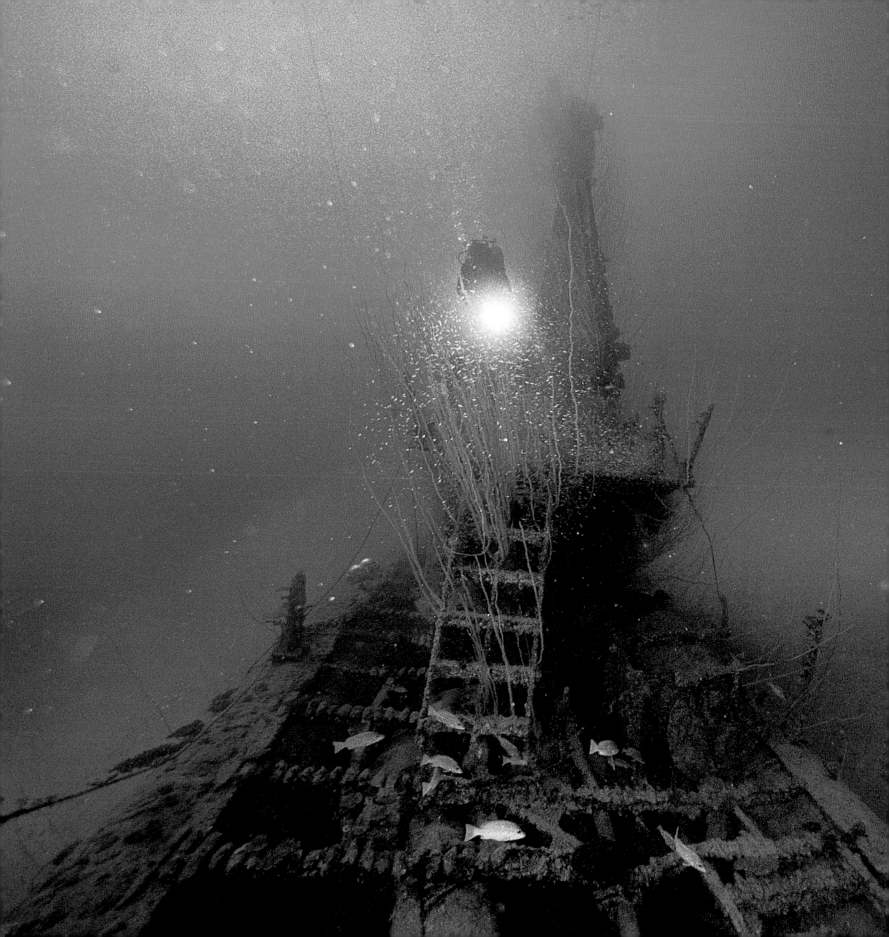

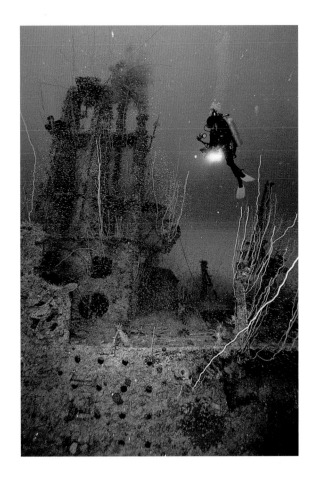

328-329 and 329  A diver swims above the wreck of the *USS Pilotfish* (SS-386), a Balao class submarine, one of several WW II vessels sunk in an atomic bomb test at Bikini Lagoon. She rests on the lagoon bed in 200 ft (60 m) of water.

330-331  The *USS Saratoga* (CV-3) sunk during Operation Crossroads rests upright on the lagoon floor. It took two nuclear detonations to sink her.

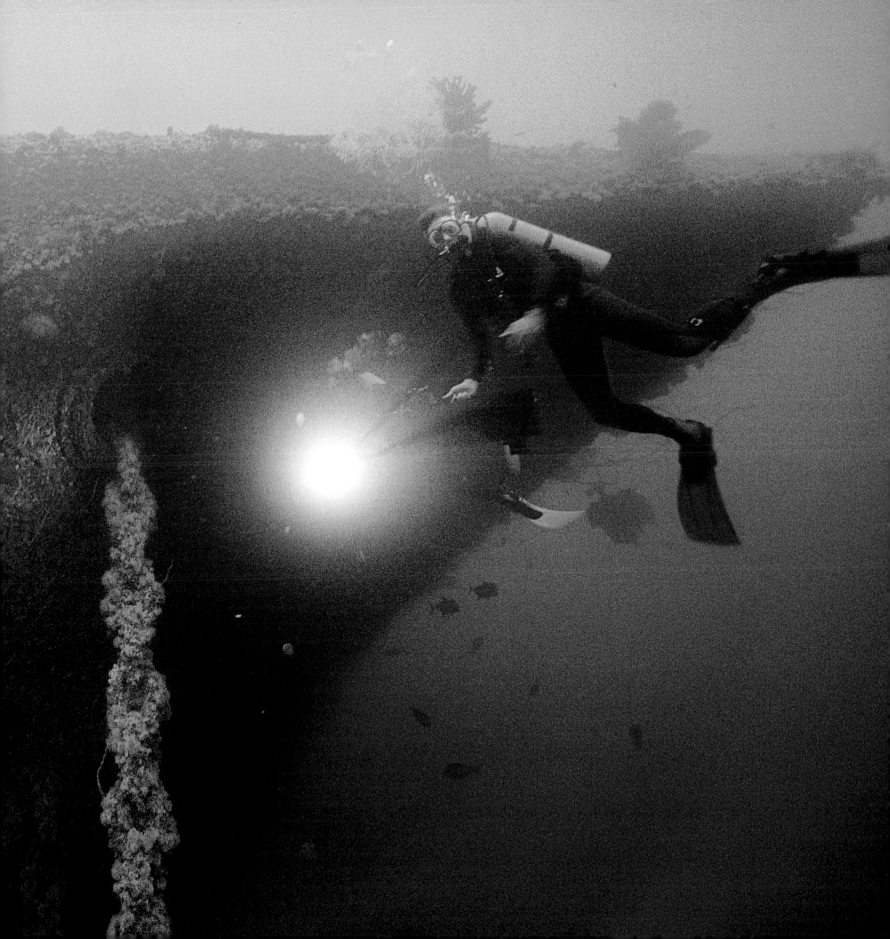

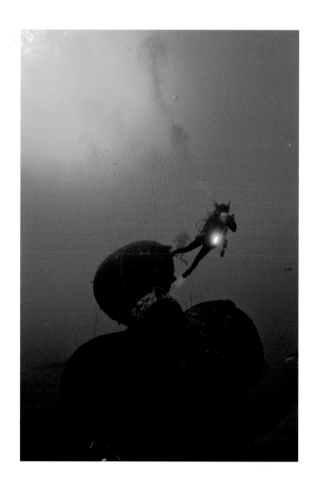

332  The propeller of the Japanase battleship
*Nagato*, sunk during atomic tests at Bikini.

332-333  The 5-inch guns of the *USS Pilotfish*, sunk
in a nuclear test at Bikini Atoll, still points defiantly
toward the surface.

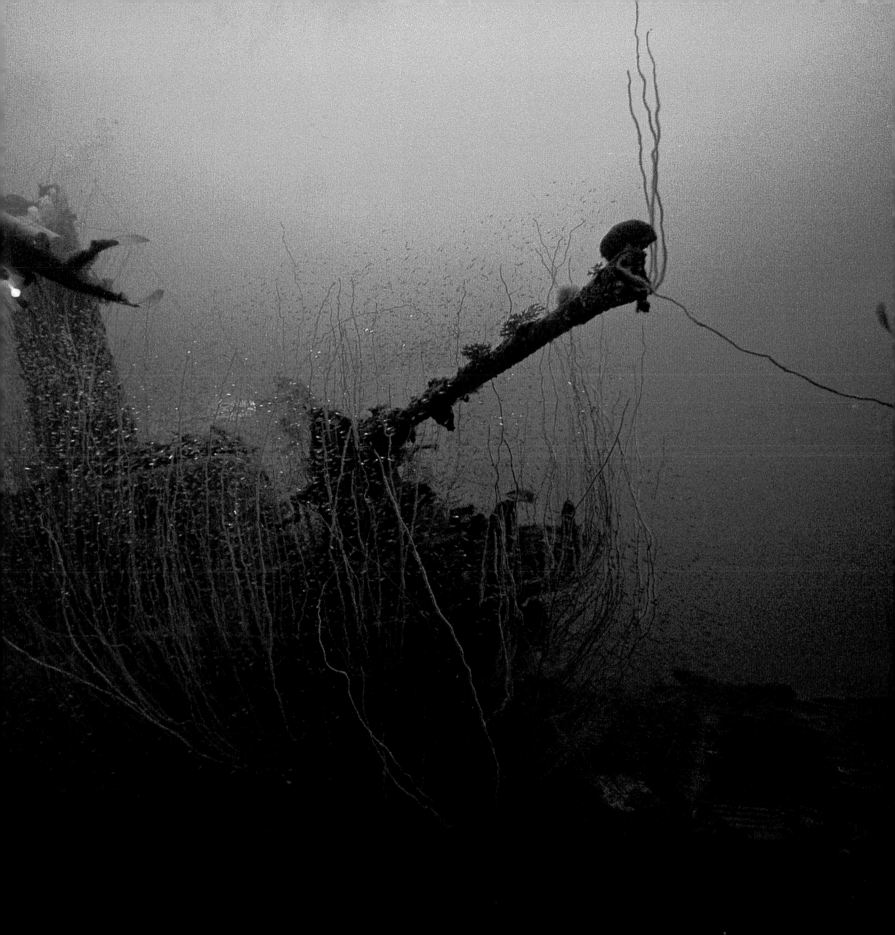

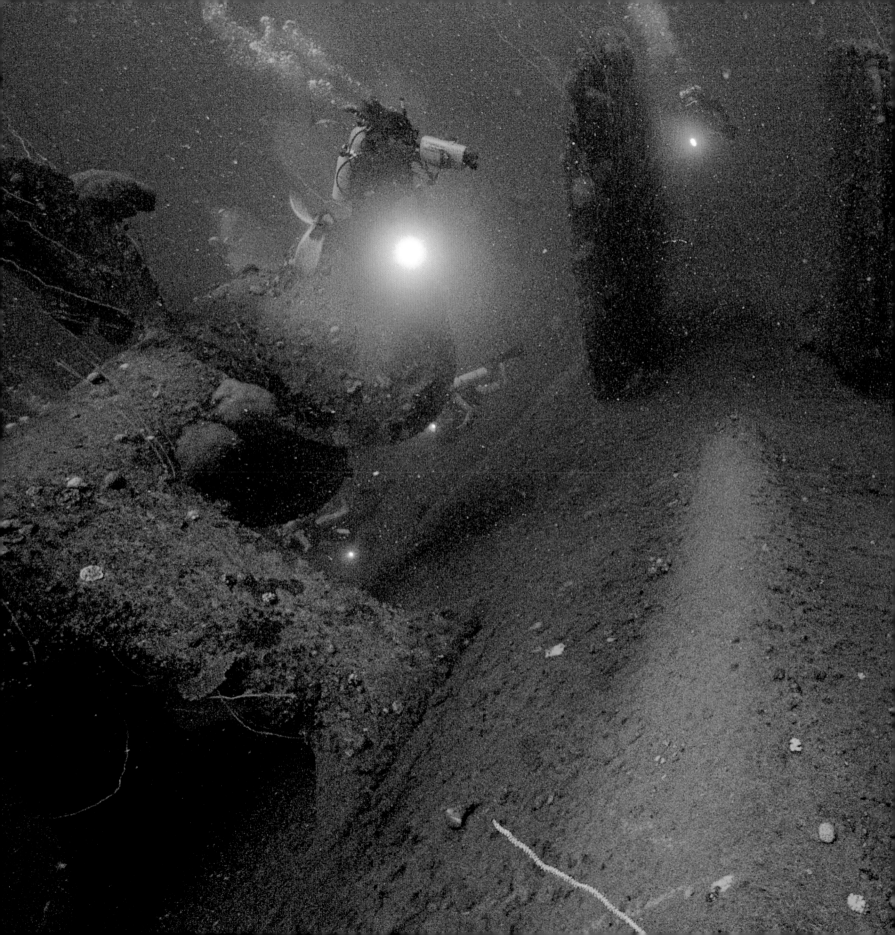

334-335  The stern of *Nagato* rests on the
Bikini Atoll's lagoon bed. The heavy guns
on a battleship's stern cause it to turn
over and sink upside down.

336-337  Bombs rests are intact on
the aircraft carrier *USS Saratoga's*
hangar deck.

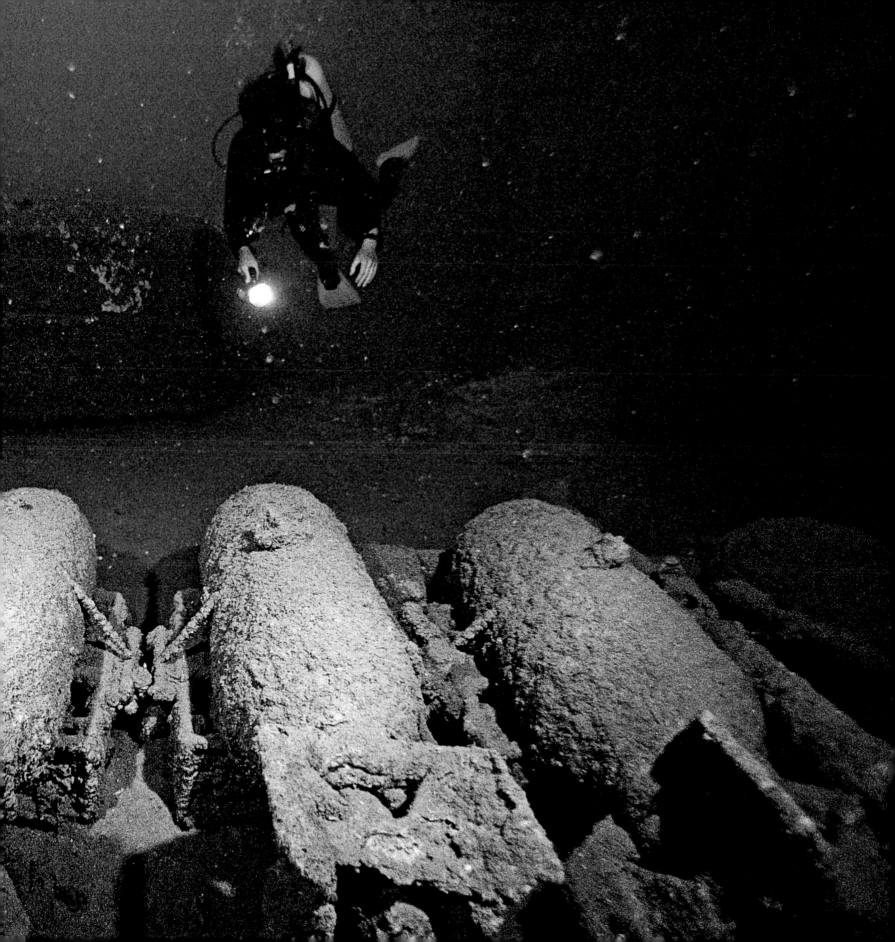

# THE KELP FOREST

## UNDERWATER CATHEDRAL

# THE KELP FOREST

## UNDERWATER CATHEDRAL

I N THE CATHEDRAL, I WAS KNEELING. THAT'S WHAT YOU DO IN A CATHEDRAL. I WASN'T KNEELING IN PRAYER EXACTLY, BUT I WAS FEELING A LITTLE REVERENT AT SO MUCH BEAUTY SPREAD OUT BEFORE ME. I WAS HUMBLED BY ITS SIZE. I put down my camera housings to take it all in. The bottom was rocky and looking up, I could see the sun dancing on the surface, framed by long strands of golden brown algae. Algae sounds like something small, but here was something big, very big. I was in over 85 ft (25 m) of water near Point Sur, off northern California. The algae strands spiraled up from the bottom to be closer to the sun's nurturing brightness. A canopy of algae fronds floated at the surface. This algae is commonly known as giant kelp, *Macrocystis pyrifera*, and it can grow to over a 100 ft (30 m) in length and as fast as 8 to 24 inches (20 to 60 cm) per day, depending on the season. It grows straight up, more or less helped by small gas-filled bladders at the base of each blade, keeping the whole kelp plant on a straight and narrow path toward the sun. Kneeling there beneath the sea's surface, I felt as if I was in a forest primeval, or an underwater cathedral. A school of blacksmith fish, *Chromis punctipinnis*, weaved its way through the forest fronds in front of my blinking camera. The giant strands of kelp were dancing. From beneath the waves, the surface swells moving towards shore were as invisible as wind is in the world above, but the effect was the same; the giant kelp swayed to and fro like any tree does in the breeze. You can feel it, but you can't really see it. You can only see what wind or water displaces as it moves through your world, above or below.

The life of a marine plant, a marine invertebrate, and a marine mammal seem forever entwined here: giant kelp, sea urchins and sea otters. It's tough to talk about the dynamics of a kelp forest system without mentioning the sea urchins and sea otters that live within it. Kelp plants are "rooted" to the rocky bottom by what scientists call, the holdfast. The kelp's holdfast looks like a big, exposed root clump. Unlike the roots of a tree, these do not transport nutrients up to the body of the kelp plant. They serve as an anchor against the tide, currents and the surge of waves above. Sea urchins eat giant kelp and will attack and devour the holdfast. If enough sea urchins are around, they can damage the structure and strength of the plant, resulting in the giant strand coming unglued and being swept away.

338  Diver with light in kelp forest off Point Sur, California.

341  Sea otters wrap kelp around their bodies when they sleep at the surface so as to not drift away.

Sea otters are found all along the west coast of the U.S. from California to Alaska. Commercial hunting of sea otters for their pelts in the 1800s reduced their numbers significantly. In 1989, thousands of otters died as a result of the infamous *Exxon Valdez* oil spill in Prince William Sound, Alaska. They are now protected under U.S. and Canadian laws. Sea otters eat sea urchins. There seems to be no definitive conclusion regarding the relationship between kelp, sea urchins and sea otters but most biologists agree; where there are sea otters, the sea urchin populations seem to stay in check. And where there are sea otters, kelp forests seem to thrive.

I once spent a frustrating three weeks trying to photograph sea otters underwater in and around California's Monterey Bay. Just to see one underwater is tough enough. To photograph one is a humbling experience. I don't think I've ever seen a marine mammal move so fast and seem so invisible. I managed to get a few photographs of wild sea otters underwater, but the images here are of an orphan being reintroduced into the wild by Monterey Bay Aquarium staff. Even in such controlled circumstances, photographs of sea otters underwater are a great challenge. Sea otters are extremely fast swimmers. Underwater, you can barely follow them with your eyes, much less a camera lens inside a bulky housing. They absorb light. I call them underwater black holes. In most of my otter photographs detail is absent due to lack of light, and the speed at which these little creatures move through the water column.

Just a thought. In the animal kingdom, there are what I call, megaspecies. Megaspecies are animals like tigers and rhinos and elephants that everyone seems to know about. Within my megaspecies class is an order of cute-species, the ones everyone wants to love, the species that are unrelentingly anthropomorphized beyond reality; panda bears, dolphins, whales, seals, wolves, bunnies, owls... you get my drift. In the sea otter you will find the ultimate example of my definition of a cute megaspecies. With their long whiskers and endearing antics, sea otters have become for many the equivalent of an underwater teddy bear. Oh, don't get me wrong, they are cute and I too fall victim to their charms -- only the -- most insensitive would not. And of course, sea otters deserve our conservation efforts as every endangered species on the planet does. But I ask: what about all the thousands of other species that need saving, that might not be as appealing as our cute-megaspecies friends? Where are the check-writing defenders of over-fished capelin in Newfoundland or the tropical rain forest insects lost to logging in South America? Just a thought.

Sea otters don't know anything about their cuteness, or their status as a protected cutemegaspecies. They are only trying to get through their day, just like you and I. They are extremely well adapted to their environment. These swift swimmers, undulate their way underwater to prey on a variety of marine invertebrates, including but not limited to, seastars, clams, crabs, octopus, abalone, along with sea urchins.

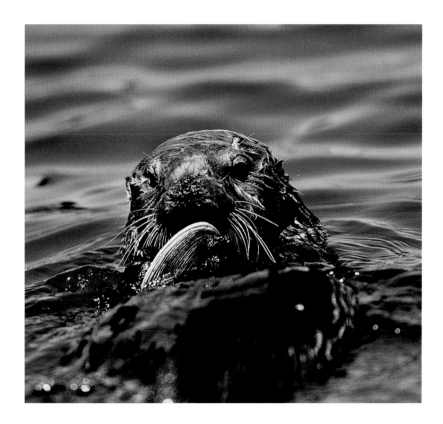

346 and 347  Sea otters - the marine mammal world's underwater teddy bear.

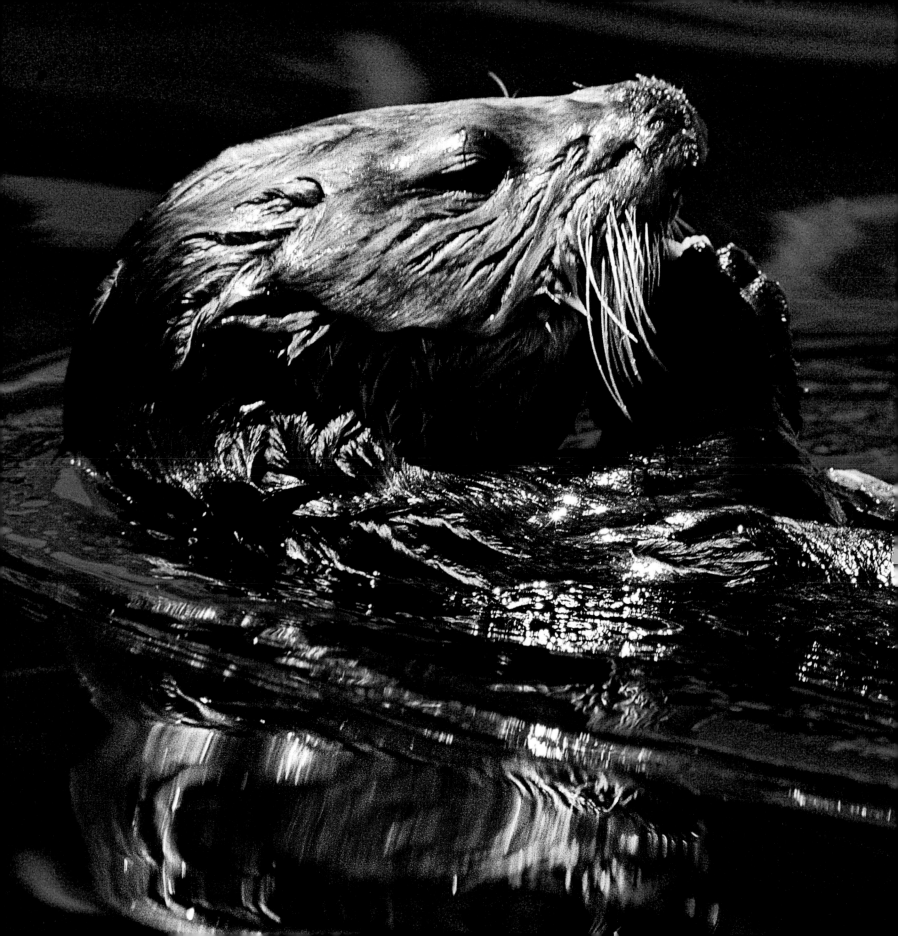

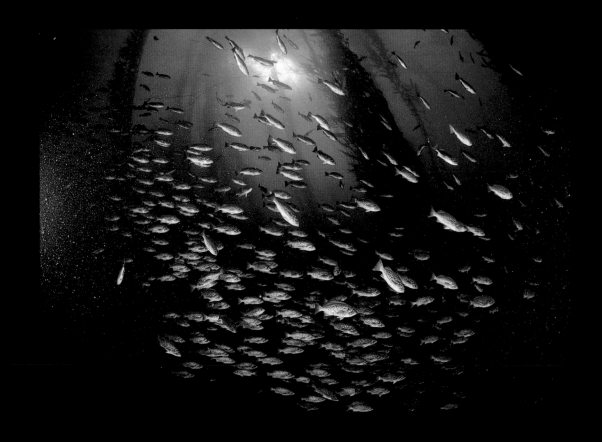

343  Blacksmith fish *(Chromis punctipinnis)* swim between giant kelp plants, Point Sur, California.

344-345  Sea otters use favorite rocks to smash open shellfish they eat.

And dare I say, sea otters seem to possess a significant level of intelligence. They can often be found at the surface, napping securely, having wrapped their bodies in anchored kelp fronds to prevent themselves from drifting away. They may be the only marine mammal to use tools, smashing shellfish open with rocks to get at the soft, meaty tissues inside. They will even carry around a "favorite" shellfish smashing-rock, as they look for clams underwater. I have seen this. They seem extremely aware of everything around them. Just ask me—I know from the hundreds of thwarted attempts I've made at getting near one underwater. They also just might have a sense of humor, because they always seemed to be laughing their cute little whiskers off at my inferior marine-mammalness as they swam away. There I go, off on my own bit of anthropomorphizing. With sea otters, I have to admit, it is almost impossible not to.

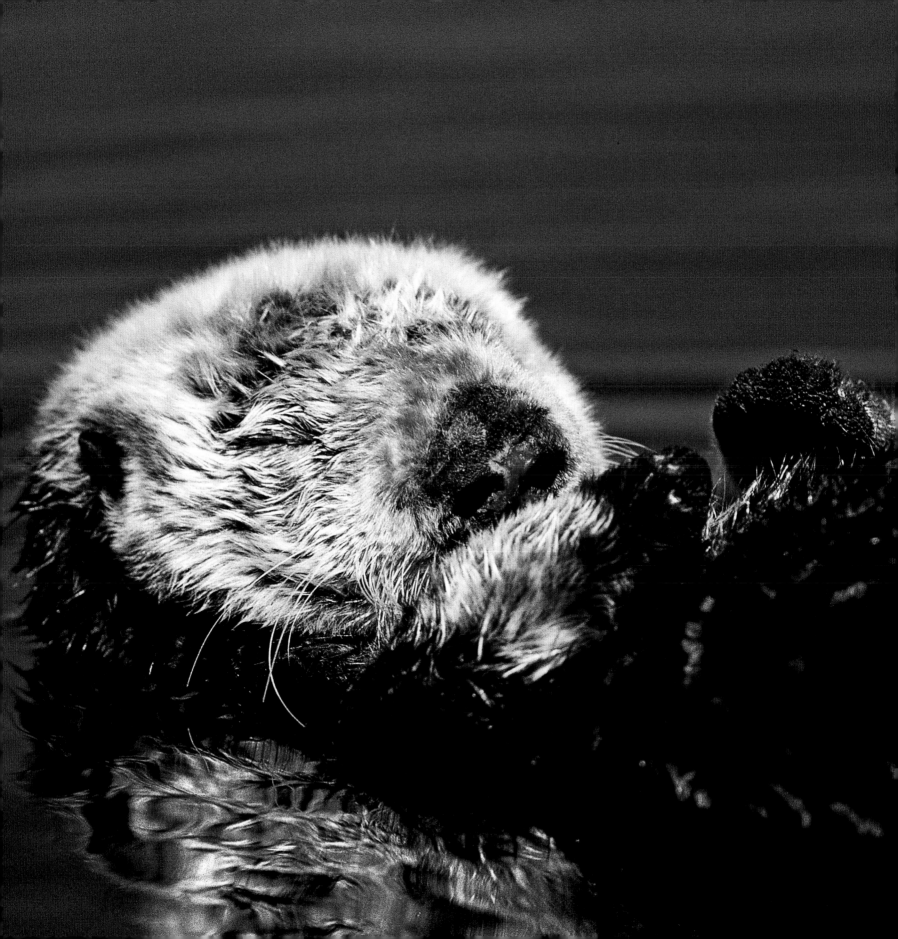

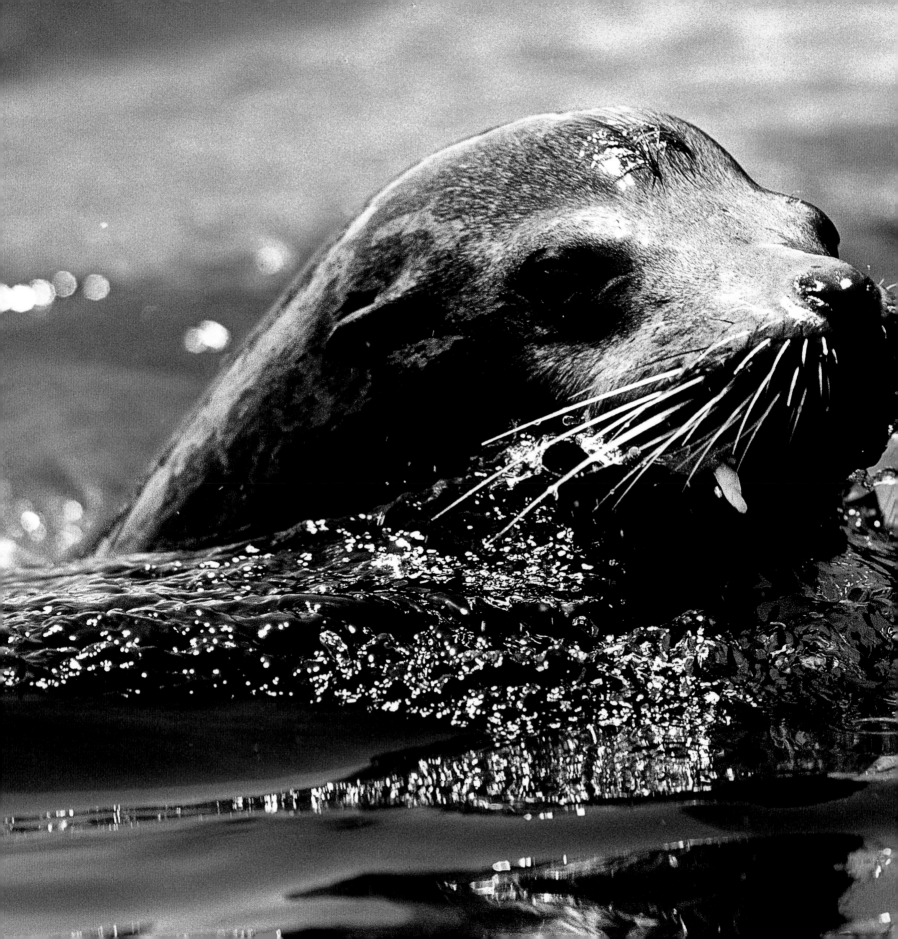

# BEAUTIFUL
## SWIMMERS
### CURIOUS AND GRACEFUL

348-349 California sea lion feeding at the
surface on unknown prey.

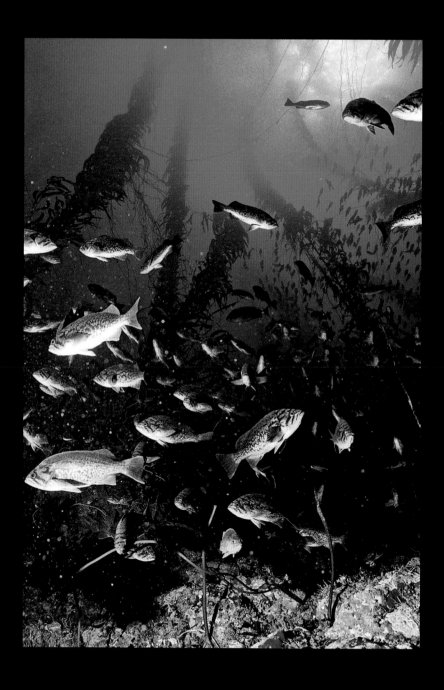

350 Blacksmith *(Chromis punctipinnis)* fish and giant kelp forest.

351 As if in an underwater cathedral, a diver swims above the author in the forest beneath the sea.

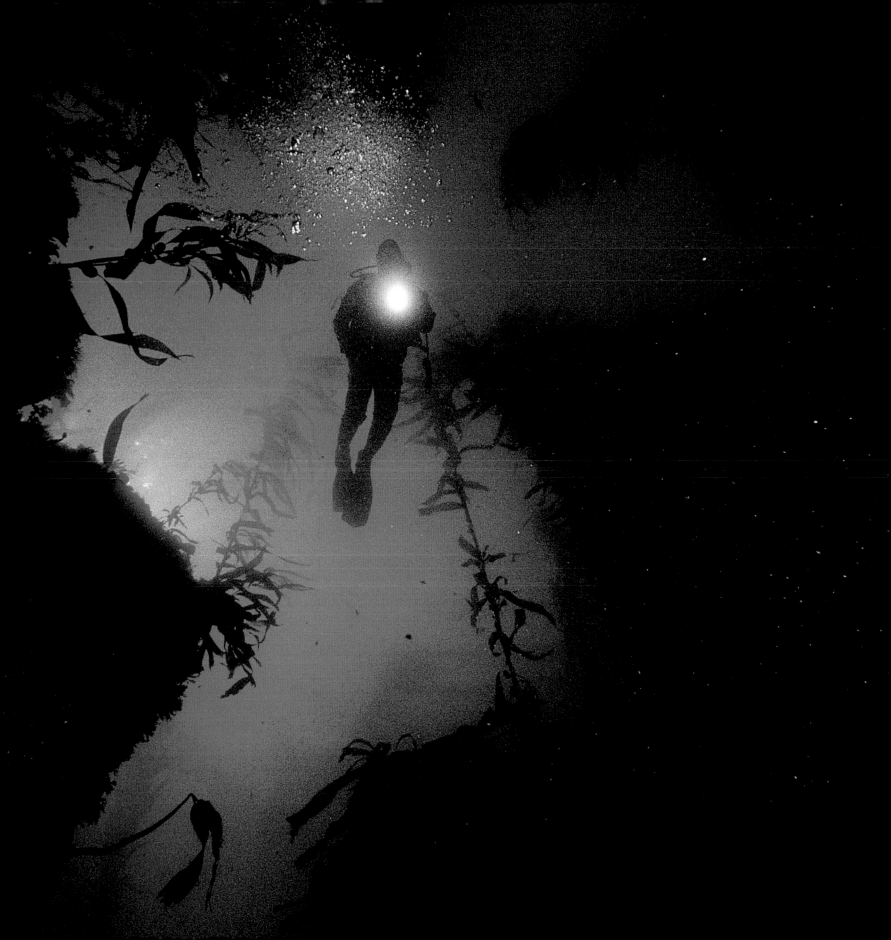

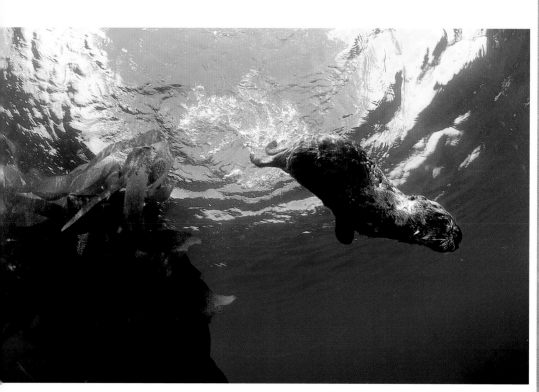

352 and 352-353  Otters, excellent swimmers, rely on a dense
layer of fur to protect them from cold waters.

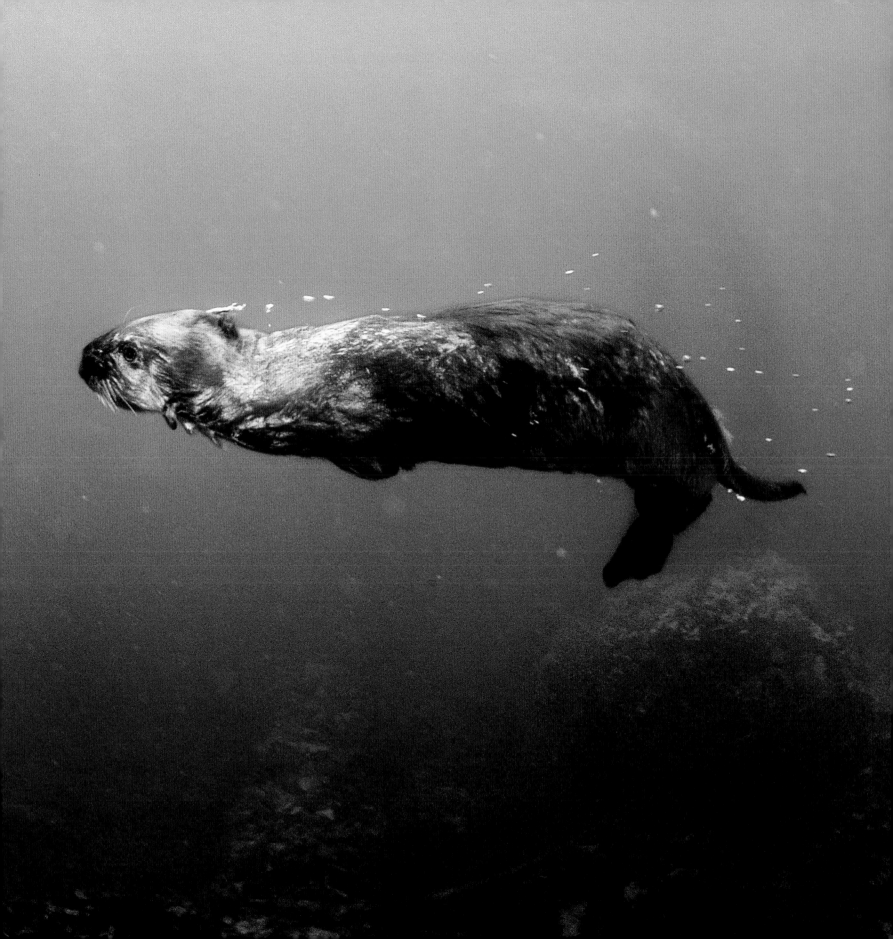

# THE SEA LION

## MASTERS OF UNDERWATER BALLET

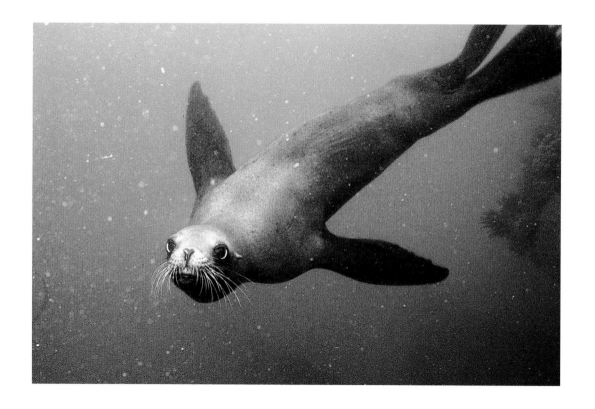

354  Marine mammals often seem curious about divers; in fact, sea lions are among the most curious of marine mammals.

355  Sea lions resting at the surface between dives off Point Sur, California.

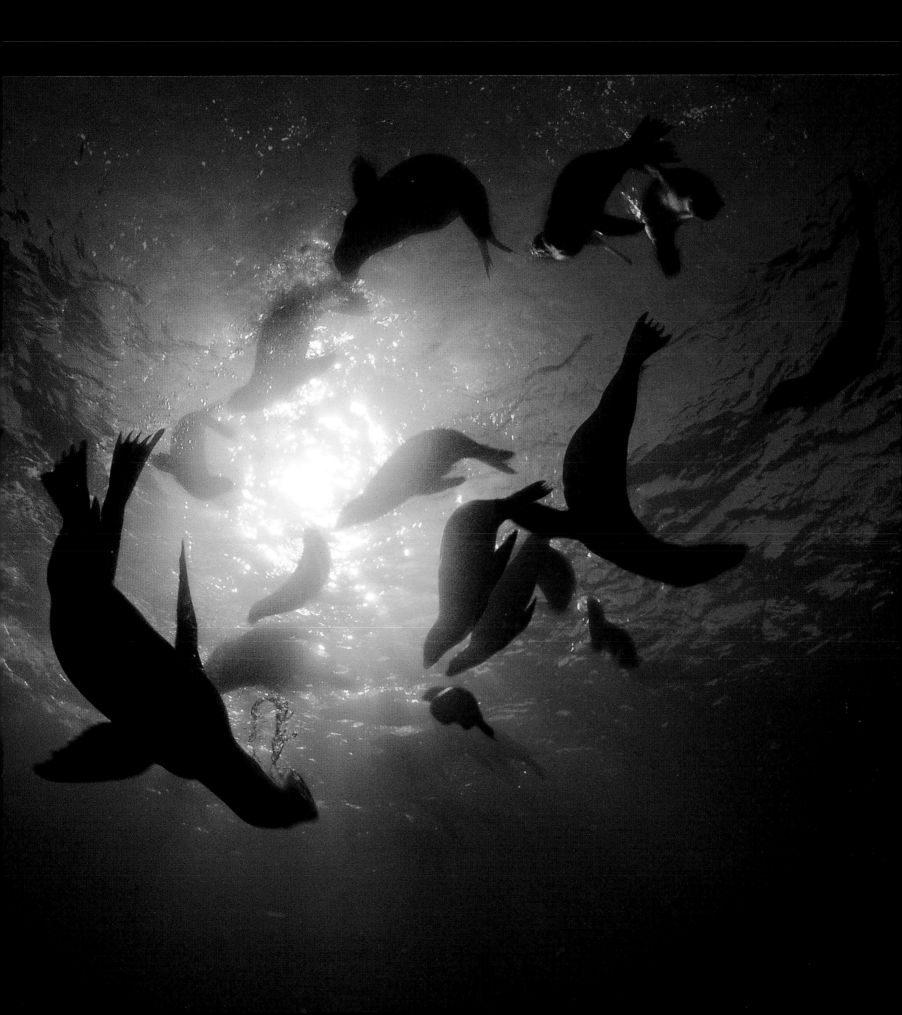

# LAKE BAIKAL

## DEEP RIFT WATERS

# LAKE BAIKAL

## DEEP RIFT WATERS

N
O SOONER HAD WE DOCKED OUR BOAT, A LONG, NARROW STEEL-HULLED RUSS-IAN LAKE BOAT AND THEY STARTED TO COME. IT WAS THE SUMMER OF 1990, EIGHTEEN MONTHS BEFORE THE BREAK-UP OF THE SOVIET UNION.

At first it was just a couple of fisherman hanging around the dock, as fisherman do, but then their numbers grew to over a dozen. They stood on the dock and leaned over the rail looking at something I had brought with me that was sitting on our main deck. To me it was just a common tool, one I've used for years; a tool I've taken to many locations around the world, one that makes my photo assignments on the water possible. For the fishermen on that dock, it was as if they were looking at a spaceship from Mars. They knew what it was of course, but they had never seen a model quite like it. It was a late-model 45-horsepower Evinrude outboard motor, mounted on the transom of a rubber inflatable boat. They thought the boat was interesting enough, but it was the motor that had their attention; a motor they might never have imagined possible.

In the 1950s the Russians had reverse-engi-neered a Johnson outboard motor and tooled a man-ufacturing plant somewhere in the Soviet Union to build them. That same style outboard motor was still being manufactured in 1990 and they were all over Lake Baikal. Nothing in its design had changed. The outboard engine cover that made it so recog-nizable as a 1950s-era Johnson motor was there, as were all the frustrations associated with running and depending on early outboard motors: no elec-tronic ignition, no electric starter, no hydraulic en-gine lifts, no modern engine cooling system. In the US we take modern outboard motor technology for granted. These Russian fishermen had never seen anything like it.

They stared, dumfounded. They asked through my interpreter if I could lift the cover so they could have a look inside. I did. There was actually a mo-ment of silence. They could not believe their eyes and I thought for a minute I might see grown men cry. They dissected the motor with their eyes and hands. They followed wires and touched every inch of the engine they could. They could probably take apart their own motors blindfolded given the number of times they had to do so, and it was clear that they un-derstood the benefits of the technology before them.

356  An indigenous sculpin in Lake Baikal.

359  Green sponges carpet Lake Baikal's shallows.

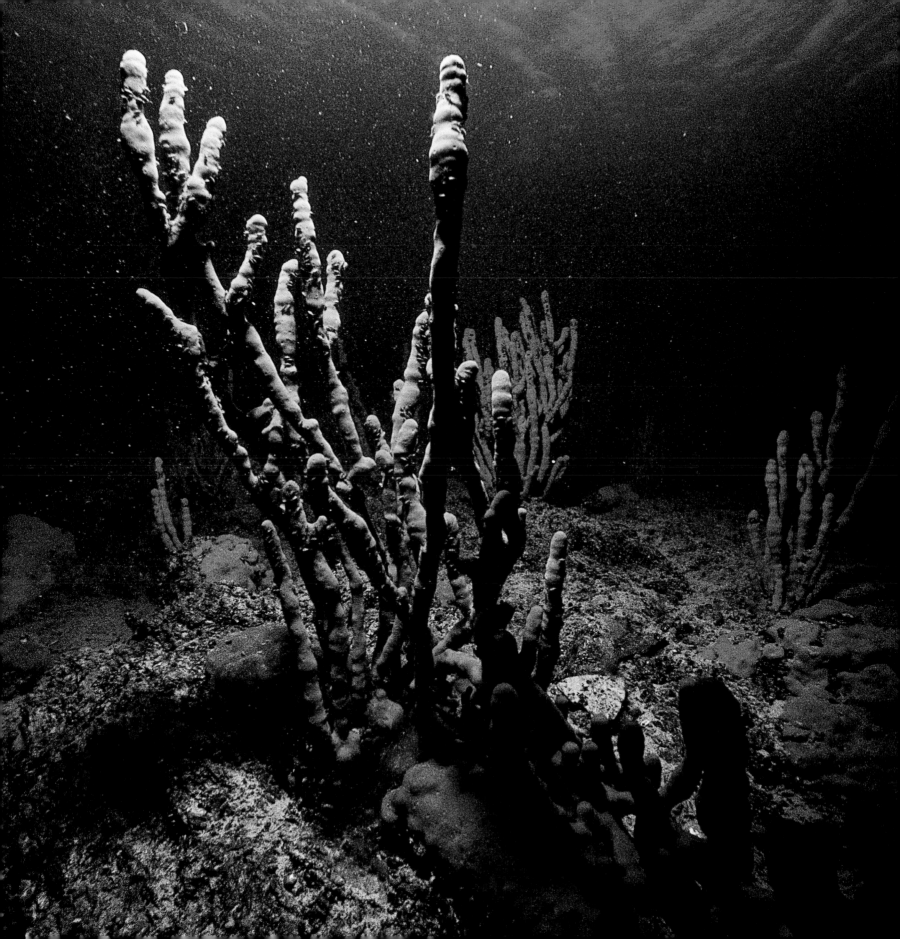

They just hadn't imagined it was possible. This happened more than once, almost every time we pulled into a remote fishing port somewhere along the shores of the largest body of fresh water in the world, Lake Baikal. On several occasions out on the lake, I saw men huddled over the sterns of their small aluminum boats trying to get stalled motors going again -- their new 1950-era motors, built with technology that was 40 years old.

When the Russians were reverse-engineering Johnson outboard motor technology in the 1950s, I was hiding under my desk in a third grade classroom drill, preparing for a Soviet nuclear attack. People were building fall-out shelters to protect their families in case the bomb arrived. Soviet Premier Nikita Khrushchev was banging his shoe on a desk at the UN while trying to make a point or get some attention. Photojournalists from America couldn't get near Russia, and the few that managed to were told what they could photograph and what they could not. Fast forward forty years: suddenly, as a photojournalist, I have an opportunity to go to Lake Baikal, to actually travel to Russia, Siberia no less, and meet these mysterious people I had only heard about through a filter of fear. I will live among them for two months. This is one of the reasons I love what I do. And so I find myself in the middle of Siberia, running around in my aquatic "spaceship" on the biggest lake on the planet. I am diving in beautiful, clear waters and photographing new and unimaginable underwater environments. I am meeting new people -- wonderful people, and I am having the time of my life. Only once or twice

did I notice any resentment about an American arriving on the shores of their lake with cameras. In general, I was free to photograph whomever and whatever I wanted.

Lake Baikal, located in Russia's Siberia, is unarguably one of the world's most important bodies of fresh water. It is the deepest lake on earth, reaching depths of more than 5600 ft (1700 m). With its combined depth and surface area of 24,000 sq. miles (61,000 sq. km), it contains about one fifth of the earth's fresh water. Lake Baikal is old, some think it is over 25 million years old. By comparison, the Great Lakes in North America are a mere 18,000 years old. The Great Rift Valley lakes in Africa -- Tanganyika, Victoria, Malawi, and Lake Turkana, are only a couple of million years old.

Like the Asian peoples that live around its shores, Lake Baikal is a real survivor. Most lakes fill with sediment after about a million years or so. Lake Baikal sits in a rift system 5.5 miles (9 km) deep where several tectonic plates intersect. Here, the earth's crust groans and moves. The land drops between the two parallel faults and the valley formed by this interaction is filled with water, in this case, Lake Baikal. Scientists believe the lake is still growing -- the submarine crusts expanding Baikal's width by a few inches every year.

Lake Baikal is habitat for almost 3000 biological species, 1500 of which are animals. Over 700 of these animals are indigenous to the lake, found nowhere else on earth. Some scientists believe that Baikal might have been, at one time, connected to some ancient sea. Others hold that there is little evi-

361 left   A lone kayaker paddles alongside our boat in Lake Baikal. The Siberian summer brings sun and warmth to this cold region.

361 right  Lake Baikal is the deepest lake in the world and contains one fifth of the world's fresh water.

dence to support that a marine system was ever anywhere near it. There is an animal at the center of this debate – the Baikal seal, *Phoca sibirica*, found nowhere else. It is related to another isolated species, the Caspian seal, found 2480 miles (4000 km) to the west. Another relative that lives a little closer to Baikal is the Artic ringed seal, separated from its freshwater cousin by 2000 miles (3200 km) of central Siberian plateau. So, where did the Baikal seal originate, and how did it get here? No one really knows.

Baikal seals are found throughout the lake, but in the summer they gather around the centrally located Ushkani Islands, where the boulder-strewn beaches are covered with sunning seals. They are very wary of any unusual activity. There was a time when Baikal seals were endangered, nearly hunted to extinction before being protected. Their numbers are now stable at around 60,000, according to Russian officials. There is still an annual hunt using rifles and nets that takes around 6000 seals in the Siberian spring. Their pelts are valued as is their meat and blubber. Baikal seals do not look like any other seal I have ever seen. They are dark gray when wet, and sort of look like a small shiny boulder. They are short and stout. You could say they are plump. They feed primarily on fish.

Like seals, sponges are usually associated with marine systems, so it was a wonderful surprise for me to see the soft carpet of green sponges covering the lake's submerged rocks and boulders. They owe

their green color to a microscopic algae, Zoochlorella, that lives in the sponges' tissues. In the lake's deeper reaches, the sponges grow like stalagmites from the bottom. Some species with thick cylindrical branches grow to a 3 feet (1 m) so in height.

Like a forest of trees, these sponges provide habitat for many species of fish and invertebrates. Fish use the sponges for many things. They use them as a perch and a hiding place from which they can attack prey. They lay their eggs on sponge-covered rocks. (There are fifty species of fish in Lake Baikal; the most diverse group is the sculpins, with thirty indigenous species.)

Also amid the sponge trees are amphipods of all shapes and sizes. These are small crustaceans related to lobsters and shrimps. The biggest amphipod I have ever seen was in Lake Baikal-about the size of a cherry. An ichthyologist friend of mine, Dr. Peter Reinthal of the University of Arizona, was my assistant and dive partner for this assignment. He told me there is only one family of amphipods found in Lake Baikal; the Gammaridae, represented there by 240 described endemic species. Impressively, this Baikal population constitutes one third of the world's known Gammarid species.

My Baikal summer was filled with wonderful moments and a unique sense of place. I remember driving by a beach that looked like any beach you would find yourself sunbathing on, except there were no people on it, only cows. Some were standing and some were lying down, and they seemed to be enjoying their beach time just as you and I would. I remember the Baikal seal we saved from sure death one day. It had become entangled in a monofilament net that was cutting into its neck. We were able to grab the seal and cut away the life-threatening plastic line. I remember losing almost twenty pounds that summer because of all the cold-water diving and hard work associated with living onboard a boat. It seemed like I was always hungry. I remember the crude World War II era dive equipment the research diver, Vladimir Votyagov, had to use in his work for the Lake Baikal Limnological Institute, which sponsored our trip. I remember the hard-working crew of the small Russian research vessel and how they used to fish. They would drive the bow of their steel-hulled ship onto gravel beaches around the lake.

The captain would place the engine in slow forward, generating a slight current off the stern with the propeller. The entire crew would gather on the stern to fish, including the cook. When I asked why they fished this way, they told me that the fish come right to the stern current thinking it a river to run up. It actually worked. I remember the Russian captain going into the trash and recycling the battery envelope that was enclosed in the Polaroid SX-70 film pack I used. He used the battery, no longer useful to me, to power a small flashlight he used to read charts with in the wheelhouse at night. I remember the crewmen walking into a field one morning to pick wild thyme to take home to their wives. Most of all I remember the qualities of the Russian people I met. They were proud, kind, curious and full of home-spun ingenuity. Like their lake, they are real survivors of a remote and harsh Siberian world.

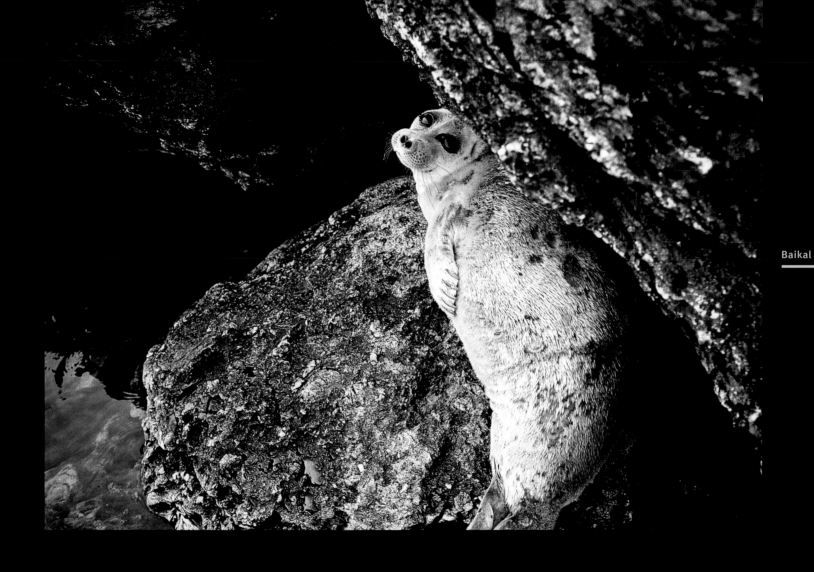

363  Lake Baikal seal, *Phoca sibirica*, basks on rocks at Ushkani Islands. Indigenous to Lake Baikal, it is one of a few species of freshwater seals that exist.

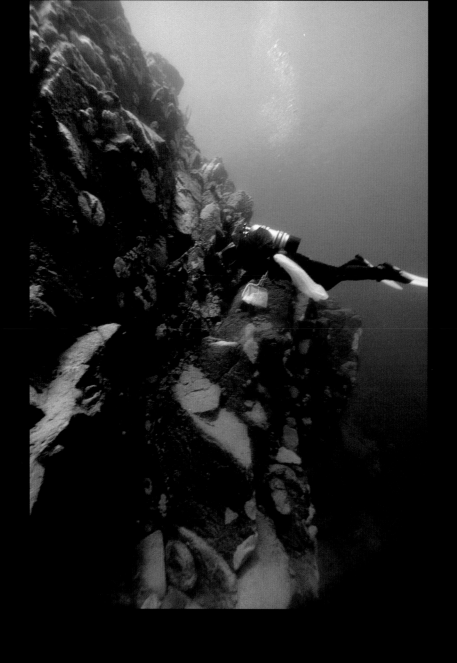

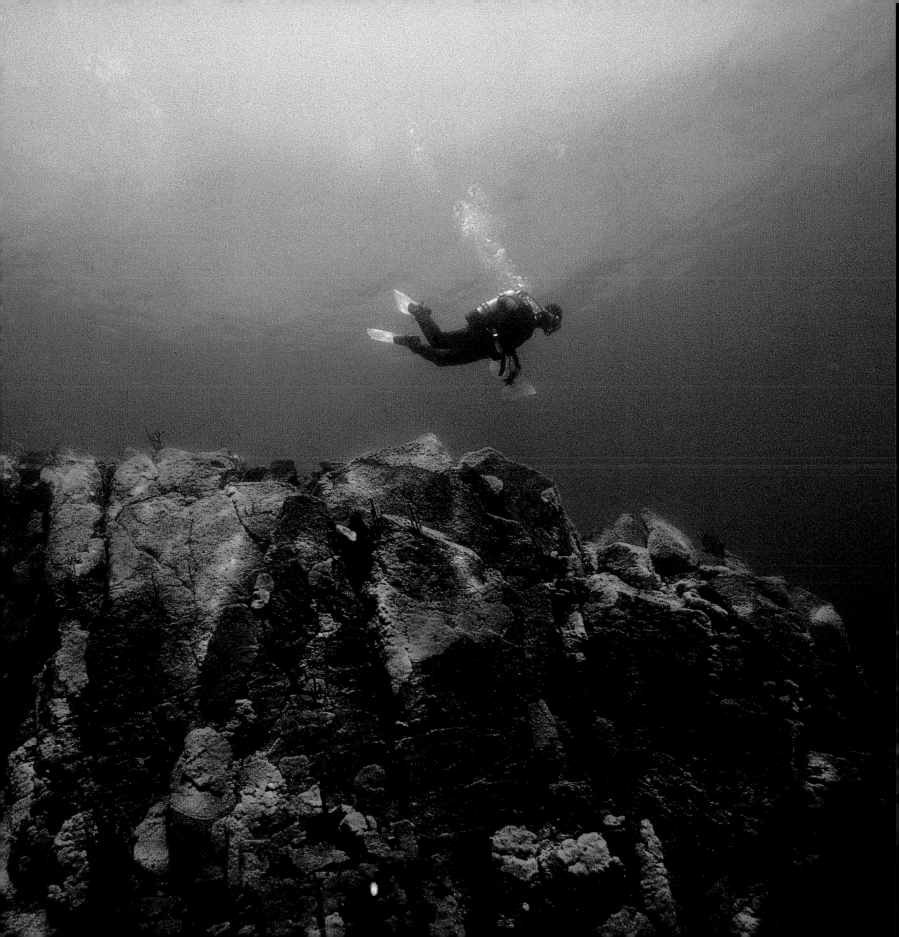

366-367 Ichthyologist Peter
Reinthal collects indigenous fish
species along Lake Baikal's
spongy bottom.

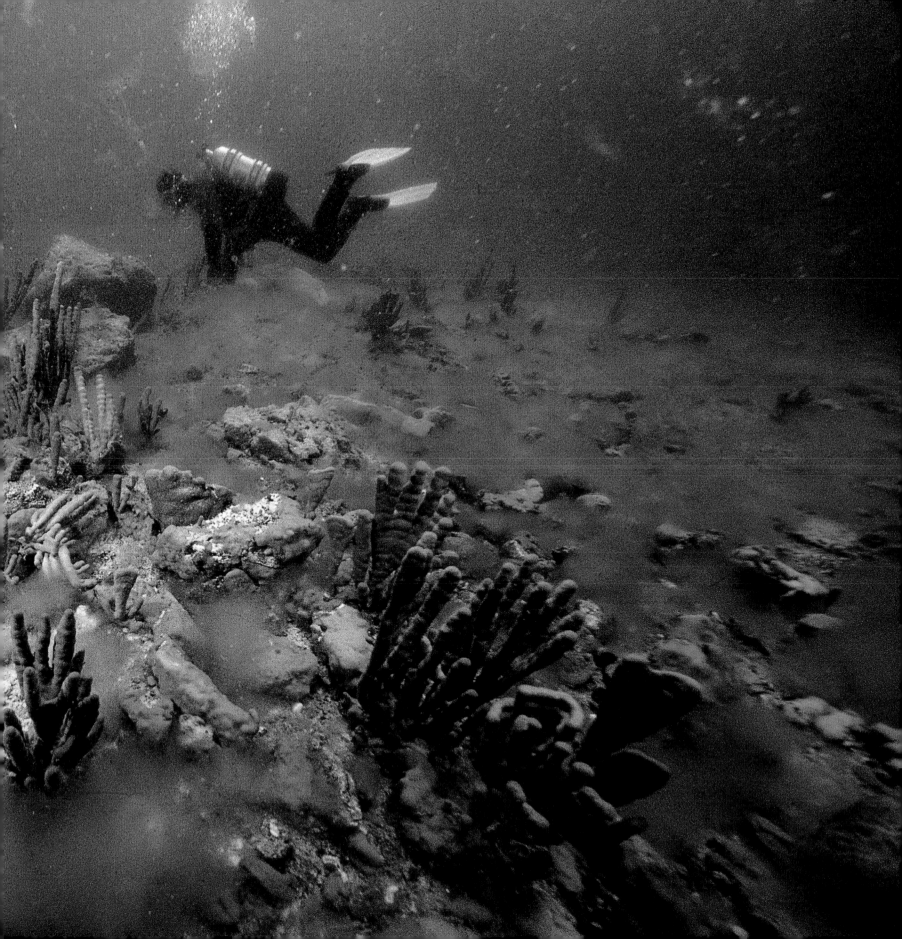

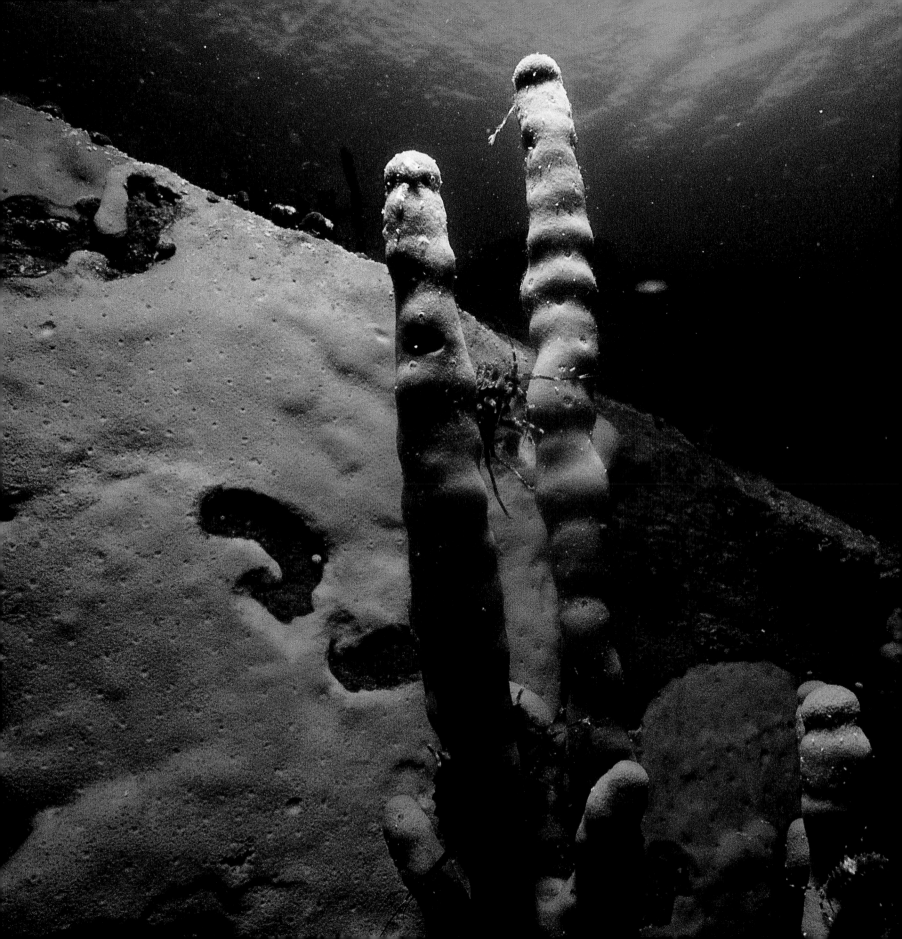

368-369 Giant amphipods crawl along vertical sponges in Lake Baikal. The sponges owe their green color to a microscopic algae, *Zoochlorella*.

# INDIGENOUS SPECIES ABOUND

## AN ISOLATED LAKE REVEALS ITS SECRETS

370  An indigenous sculpin, found nowhere else on earth, swims above the green sponge mat community of Lake Baikal.

371  Sculpin are found throughout the world but Lake Baikal has many species found only there.

372 A sculpin, indigenous to Lake Baikal, is guarding her eggs nestled amongst the green sponge community on the bottom.

373 Sculpins excavate small cavities in the sponge to lay their eggs.

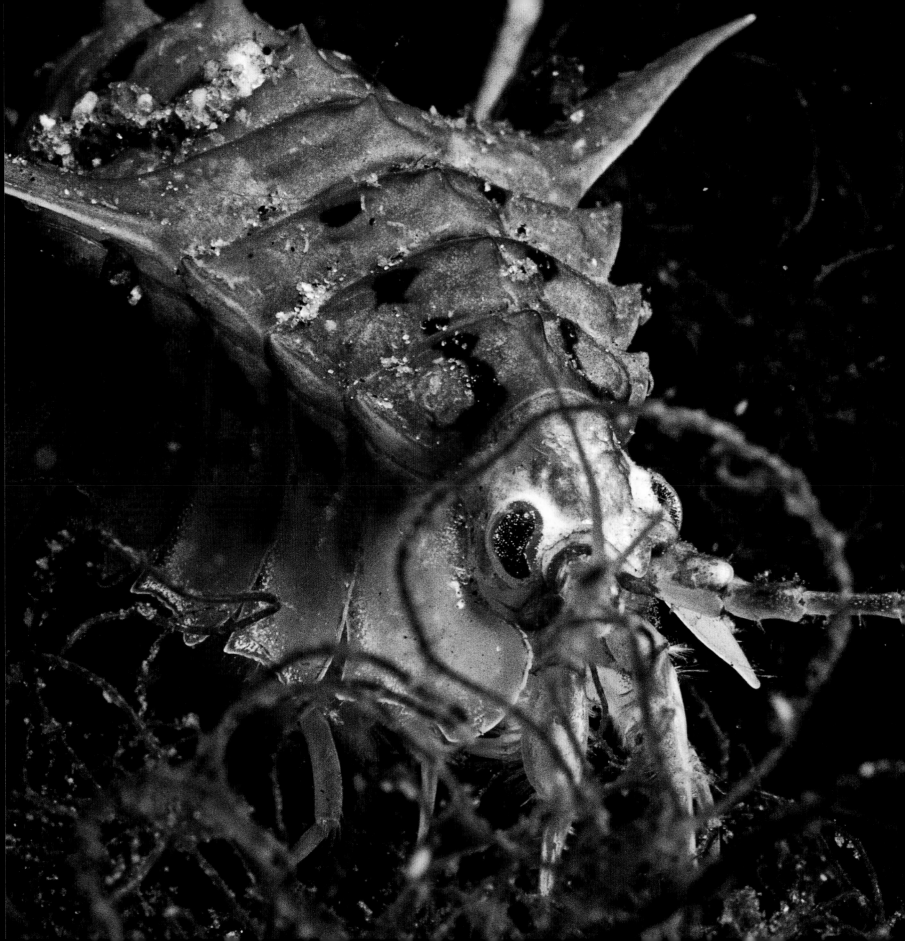

374-375  A *Gammarid* amphipod underwater in
Lake Baikal.

375  Lake Baikal has one third of the known
*Gammarid* species of amphipods in the world.

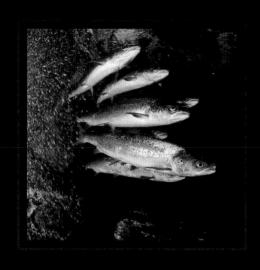

# ATLANTIC AND PACIFIC SALMON

## THE JOURNEY HOME

# SALMON

## THE JOURNEY HOME

T HE GOD OF FRESH WATER FISH, AT LEAST WHERE I COME FROM, IS THE ATLANTIC SALMON, *SALMO SALAR*. LIKE ITS PACIFIC COUSINS, IT IS AN ANADROMOUS FISH, SPAWNING IN FRESH WATER BUT SPENDING MOST OF ITS LIFE SOMEWHERE AT SEA.

Its recent absence from the rivers and streams in which it once spawned may be a statement about the poor health of those river systems, or about physical barriers erected by industry that block their passage home. The Atlantic salmon has an allure like no other, and occupies the dreams of many sport fishermen on both sides of the Atlantic. It's a handsome fish. The sight of salmon leaping up and over a waterfall, returning to their home pool to spawn, silver flanks flashing in the sun, is one of the great spectacles of nature. It is mesmerizing. I could sit along the river and watch all day. I once visited the Humber, a great salmon river in Newfoundland during a summer salmon run. In the first hour that I watched, I saw more fish leap over the river's big falls than return to all of New England in an entire season these days. But even in Newfoundland, as elsewhere along the North At-

lantic rim, salmon numbers are in decline, and nobody really seems to know why.

I'm thinking back to where my baptism as a water person took place in that dark, brown, tannin-filled river in southern New Jersey. My home pool. I didn't know then that my career would be spent swimming in more dark waters, shedding light on underwater creatures heretofore unseen, uncelebrated, unnoticed or unphotographed. In many ways this book is about my journey from the Rancocas Creek of my youth to a creek in Newfoundland where I found the pool of salmon I had been seeking for a lifetime.

Sliding down a rocky trail in western Newfoundland one morning with my assistant and fellow photographer, Heather Perry, I knew we had arrived. We had been looking for weeks for just the right pool-not only one with salmon in it, but one not too big and not too small. It was my unwavering conviction that I would find it that had kept me going. I knew I would know it when I saw it, and finally, here it was on a small tributary of a mighty river. I had been dreaming about this place, these photographs. To find the right spot after so many

376  Atlantic salmon *(Salmo salar)* traveling to their home pool hold their position beneath a waterfall on the Humber River in Newfoundland.

379  An Atlantic salmon *(Salmo salar)* leaps over the Humber River falls in Newfoundland on its journey home to spawn.

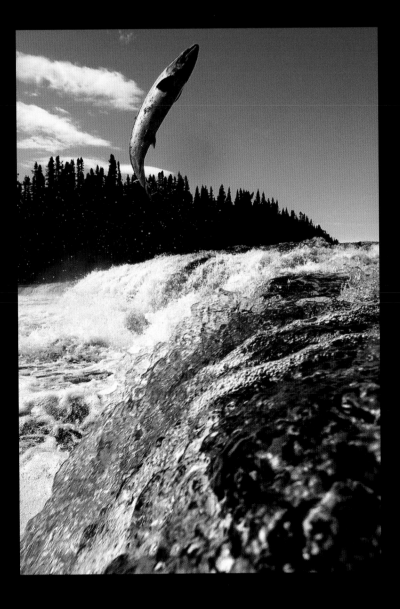

dead ends and false starts is one of the most exciting aspects of what I do.

We came to a small pool just below a short, steep waterfall. It was the perfect place. Heather and I just looked at each other and smiled. We had finally arrived after a long journey. The hard part was over and the fun was about to begin. The sun came out and sparkles of light danced across the surface of the swirling pool. As I looked through the viewfinder of the underwater camera I saw the dark brown water turn to gold. Silver bubbles from the cascading waterfall streaked by the camera dome. The pool had about twenty wild salmon holding against the current, tails beating back and forth, jockeying for position to make that signature leap, up and over the falls above.

These salmon had just completed an unimaginable journey from their North Atlantic haunts to this little river in Newfoundland, the river of their birth. Ahead of them lay a few more miles and leaps before they would finally be home. They know home when they see it, or taste it, or smell it. After a journey of thousands of miles, they must feel some comfort in coming home. I know I do.

Moments like this, when I'm making great photographs, I feel like I've come home too -- home to a wild beautiful place in the middle of nowhere, a place that I've been traveling to for most of my adult life. I'm humbled by these moments. I am in awe of the extraordinary creatures I've seen, and the wilderness in which I've found myself. I have been privileged to record these moments for others to see. After a few days in that pool in Newfoundland, I had the set of salmon photographs I needed to tell the story. To me, they are the proof that I was really there -- that such wonders are real. I've found my home pool in hundreds of places scattered around the globe. It is about the journey after all, and what a wonderful journey it has been. Who could ask for more?

These photographs of Atlantic salmon illustrate the final chapter of this book. As they do for the salmon, these images also illustrate the conclusion of part of my own journey. This was the last story I set out to cover before my wife became too sick for me to leave our home in Maine. I remember being on the road somewhere on the Gaspé Peninsula in Quebec as I worked on it. My cell phone rang; it was Kate. She had awful news about her cancer spreading to some new, more vulnerable part of her body. We were hoping to hear the word 'remission,' but this was not to be. Since her death, I have thought a lot about my life, my two sons, my friends, my work and my lifelong quest to immerse myself in cold, dark waters. I have also considered where I will go from here. It's the start of a new chapter in my personal life as well as my professional life. I have so many stories left to tell, so many photographs left to make, so many home pools left to find, that I'll need at least another life time to do it all. I will try to do a few, and I will always try to do my best. A new journey begins.

381 The Main, the great salmon river in western Newfoundland, is under threat from the area's pulp and paper industry.

382 Red tide from the air near Ketchikan, SE Alaska.

382-383 Revillagigado Channel and the Ketchikan area,
SE Alaska, is home to many Pacific salmon runs.

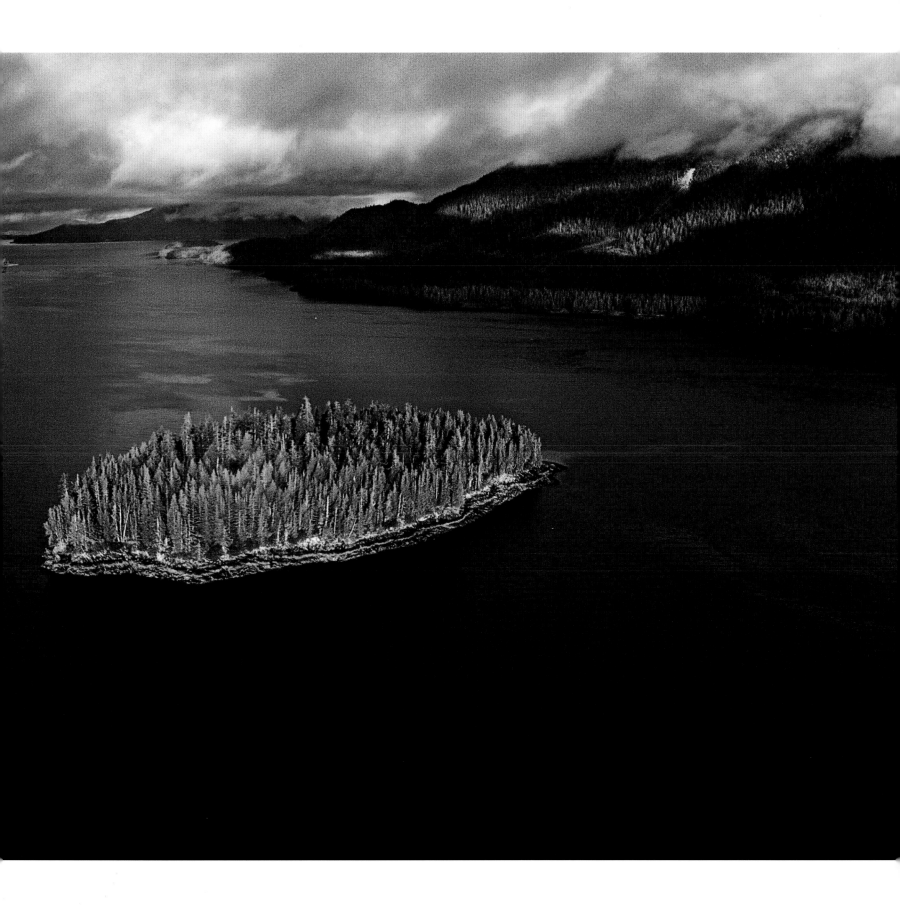

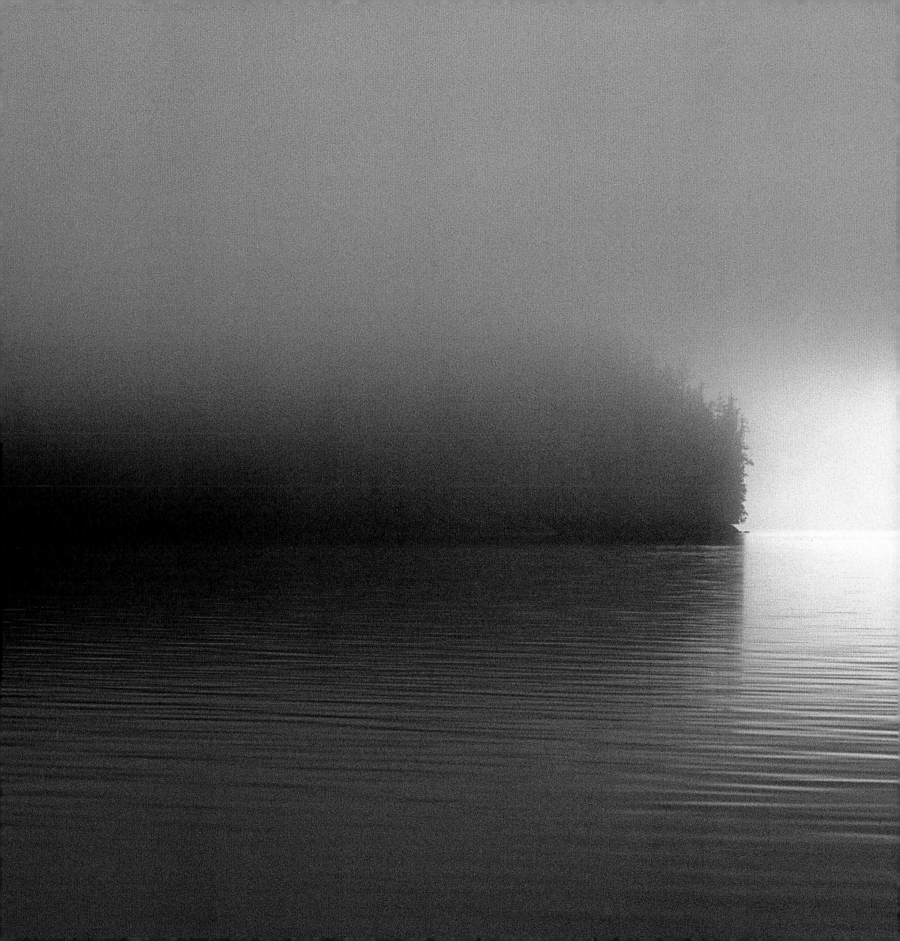

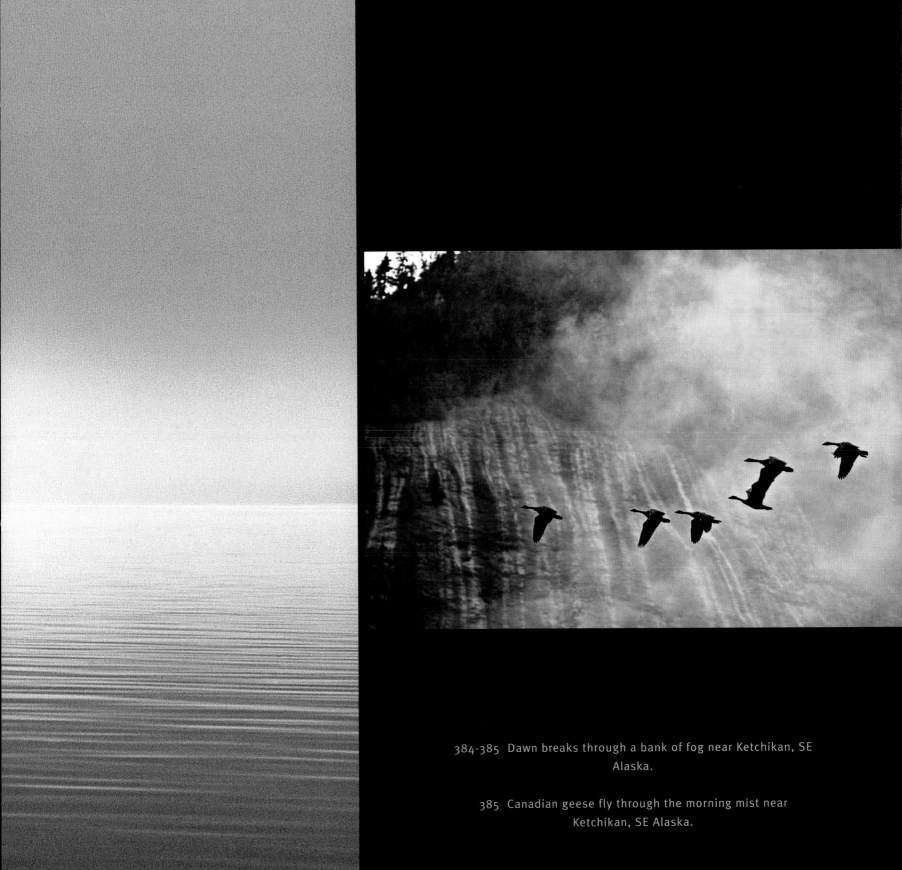

384-385 Dawn breaks through a bank of fog near Ketchikan, SE Alaska.

385 Canadian geese fly through the morning mist near Ketchikan, SE Alaska.

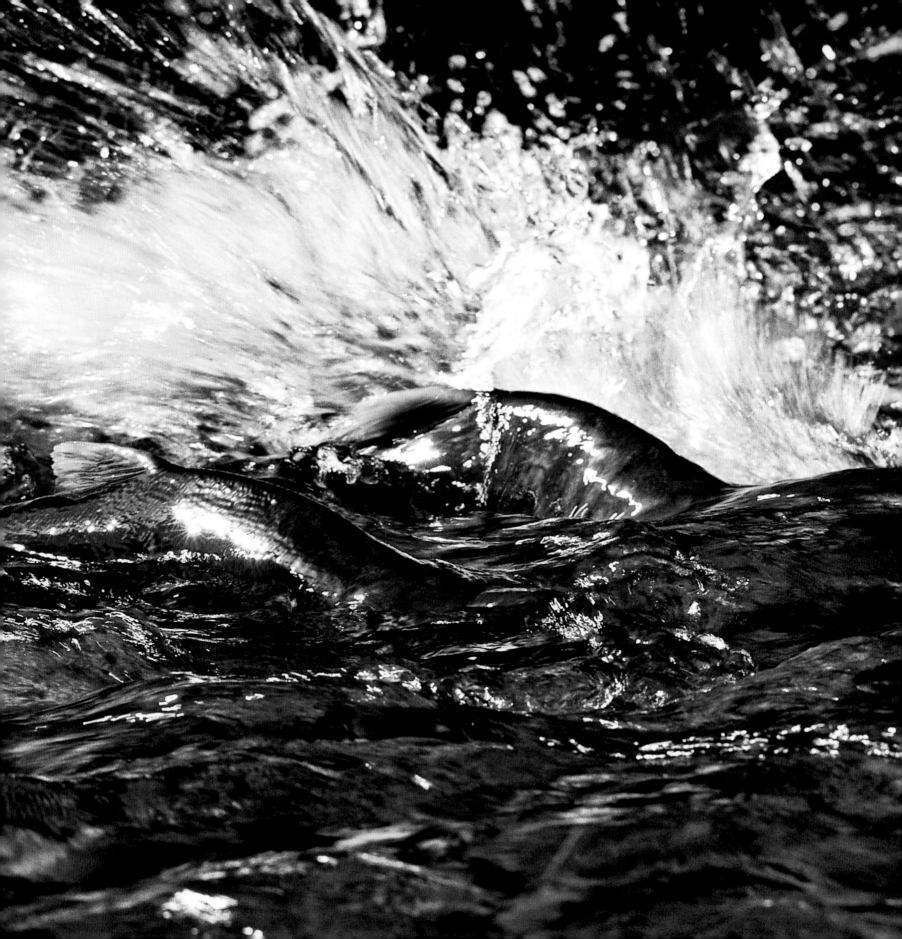

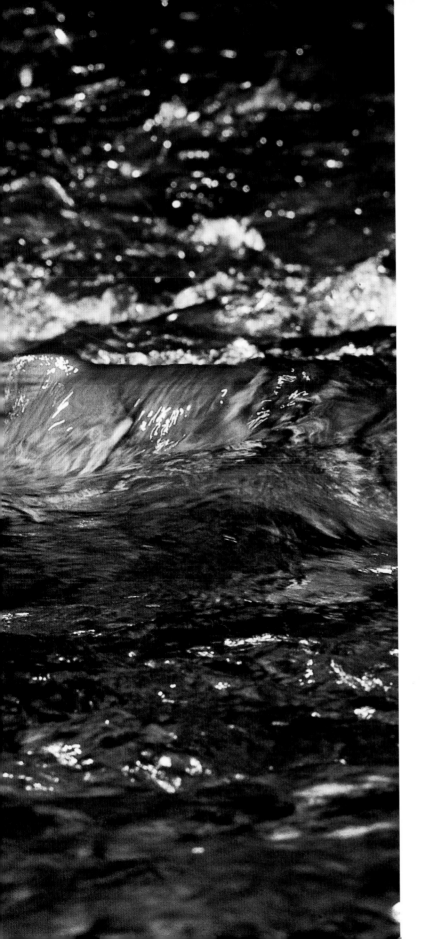

386-387  Pacific chum salmon run up a shallow
stream in British Columbia.

387  Pacific salmon die after they spawn unlike
Atlantic salmon that can return to sea to spawn
again.

388-389  Sockeye salmon, *Oncorhynchus nerka*,
driven by the instinct to spawn, navigates over a
shallow stream-bed toward its home pool
upstream.

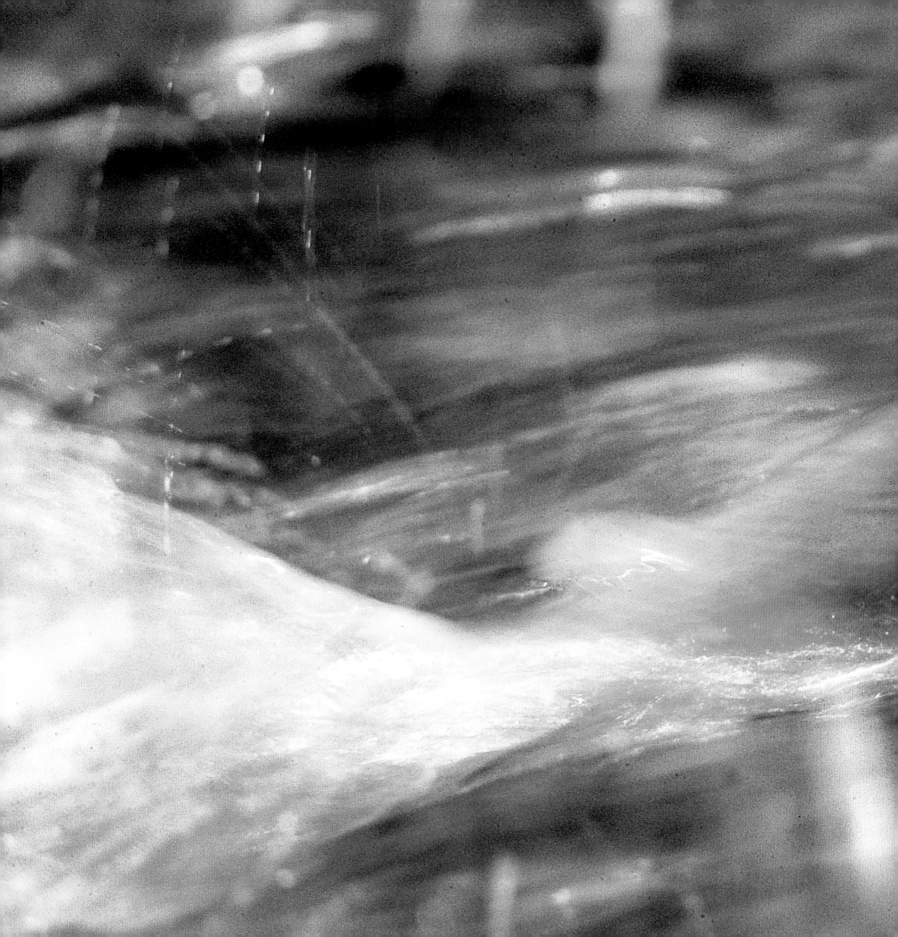

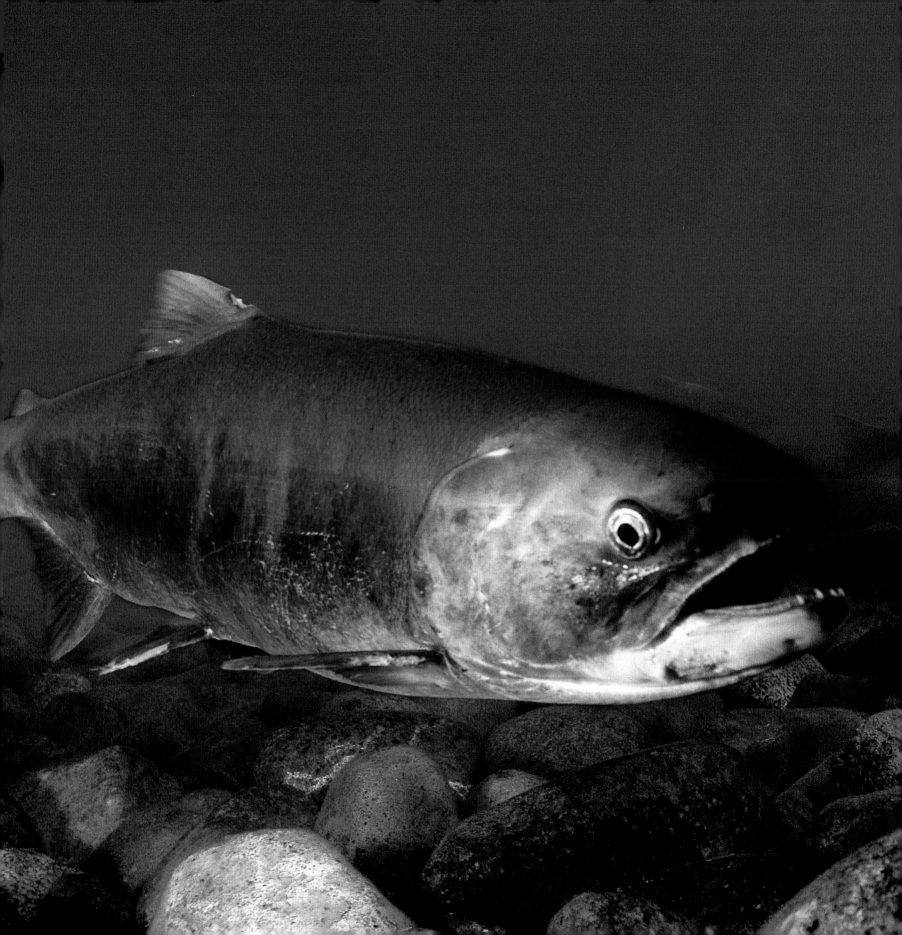

# The dance of life and death

## Pacific salmon spawn and die

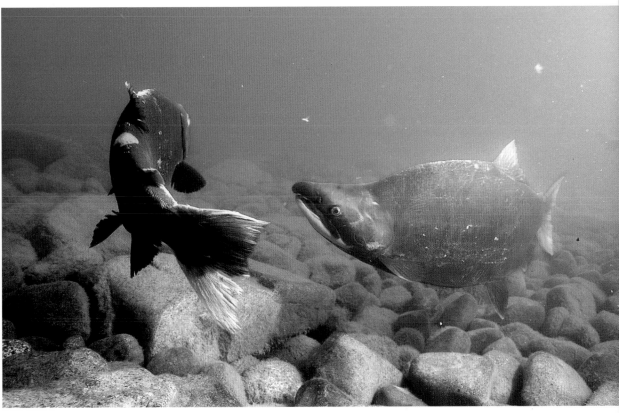

390-391  Female sockeye salmon during mating season.

391  Male sockeye salmon compete for females underwater in a British Columbia stream.

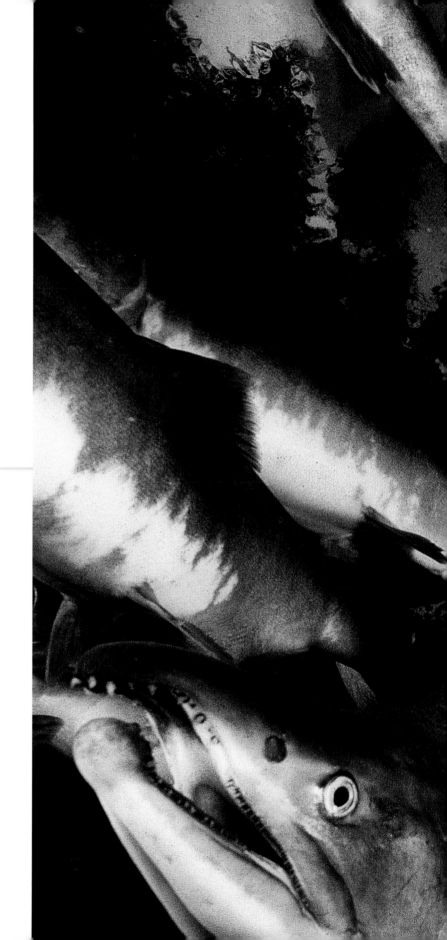

392-393 Chum salmon, *Oncorhynchus keta*, run up a small stream near Ketchikan, Alaska. The trees of the temperate rain forest through which the stream passes.

394-395 Pink salmon, *Oncorhynchus gorbuscha*, swim toward their home pool in SE Alaska.

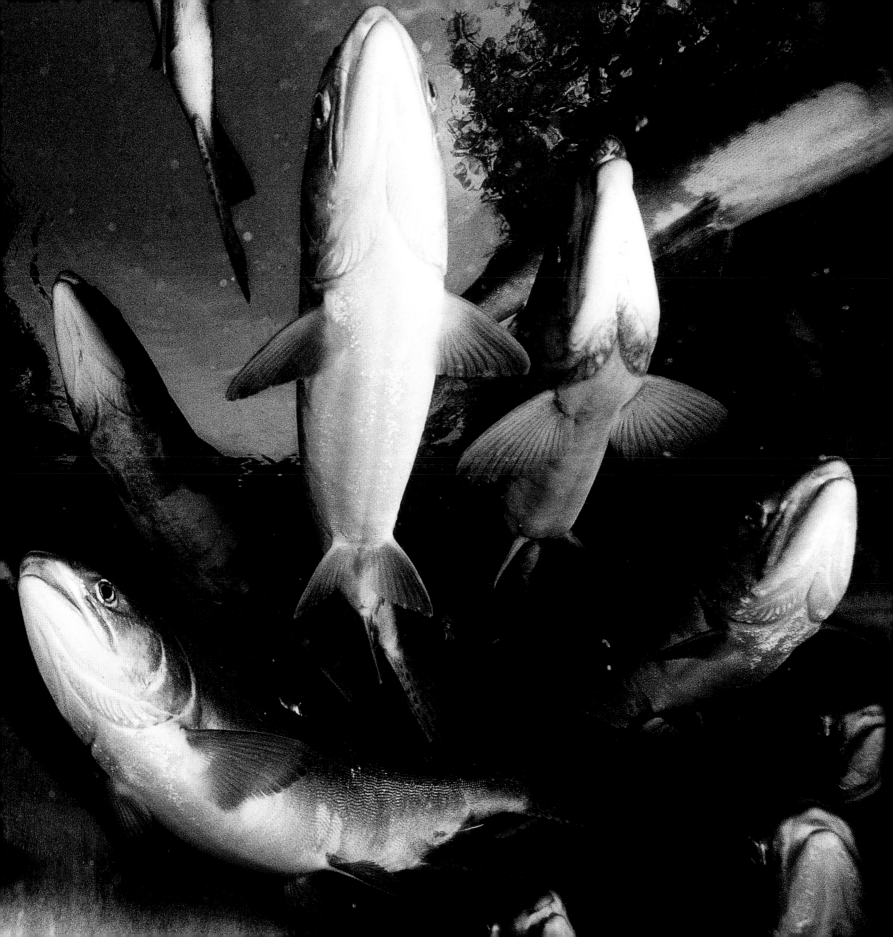

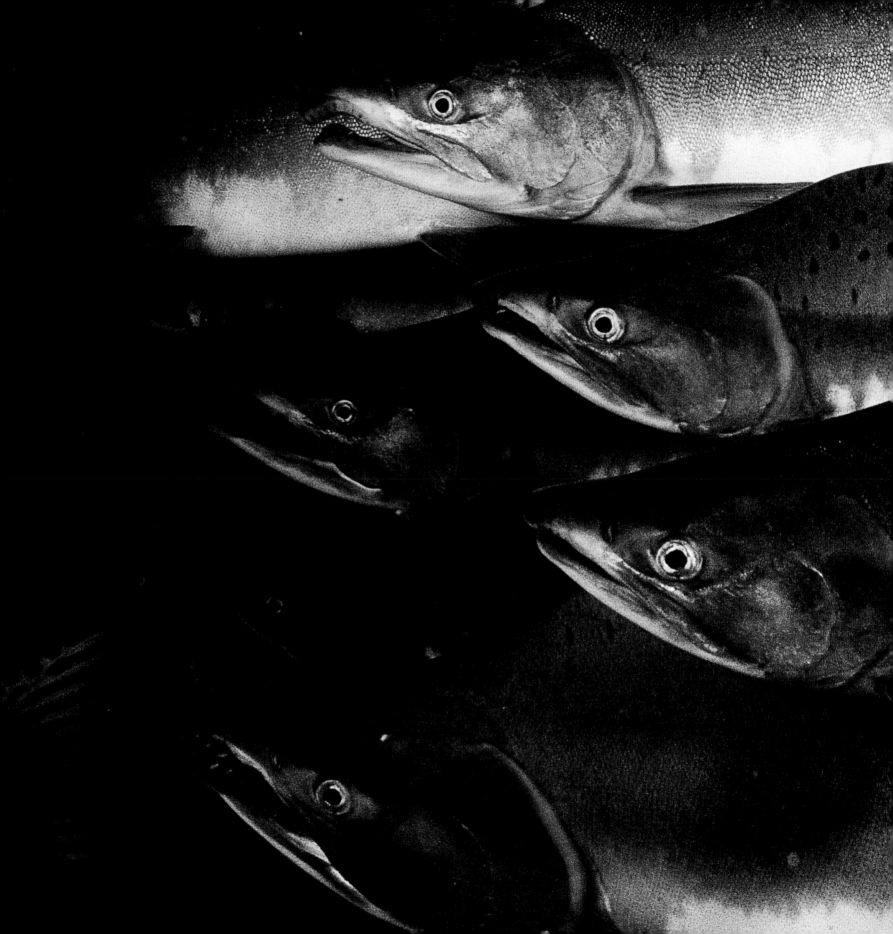

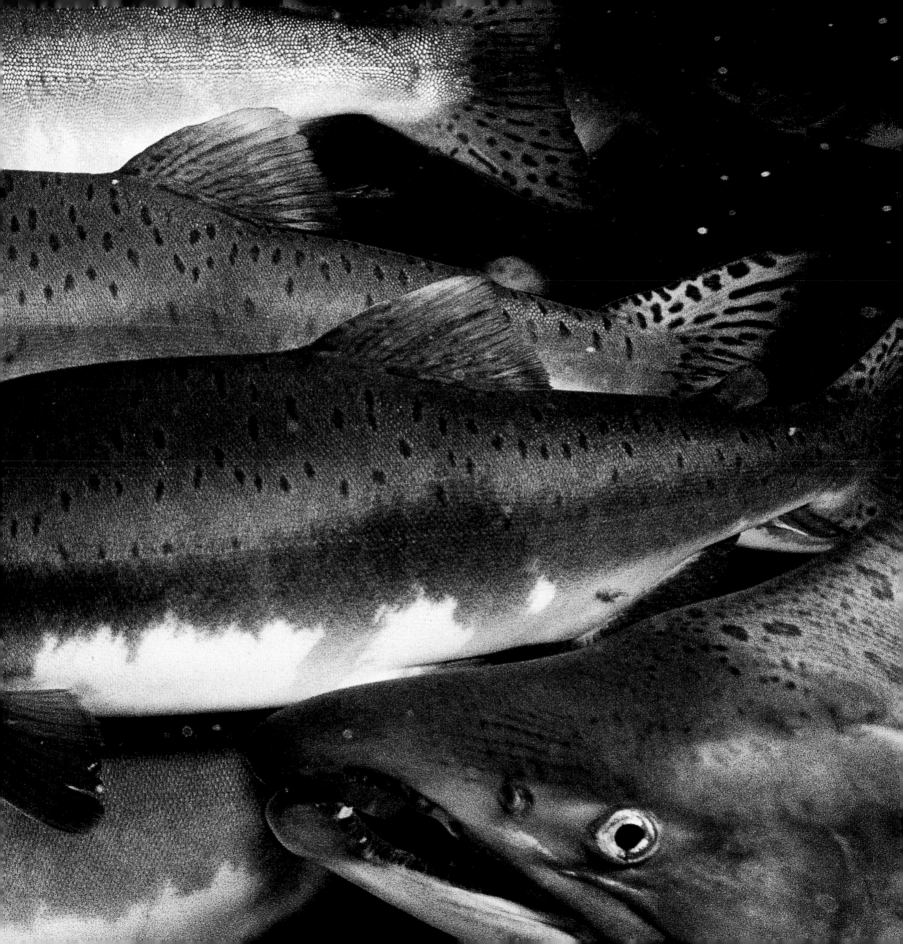

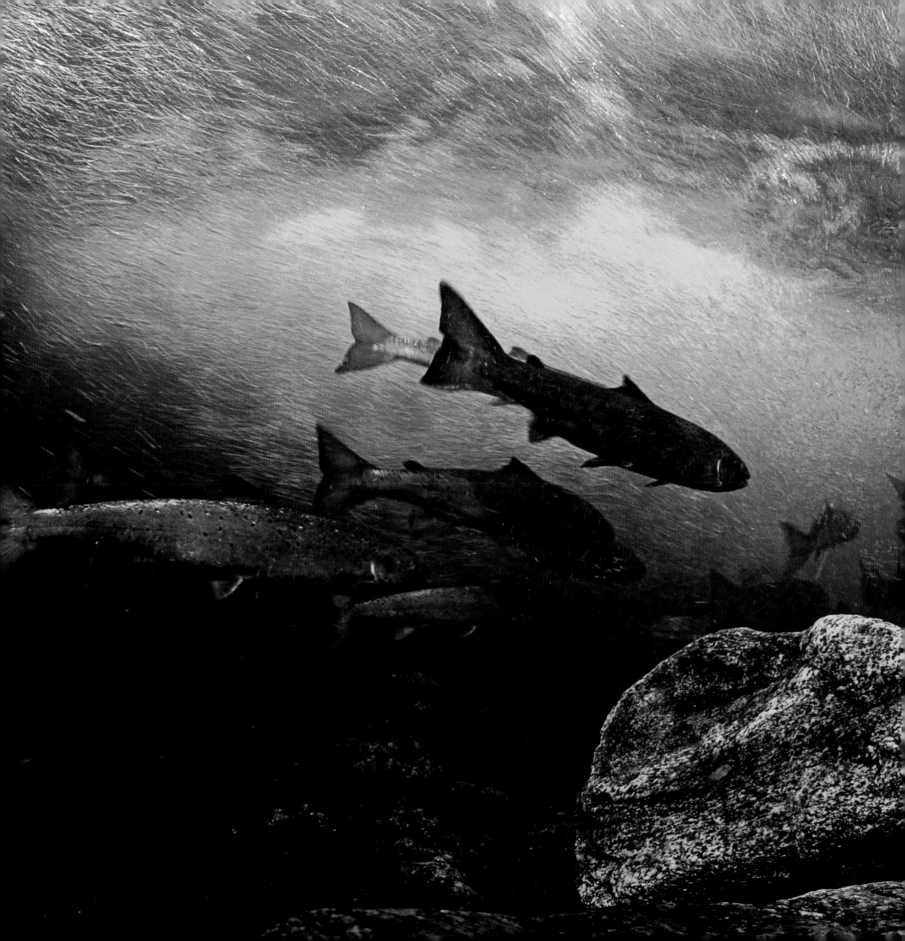

# Swimming through fire
## Atlantic salmon journey home

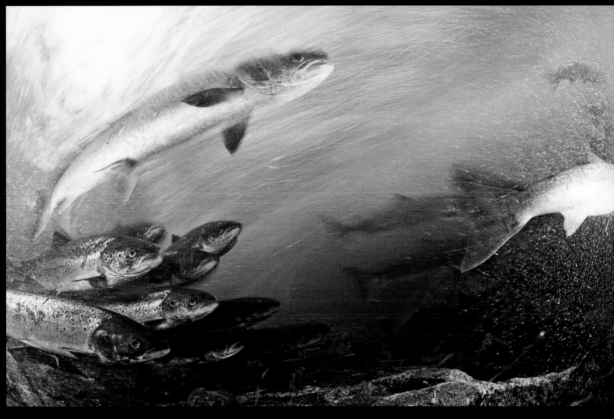

396-397  Atlantic salmon, *Salmo salar*, hold in the current of a river in western Newfoundland in a journey to their home pool.

397  Atlantic salmon travel thousands of miles to reach their home waters to spawn.

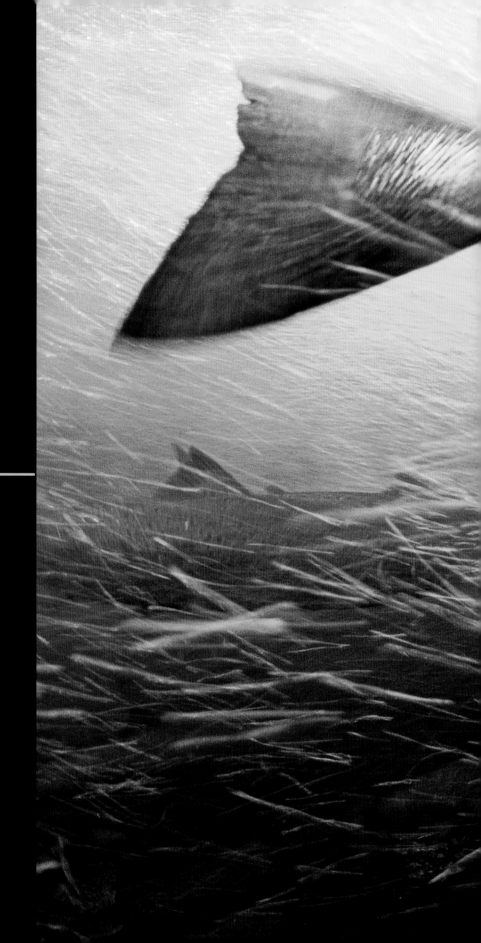

# THE GREAT LEAPER
## BELOW
### *Salmo Salar*

398-399 Atlantic salmon prepare to
leap over a falls on their journey home.
The fire-colored water is from tannin
found in the watershed.

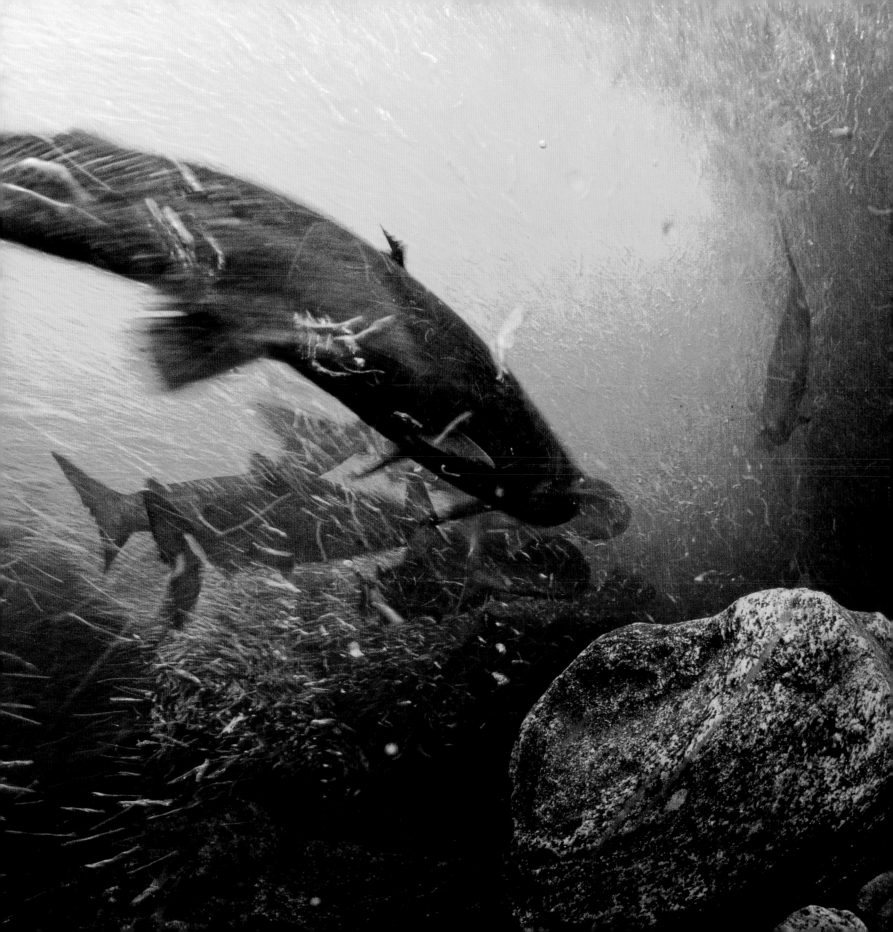

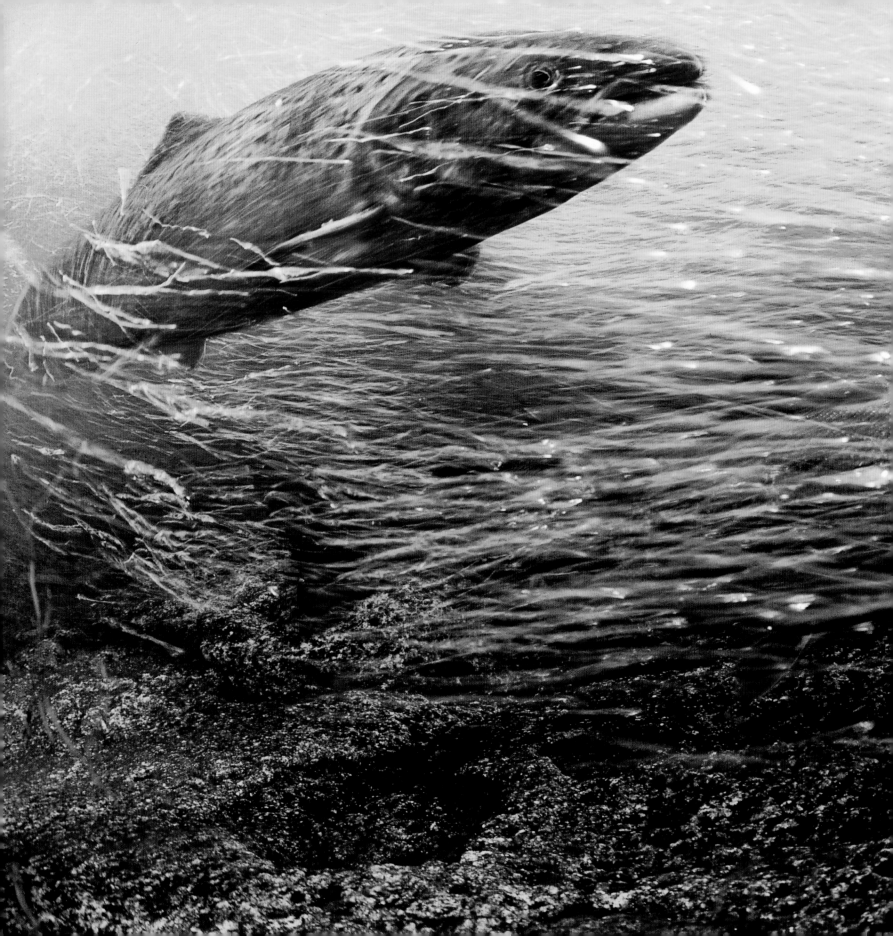

400-401  Silver bubbles generated by the
waterfall above streak by the camera
dome as Atlantic salmon hold in the
current on their journey upstream.

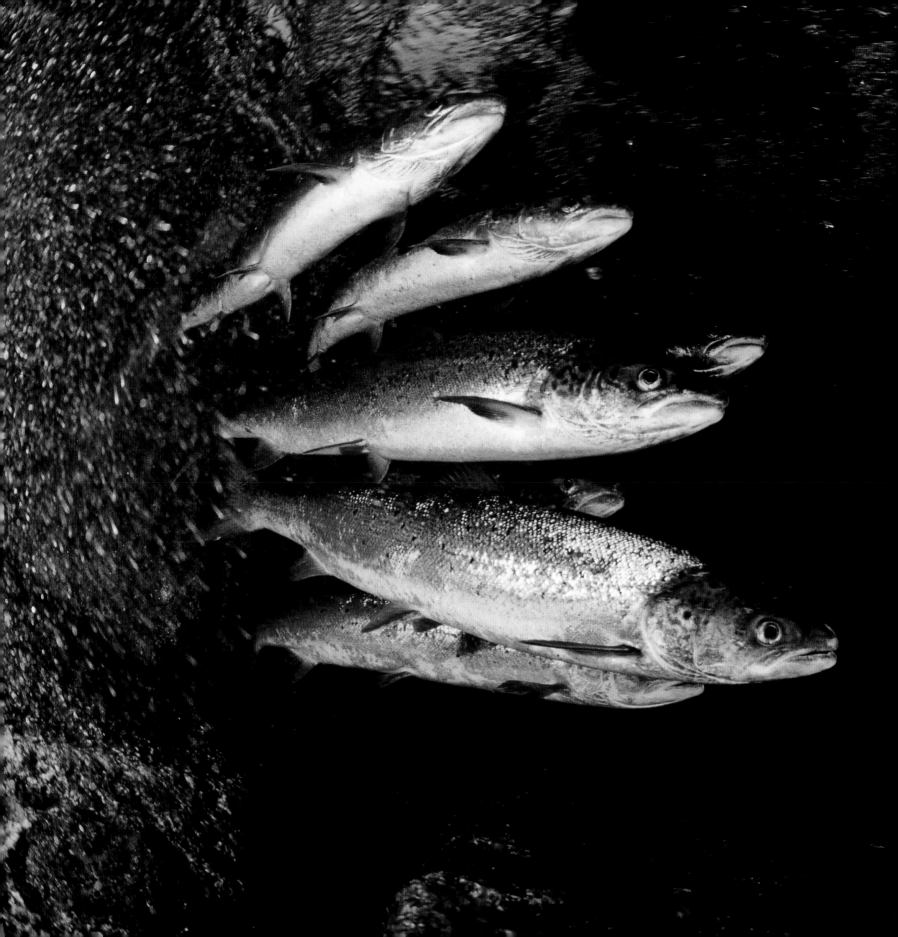

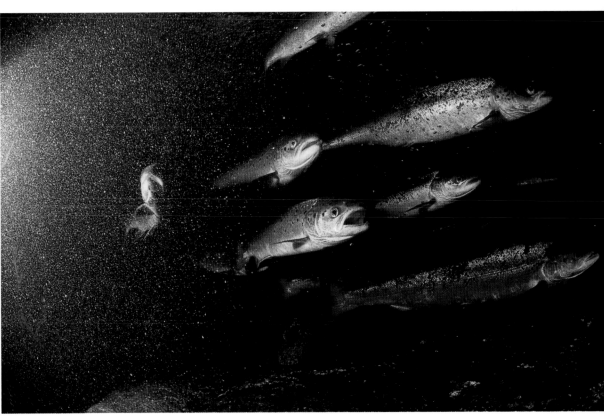

402-403 and 403  Atlantic salmon hold in the current of·their home stream.

404-405  Swimming through the fire. In the golden waters of a small stream, Atlantic salmon are almost home after a journey of thousands of miles across ocean and river.

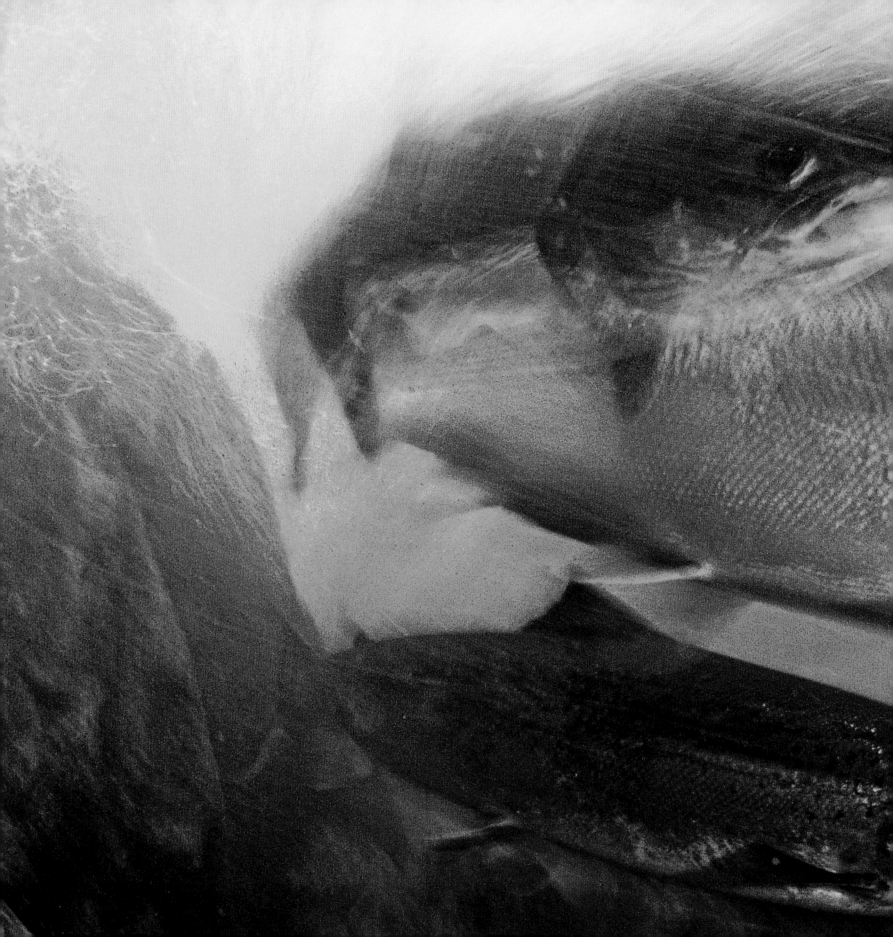

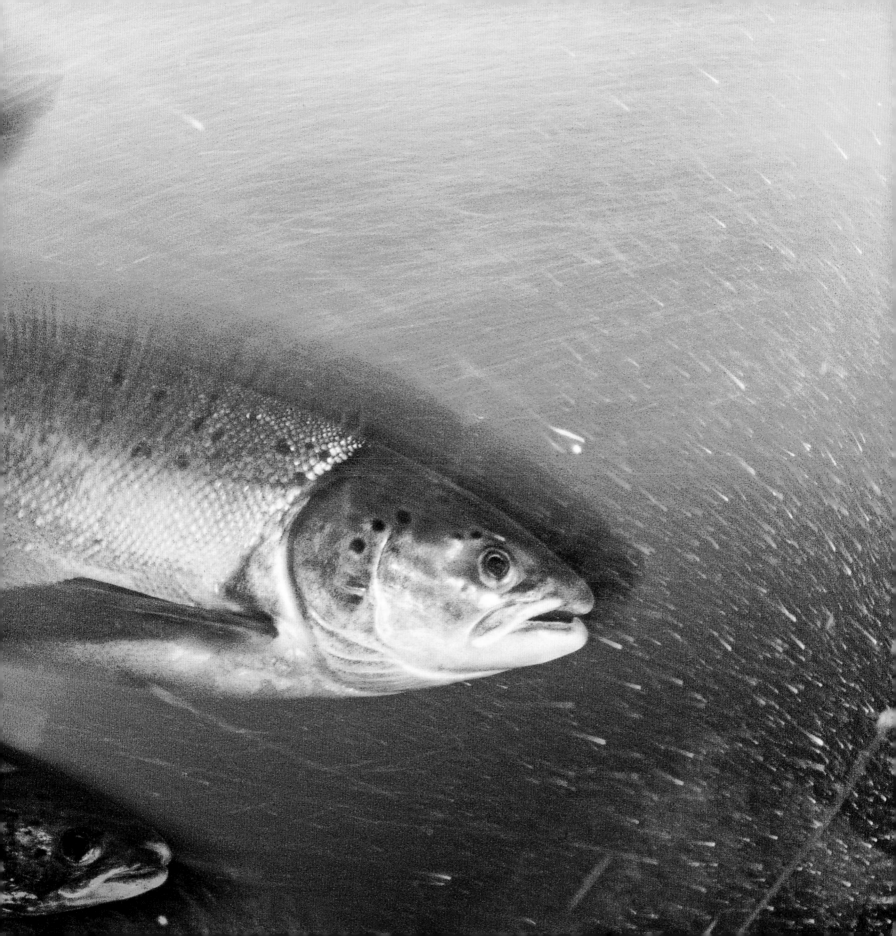

# THE AUTHOR

**B**ILL CURTSINGER was born in Philadelphia, Pennsylvania and grew up in southern New Jersey. He has lived in Maine since 1971. He attended Northern Arizona University in Flagstaff and Arizona State University in Tempe. During the Vietnam War he was a member of the elite Navy Photo Unit, Atlantic Fleet Combat Camera Group based at the Naval Air Station, Norfolk, Virginia. In pursuit of his Naval work he graduated from U.S. Navy Dive School in Key West, Florida and Navy Parachute School in Lakehurst, New Jersey.

Specializing in underwater subjects, he has photographed thirty-three articles, (six cover stories) for National Geographic Magazine. His most recent story on Harbor Porpoises appeared in the June 2003 issue. Other photographs and stories have appeared in Smithsonian, Outside, Time, Newsweek, Life, Audubon, Natural History, Islands, Aqua, Terre Sauvage, Georama Experiment, Unterwasser, Mare, Airone, Stern, Geo, Paris Match, New Look, London Sunday Express, Sinra, Shukan Asahi, BBC Wildlife, Bonniers, and other publications worldwide. He has photographed six other books including *Wake of the Whale*, Friends of the Earth & E.P. Dutton, 1979;

*The Illustrated Pine Barrens*, Farrar, Straus & Giroux, 1981; three Tilbury House titles, *Life Under Ice*, 2003; *Sea Soup Phytoplankton*, 1999; and *Sea Soup Zooplankton*, 2001; and *Monk Seal Hideaway*, Crown Publishers, 1995. He has produced video shorts and clips as well as a library of stock video footage. Bill is a founding member of the Maine based art group "10x10" and a member of the Portland based printmaking cooperative, Peregrine Press. Recent shows include a One Man Show "Elusivity" Three Decades of Nature Photography by Bill Curtsinger

Gold/Smith Gallery, Boothbay Harbor, ME, July 30, to August 25, 2004; Annual 10X10 Group Show June Fitzpatrick Gallery, Portland, ME, April 2-3, 2004; Peregrine Press Group Show, Aucocisco Gallery, Portland, ME. June 3-13, 2004. "Elusivity" Three Decades of Nature Photography by Bill Curtsinger at The National Museum Of Wildlife Art, Jackson, Wyoming, September 29, 2003 to April 19, 2004.

He can often be found in the summer tending to his high bush blueberries after swimming laps in his home pool at the Casco Bay Y.

## PHOTO CREDITS

All photographs are by Bill Curtsinger except the following:
page 28 Top Row-Left: Bora Merdsoy; page 28 Top Row-Right: Chuck Davis; page 28 Bottom Row-Right: Eric Hiner; page 28 Bottom Row-Center: Chuck Nicklin; page 29 Top Row-Left: Ann Hawthorne; page 29 Top Row-Center: Eric Hiner; page 29 Top Row-Right: Heather Perry; page 29 Bottom Row-Left: Bora Merdsoy; page 29 Bottom Row-Center: Joe Stancampiano; page 29 Bottom Row-Right: Photo-Bob Dale; page 41 right: Photo Ann Hawthorne; pages 5, 13, 102, 130-131, 146-147: Bill Curtsinger® National Geographic.

# ACKNOWLEDGEMENTS

This book would not exist without the understanding and support of so many. I want to thank the editors and staff I have worked with over the years at the National Geographic Magazine especially Editor In Chief-Chris Johns for his kind introduction, and to former Editor Bill Garrett and Associate Editor Bob Poole; Thanks to the great Photographic Directors, Bob Gilka, Rich Clarkson, Tom Kennedy, and Susan Smith that I have had the privilege of working under, and photo engineering wizards Joe Stancampiano and Larry Maurer. Thanks to my photo agent, Maura Mulvihill, Director of NGS Image Collection for her leadership at IC and to members of her staff, especially Stacy Gold for her help in getting the original images I needed for this book. And a special thank you to my picture editor, Kathy Moran, natural history guru, who has always managed to find a few great photographs among the not so great.

To my friends and field assistants over the years, I owe much; Bora Merdsoy, Ken Brower, John Botkin, Kitty Courtney, Peter Reinthal, David Anderson, Pam Slaughter, Herb Von Kluge, Alan Lishness, Nan Hauser, Susan McGrath, Chuck Davis, Terrie Klinger, Allan Macintyre, Sue Barnes, Eric Hiner, and field and office assistant Heather Perry. They have joined me in this quest and lived the moments both high and low that reside in such an adventure. It was Heather along with my dear friend, Eileen Monahan, who kept things from coming unglued here at home these last few years, just when I thought they might. To them I offer the most heartfelt thank you I can invoke here on this page.

In the summer of 2004, when I first sat down at a light table with White Star co-founder and editorial director, Valeria Manferto De Fabianis, in Vercelli, I noticed that almost without fail she paused or went back to every single photograph in the slide sheets I submitted that was meaningful and important to me. These included many images that have never been published before and many images that would be considered by some to be too "extreme." I sensed that my vision was her vision and I knew then that I was in good hands. Her wonderful sense of imagery and of design made this book one I am extremely proud of. And to her co-founder and White Star publisher, Marcello Bertinetti who came to me in the summer of 2004 knowing my work very well, with a plan to publish these images and so, Marcello, here it is and I thank you for honoring my work in this way. Thanks to Maria Valeria Urbani Grecchi of White Star, my handler, point-person, primary contact at White Star, who, along with Heather Perry, kept me, and this project on track and moving ever forward.

And to my friend and fellow photographer Jeff Rotman, thanks for planting the seed.

I dedicated my first book, Wake of the Whale published by the great nature book publisher and conservationist, David Brower in 1979, to my wife with these words; " ...And to Kate, who showed her silkie friend the heart, I owe all. This book is for her." And this book too is for her. She supported this quest and my dreams in more ways then I can say. Her art, her love and her laughter are entwined herein for all to see. But the book you are holding in your hands is for my two sons, Justin and Owen. Unbeknownst to them are the many wonderful gifts they have given me over the years, gifts too large to write of here. I see in them their beautiful mother, her incredible smile and I am reminded of her through them each day, a powerful enough gift in itself. Like their parents, they are both sensitive observers and creative travelers. I can imagine wonderful things coming from their art and their insightful nature. I wish their journey to be as rewarding and as fulfilling as mine. So to you, Justin and Owen I dedicate this book. May the force be with you forever.

408 Spotted dolphins curiously swim to me in the deep, blue waters off Hawaii. Moments like this, when a wild, free-swimming oceanic species with a relatively large brain decides to investigate the investigator makes one wonder about the universe and our perceived place at the top of it all.

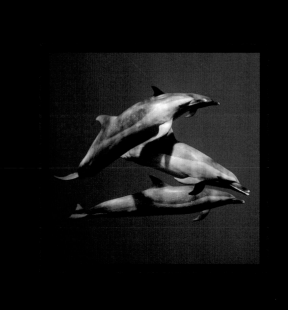